THE RUTHWELL CROSS

INDEX OF CHRISTIAN ART

OCCASIONAL PAPERS I

The Ruthwell Cross

PAPERS FROM THE COLLOQUIUM

SPONSORED BY THE INDEX OF CHRISTIAN ART

PRINCETON UNIVERSITY

8 DECEMBER 1989

·

EDITED BY

Brendan Cassidy

INDEX OF CHRISTIAN ART

DEPARTMENT OF ART AND ARCHAEOLOGY

PRINCETON UNIVERSITY

Library of Congress Cataloging-in-Publication Data

The Ruthwell Cross : papers from the colloquium sponsored
by the Index of Christian Art, Princeton University,
8 December 1989 / edited by Brendan Cassidy
p. cm. — (Occasional papers / Index of Christian Art)
Includes bibliographical references and index.
ISBN 0-691-03211-4. — ISBN 0-691-03211-4 (cl.). —
ISBN 0-691-00038-7 (pbk.)
1. Crosses—Scotland—Ruthwell—Congresses. 2. Ruthwell
(Scotland)—Antiquities—Congresses. 3. Christian art and
symbolism—Scotland—Ruthwell—Congresses.
4. Sculpture, Anglo-Saxon—Scotland—Ruthwell—
Congresses. 5. Art, Anglo-Saxon—Scotland—Ruthwell—
Congresses. I. Cassidy, Brendan. II. Princeton University.
Dept. of Art and Archaeology. Index of Christian Art.
III. Series: Occasional papers (Princeton University. Dept. of
Art and Archaeology. Index of Christian Art).
CC315.5.R56 1992
730′ .9414′86—dc20 92-34870

This book is printed on acid-free paper,
and meets the guidelines for permanence and
durability of the Committee on Production Guidelines
for Book Longevity of the Council on Library Resources.
Printed in the United States of America
by Princeton University Press
Princeton, New Jersey 08540

10 9 8 7 6 5 4 3 2 1

Contents

•

Preface

•

INTEREST in the culture of the Anglo-Saxons has never been greater. In the past decade several major exhibitions and textbook surveys have been devoted to aspects of their civilization. Among the finest manifestations of Anglo-Saxon art is the Ruthwell cross. Although isolated in a remote corner of Scotland, it bids fair to being the most discussed example of early medieval sculpture in Europe, as the copious bibliography at the end of this volume will attest.

By a happy chance, in the winter of 1989 four scholars who had written about the Ruthwell cross from the vantage of their different disciplines happened to be either in Princeton or within commuting distance. Rather than flout the astral powers that had brought this coincidence into being, the Index of Christian Art decided to take advantage of the opportunity to hold a colloquium.

The speakers were Paul Meyvaert, who explored the exegetical context in relation to the iconography of the cross and whose article of 1982 had rekindled the debate about its meaning; David Howlett, who drew attention to rather sophisticated patterns of significance in the arrangement of the inscriptions; Robert Farrell, who cast the eye of the archaeologist on what remained of the cross to issue a caution to those inclined to see there more than the surviving sculpture and inscriptions would warrant; and Douglas Mac Lean, who brought to the discussion a knowledge of the historical geography of the part of the country in which the cross was erected in order to draw out the implications for the still-disputed question of its date.

The papers published here, with the exception of the editor's chapter, represent the contributions to that colloquium. To the four authors I should like to express my warmest appreciation not only for the enthusiasm with which they entered into the project but also for the tolerance they showed to the neophyte in their area of expertise who had presumed to be their editor.

Several colleagues contributed to the success of the colloquium. When the papers were delivered at Princeton a number of scholars who had written on the Ruthwell cross or were specialists in Anglo-Saxon and early medieval art were co-opted to respond to the four speakers; to all of them I should like to express my thanks: to Jonathan Alexander, John V. Fleming, Kristine Edmondson Haney, Lawrence Nees, Jane Rosenthal and Amy Vandersall. To my colleagues at the Index who got involved in the organization of the colloquium and the subsequent publication of the papers I offer my gratitude, but especially to Marie Holzmann who was indefatigable in ensuring that everything ran to plan and to John Blazejewski who

dealt with my requests for yet another photographic detail of the cross with his usual inde-structible good humor. Adelaide Bennett was helpful in answering my questions on liturgical matters. Amy Cassens' graphic skills greatly improved the appearance of some of the diagrams in the text. At Princeton University Press, Elizabeth Powers has been a constant source of help and wise advice. At Ruthwell the Rev. Robert Nicol and Mrs. Mary Martin, the curator of the local museum, made my visit to the cross pleasurable and instructive. Michael Evans of the Warburg Institute came quickly to our assistance when we needed photographs.

Without the financial support of the Department of Art and Archaeology through its Publications Committee, and the interest of the chairman, Yoshiaki Shimizu, this volume would not have appeared.

For her forbearance I remain ever grateful to my wife, Ann Gunn, who, for longer than should be expected, has tolerated the intrusion of these large blocks of sandstone into our home life.

Finally, my greatest debt is to two people who have lived with the Ruthwell cross as long as I have and have made my involvement in this publication an especial delight. Christopher Moss, responsible for publications within the department, has employed his boundless energy and his enviable array of skills both technical and human to see this volume through the press. To Katherine Kiefer my obligation is equally great. A resourceful bibliographer, punctilious copy-editor, and clear-headed critic of muddled ideas and infelicitous prose, she invariably acted as a tonic when the spirit sometimes flagged.

<div align="right">BRENDAN CASSIDY</div>

List of Figures in Text

•

List of Plates

•

1. Ruthwell church, west front, main entrance (photo: Brendan Cassidy)

2. Ruthwell church, north and west views (photo: Brendan Cassidy)

3. Ruthwell church, interior view from west entrance showing the south and west sides of the Ruthwell cross (photo: Brendan Cassidy)

4. Ruthwell church, interior view showing the south side of the Ruthwell cross (photo: Brendan Cassidy)

5. Ruthwell church, interior view from east end showing the south and east sides of the Ruthwell cross (photo: Brendan Cassidy)

6. Ruthwell cross, south side (photo: after Mercer [1964] pl. XLII)

7. Ruthwell cross, as erected by Duncan in the garden of the manse, ca. 1823–1887, north side (photo: after Dinwiddie [1933], fig. facing p. 107)

8. Ruthwell cross, as erected by Duncan in the garden of the manse, ca. 1823–1887, south and west sides (photo: after Baldwin Brown [1924], pl. xv)

9. Wax model of the Ruthwell cross made by Henry Duncan, shown here with Duncan's descendant, Hugh Duncan F.R.I.B.A., the present owner (photo: courtesy of Mrs. Mary Martin, Curator, Ruthwell Museum)

10. Detail of Duncan's wax model: the figure with the lamb (photo: courtesy of Mrs. Mary Martin, Curator, Ruthwell Museum)

11. Ruthwell cross, south side, top section (photo: Durham University, Department of Archaeology)

12. Ruthwell cross, south side, The Archer and Martha and Mary or Visitation, detail (photo: Durham University, Department of Archaeology)

13. Ruthwell cross, south and east sides, The Archer and Martha and Mary or Visitation (photo: University of London, Warburg Institute)

14. Ruthwell cross, south side, Martha and Mary or Visitation, detail (photo: Robert T. Farrell)

15. Ruthwell cross, south side, Martha and Mary or Visitation (photo: University of London, Warburg Institute)

16. Ruthwell cross, south side, Christ and Mary Magdalene, and lower part of Martha and Mary or Visitation (photo: Durham University, Department of Archaeology)

THE RUTHWELL CROSS

The Later Life of the Ruthwell Cross:
From the Seventeenth Century
to the Present*

•

BRENDAN CASSIDY

THE RUTHWELL CROSS stands today in the little church on the edge of the village
of Ruthwell, just south of Dumfries, on the site for which, most probably, it was made.
Returned there in 1887 after a period of neglect in the churchyard, it rises, at seventeen feet
and four inches in height, almost to the roof of the church from a four foot deep well set into
the floor of the apse behind the altar. With the comparable cross at Bewcastle it is undoubt-
edly the most important sculptural survival from Anglo-Saxon Britain and arguably from
early medieval Europe. Constructed of two blocks of local sandstone, joined just above the
principal figure of Christ on the beasts (seen most clearly in Pls. 20 and 23), it is ornamented
on all four sides with images and inscriptions in both Latin letters and runes. Partly because
of the extensiveness of the iconographic program and the epigraphy, and partly because its
checkered history has left the carvings and inscriptions scarred and incomplete, almost every
aspect of the cross has been the subject of scholarly controversy. There is still uncertainty
about what is actually represented in some of the sculpted panels and opinions continue to
accumulate about the message the cross was intended to convey.

The substantial bibliography on the cross, that expands from a trickle in the seventeenth
century to a flood in the late nineteenth and twentieth centuries, allows us to chart its recep-
tion across that period. Initial bewilderment gradually gave way to understanding as the
meaning, first of the inscriptions and then the imagery, was decoded. The violent religious
hostility of the mid-seventeenth century was followed by a period of benign neglect and later
an era of discovery and reappraisal that culminated in the canonization of the cross in 1887
when it was declared a national monument under the "Ancient Monuments Protection Act,
1882." As its unique importance came to be appreciated, the volume of exegesis it inspired
increased proportionately. Often the interpretations more clearly reflected the sectarian and
nationalistic predispositions of the writers than attributes of the cross itself. This essay at-
tempts to chart the scholarly successes and failures in the long tradition of study of the cross,

* I should like to thank Ann Gunn, Katherine Kiefer, and Paul Meyvaert, who read this article in draft form and made
valuable suggestions for its improvement.

the changing patterns of reaction to it, and the sometimes misguided attempts to unlock its secrets.

It is ironic that the documented history of the Ruthwell cross, apart from Reginald Bainbrigg's brief remarks of ca. 1600,[1] begins, after almost a millennium of silence, in its darkest hour, when it was being tumbled and broken in accordance with an edict of the Church of Scotland "anent . . . idolatrous monuments in the Kirk of Ruthwell."[2] We first hear of it when sentence is being passed on its destruction and its long life as an object of Christian devotion is coming to an end. That the cross should have been singled out by the elders of the Kirk for special mention in the Act of 1642 may indicate something of its celebrity and the reluctance of Ruthwell's parish minister to comply with a previous order of 1640.[3]

The Rev. Gavin Young, although he ultimately had to obey the iconoclastic biddings of his superiors of 1642, preserved the tumbled fragments of the shaft so that the cross was not entirely lost to sight. The bulk of its eighteen-foot length lay within the church providing seating for the parishioners until 1771 when, during the incumbency of the then minister, Dr. Andrew Jaffray, the two larger pieces were hauled out to the churchyard in order to clear the way for a paved floor and more conventional pews.[4] There it lay for some thirty years before its reconstruction in the garden of the manse, where it stood for another eighty-five years before being reinstalled in the church whence it came.

EARLY TRAVELERS AND ANTIQUARIANS

Throughout the seventeenth and eighteenth centuries the broken cross attracted the attention of a handful of antiquarians and travelers. In the beginning the interest was mainly local. Occasional visitors like Mr. Hamilton of Orbeston and Dr. George Archibald of Dumfriesshire recorded their impressions of the mysterious object.[5] However, travel to a remote village in Dumfriesshire was scarcely to be contemplated until well into the eighteenth century.

[1] See Page (1959b).

[2] The edict of 1642 survives in a manuscript in the Scottish Record Office in Edinburgh, the relevant passage from which was published by Meyvaert (1982), 4–5, from information supplied him by Dr. Horn, the Assistant Keeper. "Anent the report of idolatrous monuments in the Kirk of Ruthwell the Assemblie finds that the monument therein mentioned is idolatrous, and therefore recommends to the Presbyterie that they carefully urge the order prescrived by the Acts of Parliament anent the abolishing of these monuments, to be put to execution." The title of the edict appears in the *Index of the principal acts of the Assembly holden at St. Andrews, 27 July, 1642, not printed*, which is appended to *The Acts of the General Assemblies of the Church of Scotland, from the Year 1638 to the Year 1649 Inclusive*, published in 1691.

[3] See Church of Scotland (1682). The relevant passage is also published in Meyvaert (1982), 4.

[4] Dinwiddie (1909–10), 113.

[5] See Mitchell and Clark (1906–08), 187, 189, 205. Both Hamilton and Archibald must have seen the cross before 1749, which is the date inscribed on the manuscript of vol. III of Walter Macfarlane's *Geographical Collections*. On Archibald see McKerrow (1936), 65, who says he lived in the middle of the seventeenth century and wrote an "Account of the Curiosities of Dumfries."

Only the prodigious enthusiasm of William Nicolson, sometime Bishop of Carlisle and the first teacher of Anglo-Saxon at Oxford, could have led him to make the journey to Ruthwell twice, in 1697 and 1704.

With the Turnpikes Act and the network of roads constructed by General Wade in the 1720s, and following the Jacobite Rebellion of 1745, it became possible to travel more conveniently in Scotland. In the second half of the eighteenth century, the books of views published by Paul Sandby and Francis Grose helped create a taste for Scottish scenery that loosed upon the country an invasion of sightseers and seekers after the Picturesque and the Sublime.[6] Dumfriesshire, bestriding the route between Glasgow and England, was one of the entry points to the north and was especially well-served by roads. Through Ruthwell itself there passed at least three major thoroughfares: the high road from Dumfries to Annan, the military road connecting Portpatrick with Gretna Green which was built between 1763 and 1765 along the route of an earlier road,[7] and, from 1791, a third road going north to Dumfries.[8] But despite this greater accessibility and the frequent use of the roads by tourists, only a very few of those whom we know to have been in the vicinity of Ruthwell were inclined to turn off the road to visit the cross. Or, if they did, they did not find it sufficiently impressive to deserve mention.[9]

This is hardly surprising. Until the Rev. Henry Duncan's reconstruction of the cross in the garden of the vicarage in 1802 it must indeed have presented a pitiful sight; partly sunk in the clay floor of the kirk until 1771 and later abandoned to the mosses and lichens of the churchyard. Only an occasional divine like Richard Pococke, Bishop of Meath, alerted to the cross's existence by the engraving in Alexander Gordon's *Itinerarium*, was tempted to visit the church.[10] Likewise the indefatigable Thomas Pennant, following on the enormous success of his *Tour in Scotland* of 1769, resolved on a second journey "to make a visit to the places I have not yet seen." In preparation for this he published an open letter in the *Scots Magazine* of April 1772 requesting to be notified of things worth seeing, and, presumably as a result, his

[6] By 1773 tourism had clearly become something of a nuisance. Lord Breadalbane wrote to his daughter: "We have had a great deal of company here this summer, sixteen often at table for several days together; many of them from England, some of whom I knew before, and others recommended to me, being on a tour thro the Highlands which is becoming Le bon ton, but sometimes a little troublesome," as cited in J. Holloway and L. Errington, *The Discovery of Scotland. The Appreciation of Scottish Scenery through Two Centuries of Painting*, exh. cat., National Gallery of Scotland, Edinburgh (1978), 63.

[7] See W. Taylor, *The Military Roads in Scotland*, London (1976), 100–111.

[8] Information on Ruthwell's roads was provided in 1792–93 by the Rev. John Craig, the minister of Ruthwell, in his contribution to *The Statistical Account of Scotland*; see Sinclair (1794, repr. 1978), 450.

[9] For travelers in Dumfriesshire see M.-H. Thevenot-Totems, *La decouverte de l'Ecosse du XVIII^e siècle a travers les recits des voyageurs Brittaniques*, Paris (1990), passim. Among the more distinguished visitors to the area were Daniel Defoe, who records his visit to Caerlaverock Castle a few miles from Ruthwell; Lady Oxford in 1745; and William Gilpin, "the venerable founder and master of the picturesque school" in 1776.

[10] See the Bishop's letter of May 1760 to his sister in Pococke (1887), 32. It is not informative. Here I give the relevant part: "On the 7th I went to Ruthvel Church to see an extraordinary square obelisk, broken in two, which is engraved in Gordon, to which I refer for an account of it, on which there seems to have been a cross. It is 12 ½ ft. long, 1 ft. 10 ins. at bottom, and one foot three inches at top another way, and was put in a round base which is in the church." The round base is probably that which is engraved in Duncan (1833), and in his time was referred to as the pedestal of a baptismal font (see Pl. 41).

second itinerary included a visit to Ruthwell.[11] For a professional tourist and writer of guide-books like Pennant, an unusual runic stone offered some interest, but the Ruthwell cross was clearly not numbered among the obligatory sights to be seen by a typical tourist on a Scottish progress.

Indifference to the cross continued into the early decades of the nineteenth century. Occasionally it was referred to by philologists and historians, but they tended to know it only at second hand from the few illustrated accounts that had been published since 1703.[12] The turning point in its fortunes came in 1833. In this year the Rev. Henry Duncan published a descriptive essay on the cross accompanied by accurate engravings which brought it to the attention of a much wider audience and paved the way for John Mitchell Kemble's remark-able explanation of the runic inscription a few years later.

The earliest witnesses of the cross wrote more with enthusiasm and imagination than with knowledge. Such an enigmatic object with its indecipherable runes stood so far outside the experience of most antiquarians that their attempts to explain it provide little more than a reiteration of the popular lore that had grown up around it. Its provenance was for long shrouded in the same mystery as the runes. William Nicolson, who supplied George Hickes with a transcript of the Ruthwell runes for his treasury of old northern languages, recorded in his diary some of the local legends attached to the cross:

> The common Tradition of ye Original of this stone is this: It was found, letter'd and entire, in a Stone-Quarry on this Shore (a good way within ye Sea-mark) call'd Rough-Scarr. Here it had laid long admir'd, when (in a Dream) a neighbouring Labourer was directed to yoke four Heifers of a certain Widow yt liv'd near him; and, where they stop'd with yir Burthen there to slack his Team, erect ye Cross & build a Church over it: All of which was done accordingly. I wonder'd to see a Company of Modern Presbyterians (as ye present parishioners profess ymselves to be) so steady in this Faith; and even to believe, yet farther, yt the Cross was not altogether so long (at its first erection) as it was afterwards: But that it miraculously grew, like a Tree, till it touched the Roof of the Church.[13]

The legends of the cross's origins existed in other recensions that included more or less plau-sible variations in the episodic detail. Another version had it that the cross was being trans-ported by sea from some distant place when it was shipwrecked and washed up on the banks of the Solway at a place called Priestwoodside. The pillar was erected on the spot, but when it was decided to remove it further inland the widow's oxen were recruited for the task. When the tackle gave way it was interpreted as a sign and the cross was re-erected where it chanced to fall and the church of Ruthwell raised over it.[14] Pennant records a story that takes the

[11] Thevenot-Totems (as in n. 9), 109.

[12] The illustrated essays are those of Hickes (1703), Gordon (1726), Gough (1789), Duncan (1833), and Stuart (1856–67). Among the philologists who mention the cross is Sjöborg (1822), 34, with reference to Hickes. The historian Chalmers (1807) cites Gordon's *Itinerarium*.

[13] Nicolson (1902), 196.

[14] The legend was often repeated in the literature: see the Rev. John Craig's account of Ruthwell parish in Sinclair (1794, repr. 1978), 456; Duncan (1833), 317; Haigh (1857), 167; Barbour (1899–1900), 28.

myth of origin further into the realm of the miraculous. In this account, the cross, like the Santa Casa at Loreto and the Volto Santo of Lucca, was transported to Ruthwell by Angels.[15]

The stories, drawn from an oral tradition spanning centuries, were a common way of explaining the existence of an object both alien in appearance and of an antiquity that transcended local memory.[16] The topoi of the Ruthwell legends, of dreams and shipwrecks and the sudden recalcitrance of oxen, appear to be drawn from the mythology of other Northumbrian cult objects. The Lindisfarne Gospels, according to Simeon of Durham, were lost at sea, again in the estuary of the Solway, and rediscovered on the shores of Whithorn after Saint Cuthbert appeared in a dream to a monk.[17] And the relics of Saint Cuthbert himself were reputedly being borne by a cow that came to a halt on the site where Durham Cathedral was later erected.[18] In the case of the Lindisfarne Gospels the legend may have some basis in fact. Of the cross, however, there can be no doubt of its local manufacture. The grey and red sandstone from which it is carved is the product of quarries near Ruthwell.[19]

The very singularity of the cross inclined some writers to grant to the stories of shipwrecks and widows' cows more credence than they might otherwise have received. For want of a better explanation the popular lore was often accepted at face value. This gave writers such as Daniel Haigh the opportunity to exercise their erudition by explaining why the cross should have been on board ship and who it was that might have been transporting it. Haigh's was one of the more ingenious explanations. Recognizing the commonality in style and iconography between Ruthwell and Bewcastle, he surmised that the two crosses had "once formed the same monument, one at the head and the other at the foot of the grave," and he was disposed:

> to credit that which tells us that the Ruthwell cross came thither by sea, and was cast on the shore by shipwreck. If this be really true, whence did it come? Most probably from Cumberland; carried off, perhaps on account of its beauty by an army of Danes or Scots, and cast upon the shore of the Solway by a sudden storm.[20]

It was this tendency to invent detailed histories from the most insubstantial evidence that had brought down upon the heads of injudicious antiquaries the ridicule of their peers. Sir Walter Scott's Jonathan Oldbuck, *The Antiquary*, is only one in a long line of fictional characters to represent the fraternity of antiquarians that inspired so much eighteenth- and nineteenth-century satire.[21] The character from whom Scott's hero was partly derived, Sir John

[15] Pennant (Pinkerton ed. 1809), 214.

[16] See the remarks of Barbour (1899–1900).

[17] See the legend in Kendrick, Brown and Bruce-Mitford (1960), vol. II, 21–23.

[18] See Cook (1902), 373.

[19] Barbour (1899–1900), 29–31.

[20] Haigh (1857), 176. Craig Gibson (1859), 122, was inclined to believe that there was more probability in Haigh's supposition than the Irish claim to Stonehenge.

[21] On this see I. G. Brown, *The Hobby-Horsical Antiquary. A Scottish Character 1640–1830*, Edinburgh (1980); and S. Piggott, "The Ancestors of Jonathan Oldbuck," *Antiquity* xxix (1955), 150–156, reprinted in S. Piggott, *Ruins in a Landscape. Essays in Antiquarianism*, Edinburgh (1976), 133–159.

Clerk of Penicuick,[22] was the patron of Alexander Gordon, who compiled the volume that for over a hundred years was to remain the principal authority for students of the Ruthwell cross.[23]

Gordon's *Itinerarium Septentrionale* of 1726 was a folio volume "chiefly intended to illustrate the Roman actions in Scotland" and in particular "Julius Agricola's march into Caledonia." Modeled on his friend William Stukeley's *Itinerarium Curiosum* of 1724, its avowed intention was to do for the study of Roman antiquities in Scotland what Stukeley's volume had done for those in England.[24] Gordon, the 'Singing Sandy' whose *Itinerary* Oldbuck pores over while being conveyed in the Queensferry diligence at the beginning of Scott's novel, dedicated each of the sixty-five plates to one or other of his patrons or subscribers. The Ruthwell cross figures in Part II of his volume, in his "Account of the Danish invasions on Scotland, and of the monuments erected there on the different defeats of that people." The two Ruthwell plates (Pls. 35, 36) are inscribed to Richard, Earl of Burlington and David Murray of Stormont on whose land the church at Ruthwell stood. Both record only the largest fragment of the shaft and neither can be relied upon as an accurate record of what could then be seen.

Although Gordon's transcriptions of the runes are not entirely trustworthy, they do at least suggest his concern to record faithfully the marks inscribed. His versions of the images, however, are more fanciful, despite his claim that "all the monuments in this work are truly and faithfully exhibited from the originals, drawn on the spot by my own hand." He drew what his education and experience led him to expect and not what was actually there, and his expectations, despite an enthusiasm for Italy and presumably some acquaintance with the imagery of its churches, were formed from a limited understanding of Christian iconography.[25] It is instructive, however, to take note of what Gordon thought he saw, especially since his plates were to provide the basis of subsequent reconstructions and interpretations of both the imagery and the inscriptions.[26] In his defense, it should be stressed that Gordon's interest in the figurative reliefs was considerably less than his interest in the epigraphy. Like most of his contemporaries, the value for him of history's artifacts lay chiefly in the inscriptions that they bore.[27] As he says in his preface, among the studies that are most improving, "Antiquity claims a great share, particularly Archiology, which consists of Monuments, or rather Inscriptions, still subsisting; in order to prove demonstratively those facts which are asserted in History."[28]

[22] I. G. Brown, "Critick in Antiquity: Sir John Clerk of Penicuick," *Antiquity* LI (1977), 201–210.

[23] On Alexander Gordon see D. Wilson, "Alexander Gordon, The Antiquary," *The Canadian Journal* n.s. LXXIX, (November 1873), 9–37; and D. Wilson, "Alexander Gordon, The Antiquary. A Supplementary Notice," *The Canadian Journal* n.s. XCI (July 1876), 121–144.

[24] S. Piggott, *William Stukeley, an Eighteenth-Century Antiquary*, London (1985).

[25] Gordon had spent several years in Italy and had written a history of Pope Alexander VI; see Wilson (as in n. 23), 26, 28.

[26] See, for instance, Chalmers (1807), 466.

[27] S. F. Badham, "Richard Gough and the Flowering of Romantic Antiquarianism," *Church Monuments* II (1987), 33, ascribes the shift of attention later in the eighteenth century from inscriptions to monuments as works of art to the influence of Richard Gough (1735–1809) and his circle.

[28] Gordon (1726), Preface, 1.

In his drawings of the main faces Gordon distributed the letters over more space than they occupy on the cross. The inscriptions, as a result, although rendered more legible, are not aligned with the images to which they refer. Thus, the final words around the figure of Christ on the beasts, where he is identified as the SALVATOREM MUNDI, appear alongside the figures of Saints Paul and Anthony in the panel below. In order to accommodate his attenuated inscription, Gordon had to increase the size of the surviving fragment. As can be seen in Plate 24, the attack of the iconoclasts had left the cross broken just below the heads of the two hermit saints. Gordon supplied them with bodies and placed a scroll in the hand of the figure on the right instead of the bread that the raven brought for the saints to share. Also, taking his cue from the inscription "SCS. PAVLVS" above their heads, Gordon reconceived one of the figures as the conventionally bald-headed and bearded Apostle Paul, instead of his desert namesake who, on the cross shaft, is blessed with a full head of hair.[29] A similar indifference marks Gordon's representations of the other figurative panels. To mention only one other example, the amorphous beasts with crossed limbs on which Christ stands (Pl. 23), which in the literature have been variously identified as pigs, otters, and dragons,[30] are made to look like dancing dogs, their paws raised as if partnering each other in a minuet (Pl. 36).

Gordon's prints provided the models for the engravings commissioned from Adam de Cardonnell to accompany Richard Gough's *Vetusta Monumenta* of 1789. Cardonnell, unless he had access to drawings that we no longer know about, undoubtedly visited Ruthwell, since he reproduces parts of the cross that Gordon had ignored (Pl. 38). But, although he realigned the inscriptions with their appropriate images, he deferred to Gordon by reproducing the latter's dancing dogs, a bald-headed Saint Paul, and the singular physiognomy of the Man Born Blind. It is probable that in the manner of eighteenth-century topographical printmakers, Cardonnell made sketches of his subject on the spot to be worked up in the studio when he returned to Edinburgh. For the central fragment of the shaft, however, Gordon's prints already existed as convenient *aides-memoires*. Cardonnell relied on these, with modifications, when he came to produce his own engravings, and Richard Gough in turn based his descriptions in his edition of Camden's *Britannia* on the plates that had been sent him.[31]

There is a clear distinction in style between those parts that Cardonnell borrowed from Gordon, with their firm contours and careful shading, and the hazy, uncertain quality with which the other reliefs are drawn.[32] This attempt to suggest the abraded surface of the stone, however, should not be taken as evidence of the pains Cardonnell took to produce a scrupulously faithful record of what was then visible.[33] It is clear that Cardonnell, like Gordon, was

[29] Nicolson had identified correctly the figures represented in this panel. Had Gordon consulted the drawing of the Ruthwell inscriptions in Hickes's *Thesaurus*, he would have seen that the space occupied by these figures is labeled "Effigies Sti. Pauli et Sti. Antonii" (see Pl. 34).

[30] Maughan had thought they were pigs, see Cook (1914), 70; for Haney (1985), 216 they are "otter-like creatures." And frequently they have been identified with the "DRACONES" to which the surrounding inscription refers or the "asp and the basilisk" of Psalm 90.

[31] Camden (1789, 2nd ed. 1806), 60.

[32] This is true for all the panels except that with the lower half of the figure standing on two globes. The reason for the precise drawing here is that this panel alone had a legible inscription on two of its sides. The inscription accompanying the Flight into or out of Egypt survives only along the top border of the relief.

[33] Certainly he provided new information, not all of which has been capitalized on by recent scholars of the iconographic

not primarily concerned with providing an accurate iconographic record. From the Crucifixion he omitted much of the detail that even today can be seen (Pl. 19). He ignored the globe, probably of the moon, at the top of the panel and the carved lines that define Christ's legs and right shoulder; neither did he reproduce the slight swelling of the shaft that occurs beneath the Annunciation and the Flight into Egypt (seen most clearly in Pl. 25). Again, Cardonnell's interest, or more probably that of Richard Gough, who commissioned him to travel to Dumfriesshire to draw the cross, was the inscriptions and not the "rude figures" about which Gordon was so dismissive.[34]

THE EARLY RUNOLOGISTS

The inscriptions rather than the images continued to receive most attention until the second half of the nineteenth century.[35] The runes in particular excited curiosity as mysterious symbols that betokened the legendary past of the ancient Britons. Indeed, the cross for much of its history was referred to as the "runic rood" or "runic monument" or "runic obelisk" of Ruthwell.[36] In 1885 James McFarlan, the vicar of Ruthwell, could still remark: "The supreme interest of the Ruthwell cross rests in its Christian inscriptions, and especially in its Runic legends round the vine-scroll work on its sides."[37] The fact that throughout the eighteenth century the meaning of the runes was completely unintelligible enhanced their interest to antiquarians who treasured the exotic and enjoyed pitting their learning against this apparently intractable curiosity.

The very earliest record of the cross, made while it was still standing, focused on the runes. Reginald Bainbrigg of Appleby, who traveled in the north in 1599 and 1601 to collect material for a new edition of Camden's *Brittania*, transcribed some of the runes from the cross, "quae est in templo de Revall" (see Pl. 33).[38] Camden did not use Bainbrigg's drawing. However, in his 1607 edition he did reproduce the runes on the Bridekirk font, and in a note

program. The base of the cross, for instance, would seem to have been carved with figurative panels on three and probably four sides, and on two of these panels there appear to have been pairs of figures.

[34] Gordon (1726), 161.

[35] As late as 1926 a poem on the cross published by Lady Ashmore in her *Songs of the Solway* repeated the traditional view that the cross was more favored by its inscriptions than its imagery:

> Here, like a beacon on the Solway Moss
> Shining aloft upon a waste of sand
> Here once was set the finest Runic Cross
> In all the land.
>
> Here is no miracle of sculptor's art—
> No marble of a Michael Angelo—
> Here is the dream from out a poet's heart
> Long, long ago.

[36] See for instance, Dinwiddie (1909–10), 109.

[37] McFarlan (1885), 6.

[38] British Library, MS. Cotton Julius F VI, fol. 352; see Haverfield (1911) and Page (1959b). See also Meyvaert (1982), 3–4.

accompanying a copy of the inscription, sent probably to his patron Sir Robert Cotton, he spoke of the font as "a curiositie wrought with fair and gallant purenes. I send it to you for the barbarous straingnes of the characters."[39] The strangeness of the runes, a word etymologically derived from the Old English *run* (a secret or a mystery), persists. One modern scholar has defined their resistance to interpretation in what he has called the First Law of Runodynamics; "for every inscription there shall be as many interpretations as there are scholars working on it."[40] It is not to be wondered at, therefore, that antiquarians of the seventeenth to nineteenth centuries should have been mystified by the Ruthwell runes.

William Nicolson, who had heard of the cross from Rev. James Lason, Episcopal minister of Dumfries, first visited Ruthwell in April 1697. He communicated his excitement in two letters to his friend Mr. Lhwyd in Oxford. On 22 April he wrote:

> I took a progress (last week) into Scotland to view a famous cross in a church near Dumfries. I was surprised with the inscriptions, very fair and legible on all its four sides. They were Latin and Runic intermixed If you have any Danish gentlemen in the University (now that my friend Worm has left it) who are skilled in their antient language, I should be ready and glad to communicate the whole to them, and my thoughts upon it.[41]

On 24 May 1697 he wrote again to Lhwyd:

> I very well remember my answering of the last letter I had from you before your leaving Oxford. When I received it, I was newly returned from Scotland; where I met with a most ravishing Runic monument, whereof I gave you some account. I shall again do that more at large; sending you the inscription, which most affected me. It is on a square stone-cross in Revel church (or St. Ruel's) within eight miles of Dumfries. They have a long traditional legend about its being brought thither from the sea-shore, not far distant. On the other two sides of the square there are draughts of Christ and Mary Magdalen; St. Paul and St. Anthony in the Wilderness, &c.; and a Latin circumscription, in the same character with that of the Gospels in Brideferth of Ramsey's book, whereof you sent me a specimen. The old Danish letters are the most fresh and fair that I ever saw. If, in your travels, you meet with any Oedipus that can perfectly unriddle them, it is more than I am yet able to do; though I hope shortly to give some tolerable account of them.[42]

Nicolson transcribed the runes as best he could and sent copies of his readings to antiquarian colleagues in England and Sweden in the hope that someone could make sense of them. In 1703 his transcriptions were published in Hickes's *Thesaurus*. A year later Nicolson made his second visit to Ruthwell when he made another draft of both the Latin and runic letters. But he never could make sense of the runes, despite his familiarity with Old English and despite having access to the keys to transliteration in the form of Latin glosses on the runic

[39] British Library, MS. Cotton Julius C III, fol. 305, cited in Bennett (1950–51), 270. In 1615 Cotton sent Camden a copy of some runes from a part of the Bewcastle cross that is now lost. The fragment had apparently been given to Cotton by Lord William Howard; see Bennett, *loc. cit.*

[40] D. M. Wilson as cited in Page (1987), 10.

[41] Nicolson (1809), 62 (no. 23); see also Cook (1902).

[42] Ibid., 63 (no. 24).

alphabets. Other eighteenth-century writers, although they mentioned the runes, and in Gordon's case even published a view of the two runic sides of the cross, were less well-prepared than Nicolson to interpret their meaning.

For early enthusiasts there were two chief obstacles to deciphering the runes: the characters themselves and the language that they were used to express. Runes exist in a variety of related scripts that may differ not only in the forms of certain letters, but also in the number of letters in the alphabet. In use for almost a millennium, they were employed by the peoples of Scandinavia, Germany, and Britain to write several distinct tongues. Transliteration of some runic characters into their Roman alphabet equivalents had been possible already in the late sixteenth century for Camden and others because of the survival of Anglo-Saxon manuscripts such as British Library MSS. Domitian A IX and Titus D XVIII, which contained runic futharks and Latin glosses on the characters. But this was only a first stage. Translating the letters into recognizable words required identification of the language and the dialect of the language that the runes were expressing. The difficulty of translation was compounded by the fact that the words of runic inscriptions were run together, giving no clues as to where one word ended and another began, and usually the characters were only partly legible due to abrasion.

After Wilhelm Carl Grimm in 1821 had noted that its runes were Anglo-Saxon, the Ruthwell cross could no longer be regarded as a product of Danish culture.[43] But a satisfactory translation of the inscription had to wait until 1840 when John Mitchell Kemble, an early editor of *Beowulf*, recognized in the language of the runes the Northumbrian dialect of Anglo-Saxon. Their meaning had remained so long unfathomable because of the assumption that, as well as being a script, Runic was a language. All prior attempts at translation had begun from the mistaken premise that the language they represented was a Scandinavian dialect, or at least a mixture of Old Norse and Old English.

In the early nineteenth century Anglo-Saxon runes were not even an object of study:

> Much obscurity has hitherto rested on the subject of Anglo-Saxon runes; and indeed of these letters there is only known to have existed one specimen, the authenticity of which is generally admitted. This is the Exeter manuscript, from which an alphabet was constructed, which was first published by the learned Hickes.[44]

Duncan's assessment of the survival rate of Anglo-Saxon runes has proved unduly pessimistic.[45] Nevertheless, in the early decades of the nineteenth century it was to Scandinavian scholars, in whose lands more runic remains had survived, that one instinctively turned for explanations. Tentative readings of the Ruthwell inscription were first published at this time. The earliest appeared in a letter written in Latin by the Icelandic philologist Thorleif

[43] Grimm (1821), 169; for the background see G. H. Heyerdahl, "Wilhelm Grimm and the Study of Runes," in *The Grimm Brothers and the Germanic Past* (Studies in the History of the Language Sciences, vol. 54) ed. E. H. Antonsen, Amsterdam and Philadelphia (1990), 61–69.

[44] Duncan (1833), 321.

[45] Fewer than one-hundred Anglo-Saxon runic inscriptions survive, not counting those on coins; see Derolez (1990), 400.

Gudmundson Repp to the Hon. Mountstewart Elphinstone and appended to Henry Duncan's article of 1833. Although he could not make sense of the complete inscription, he identified certain words and phrases:

> Ashlafardahl the expiation for an injury The vessel of Christ, of eleven pounds weight, with ornaments By the authority of the Therfusian fathers, for the devastation of the fields Thirteen cows.

From this fractured translation the Rev. Duncan wove a plausible narrative:

> Some powerful chief having ravaged the lands of the church in a particular district, and having afterwards become penitent, had procured a reconciliation with the monks by various gifts, including a rich baptismal font, and perhaps an annual payment of cattle. All this was probably recorded by the holy fathers of Therfuse upon what is supposed to have been the original column It is obvious that, in future inquiries on this subject, it will be of considerable importance to fix the locality of Ashlafardahl and Therfuse, more particularly in connection with the tradition of the monument having been brought by sea from some distant country.[46]

After the publication of Duncan's article with engravings, Professor Finn Magnusen published in Danish and English another reading of the runes. Although he agreed with Repp that they were in a language comprised of Anglo-Saxon and Old Norse words, he modified Repp's reading on the basis of

> a large folio copperplate engraving It was given to me some years ago by my much-lamented friend and predecessor, Professor Thorkelin, who, however, his memory being impaired by age, could not remember anything more about it than that it represented a column in Scotland, and that he had obtained it, he knew not how or of whom, during his travels in Britain.[47]

The engraving was none other than one of Cardonnell's prints for the *Vetusta Monumenta* (Pl. 37) which Gough records having sent to Thorkelin in order to solicit his opinion. Magnusen's reading varied significantly from that of Repp. He saw references to Ofa, a descendant of Voda, who had caused it to be carved. He associated the cross with a wedding rather than Repp's devastation of the fields, and he found there other historical names that allowed him to date the cross with precision to the year 650. Both scholars had read the individual runes correctly enough but had combined them to form words reflecting the old Scandinavian languages with which they were familiar rather than the Anglo-Saxon in which the inscription was actually written.

In 1840 Kemble provided a third interpretation that related a quite different story. His translation of the runes revealed a poem in which the cross on which Christ was crucified was given voice to recount its experiences on Good Friday.[48] His reading was then confirmed by a

[46] Duncan (1833), 323.
[47] Magnusen (1936), 88–89.
[48] Kemble (1840), 354–356.

remarkable discovery. Some years before, a Dr. Blum had uncovered in the library at Vercelli near Milan an Anglo-Saxon manuscript that comprised some homilies together with six unknown poems of considerable literary value. Publication of the poems was entrusted to Benjamin Thorpe, but before the volume could be properly distributed and publicized the Commission that had undertaken its publication was dissolved.[49] One of the few copies that ended up in private hands was acquired by Kemble. Of the shorter poems in the collection, one, *The Dream of the Holy Rood*, was recognized by him to include verses that compared very closely with the prosopopoeic lines he had reconstructed from the cross. He published his discovery in 1844, noting the following passages in the Vercelli poem that reflected the runic version at Ruthwell:

> Then the young hero prepared himself
> that was Almighty God
> strong and firm of mood
> he mounted the lofty cross
> courageously in the sight of many
>
> I raised the powerful king
> the lord of the heavens
> I dared not fall down
> They reviled us both together
> I was all stained with blood
> poured from the man's side
>
> Christ was on the cross,
> yet thither hastening
> men came from afar
> unto the noble one
> I beheld that all
> with sorrow I was overwhelmed
>
> I was all wounded with shafts
> They laid him down limb weary;
> they stood at the corpse's head;
> they beheld the Lord of heaven.[50]

On the evidence of the manuscript, Kemble's reading of the Ruthwell poem required to be amended only slightly and the enigma of the runes was finally solved.

The satisfaction that he took in his solution to the puzzle had as much to do with the discomfiture that he caused to the hapless Scandinavians as anything else. The taste for invective, for which he was feared and which he more usually reserved for his own countrymen,

[49] The poem was first published by Thorpe in C. P. Cooper, *Report on Rymer's Foedera*, London (1836–37), Appendix B.

[50] Kemble (1844), 36–37. The poem has, of course, been published many times since in more accurate and poetic translations.

was given free rein in his ridicule of the "two learned Icelanders [who] with great valour, if not much discretion" attempted to make sense of the cross:

> Professor Finn Magnusen improves on his learned countryman (i.e. Repp)—makes the cross out to be the record of Ashlof's marriage settlements, gives us chapter and verse for Ashlof, with a full account of her birth, parentage and education, and winds up 105 stupendous pages, by composing a chapter of Anglo-Saxon history, such as I will take upon myself to say was never ventured before by the wildest dreamer even in Denmark.[51]

The manner of debate in the early years of English philology was decidedly confrontational. Kemble in particular, never one to observe the academic niceties,[52] was merciless in his humiliation of the unfortunate scholars whom he had vanquished with what a modern commentator in another context has called, "one of those red-blooded, two-fisted arguments," typical of "that wild and western two-gun spirit which . . . prevailed upon the philological frontiers" of Old English studies in the middle decades of the nineteenth century.[53]

His co-nationals were equally gleeful at this triumph of the home team. Wilson, with barely concealed smugness, remarked that the poem, "will help the reader to form some idea of the refinement of the period when the cross was erected; and may also suffice to show how little need there is to seek in Scandinavian, or other foreign sources for the taste or skill manifested in the works of early native art."[54] This sense of Britain versus the rest was to persist in the scholarship of the cross well into the twentieth century. Serious scholarly attention marked time for several decades while the cross became better known through a number of popular publications. In these, the runes and the *The Dream of the Holy Rood* and the discovery of their association were related with some accuracy, while most everything else about the cross remained mired in speculation.[55]

MINISTERS AND MASONS

Much of the history of the cross has been bound up with the Presbyterian clergymen, who, as successive ministers of Ruthwell parish, also became in effect the curators of its celebrated monument. To them is due an inestimable debt, for without their interest the Ruthwell cross

[51] Kemble (1840), 351. He was, if possible, even more scathing of Magnusen in a letter he wrote to Jakob Grimm in 1842: "That wild goose Finn Magnusen will inundate the world with trash, if someone does not stop his mouth." See Wiley (1971), 231.

[52] On Kemble see Dickins (1939), and most recently G. P. Ackerman, "J. M. Kemble and Sir Frederic Madden: 'Conceit and Too Much Germanism,'" in *Anglo-Saxon Scholarship, the First Three Centuries*, ed. C. T. Berkhout and M. McC. Gatch, Boston (1982), 167–181, with bibliography.

[53] The metaphors of the Old West are those of A. G. Kennedy, "Odium Philologicum, or, a Century of Progress in English Philology," *Stanford Studies in Language and Literature*, ed. H. Craig, Stanford (1941), 11–12.

[54] Wilson (1863), 327.

[55] Kemble's decipherment and its spectacular corroboration dominated the literature for a time; Haigh (1856) called it "the most interesting discovery that has ever been made in the field of Anglo-Saxon antiquities;" see also Craig Gibson (1859) and Wilson (1863).

doubtless would have gone the way of much of the religious art in Scotland, destroyed by
successive waves of iconoclasm.

The Rev. Gavin Young is generally credited with saving it from total destruction in
1642, but it is his early-nineteenth-century successor, the Rev. Henry Duncan who is most
deserving of praise. The long period of his vicariate in the parish can rightly be called "the
age of resurrection of the cross."[56] Duncan gathered the pieces and had them re-erected in the
garden of the manse at Ruthwell in 1802 and had a local mason add a transom to the cross in
1823. The decision, as the Rev. John Dinwiddie, one of Duncan's successors to the parish,
observed, was a courageous one, for suspicion of what were regarded as the relics of Popery
was still strong.[57] Perhaps this explains why, when he came to replace the missing cross
piece, the Rev. Duncan had a local mason emblazon it with symbols, the most prominent of
which are Masonic.[58]

On the front of the transom the equilateral triangle, a Masonic symbol commonly indic-
ative of perfection and the Deity, is flanked by what look like a winged serpent and a whale.
At the back, a sunburst, another favorite Masonic device, occupies the central roundel be-
tween a rooster and a lamb or calf. The animal emblems are less obviously Masonic,
although even these, with the exception of the whale, can be found among the arcana of Free-
masonry.[59] All four of the animals, however, whether real or fantastic, are ubiquitous devices
in a number of contexts, and not least within the traditional iconography of Christianity. The
crowing cock that announced Saint Peter's denial, the sacrificial lamb, the whale from whose
belly Jonah was spewed forth after three days, and the serpent of evil over which Christianity
triumphed can all be related, whether directly or typologically, to Christ's Crucifixion and
Resurrection. The polysemy of the animal symbols permits readings in a number of direc-
tions.[60] What Duncan may have intended, if indeed he intended his symbols to be read as
constituting a coherent program at all, is impossible to know. What is likely, however, is that
his choice of Masonic imagery was purposive and significant. It is doubtful that he was
simply celebrating the craftsmen who erected the cross originally, as Dinwiddie supposed.[61]
Had this been his intention the dividers and set square of the Freemasons would have been
more recognizable and appropriate symbols. His choice was determined, most probably, by
other considerations.

[56] This is Paul Meyvaert's comment; see his essay in this volume, p. 99.

[57] Dinwiddie (1909–10), 113.

[58] Dinwiddie (1933), 105–106 notes that Duncan "the worthy parish minister, who was an enthusiastic Freemason, was
convinced that the great Cross had been originally sculptured and set up by Freemasons." He continues, "we may very well
look upon this gift of the famous Cross to the brethren of the Masonic Craft as an act of harmless and pardonable gener-
osity."

[59] See J. S. Curl, *The Art and Architecture of Freemasonry*, London (1991); for the sun and moon and triangle see
245–246.

[60] Some of the symbols might also reflect incidents in the legendary history of the cross. The whale from whose mouth
Jonah was spewed forth might allude to the cross carried safely to shore on the banks of the Solway. The cow might allude to
the yoke of oxen that came to a halt at Ruthwell while transporting the cross. The winged serpent and the rooster, however,
would not fit obviously into this program.

[61] Dinwiddie (1933), 105–106. Rousseau (1902), 69, suggested that Duncan's choice of symbols might have been an
allusion to the animals that populate the Apocalypse, given that a contiguous figure on the cross head is the Evangelist John.

The cross had been tumbled by Duncan's co-religionists some centuries before because it was an idolatrous monument of Popish superstition. Although Duncan tells us that "on comparing the monument with drawings of similar Popish relics," he believed he could restore the arms of the cross, "in nearly their original form,"[62] he did not attempt to supply them with the Christian figures that would have continued the iconographic program of the surviving panels. Perhaps the "country mason" he employed was not capable of carving images of any complexity. But this could not have been the decisive consideration. It is more likely that Duncan, as a member of a Presbyterian church that still regarded images with suspicion, resolved on subjects that were allusive rather than illustrative. His choice of imagery was most likely an attempt to make the cross more acceptable to his superiors and parishioners who still shared the iconoclastic convictions of their predecessors.[63]

By the nineteenth century Freemasonry had long been anathema to Catholics. Pope Clement XII with his Bull *In Eminenti* of 1738 had denounced the Brotherhood and threatened with excommunication anyone belonging to it.[64] Other papal denunciations followed. In Scotland, the Masonic Lodges had developed close ties with the kirk, and at a time when enmity between Scots Protestants and Catholics was particularly strong the religious affiliation indicated by the emblems of the cross head would have been unambiguous.[65] In choosing Masonic symbols, therefore, Duncan not only avoided offending Presbyterian aniconism but, at the same time, he annexed the cross as a monument of the Protestant rather than the Roman church.

Successive Presbyterian ministers of Ruthwell, through whose publications and guidebooks the cross became known to a wider public, found it difficult to come to terms with the destruction visited on the monument by their forefathers. Their writings are marked by a defensiveness and an urge to explain, or rather, to explain away. Duncan's successor, the Rev. James McFarlan in his "Dates of Interest in the History of the Cross" fails to include in his list the fateful year 1642 and forgoes mention of the General Assembly who pronounced the Act of demolition. Instead, he refers to the events of that year only in the most oblique terms:

> It was thrown down during the ecclesiastical troubles of Charles the First's reign in 1642 or 1644, during the ministry of the Rev. Gavin Young, who allowed the broken pieces to remain within the church, where they found protection for 130 years or more, in the old-fashioned earthen floor.[66]

[62] Duncan (1833), 319.

[63] Anti-Catholic feeling was strong in Ruthwell. When Duncan voiced his support for the Roman Catholic Relief Bill of 1829 he met with extreme opposition from his parishioners. They agitated against the Bill and put pressure on him to reverse his opinion and oppose the legislation; see the account in George Duncan's memoir of his father, Duncan (1848), 157–158.

[64] See *Enciclopedia italiana di scienze, lettere ed arti*, vol. XXII, Rome (1934), ad voc. *massoneria*.

[65] The tension between Catholics and Protestants was exacerbated by the mass immigration of Irish in the opening years of the nineteenth century. For anti-Catholic sentiment on the west coast of Scotland in the late eighteenth and early nineteenth centuries, see T. Gallagher, *Glasgow, The Uneasy Peace: Religious Tension in Modern Scotland 1819–1914*, Manchester (1987), 7–13. He records an incident that throws some light on the persisting abhorrence of images; in 1788, 12,000 Protestants gathered in Glasgow and vowed to suppress idolatry.

[66] McFarlan (1885), 18–19. In the second edition of this work, published in 1896, he does include the years 1640 and 1642 in his list of important dates.

He skirts the issue to avoid apportioning to the kirk fathers the blame for destroying a monument which by the late nineteenth century had been deemed a national treasure. He is equally resourceful in interpreting the cross as a monument erected by supporters of native British religion as opposed to the Church of Rome.

The attempt to mitigate the kirk's responsibility for the destruction continues with the Rev. John Dinwiddie. Although he calls the Act of the General Assembly an "obnoxious order," he nevertheless says that if it had not been for the Act the cross would not have reached us in such good condition, and that besides, the General Assembly had not been fully informed of its early history:

> For nothing can be clearer to a student of the first beginnings of Christian history in these islands than just this, that our cross was made and raised by the Columban or Scotic church as a protest against the attempt which the masterful might of the Church of Rome was, even thus early, making to expel the Church of Iona and its saintly bishops from Northumbria, and to establish her undisputed supremacy over the whole realm of England. It was, we believe, the work of the Scottish and not of the Roman church, and was during the first centuries of its existence, a standing protest against Roman usurpation.[67]

He then suggests that it was Colman, Bishop of Lindisfarne, and his fellow presbyters who erected the crosses on their journey home after the disastrous Synod of Whitby in 664 had declared in favor of Roman over Celtic forms of worship, and that they "were designed to mark the consecrated spots on which the worship of God was to be conducted in its primitive simplicity and purity for many centuries to come."[68]

Dinwiddie's praise for "the primitive simplicity and purity" of religious worship that the cross exemplified carried with it an implied criticism of the ostentatious ceremonial of Catholicism. His recruitment of this Anglo-Saxon monument in the polemic against the Church of Rome typified a stratagem of Protestant propaganda with a long history. Under the early Tudors research into the culture of the Anglo-Saxons had been undertaken precisely with the intention of finding in the early English church endorsement of Protestant practice and beliefs. Most active in this regard, Matthew Parker (1504–1575), Archbishop of Canterbury under Elizabeth I, collected Anglo-Saxon manuscripts that had survived the dissolution of the monasteries and coordinated research into the Anglo-Saxon church in order to establish the antiquity and independence of the *Ecclesia Anglicana* from the Church of Rome.[69] Protestant apologetics continued to bias the Anglo-Saxon scholarship of the nineteenth century. In his inaugural address in 1807 as Professor of Anglo-Saxon at Oxford, James Ingram echoed the views of Parker in reemphasizing the importance of studying Old English as proof of the venerable age and tradition of the Anglican church.[70] The pastors of Ruthwell who wrote the guidebooks, likewise, would point to their famous cross as an

[67] Dinwiddie (1909–10), 111–12.

[68] Ibid., 112.

[69] On Parker's promotion of Anglo-Saxon studies see M. Murphy, "Antiquary to Academic: The Progress of Anglo-Saxon Scholarship," in *Anglo-Saxon Scholarship: The First Three Centuries*, ed. C. T. Berkhout and M. McC. Gatch, Boston (1982), 1–3.

[70] Ibid., 13.

example of the simple sincerity of early British religion in contrast to degenerate Roman Catholicism.

The view, expressed by scholar and popularizer alike, that the cross was a manifesto of Celtic defiance against the Church of Rome continued to surface intermittently even in the present century. Lethaby, for instance, proposed that the scene of Paul and Anthony Breaking Bread (Pl. 24) represented a "link with eastern monasticism . . . that the monument derives its inspiration rather from the Celtic than from the Roman church which took the ascendancy in Northumbria after 664."[71] Schapiro was of the similar opinion that the cross was probably a piece of Celtic propaganda.[72]

FOREIGNERS AND ENGLISHMEN

The writing on the Ruthwell cross was colored not only by sectarian zeal but also by an ardent nationalism that, at times, bordered on xenophobia. Much local and national pride was invested in the cross. With the runes deciphered, scholarly attention turned to other aspects of its history and meaning. The vexed problem of when it was actually carved was to prove the most contentious issue in the first quarter of the present century. And it was an issue that divided those involved into two opposing camps, the one English, the other foreign. The date of the cross continues to be debated, although now with the generation of less heat. Nowadays, the most considered opinions alternate between the late seventh century and the first half of the eighth century.

With the study of Anglo-Saxon art still in its infancy in the nineteenth century and with few securely datable monuments, confusion was inevitable regarding the dates of the Ruthwell and Bewcastle crosses. But by the end of the century, in England at least, the writers, with only a few exceptions, had reached a tacit consensus about the late seventh-century date of Ruthwell, even though some of the evidence on which their assumptions were based had been discredited. The route by which the seventh-century date had come to be accepted was paved with inaccurate transcriptions, unjustifiably optimistic hypotheses based on mistaken information, and a great deal of wishful thinking. That this date still remains a plausible alternative for the carving of the cross is on no account due to the early arguments adduced in its favor. The schism over the date that arose between foreigners and Englishmen from about 1890 to 1920 became most divisive around 1912.

The date of the Ruthwell cross is intimately bound up with that of Bewcastle. When the Revs. Daniel Haigh and John Maughan read the name of the Northumbrian nobleman Alhfrith and his wife Cyneburh among the runes of Bewcastle, they assumed that the monument had been erected to commemorate the death of the prince in 665.[73] Given the similarity of Bewcastle to Ruthwell, it was assumed that the latter must also date from around the same

[71] Lethaby (1913), 147.

[72] Schapiro (1944, reprint 1979), 172–176.

[73] Haigh (1857), 163. The reading of Alhfrith's name was later confirmed by Vietor (1895), 16; and by Blyth Webster in Baldwin Brown (1921), 255–256, 268–272.

time. In this way the foundations were laid for an accretion of circumstantial evidence that combined to secure a seventh-century date for both crosses. Bede's fulsome account of the seventh-century poet Caedmon as the first composer of religious verse in England led Haigh, with a characteristic leap of the imagination, to ascribe to Caedmon the Ruthwell poem.[74] When George Stephens later believed he read the name of Caedmon among the runes at the top of the Ruthwell cross, Haigh's conjecture appeared to be confirmed.[75] But Stephens had never visited the cross, as his romantic engraving of it clearly shows (Pl. 46), and his reading of Caedmon's name among the runes of Ruthwell was soon after shown to be spurious.[76] Nevertheless, the late seventh century continued to be the preferred date for many writers, despite the fact that, apart from vague remarks about its being the heyday of Northumbrian power in the region,[77] the case for it had never been cogently argued.

The consensus was breached and doubts raised by foreign scholars. As early as 1880 Sophus Müller had assigned Ruthwell to around the year 1000 A.D. on the basis of the vine scroll ornament and its relation to continental examples.[78] In 1890 Albert S. Cook, Professor of Old English at Yale concluded that " . . . the inscription on the Ruthwell cross is at least as late as A.D. 950 when the interlinear gloss of the Lindisfarne Gospels is supposed to have been written, while certain indications . . . would point to a still later date." This was the first in a series of studies in which Cook sought to undermine the conventional wisdom that the Ruthwell cross was carved in the seventh century. In 1901 he adduced further proof drawn from the meaning, meter, and diction of the runes, and in 1912 he "added other arguments based upon the language of the decipherable runes and endeavored to confirm the resulting conclusions by considerations deduced from the figure sculpture and the decorative sculpture on the two monuments." By 1912 he was also suggesting that "a date not far from 1150 would perhaps harmonize all the indications better than any other that could be named." Although Cook's arguments were based almost exclusively on the linguistic evidence of the runes, he drew upon the opinions of archaeologists sympathetic to his views for corroborating evidence from the style of the sculpture. He relied initially upon the opinion of Sophus Müller before switching his allegiance to the more recent work of the Italian, G. T. Rivoira.[79]

In 1907, and more fully in 1912 in a discussion of some fragments at St. Andrews, Rivoira claimed for the pattern of carved interlace an origin in late eighth-century Lombardy. From there it passed to St. Gall and then to the Northumbrian centers of Latin culture at Jarrow, Monkwearmouth, and Hexham. The Lombards had derived it either from antique Roman models "or else from their own powers of invention."[80] However, key patterns,

[74] Haigh (1857), 173.

[75] Stephens (1884), 132 read "CADMON ME FAWED" (Caedmon made me).

[76] Black (1887b), 225 stated that "The name Caedmon has all but disappeared, being represented only by five faint perpendicular strokes." Bugge (1889), 494–496 also criticized Stephens's reading (see the English translation of the relevant passage in Cook [1890a], 153–155). Browne (1897), 239, however, claimed to read "Kedmon mae fauodho."

[77] See, for instance, Lethaby (1912b), 59.

[78] Müller (1880).

[79] He cites Müller in (1890a), (1890b), (1902), and Rivoira in (1917) and (1921). Because written in Danish, Müller's thesis had limited impact. His views were known to Cook from Brenner's German translation of Bugge's work; see Bugge (1889).

[80] Rivoira (1912), 23.

he concluded, "are, in their elementary forms, the result of rude imitation of ordinary classical meanders; in their more elaborate forms, of a confused, childish and inartistic use of complex meanders and the designs of pavements in *opus spicatum*. They seem to have originated in England, for they appear for the first time in the Lindisfarne Gospels." The article, peppered with similar insults and remarks on the poverty of the native artistic imagination, and published in the *Burlington Magazine*, a journal recently founded and at the heart of the British art establishment, also included a challenge calculated to arouse the indignation of any self-respecting Englishman:

> The history of the interesting early mediaeval stone carvings in England, Scotland and Ireland will, if I am not mistaken, have to be entirely rewritten; and in the process we shall have to abandon (1) a number of attributions which have become traditional and deeply rooted, though in some cases purely imaginary; (2) the influence of various illuminated manuscripts which do not always belong to the age ascribed to them; and (3) the existence of schools of artists which are often quite gratuitous.
>
> What is wanted is that this important but difficult task of historical reconstruction should be undertaken by some one who is not imbued with the prejudices of a school; who possesses that combination of philological, artistic and archaeological equipment which is indispensable for the purpose; who has trained both eye and mind by the study of the actual carvings before going on to compare them, not only with one another, but also with contemporary specimens in other lands. His object would be to reach a conclusion evolved from the facts, and not a mere product of the imagination or a repetition of what has been said before.[81]

In the conclusion of the article Rivoira turned to the Bewcastle and Ruthwell crosses and with rapid dispatch assigned them to a date not earlier than the first half of the twelfth century.

Incensed, British scholars closed ranks. This foreign interference had touched a nerve. Besides the charges leveled against their competence as scholars, the objects of the attack were, as Lethaby remarked, among the few national monuments, which along with the Bayeux tapestry and Stonehenge could claim a truly international significance.[82] A Ruthwell cross from the seventh century was uniquely important, a cross from the twelfth century was significantly less so. Sir Henry Howorth, writing in 1914, expressed the prevailing view of his English colleagues:

> Among the early monuments of our country few can rival in beauty, in artistic interest and in historical importance, the stone crosses erected in northern England in early days. They have recently aroused a good deal of attention, and have given rise to some theories which in my view are contrary to sound induction and archaeological good sense, and I deem it necessary to devote some pages to their discussion. This objection extends to their assumed date, their ornamentation, and the meaning and interpretation of their inscriptions, where such exist. It is not perhaps singular that the writers who have published the most impossible theories about them have not been Englishmen, who have made a long study of our

[81] Rivoira (1912), 17–18.
[82] Lethaby (1913), 145.

archaeology, and have in consequence learnt to treat our archaeological facts in rational perspective, but foreigners, who have had a very casual knowledge either of our history or of our antiquities. America, Germany, and Italy have all furnished critics of our subject, whose conclusions are largely based on subjective methods which seem to ignore the most elementary facts underlying the subject.[83]

Lethaby, Conway, and Baldwin Brown picked through the arguments of the presumptuous foreigners to unravel their illogicalities and show up their deficiencies in knowledge of Anglo-Saxon art. The language of the debate was couched in the metaphors of war:

> If—as I have no doubt—English scholars make good their position, the attack of the learned Italian author will have brought out, better than anything else could do, the extraordinary character of these two monuments.[84]

Cook replied, and for a time the argument seesawed back and forth.

The attack from outside elicited responses other than the purely defensive. It encouraged a certain national introspection. Baldwin Brown complained of British indifference to the Fine Arts and an unwillingness of scholars to admit to a native (and by this he meant Anglo-Saxon and not Celtic) capacity for producing great works.[85]

The controversy eventually spent itself with neither side relinquishing the position it held. The debate, however, had been fruitful in another way. It required of British scholars to revisit the evidence and to assess it with more thoroughness than they had done previously. There emerged from this what still remains the most comprehensive study of the cross, volume five of Baldwin Brown's *The Arts in Early England*, published in 1921, which he wrote with Blyth Webster (to whom he entrusted the discussion of the inscriptions) and the series of magisterial articles by Collingwood. Other scholars were inspired to extend the scope of their inquiry beyond Anglo-Saxon Britain to seek the proof that both the ornament and the iconography of the crosses could be paralleled in monuments abroad from a similarly early date.[86] With these initiatives, the scholarly focus was considerably widened.

ARCHAEOLOGISTS AND HISTORIANS

The carvings, over which much modern ink has been spilled, were ignored, even despised, by early observers of the cross. Gordon and Pennant dismissed the workmanship of the figures as "rude."[87] If ever the sculpture was discussed it was the inhabited plant scroll of the sides, with its echoes of classical ornament, that was preferred to the crude figures and narrative scenes of the main faces. For Henry Duncan there was a:

[83] Howorth (1914), 45.
[84] Lethaby (1912), 145.
[85] Baldwin Brown (1916), 171.
[86] See the summary of these arguments in Howorth (1914), 51–52.
[87] Gordon (1726), 58; Pennant (Pinkerton ed. 1809), 213.

manifest superiority of the work, both in elegance of design and skill of execution, on the sides inscribed with Runic characters, when compared with those on which Roman letters are found. There is a boldness, a freedom, and a beauty in the sculpture on the Runic sides, which would not disgrace a classic age, and which the Christian figures on the other sides are far from exhibiting in an equal degree. It is scarcely possible, indeed, that they could have been designed by the same artist, or executed by the same workman.[88]

The pleasure that he took in the scroll work led him to replicate a part of it in plaster for the cornice of his drawing room in the manse.[89]

By the mid-nineteenth century, when medievalism had acquired the accretions of nationalism and romanticism and established itself as a respectable alternative to the enthusiasm for Greek and Roman antiquity, the climate for appreciation of the Ruthwell figures was more favorable. In 1857 Daniel Haigh could acknowledge the quality of the carving on the main faces: "The three figures on the cross at Bewcastle are very superior in dignity and grace to any thing I have ever observed even of Norman art, and the same may be said of those on the Ruthwell monument."[90]

The tilting of the balance of interest towards the imagery occurred only gradually from the late nineteenth century and accompanied the maturing of the fledgling discipline of art history.[91] The flourishing industry that the study of the Ruthwell cross has since become received its impetus from two circumstances: the invention of photography and the distribution to museums of casts of the cross that were taken from molds made by Italian craftsmen in 1894.[92] Without traveling to Dumfries it became possible to see high-quality and full-size replicas in London, Glasgow, Edinburgh, Dublin, Brussels and elsewhere.[93] The publication of illustrated guides and art books likewise helped disseminate knowledge not only of the crosses but also of the exotic art of the Copts and of Syria with which the Ruthwell decoration came to be compared.

Fashions in scholarship have impinged upon the study of the sculpture. A rough and ready census of the art-historical scholarship in the present century would show scholars in the first half more interested in Ruthwell's style with those in the second half more concerned with its iconography. Three questions in particular occupied students of the style of the crosses: their dates, the likely models from which the figures and decoration were adapted,

[88] Duncan (1833), 315–316.

[89] See Duncan (1848), 150.

[90] Haigh (1857), 175.

[91] At the same time the demarcation arose, that still persists, between scholars who studied the runic poem and those who studied the sculpture. Inevitably, those who have approached the cross only from the vantage of their own discipline have aroused the criticism of colleagues in cognate fields. Literary critics, in particular, have criticized the art historians for paying insufficient attention to the runic poem, see for instance, Burlin (1968), 23. Textual scholars have been more enterprising in dealing with the cross as a whole, see Meyvaert (1982) and his essay in this volume, and the writings of Ó Carragáin.

[92] Hewison (1913), 351.

[93] Rousseau (1902) wrote his article from study of the cast in the Musées du Parc du Cinquantenaire in Brussels. Lethaby (1912a), 146, notes that he worked from the cast in the S. Kensington Museum. Dinwiddie (1910), 121, mentions other casts in Durham and Dundee.

and the nationality of the men who carved them. It is not to exaggerate to say that the out-pouring of opinions on these questions in the decade 1911–21 was the result of English indignation at Cook's and Rivoira's late dating of the crosses. Article after article begins by rehearsing the claims of the heretics as a prelude to proving them wrong. But the task was not straightforward. Rivoira, whatever his prejudices, was a formidable authority. His copiously illustrated *Architettura lombarda*, reveals a scholar with a wide-ranging knowledge of early medieval art and, in the great tradition of nineteenth-century Italian art history, an enviable command of the written sources.[94] The English tradition of study of the crosses had not prepared native scholars to compete at this level. The history of art had scarcely emerged as a professional discipline in Britain. It took some time to shed the dilettante approach of Victorian antiquarianism that had marked the local study of Ruthwell.[95]

Serious English scholarship of the crosses was forged in the heat of the dispute with the foreigners and, thereafter, the quality of research shifted to a higher plane. Various approaches were brought to bear on the unsolved problems. To determine the dates of the crosses Collingwood tried to establish order among the inchoate mass of sculptural remains. Almost single-handedly he collected, described and classified the several hundred fragments that survived from Northumbria.[96] In a series of books and articles, often illustrated with his own careful drawings, he attempted to slot each piece into a stylistic sequence. A refrain throughout his career was that the Ruthwell cross was "only one of a class of monuments which must be studied together if any single example is to be understood at all."[97] Implicit in this was a criticism of the much larger group of scholars, both English and foreign, who pursued a different line of approach.[98] They tended to study only the masterworks of the series as if they were unique examples of Anglo-Saxon carving, and their prime concern was to establish the stylistic etymology of the crosses in the art of other lands. Collingwood's attention was fixed on the evidence that had survived locally in the museums and churchyards of England, while the focus of the other group was decidedly international.[99]

The conclusions reached by Collingwood and the 'internationalists' regarding the dates of some of the crosses were often at odds. Collingwood's arguments were based on current notions of stylistic evolution. His study of the ornament of the whole series led him to posit a

[94] He paid more attention to the evidence of Bede and Eddius Stephanus, for instance, than did his English contemporaries. Italian art historians, Gaetano Milanesi and Cesare Guasti to name only two, were pioneers in the study of archival records relating to works of art.

[95] The nineteenth-century study of the cross had been the work mainly of clerics whose antiquarian pursuits were hobbies rather than careers. Duncan, Haigh, Dinwiddie, McFarlan, McAdam Muir, Hewison were all clerics. For the general background see P. Levine, *The Amateur and the Professional: Antiquarians, Historians and Archaeologists in Victorian England, 1838–1886*, Cambridge (1986).

[96] Around the same time Haverfield and Greenwell (1899) collected the material for Durham, and Calverley (1899) that for Cumberland. T. D. Kendrick started a photograph file at the British Museum to record early sculpture.

[97] Collingwood (1916), 34, 52.

[98] English scholars at least paid lip service to Collingwood's axiom. In their dispute with Cook and Rivoira it became a popular opening gambit to remind the foreigners that Ruthwell and Bewcastle were only two out of many hundreds of surviving Anglo-Saxon sculptures; see Baldwin Brown and Lethaby (1913), 43–44; and Conway (1912), 193.

[99] The difference in approach was exemplified in the journals in which the exponents of the rival methodologies chose to present the results of their research. Collingwood's articles appeared in local antiquarian journals, the preferred organ for the other group was the more international *Burlington Magazine*.

three-stage process in the development of plait work.[100] With this governing principle he was able to establish relative dates for the crosses within his typological sequence. And, in accepting Rivoira's contention that the plait was a Lombard invention, he could refer to more securely datable Italian monuments as a means of dating the English carvings. Bewcastle's double-stranded plaits pointed to the late eighth century and although Ruthwell was devoid of plait work its similarity to Bewcastle in other respects suggested a comparable date for that also. Although Collingwood's local and archaeological approach was to have an influence on some of his colleagues his proposed chronology made few converts. Both Baldwin Brown and Kendrick emphasized the place of the two crosses within the Insular traditions but they remained convinced of their late seventh-century origins.[101]

For the 'internationalists' also, Ruthwell and Bewcastle were products of the late seventh century. They offered a number of reasons, some stylistic, others historical, to support this the traditional view. Bewcastle's inscription with Alhfrith's name continued to be cited despite its legibility having been cast in doubt. More persuasively, they argued that appropriate foreign models for the sculpture were available before this date and that the late seventh century had witnessed contacts at the highest level between England and continental Europe and the Mediterranean. The resemblance noted between Ruthwell's Latin lettering and the "semi-Irish" script of the Lindisfarne Gospels, datable around 700, was seized upon as conclusive evidence of their similar dates.[102]

Almost everyone accepted that foreign craftsmen must have played a role in the introduction of stone carving into England. How else could one explain the sudden appearance of sculpture of such high quality? And there was contemporary testimony of the existence in Northumbria of immigrant masons; Bede recorded that in the 670s Benedict Biscop had invited skilled workers from Gaul to build his new church at Monkwearmouth 'juxta morem Romanorum.' Against this background two issues emerged that became almost as controversial as the date; the likely models for Ruthwell's sculpture and the nationality of the men who carved it.

> It is perfectly plain that the crosses and the ornaments they bear were not developed out of anything previously existing in these islands. Nothing like them is to be found at an earlier date either in England, Ireland or Scotland, and yet they appear here not in an immature and elementary form, but in full-blown beauty, the earliest ones being the most perfect, most beautiful, and most important from their size and distinction. It is equally plain that we can find nothing like them in the west of Europe. They are non-existent in Germany, France or south of the Pyrenees, notably in France, whence so much of our early artistic work, our buildings, church furniture, plate, and the like were derived. Italy at this time was a land of desolation and decrepitude
>
> . . . We are driven, therefore, to seek for our explanation farther afield There can be no doubt that when the Muhammedans made their terrible onslaught on the empire, in

[100] Collingwood (1915), 129.

[101] Baldwin Brown (1921); and Kendrick (1938). Earlier, Baldwin Brown (1913) had opted for a date in the eighth century on the evidence of some of the rune forms and the presumed shape of the cross-head.

[102] See Lethaby (1912) and (1913). His researches into the epigraphy have been pursued by Okasha and Higgitt.

the time of Heraclius and his family, the areas where the arts were most flourishing and perhaps most fresh and living were Syria, Asia Minor and Egypt.[103]

The belief that the style of Northumbrian sculpture originated somewhere in the eastern Mediterranean was to prevail as the orthodox point of view, although some foreign writers were more disposed to cite models from their own country's patrimony. Rivoira, remained emphatic about the Italian origin of Northumbrian interlace.[104] Hubert, less stridently, indicated the stylistic resemblance between Ruthwell and the tombs in the crypt of Jouarre, concluding, "Si la Grande-Bretagne donnait au continent des moines et des religieuses, La Gaule lui envoyait non seulement des évêques mais aussi des architectes et des artistes."[105]

Although native English scholars had not the same vested interest in promoting the rival claims of other countries, their hypotheses about sources and the origins of the carvers, nevertheless, reflected their individual sympathies. For Sir Martin Conway, an Italophile and author of *Early Tuscan Art*, the carvers of the Ruthwell cross "were probably craftsmen of the Ravenna school."[106] For Baldwin Brown the style of the cross was clearly based on classical prototypes, and not on Roman but rather late Greek or Hellenistic models.[107] Lethaby, who had written on Hagia Sophia and was a founding member of the Byzantine Research Council,[108] drew attention to the fact that some of the motifs at Bewcastle and Ruthwell were similar to works from the eastern Mediterranean. They suggested to him the art of Coptic Egypt and Syria, knowledge of which he supposed to have been carried throughout Europe by Christians escaping from the Arab conquests of the seventh century.[109]

Although the seekers after sources ranged widely in their search for comparanda, from Roman Gaul to Coptic Egypt, they were less systematic in their researches than Collingwood, whose results depended on exhaustive field work. To some extent they were dependent on illustrated studies of foreign art for the resemblances that they observed and the happenstance of publication influenced the conclusions they reached.[110] The primacy attached to the influence of Syrian and Coptic art on the Ruthwell sculpture was partly due to Josef Strzygowski's well-illustrated catalogue of 1904 of the Coptic antiquities in the Cairo museum and his study of the ruins of Mschatta.[111] His clarion call in *Orient oder Rom*, of 1901, to

[103] Howorth (1914), 56–57. It is difficult to escape the conclusion that Howorth in his dismissive remarks about Italy and particularly Lombardy ("the Lombards were still in their barbarous condition") was responding in kind to Rivoira.

[104] Rivoira (1912), 23.

[105] Hubert (1938), 158.

[106] Conway (1913–14), 86. Earlier, Conway (1912) had subscribed to the view, based on his study of Strzygowski's *Koptische Kunst*, that Coptic influence was discernible.

[107] Baldwin Brown (1916), 190.

[108] See G. Rubens, *William Richard Lethaby, His Life and Work 1857–1931*, London (1986), 253.

[109] W. R. Lethaby, "The Origin of Knotted Ornamentation," *Burlington Magazine* x (1907), 256 suggested that for the origin of Saxon ornament it would be worthwhile looking at Coptic work. Dalton (1911), 236, directed attention to east Christian sources for the Northumbrian crosses. He was followed in this by Lethaby (1912a), 146, and by Howorth (1914), 56–60.

[110] See Conway (1912), 193 and Howorth (1914), 57–58.

[111] J. Strzygowski, *Catalogue général des antiquités égyptiennes du Musée du Caire. Koptische Kunst*, Vienna (1904); idem, "Mschatta, Kunstwissenschaftliche Untersuchung," *Jahrbuch der königlich-preuszischen Kunstsammlungen* xxv (1904), 225–373.

recognize the origins of Christian art in the eastern provinces of the Roman empire rather than Rome itself, made several converts among English and American historians in the early decades of the century and influenced their approach to medieval art.[112]

The search for foreign models initiated by English scholars was pursued more methodically between the 1920s and the 1940s by foreign and immigrant scholars who brought to the subject a more compendious knowledge of other traditions. The plant scroll and its genealogy gave rise to a substantial volume of research. Brøndsted inclined to the view that the form of the plant scroll on Ruthwell and Bewcastle indicated a date around 700, and that they were carved by an "Oriental colony of foreigners."[113] Kitzinger, lately arrived from Germany and working at the British Museum, concluded that Ruthwell's ornament came to England not via some European intermediary, as was commonly supposed, but "directly from the East."[114]

Saxl, shifting the focus to the figure sculpture to examine it "in relation to the repertory of Mediterranean art," ventured to suggest, in conformity with a then current tendency among art historians to assume lost models when the stylistic antecedents of an object could not be identified, "that only one ivory showing Christ over the Beasts and narrative scenes reached the North, and provided the model for both Crosses."[115]

The work of non-British scholars did much to establish the Northumbrian crosses in a wider artistic context and to confirm their place among the greatest achievements of the age. For a few Englishmen, however, it was difficult to accept that the finest sculpture of the Anglo-Saxon tradition might be the product of a foreign imagination and perhaps of a foreign hand. While even the most patriotic were compelled by the evidence to admit that the Anglian carver had been introduced to the craft of sculpture by men from abroad, the precise nature and extent of foreign involvement in the two great crosses became an increasingly emotive issue. Attempts were made to claw back for the native artist a more ample measure of recognition:

> The Anglo-Saxon possessed an artistic capacity quite on a level with that of his continental contemporaries, . . . it is impossible to withdraw from native Anglian brains and fingers a large share of the responsibility for the Ruthwell and Bewcastle crosses.[116]

Most non-Britons, however, remained unconvinced:

> The sculptured figures on the Bewcastle and Ruthwell crosses are foreign artwork. That these advanced and admirably executed sculptures, dating from shortly after A.D. 700

[112] For early assessments of Strzygowski's views see, A. Marquand, "Strzygowski and His Theory of Early Christian Art," *The Harvard Theological Review* III (1910), 357–365; and E. Strong, "Professor Joseph Strzygowski on the Throne of St. Maximian at Ravenna and on the Sidamara Sarcophagi," *Burlington Magazine* XI (1907), 109–111. See also the discussion in W. E. Kleinbauer, *Modern Perspectives in Western Art History*, New York (1971), 22–24.

[113] Brøndsted (1924), 80, 88.

[114] Kitzinger (1936), 67–68. He indicated the mosaics of the Dome of the Rock in Jerusalem (A.D. 691) as providing particularly close parallels.

[115] Saxl (1943), 13.

[116] Baldwin Brown (1916), 193–194.

should be the work of native Anglo-Saxon stone-carvers I consider absolutely out of the question.[117]

Baldwin Brown's article "Was the Anglo-Saxon an Artist?" was something of a *cri-de-coeur*. He was serving notice on his compatriots that the credit being given to the foreigners, whether Celt or Copt, for the treasures of Anglo-Saxon art had gone too far.

> Observers of British national idiosyncracies will have noted that many of our countrymen fall unconsciously into the pose of the ancient Romans, who affected to despise the practice of the fine arts, and deemed it more dignified to pay the foreigner, the 'hungry Greekling' of Juvenal, to produce for them whatever in this line might be desired. These people ignore the possibility of any effective artistic operations on the part of the British born. With others of our fellow citizens the same peculiarity shows itself in a different form. They do not despise the practice of the fine arts, but on the contrary glorify it, while at the same time they refuse to credit their countrymen, past or present, with any special ability in this department, or if they are driven to admit ability they confine it to the Celtic element in our population. It is with both parties almost an article of faith that anything conspicuously good in art that is found in Britain must in some way or another have come from abroad. If the masterpiece in question be a portable object it has been ferried across the sea, while if it is a fixed monument it is the work of some imported artist.[118]

Baldwin Brown had a point. Lurking between the lines of many an article was the unspoken assumption of the native craftsman's inferior abilities.[119] As was generally believed, Ruthwell and Bewcastle not only marked the high point of Anglo-Saxon sculpture they were also the earliest in the series of stone crosses. Since some foreign involvement was also assumed, the subsequent decline of the craft was, by implication, to be attributed to the demise of the immigrant craftsmen and the inability of their Anglo-Saxon followers to match them in skill.[120] Put bluntly: better was earlier and better was associated with foreign handiwork.

Understandable though it may have been for an Englishman to want to claim for his forebears sole responsibility for these wonderful works it was difficult to demonstrate the thesis on stylistic or historical grounds. Nevertheless, Baldwin Brown's plea was heard and the belief insinuated itself into the scholarship.[121] In some ways the Ruthwell cross had become more than just a fascinating artifact. It was a national symbol, a testament to native genius, and as such was not entirely amenable to impartial investigation. English scholars jealously guarded their proprietorial rights to it. Resident foreign students were sensitive to the place that it occupied in the national consciousness. It was presumably in deference to the feelings of their colleagues in the country that had provided them with a refuge from Hitler's Germany, that Kitzinger and Saxl avoided explicit reference to the nationality of Ruthwell's

[117] Brøndsted (1924), 79.

[118] Baldwin Brown (1916), 171.

[119] Baldwin Brown was himself not free from this prejudice. His argument that Ruthwell was the product of an Anglo-Saxon carver was based in part on what he recognized as clumsiness in the execution of the panel with Christ and the Magdalene; see Baldwin Brown (1921), 136.

[120] The most explicit statement of this position was that of Dalton (1911), 236; and Gardner (1935, new. ed. 1951), 26, 29.

[121] See, for instance, Kendrick (1938).

carvers, even although it would have been an appropriate topic to consider in the articles that they wrote.

Saxl's study was one of the last sustained attempts to relate Ruthwell's figures and scenes to the art of other countries. The conclusions reached many decades ago remain essentially undisturbed.[122] The 'internationalist' approach no longer arouses the same enthusiasm, or strong emotion, that it once did. This may be due in part to the increased specialization within the discipline and the inability of modern scholars, because of the relentless proliferation of published material, to keep abreast of research across a wide geographical and chronological range. This is to be regretted since the opportunities for cross-cultural comparisons have never been better.[123]

Collingwood's local and archaeological approach and the syntheses of Baldwin Brown and Kendrick, on the other hand, established the foundations for what is the most important development in the study of Anglo-Saxon sculpture of recent years: the publication of the multi-volume *Corpus of Anglo-Saxon Stone Sculpture* that has been appearing since 1984. When completed it will put before the public a well-illustrated catalogue of all the surviving English carvings. Although some of Collingwood's conclusions have been overturned by later research, the general editor of the *Corpus*, Rosemary Cramp, and her colleagues have made clear their debt to his pioneering efforts.[124]

ICONOGRAPHERS

The interest of the antiquarians in the iconography of the cross was negligible. Gordon, as we have seen, misidentified some of the scenes. Only Daniel Haigh, in one of the earliest expansive discussions of the sculpture and reacting to a remark by a contemporary French iconographer, briefly considered the subjects represented.[125]

This was an isolated instance. Up until the 1940s the attention devoted to the figure style and ornament was accompanied only occasionally by desultory discussions of the subject matter. In itself iconography was of little intrinsic interest, unlike in France where from the mid-nineteenth century the study of iconography had been pursued for its own sake as a legitimate subject for research by men like Didron and Mâle. Scholars of the Ruthwell cross generally had an ulterior motive for raising the issue of its iconography. Those who postulated an eastern source for the style of the sculpture invoked the Egyptian origins of the scene

[122] Cramp (1986a) is one of the few studies to reconsider the question with regard to Anglo-Italian links.

[123] Convenient, illustrated corpora of English and foreign stone sculpture of the Middle Ages have made possible the kind of detailed comparisons that were impractical before. See, for instance, the *Corpus della scultura altomedievale*, now in twelve volumes (by various authors) Spoleto (1959–1985). The *"Corpus" della scultura paleocristiana bizantina ed altomedievale di Ravenna*, ed. G. Bovini, 3 vols. (by various authors), Rome (1968–69); and A. Grabar, *Sculptures byzantines de Constantinople (IVe au Xe siècle)*, Paris (1963); and idem, *Sculptures byzantines du Moyen Age (XI–XIVe siècle)*, Paris (1976).

[124] See Cramp (1984); Bailey and Cramp (1988); and Lang (1991).

[125] Haigh (1857), 173–174, reacting to a comment by Didron that representations of the Crucifixion rarely occurred before the tenth century, cited analogous instances in other early English monuments.

of Saints Paul and Anthony Breaking Bread as corroboration of their views.[126] The same
scene was adduced as evidence that the cross was of very early date and that it was an Anglo-
Celtic work inspired by eastern monasticism before the Northumbrian church succumbed to
Romanism after the Synod of Whitby in 664.[127] To support his argument for a very late date
in the eleventh or twelfth century, Cook pointed to the scene of the Flight into Egypt which
he claimed, erroneously, was unknown in Christian art before the tenth century.[128] The very
few writers who paid more than passing attention to the subjects were content to list sources
and analogues for particular scenes.[129]

Although the great crosses attracted international attention the agenda for their study
was determined by the majority who were Englishmen and the English approach to works of
art was resolutely formalist. Although Mrs. Jameson had seen to it that Christian iconogra-
phy was not entirely neglected,[130] it was connoisseurship and aesthetic criticism in the tradi-
tion of Ruskin and Fry and the stylistic typology of archaeologists like Collingwood that
prevailed in English art history in the first half of the present century. Among those countries
with a more vital tradition of iconographic scholarship France was pre-eminent, but French
iconographers rarely ventured into Anglo-Saxon England. In America, approaches to medie-
val art were more eclectic. From the second decade of the century iconography was cultivated,
particularly in regard to Early Christian art, by Charles Rufus Morey and his students and
colleagues at Princeton.[131] Although it tended to be recruited as an auxiliary tool in the
service of style criticism with the purpose of determining the origins and dates of works of
art,[132] iconography, nevertheless, became an established subject of enquiry. And when the
diaspora of the Warburg school brought German-speaking scholars to America and England
in the 1930s, iconography provided the convenient stock on to which could be grafted the now
much-maligned iconology that was to enliven the art-historical scene after the War.[133]

Detailed iconographic study of the Ruthwell cross began with two remarkable articles
that appeared about the same time: one in 1943, the other in 1944. If not quite as decisive as
Kemble's translation of the runes, the articles of Saxl and Schapiro can, nevertheless, be said
to have shifted the focus of scholarship in an entirely new direction. The problem that en-
gaged them has remained of interest to scholars in the half-century since. In brief, they

[126] Lethaby (1912a), 146.

[127] Lethaby (1913), 155.

[128] Cook (1912); see Lethaby's reply in Baldwin Brown and Lethaby (1913), 48.

[129] Baldwin Brown and Lethaby (1913), 44; Lethaby (1917), 235; Baldwin Brown (1921), 280; Kingsley Porter (1929).

[130] Mrs. A. Jameson, *Sacred and Legendary Art*, 2 vols., London (1848, new ed. 1891).

[131] See C. H. Smyth, "Charles Rufus Morey (1877–1955): Roma, archeologia e storia dell'arte," in *Roma, centro ideale
della cultura dell'antico nei secoli XV e XVI. Da Martino V al sacco di Roma, 1417–1527*, ed. S. Danesi Squarzina, Milan
(1989), 14–20.

[132] It was to this end that Morey established the Index of Christian Art at Princeton in 1917.

[133] The terms 'iconology' and 'iconography' have been used to indicate both a method and a sub-discipline of art history.
Although the term 'iconology' is most closely associated with Panofsky it was first introduced to modern scholarship by
Warburg at a conference in Rome in 1912: see W. S. Heckscher, "The Genesis of Iconology," in *Stil und Überlieferung in
der Kunst des Abendlandes. Akten des 21. Internationalen Kongresses für Kunstgeschichte*, Bonn 1964, Berlin (1967), vol.
III, 239–262, reprinted in W. S. Heckscher, *Art and Literature. Studies in Relationship*, ed. E. Verheyen, Durham, N.C.
and Baden-Baden (1985), 253–280.

wanted to discover the meaning the cross might have had for the people for whom it was made. The conclusions they reached, despite their reliance on different evidence, were singularly compatible.

Deciphering the message of the cross was contingent upon the precise identification of the subjects represented.[134] Both scholars recognized the primacy of the largest panel with Christ on the Beasts (Pl. 23) and both rejected the traditional identification of this figure with the Christ prophesied in Psalm 90: "Thou shalt walk upon the asp and the basilisk: and thou shalt trample under foot the lion and the dragon."[135] It seemed clear that the docile creatures with their crossed paws on the Ruthwell panel were not symbols of evil but were paying homage to their Lord as intimated by the surrounding inscription: " . . . BESTIAE ET DRACONES COGNOVERUNT IN DESERTO SALVATOREM MUNDI." Their further hypotheses about the programmatic meaning of the cross as a whole were again in striking agreement. The preponderance of desert allusions and the choice of figures associated with the eremitic life suggested the monastic milieu of the early Northumbrian church.

To interpret the message both scholars had ranged widely drawing into their purview texts and images that seemed to offer clues. Saxl's approach was adapted from that pioneered by Aby Warburg. Underlying Warburg's strikingly original approach to art was the premise that images reflected the attitudes of the cultures that produced them. Awareness of the iconographic tradition and the ways in which different societies at different times represented or gave emphasis to particular themes could reveal predispositions within the societies. To interpret the visual signs correctly required that the historian immerse himself in the culture within which the work originated. Nothing was to be neglected as a potential source of information: the philosophical and religious ideas of the society, its rituals and customs, its high art and low art, all might provide the *trouvaille* that would unlock the secret of the mute image. The art historian was to refuse to be hemmed in by the border police who patrolled the boundaries of the discipline.[136] Warburg's famous library was organized to facilitate the interdisciplinary and cross-cultural browsing that he advocated. When it was removed to London ahead of the rising tide of Nazism, Fritz Saxl was the director.[137] He, and colleagues like Edgar Wind, were to expand the outlook of English art history and criticism with a healthful infusion of Warburgian *Kulturwissenschaft*.

Schapiro's intellectual roots are less clear. His political sympathies with Marxism inclined him to see art as symptomatic of broader issues in society. Impatience with traditionalists who wrote about art as if it was hermetically sealed against influences from the society that produced it expressed itself in sometimes trenchant reviews of colleagues' work. In 1937

[134] Or, in Panofsky's formulation, the iconology was predicated upon the iconography, see E. Panofsky, *Studies in Iconology*, Oxford (1939, Icon ed. 1972), 3–17.

[135] Psalm 90:13.

[136] The metaphor is Warburg's own; see A. Warburg, "Italienische Kunst und internationale Astrologie im Palazzo Schifanoja zu Ferrara," in *Atti del X Congresso internazionale di Storia dell'Arte in Roma. L'Italia e l'arte straniera*, Rome (1922), reprinted in his *Gesammelte Schriften*, vol. II, Leipzig and Berlin (1932), 478–479.

[137] On Saxl see the splendid essay of G. Bing, "Fritz Saxl (1890–1948): A Memoir," in *Fritz Saxl 1890–1948. A Volume of Memorial Essays from his Friends in England*, ed. D. J. Gordon, London (1957), 1–46.

he denounced as arid the prevailing formalism in art-historical writing that divorced art from the social conditions of its creation.[138] And, for the same reason, he was equally unsympathetic to the current orthodoxy in American iconographic studies as represented by the 'Princeton School.'[139] His belief in images as potentially expressive of social conflict led him to view the Ruthwell cross in terms of the dispute between the local Celtic church and the church of Rome.[140]

Whatever their difference in emphases (Saxl was more concerned with the theological background and Schapiro with the historical), both scholars were united in their belief that a clearer understanding of the cross could only be achieved by expanding the parameters of the debate. In exploring the religious and social context at the time it was carved they opened wide the search for evidence across the whole range of historical disciplines. In this they anticipated the kind of research that was to become the major growth area in Anglo-American art history from the 1950s; the study of art in context and its corollary art as social signifier (to use terminology that might receive a more polite reception these days than 'iconology' although in the main their methodological thrust is the same). Much of the credit for popularizing what we may broadly call the contextual approach rests with another Warburg disciple, Panofsky.[141] When he emigrated to America, first to New York and then to Princeton, Panofsky became an articulate, erudite and prolific evangelist of the Warburgian method. Although he wrote nothing of substance on the Ruthwell cross itself his enormous influence on the field as a whole was sufficient to ensure that the methodological principles espoused by Saxl and Schapiro should take firm root in art historical practice.

The influence of Saxl's and Schapiro's analyses has been immense, and not only on art historians. In shifting the discussion beyond the limits of stylistic source hunting and motif development they broke the monopoly of the art historians on the sculpture. The cross was made available to a wider constituency of expertise. Their ideas may have taken some twenty

[138] See his essay on the "Nature of Abstract Art," first published in *Marxist Quarterly* I (1937), 77–98, and republished in M. Schapiro, *Modern Art, 19th and 20th Centuries. Selected Papers*, New York (1982), 187–188.

[139] See his review of C. R. Morey, *Early Christian Art*, Princeton (1942) in *The Review of Religions* (January 1944); on Morey's approach to iconography he has this to say (p. 168): " . . . for the subject-matter is less significant to him as a vehicle of changing Christian ideas and feelings than as a clue to the geographical or typological place of the object. There is a tendency throughout the book to convert artistic problems into questions of ancestry and influence If he observes in the art of the fourth century an increase of Old Testament subjects and Passion scenes, Morey explains this fact by the 'dissemination in the Latin West of illustrated manuscripts from the East' (p. 68); not a word about the new content of Christian sentiment and doctrine at this time, and no effort to interpret the choice of narrative scenes and to bring it into relation to what we know of that period of Christian history."

[140] Schapiro had already drawn upon the notion of 'social oppositions' in his essays of 1939 on the sculptures of Souillac and Silos: "The Sculptures of Souillac," in *Medieval Studies in Memory of A. Kingsley Porter*, vol. 2, Cambridge, Mass. (1939), 359–387, and "From Mozarabic to Romanesque in Silos," *Art Bulletin* XXI (1939), 312–374, both reprinted in M. Schapiro, *Romanesque Art, Selected Papers*, New York (1977), 28–101 and 102–130; on this topic see the fine review of Schapiro's work on Romanesque art by O. K. Werckmeister in *The Art Quarterly*, n.s. II (1979), 211–218, I thank Thomas DaCosta Kauffmann for drawing this review to my attention. On Schapiro see the issue of *Social Research. An International Quarterly of the Social Sciences* XL (1978), devoted entirely to his thought with essays by various contributors; and the sketch in U. Kultermann, *Geschichte der Kunstgeschichte. Der Weg einer Wissenschaft*, Munich (1990), 220–223.

[141] He makes explicit acknowledgement of his debt to Warburg in the preface to *Studies in Iconology* (as in n. 134), xv–xvi.

years to percolate across the boundaries between the disciplines but students of literature and religion, who in some ways were better prepared to avail themselves of an approach that relies so heavily on texts, have profited from the two art historians' insights for their own analyses of *The Dream of the Rood*. Recent interpretations of the sculpture have come by way of the poem from scholars not usually associated with art history.[142]

Where does the iconographical scholarship stand today? The broad conclusions reached by Saxl and Schapiro, that the cross proclaims the ideology of the monastic culture from which it sprang, have stood the test of time.[143] One unexpected result of the attention to the iconography has been to open to question the traditional assumptions about what the various panels actually represent. Doubts have been cast on whether the Visitation (Pl. 15) does not rather represent Martha and Mary embracing;[144] whether John the Baptist with the Lamb (Pl. 21) should not be seen as the figure of the Majestas from Revelations 7:10–12;[145] whether the Flight into Egypt (Pl. 25) is not instead the Return from Egypt;[146] and whether the archer (Pl. 12) is a religious or secular figure, whether he represents good or evil, and whether he is Ishmael or an allusion to the arrow that flies by night or the preacher taking aim with the arrow of God's word.[147]

Deciphering the message of individual reliefs or the program as a whole remains a flourishing industry. There is now a wide range of competing theories supported by an equally extensive array of contemporary texts. For Medd the central idea of the cross is that of conversion.[148] Haney believes the dominant theme to be the "recognition and adoration of Christ as saviour" and indicates Jerome's *Vita S. Pauli* as the source for some of the reliefs.[149] Recognition and acknowledgement also figure prominently in Baird's interpretation; for him, the iconography of the cross and *The Dream of the Rood* both point to the distinction between the brute beasts who spontaneously acknowledged Christ as Lord and sleeping man who required to be awakened to the fact.[150] For Farrell,[151] Psalm 90 and the commentary it attracted from the church fathers, particularly Jerome, remains significant for understanding the imagery while Howlett stresses the importance of Bede's commentary on the Gospel of St. Luke.[152] Meyvaert has marshalled an impressive collection of contemporary and early writings to establish the theological frame of reference within which the iconographic program was devised;[153] while Ó Carragáin prefers to view the cross as a functional object serving the

[142] See, for instance, Fleming (1966); Burlin (1968); and Baird (1984–86).

[143] Their suggestion has been the starting point for more detailed studies along the same lines; see Fleming (1966); Burlin (1968); and Meyvaert (1982).

[144] Howlett (1974).

[145] Meyvaert (1982) and his discussion in this volume. See the counterarguments of Henderson (1985).

[146] Henderson (1985) questioned the traditional view and he has received some support from Farrell (1986), 370.

[147] See Saxl (1943); Kantorowicz (1960); Schapiro (1963); Raw (1967); and Farrell (1978).

[148] Medd (1962).

[149] Haney (1985). Clayton (1990), 150–151, also sees the main theme as recognition of Christ.

[150] Baird (1984–86).

[151] Farrell (1978).

[152] Howlett (1974) and his paper in this volume.

[153] Meyvaert (1982) and especially his paper in this volume.

practice of the liturgy, its imagery being explicable in terms of the rituals of the church year and the initiation of catechumens.[154]

The iconography has proved a rich lode for scholars and there is no evidence that its potential has been exhausted. It is not to be expected that there will ever be a definitive explanation of the meaning of the Ruthwell cross. It carries no single unequivocal message and never did. Its message is as much a function of the individual scholar's education and experience as anything inherent in the cross itself. Competing hypotheses will continue to appear. For a time some interpretations will command more respect than others on the strength of the evidence adduced and the cogency of the arguments. At some point, however, the law of diminishing returns will take effect as the focus on the meaning of the iconography fails to reveal significant new insights. The questions that are currently of interest are bound to change. Research will be directed into new and more promising channels and the importance of the Ruthwell cross will be redefined for another generation. In our own time the iconographic approach, whatever its limitations, has been of inestimable heuristic value. In attempting to make sense of the cross's idiosyncratic program, our understanding of the social, religious and historical situation in Northumbria at the time the cross was supposedly made has been greatly enhanced; and of scholarship little more can be asked.

The papers presented in this volume reveal the variety of approach to the cross that exists today. If anything unites these studies, apart from the cross itself, it is the wanton disregard that their authors show for the traditional boundaries of their own disciplines. Whatever task they have set themselves, whether it is establishing a likely date for the cross (Mac Lean); or determining what precisely survives of the images and inscriptions (Farrell); or elucidating the suggestive interplay of meaning and arrangement in the epigraphy (Howlett); or clarifying the messages that the cross was meant to convey (Meyvaert); the authors move freely beyond the confines of their own specializations to draw upon the evidence secured by research in cognate fields. This is as it should be. More than other comparable monuments, the Ruthwell cross demands an interdisciplinary approach. The vicissitudes of its long life may have left it in a less than pristine state but it remains unique in combining the finest figurative sculpture and one of the greatest poems of its age. Few monuments of the Middle Ages can lay claim to the status of a *Gesamtkunstwerk* with the same degree of assurance that the Ruthwell cross can.

[154] The several articles of Ó Carragáin cited in the bibliography articulate this argument in more or less detail.

The Construction, Deconstruction, and Reconstruction of the Ruthwell Cross: Some Caveats

•

ROBERT T. FARRELL with CATHERINE KARKOV

THE PURPOSES of this brief paper are to provide a realistic appreciation of what is left to us of the Ruthwell cross, an outline of how I believe it was demolished in the seventeenth century, and an interpretation of how it was reassembled in the nineteenth century. I will add a few words on the Bewcastle cross that will help to explain some aspects of the Ruthwell design.

Before turning to the cross itself, some discussion of the geomorphology of the area will be useful. It is very probable that the Ruthwell cross was originally much closer to the sea than it is now, for Roman outlier fortifications on the Solway Firth are now more than a mile inland, and an excavated storm terrace of the post-Roman period shows a sea level higher than at present.[1] The cross lies at the end of Hadrian's wall, with easy communication by land with the monastic centers at Monkwearmouth and Jarrow, and a quick, direct route by sea to Ireland by way of the Solway Firth. This places the cross at a series of major nexus points with the possibility that it might originally have served as a beacon for those arriving from Ireland.

Regarding the physical state of the Ruthwell cross the news is not good. It has suffered damage by weather during two or more stages of its history, and it was savagely attacked and struck down by very efficient and dedicated iconoclasts in the seventeenth century. Despite the good will of the enlightened ecclesiastic—one Dr. Duncan—who held the living at Ruthwell church from 1799 to 1843, and who instigated a rescue effort, the cross suffered further

[1] During the past two thousand years sea level changes have been dramatic on the shores of the British isles. While precise information is not available for all areas, it is generally accepted that sea level has been rising in the south of England, and falling in the north, see A. V. Akeroyd, "Archaeological and Historical Evidence for Subsidence in Southern Britain," *Philosophical Transactions of the Royal Society of London*, ser. A, CCLXXII (1972), 151–169; I. Morrison, "Comparative Stratigraphy and Radiocarbon Chronology of Holocene Marine Changes on the Western Seaboard of Europe," in *Geoarchaeology: Earth Science and the Past*, D. A. Davidson and M. L. Shackley, eds., London (1976), 160–74; I. Morrison, "Geomorphological Investigation of Marine and Lacustrine Environments of Archaeological Sites, Using Diving Techniques," *Proceedings of the Third Scientific Symposium of Centre Maritime*, London (1973), 41–47; and I. Morrison, *The North Sea Earls*, London (1973).

when it was badly reconstructed in the nineteenth century, first in the manse garden at Ruthwell (Pls. 7, 8), and subsequently in a specially-built, cannily economical and maddeningly inappropriate addition to Ruthwell church (Pls. 1–6).[2] The 1887 removal of the cross to within the church was forward-looking, for only recently has the notion of moving stone crosses indoors gained popularity.[3] What, then, is wrong with the indoor placement of the cross? First, it is sunk some 1.8 meters into a pit, which makes difficult an appreciation of its impressive mass and stature, and obscures the original effects of perspective. Second, the original front of the cross is clearly the face with the largest surviving figurative panel depicting Christ in Majesty with his feet on two beasts (Pl. 23), and in the panel above a figure holding a lamb (Pl. 21).[4] When one turns to the Bewcastle cross only one face—the West—has figural sculpture on it (Pl. 49). The central panel of Bewcastle represents once again Christ in Majesty standing on the beasts, and the panel above has the figure with the lamb. Though there are minor variations between the two crosses, these two iconographies are central and virtually identical on both. On the strength of this evidence, the face with Christ in Majesty on Ruthwell (and Bewcastle) should be regarded as the main or "front" face. At present, a visitor entering the church at Ruthwell is confronted not with the major face but

[2] Dr. Duncan is responsible for both the 1802 re-erection of the cross in the garden of the churchyard at Ruthwell and for the addition of the modern transverse arm of the cross-head in 1823. He is also the author of one of the most important early discussions of the cross and its history, see Duncan (1833). This paper was read to the Society of Antiquaries in 1832 and was published in *Archaeologia Scotica* in 1833 together with a letter by Thorleif Gudmundson on the Ruthwell inscriptions.

[3] Compared to that at Ruthwell, the similar cross at Bewcastle which has remained out of doors shows how severe has been the damage from weathering. Professor Page's analysis of the runic inscription on the Bewcastle cross tends towards the conclusion that by the mid-1950s weathering and the overzealous attempts of nineteenth-century antiquarians to "recover" the inscriptions had made it virtually impossible to decipher most of the characters on the west face of Bewcastle (R. Page, "The Bewcastle Cross," *Nottingham Medieval Studies* IV [1960], 36–57; and Farrell [1977]). Studies and photographs made by the present writer show that the Bewcastle cross has suffered significant further damage since 1966. It is unfortunate that the Bewcastle cross had not the zeal of a Dr. Duncan to protect it, and that there appear to be no plans in hand to take the cross under cover, as has recently been done for a number of major Irish stone crosses at sites such as Cashel and Clonmacnoise.

[4] The case for interpreting this panel as a *Majestas Domini* has been argued by Paul Meyvaert (1982), who points out that a seated, haloed figure holding a lamb has apocalyptic connotations, and that the two objects beneath the figure's feet (which Meyvaert takes to be globes) would be more appropriate to an image of God the Father rather than John the Baptist. Meyvaert also notes that the 692 Council of Trullo, concerned about the popularity of the image of the Baptist pointing to Christ as Lamb, had prohibited the depiction of Christ in this manner. Ó Carragáin (1978) has pointed out, however, that the canons of the Council of Trullo were rejected by Pope Sergius and in a separate paper (Ó Carragáin [1986]) he went on to note that the figure of the Baptist bearing the *Agnus Dei* could be interpreted in both a liturgical (referring to the sacraments of Baptism and the Eucharist) and an eschatological context, and that the eucharistic reference of the scene was echoed in the figural panels on the cross. He also noted that: "Bede wrote a whole homily on the lection from St. John's Gospel in which Christ is recognized as 'Lamb of God' by John the Baptist (John 1:29–23). The homily was intended for use on the Sunday after the Epiphany, the Sunday on which Christ's baptism was commemorated. The opening paragraph of this homily is an extended meditation on the various meanings of the title 'Agnus Dei,' and this passage is the *locus classicus* for understanding how an eighth-century monastic audience would have interpreted the Ruthwell and Bewcastle 'Agnus Dei' panels." (Ó Carragáin [1986], 393). George Henderson (1985) has also drawn attention to the eucharistic significance of the panel and pointed out that the probable existence of an Apocalypse scene in the cross-head would make an interpretation of the present panel as God the Father unlikely. A further difficulty with Meyvaert's interpretation is the state of the cross itself. Because the cross is so fragmented in precisely this area it is by no means certain that this figure is seated.

with the "back" of the cross showing, as its central scene, Mary Magdalene Washing the Feet of Christ (Pls. 3–6, 16).

The original front face as it now stands is both difficult to see and virtually impossible to photograph because it stands only some 2.5 meters from the wall of the specially-constructed apse. In addition, the light that plays on the cross from the windows in the ceiling illuminates it in such a way that the eye is constantly confused by changing, multiple light-falls on the monument (Pls. 3–5).[5] In our efforts at photography, first by an Oxford team in 1967, and then in a series of forays from Durham, we have found that artificial light is preferable for the reasonable stability that can be achieved. The photograph in Pl. 14 is a product of the 1967 venture, the prime purpose of which was to study inscriptions. Pl. 12 is a product of the photographic unit of the Department of Archaeology at Durham University, which provides an accurate if unflattering record of what remains to us. Both of these photographs were taken from specially-erected scaffolding, without which accurate or even adequate documentation of the cross is all but impossible.

Photographs of the cross taken from the perspective of a visitor entering the main door of Ruthwell church and first seeing the cross illustrate the points I made above (Pls. 3–6); as light, distance from the object and angle change, the carvings also appear to change. Most important of all, the sculpture is *enhanced*, and the light tricks the eye into seeing a monument far more complete than is actually the case. The major point of this paper is that most scholars who write about the Ruthwell cross recount only in passing the damage it has sustained and confront the problem directly only when damage is so immediately obvious in photographs that the question cannot be ignored. In fact, a partial survey of the figurative panels reveals the significant *lacunae* on the monument. Originally there were twenty panels of figural sculpture, ten on the cross-head, and five on a larger scale on each of the principal faces of the shaft. Although a small fragment now bolted to the railing of the cross enclosure in Ruthwell church may have originally been part of the cross-head,[6] six of the panels from the cross-head sequence are lost and the remaining four panels are heavily weathered. The sequence of ten large-scale panels on the shaft appears to be complete although all are heavily damaged and have suffered from weathering. One is totally effaced (the lowermost panel on what I take to be the original west or front face), and others, like the Crucifixion (Pl. 19), are almost completely illegible. The damage to the panels on the upper part of the cross shaft will be dealt with in some detail, but close examination of the Flight into (or out of) Egypt will serve to illustrate the severity of the deterioration of the lower section (Pl. 25). The Virgin and Child are virtually obliterated. The larger figure was destroyed by fracturing of the surface of the stone on both sides of the body, so that we have only a wedge-shaped fragment

[5] Though the light may confuse the eye of the modern viewer it is probable that the original audience for the Ruthwell cross would have been delighted by the effect, for these complex light sources enhance the interplay of light and dark on the subject defining in real terms the Anglo-Saxon adjective *fah*. For discussions of the term *fah* as it relates to the interplay of light and dark in various media during the Anglo-Saxon period see R. Cramp, "Beowulf and Archaeology," *Medieval Archaeology* I (1957), 57–55; N. F. Barley, "Old English Colour Classification: Where do Matters Stand?" *Anglo-Saxon England* III (1974), 15–28; and Dodwell (1982), 34–35.

[6] On this fragment see Cramp (1978).

left. All that remains of the Child is a set of triple incised lines, almost certainly those inscribed on the halo on the right side of the head. There is extensive damage to the animal on which they ride: the ears have been struck off, and though the placement of three of the four legs and hoofs can be made out, all of them are damaged. It appears that the nearside hind leg extended into the right border, and that it has been entirely cut away. It is very likely that parts of the ears and legs were in very high relief, possibly free of the ground.

DECONSTRUCTION OF THE CROSS

It will be useful in appreciating its present appearance if we understand how the cross was constructed and reconstructed at various stages of its life and how it was tumbled down or deconstructed by the iconoclasts of the seventeenth century. Any account, of course, must remain hypothetical.

We are fortunate in having a letter, dated 14 February 1913, to J. K. Hewison from John W. Dods, the mason and sculptor who re-erected the cross in the church in 1887, regarding the question of whether or not the cross originally had a wheel-head (Fig. 1).[7] As it was hand-written in some haste, it is ambiguous on several important points. This discussion of the destruction and re-erection of the cross makes use of Mr. Dods' comments, and the observations of Mr. Ugo Spadolini of Ithaca, New York, a master mason of forty years' experience. Dods tells us that the joint between the two monoliths "has been made in the most approved masonic form with a socket and tongue." Unfortunately, the past progressive tense he employs does not make it clear whether this joint was made by the Anglo-Saxon craftsman who made the cross, by the person who set up the shaft in the garden of the manse in 1802, or by Dods himself. Dods is very specific about how the base of the cross was set into the floor of Ruthwell church: "The shaft of the cross was fixed by me in the same manner into a Base block below the floor line" (the phrase "by me" was added by Dods to his original text). The implication is then that the joining of the two monoliths by means of socket and tongue was accomplished before Mr. Dods worked on the cross. It is also quite probable, for load-bearing reasons, that the cross was moved into the church in at least two pieces in the 1887 reconstruction. As for the setting of the base, it would appear that Mr. Dods set a pre-existing tongue into a base-block that he had made. While the sequence of figural panels on the cross appears to be complete, the lower sections are badly damaged and the bottom panel on what was formerly the front face is reduced to a blank. However, as the floor of the Ruthwell pit is cemented over, it is just possible, although unlikely, that the part of the cross buried in the floor includes vestiges of sculpture.[8] Comparison with Bewcastle, where the base-block is still visible, makes it likely that the tongue and socket jointure was an original Anglo-Saxon

[7] Dods' letter was found in an envelope interleaved in the National Museum of Scotland's copy of J. K. Hewison's *The Runic Records of Ruthwell and Bewcastle*, Glasgow (1914). The book was formerly in the possession of Mr. Hewison. On the 1887 re-erection within the church see Baldwin Brown (1921), 105.

[8] Baldwin Brown (1921) tells us that the floor is cemented over to a depth of nine inches.

Fig. 1. Part of the letter from J. W. Dods, stonemason, to J. K. Hewison, 14 February 1913

feature at Ruthwell, for if the two crosses were not similarly constructed, and the 19th century mason had had to make a tongue, he would have had to cut away part of the column.[9] An argument will be put forward below to support the contention that some version of a tongue and socket joint between the upper and lower stones was Anglo-Saxon as well.

As for the deconstruction of the cross, Mr. Ugo Spadolini, after close scrutiny of a large number of photographs, put forward the following hypothesis: the cross was tumbled, very likely with the pull being exerted from the east on the west face, that is, with a rope slung around the top of the cross. A fracture is still visible, extending through the front and back

[9] Tongue and socket construction is also a feature of Irish stone crosses, occurring not only at the juncture of shaft and base, but at that of capstone and cross-head as well. See, for example, the cross-base preserved at Old Court, Co. Wicklow (most recently published by P. OhEailidle, "The Cross-base at Old Court, near Bray, Co. Wicklow," in E. Rynne, ed., *Figures From the Past*, Dublin [1987], 98–110), and the stone crosses at Castledermot and Duleek.

faces just below the cross-arm. The missing wedge was made up in the nineteenth-century reconstruction (Fig. 2 and Pls. 11, 20).

This explanation is very close to Mr. Dods' assumption of how the cross was dealt with:

> My impression of the Mutilated heads on the Figure work has all been vandalism Smashed either with a hammer or with stones the stroke dents are visable the Breaking of the lower shaft has been caused either by the cross [from ? – unclear short-form mark] or allowed to fall [– ? – from ? same mark as above] great height would naturally break the top most which was the weakest part [and?] had the greatest distance to fall.

The loss and presumably the fragmentation of the lower half of the west face of the upper stone (Pl. 29) is consonant with the forces generated by an internal element or elements pinning the two monoliths together. This implies that the socket and tongue jointure was an original Anglo-Saxon feature. After the joint had been fractured, the great weight of the uppermost part of the cross, falling from such a height, would have broken the cross-head and arms into fragments. The largest piece to have survived the fall comprises Matthew and his angel and the upper part of the figure holding a lamb (Pl. 20). This large fragment was buried, it seems, and came to light before or during 1802, when an exceptionally deep grave was required to be dug in the churchyard.[10]

The break in the lower monolith is very different from that on the upper. There is no fragmentation, but rather areas which seem to have been cut through. Damage is most severe on the right side of the front face, from which the figure—Paul or Anthony—has been completely cut away, save for the head and a small fragment of his garment (Pl. 24). The depth of the cut and the area below it that has been effaced is most clearly seen by examining the west face (Pl. 27). It is difficult to determine whether the damage took place while the cross was vertical or horizontal, though the job would certainly have been much easier once the cross was lying on the ground. As the lower monolith was cut into two very substantial pieces, we can make some deductions about the disposition of the various fragments of the cross. It is at this point that the evidence of weathering must be taken into consideration as well. Mr. Dods' testimony on the state of the upper part of the cross is puzzling:

> The upper section of cross is of a darker red shade. I would call it a light coloured red stone. To all appearances it has been as good a weather stone as the lower part is not more weathered.[11]

His remarks about the color of the stone and its weathering are important. Color casts in the sandstones of the Ruthwell area are quite variable with light and dark casts layered in the same matrix. As for the weathering it is hard to see how Mr. Dods could have concluded that the upper stone is not more weathered than the lower, a close analysis of this section is necessary to show how Dods was mistaken. It should be noted that the upper section of the cross is in fact a series of no fewer than nine fragments, five of them modern stones (see Fig. 2 and

[10] This event is discussed by Meyvaert (1982), 6–7, in his most useful account of what has been said about the Ruthwell cross since its first mention in modern times up to the present day. See now his paper in this volume.

[11] From Dods' letter (as in n. 7).

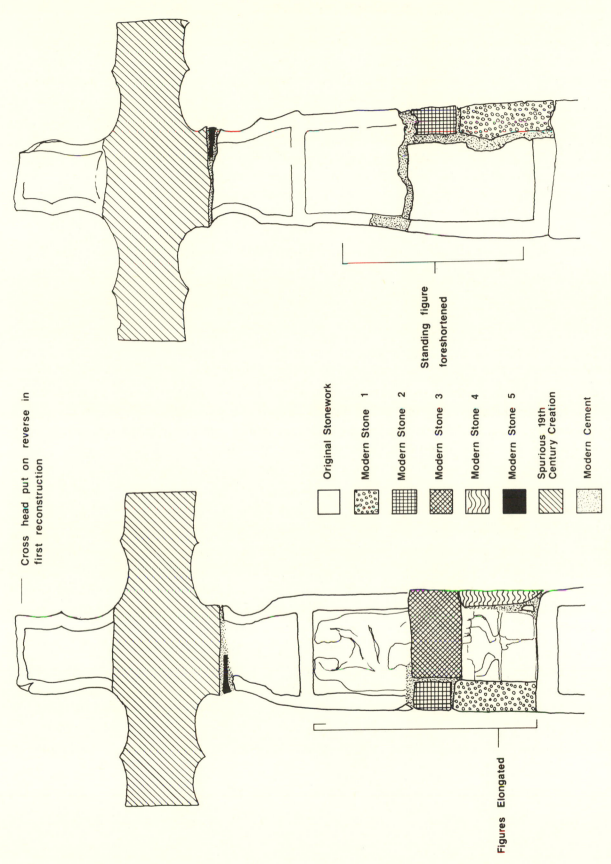

Cross head put on reverse in first reconstruction

Standing figure foreshortened

Figures Elongated

Original Stonework

Modern Stone 1

Modern Stone 2

Modern Stone 3

Modern Stone 4

Modern Stone 5

Spurious 19th Century Creation

Modern Cement

Fig. 2. Drawing showing the arrangement of original and modern stones in the upper section of the Ruthwell cross. Left: back of cross; right: front of the cross. (drawing by Robert T. Farrell and Amy Cassens)

Pls. 11, 20). The fate of the fragments of the cross may be determined from the accounts of seventeenth to nineteenth-century visitors to Ruthwell. Some pieces were left in the church, especially in "Murray's Choir," and others were scattered in the church-yard, having being thrown under "through stones," that is, full-length grave slabs.[12] The discovery of the crucial large fragment, bearing part of the figure with the lamb and Matthew and his symbol (Pls. 20–22), in a grave just at the turn of the nineteenth century provided the impetus for the re-erection of the cross.[13] When the upper and lower parts of the cross are compared it is clear that surface wear is uneven and that the topmost parts are heavily weathered. Since no weathering could have taken place between 1913, when Mr. Dods wrote his letter, and today we must assume that he wrote in haste when he concluded that both stones, the original upper and lower monoliths of the Ruthwell cross, were equally unworn.

Paul Meyvaert's invaluable survey of the history of the cross from 1600 to the present provides us with some details and inferences about which parts of the cross remained within the church.[14] In 1704, Nicolson spoke of the "heavy pedestal of the Cross which lyes in Murray's Quire." This was clearly the base, for Nicolson read ET INGRESSUS ANGE-LUS on it. In 1726, Alexander Gordon spoke of three parts, and in 1772 Thomas Pennant relates:

> The pedestal lies buried beneath the floor of the church. I found some fragments of the capital [he means the uppermost portion], with letters similar to the others; and on each opposite side an eagle, neatly cut in relief. There was also a piece of another, with Saxon [he means non-runic] letters round the lower part of a human figure, in long vestments, with his foot [sic] on a pair of small globes; this too seemed to have been the top of a cross.[15]

Thus, we can infer with some confidence that the pieces left in the church, from 1642 until ca. 1772, were the two large fragments of the lower monolith, and the lowermost part of the front face of the upper monolith. Pennant's "fragment of the capital" is almost certainly the uppermost fragment of the cross-head with the symbol of John the Evangelist. The "piece of another with Saxon letters round the lower part of a human figure" is the lower part of John the Baptist, the upper part of which came to light when the deep grave was dug. The least weathered part of the upper monolith is the small remaining triangle of vinescroll and inscription of the east face (Pls. 31, 32) which shows on the front face the lower part of the figure holding a lamb. We may perhaps account for its relatively fine state of preservation by holding that it was face down and thus totally protected from wear. It remains difficult to

[12] "Through Stone" is a problematic term. The *Oxford English Dictionary* lists several meanings from the seventeenth and eighteenth centuries, the most appropriate of which is a full-length grave slab, either laid flat at ground-level over a grave, or raised up by corner pillars. Both sorts are still to be found in Ruthwell churchyard, though most of those remaining date from the eighteenth century or later.

[13] An elderly couple having died within a few days of one another an exceptionally deep grave had been dug to accommodate both bodies. Dr. Duncan surmised that the fragment had been "surreptitiously buried along with the body of some votary of the church of Rome, from a superstitious belief in its supernatural virtues," see Duncan (1833), 319.

[14] Meyvaert (1982), and now his paper in this volume.

[15] Pennant (1774) as quoted in Meyvaert (1982), 6.

account for the discovery of the largest fragment of the upper stone in the graveyard buried at some depth. This question will be taken up in the discussion of the figure with a lamb.

RECONSTRUCTION

Though the nineteenth-century mason who first re-erected the cross in the manse garden in 1802 presumably worked under the direction of Dr. Duncan, his work is not of a very high standard. Baldwin-Brown remarks on the care taken to match the color of the original fragments,[16] but Dr. Duncan's mason, or Dr. Duncan himself, displayed serious misconceptions about other more important aspects of the sculpture. Whoever made the decision, he appears to have chosen the wrong starting point for his reconstruction of the upper monolith, that is, what is now the lowermost fragment of the original back of the cross with broad plain border and two pairs of feet (Pls. 11, 13, 15, 16, and Fig. 2). He set two modern stones (numbered 1 and 2 in Fig. 2) of the same width, against the fragment of Anglo-Saxon sculpture with two pairs of feet to form an atypically broad border at the left of the back face; these run through one of the sides (Pls. 29, 30), and appear, end on, on the front. Because of their width they displace to the left the lower part of the figure holding a lamb on the front of the cross (Pls. 20, 21). In other words, the mason working under Dr. Duncan's direction chose to begin his work with an isolated, atypical *fragment*, the dark-red sandstone showing two pairs of feet now positioned in the lower half of the Visitation scene (Pls. 11, 15). He cut his border stones (modern stones 1 and 2) to match the wide, blank border below the feet, rather than the much narrower border on the cross as a whole. I have elsewhere made a case that this fragment, chosen as the starting point for the re-erection of the Ruthwell cross, is incongruous, out of context, and very possibly not a part of the single cross we now have in Ruthwell church.[17] It is curious that the mason chose to use two stones. The more accepted practice would have been to use one stone to avoid troublesome seams. *Color match* seems to have been the reason for this odd choice. Again, the *fragment* is matched rather than the cross. This aspect of the reconstruction adds somewhat to the incongruity of the inserted fragment with two pairs of feet, for it is of a distinctly different color from the sculpture just above it. The two modern stones (1 and 2) which provide the left border for this fragment are set in such a way that the fragment of the original monument on the front of the cross with the upper part of a figure holding a lamb on it extends beyond the inserted modern stones 1 and 2 (Fig. 2 and Pls. 20, 21). Had the mason set his stones (modern stones 1 and 2) so that they extended *outward* from the line of the original fragment of figural sculpture, it would have taken very little effort to dress them to match the original line. Once the stones were set in too close there was no way to correct the error. The most obvious effect is the displacement of the lower part of the figure with the lamb to the left, which then was "corrected" by filling the missing central

[16] Baldwin Brown (1921), 111.
[17] Farrell (1986), 257–276.

third of the left border with mortar. The end result is a sudden bend of this mortar fill, in order to join together pieces of sculpture which were out of line by 6 cm.

There are other problems. The figure with the lamb appears to be foreshortened in the present reconstruction. This is all the more curious when one recalls that the two confronted figures on the corresponding panel on the back of the cross appear elongated, even though the two panels are at the same level of the upper monolith.

Returning again to the back face, the lower right-hand part of the panel (Pl. 15) is made up of two inserted stones, 3 and 4 (Fig. 2). The upper stone runs through the face, meeting the uppermost of the two modern stones which fill the left border. This stone (modern stone 3) has a series of incised lines running diagonally across it, which must have been made with a toothing chisel. In other words, this stone is in the rough, and it is hard to escape the conclusion that another stage of work was intended in the nineteenth-century reconstruction, that is, the dressing of the inserted make-up stones to fit more appropriately in the places they occupy on the monument. On the cross we have four relatively smoothly-cut fill stones (1, 2, 4 and 5) and one rough faced (3). *None* of these blank blocks have been cut to match the profiles or finish of the sculpture which surrounds them. The cross was made up with a series of rough stones that were never dressed to match the original sculpture adjacent to them.

Looking at the broader context, there is much that is unclear about the reconstruction. Dr. Duncan tells us that the shaft went up in Summer 1802, as soon as possible after the discovery of the buried fragment. The spurious cross-head was not carved until 1823, when Dr. Duncan himself attempted the reconstruction of the top of the cross, "by the aid of a country mason." On the basis of the engraving purportedly by "the ingenious artist, Mr. Penny," that was printed in 1833 (Pl. 39), in which the errors in the reconstruction are partially corrected, I might put forward the notion that the sloppy, haphazard way in which the missing pieces were made up in the 1802 reconstruction caused Dr. Duncan to call a halt to the activities of someone who had already made an irreversible hash of some important elements of the reconstruction. It is extremely significant that the drawing published in 1833 and apparently first drafted by Dr. Duncan, is erroneous in several respects, and that the misalignment occasioned by the reconstruction of the upper part of the cross is silently amended in the engraving published in conjunction with Duncan's paper. This "amended" representation—relatively late in the series of Ruthwell drawings—should serve as a *caveat* for those modern scholars who are sufficiently trusting to accept the evidence of early drawings both of the sculpture and of the inscriptions.

The Ruthwell and Bewcastle Crosses

In the literature, the Ruthwell cross is almost invariably linked with the similar monument at Bewcastle (Pls. 49–52).[18] Both crosses have close stylistic links with the workshops of

[18] Browne (1916); Baldwin Brown (1921); Willett (1957); Mercer (1964); Ó Carragáin (1978); Cramp (1984), 357–376; Ó Carragáin (1986); Bailey and Cramp (1988).

Monkwearmouth and Jarrow; both crosses have affinities with the Irish church and its traditions, Ruthwell primarily in some of its iconography, Bewcastle in its decoration.[19] Both crosses are in strategic locations. The Bewcastle cross is located in an outlier fort of Hadrian's wall, on a site which has clear cultural continuity from Celtic through Roman to Anglo-Saxon and later medieval times. It is almost certainly *in situ*, one of very few pieces of Anglo-Saxon sculpture in its original position. Ruthwell lies at the very end of Hadrian's wall, facing onto the Solway Firth, an easily accessible and convenient landing point for travellers to and from Ireland. Most important of all, Ruthwell and Bewcastle are among the four or five most complex examples of Anglo-Saxon stone crosses. Both monuments have Christ in Majesty as the largest sculptural panel centered on the west face, and both have a nimbed figure holding a lamb above the Christ in Majesty panel. It, therefore, seems highly improbable that the two monuments are not closely related. The third element of Bewcastle's figural iconography, at the bottom of the shaft, is problematic, for it shows a standing figure in semi-profile, with a large bird apparently perched on the figure's gauntleted left arm (Pl. 49). Certain aspects of the dress of this figure have caused some scholars to view it as a very early representation of a secular figure, perhaps with a bird of prey, but the most comprehensive discussion to date of Bewcastle's iconographic sequence in the *Corpus of Anglo-Saxon Sculpture* concludes that this panels shows in fact an unusual representation of John the Evangelist with his symbol.[20] The question, however, is by no means settled. Thus, the only three figural panels on Bewcastle accord with Ruthwell, though the Ruthwell evangelist is part of a series at the top of the cross. As the Bewcastle shaft is a single stone, the relationship between the nimbed figure with a lamb and the figure of Christ in Majesty below is fixed. Even though the jointure of the two stones at Ruthwell comes between these two figures, the inferential evidence from Bewcastle supports the correctness of the juxtaposition. There is thus a very strong burden of proof on anyone who choses to disassociate these figures. The archaeological conclusions, therefore, militate against the rotation of the cross-head, *pace* Meyvaert. His imaginative discussion provides a possible sequence for an Anglo-Saxon cross, but it is not supported by the conclusions reached in this paper.

The iconography of early medieval art is often an intractable subject, and explanatory parallels are often sought from objects made in far distant places. Eastern links, for instance, are often proposed for early Insular artifacts.[21] It is therefore quite telling to have the figural

[19] Cramp (1986b); Farrell (1986); Bailey and Cramp (1988); Ó Carragáin (1988).

[20] See Bailey and Cramp (1988) entry on Bewcastle cross. This interpretation is, however, still in doubt. The representation of John the Evangelist in this position on the cross-shaft is unparalleled in the corpus of Anglo-Saxon sculpture. Given the similarities between the Ruthwell and Bewcastle crosses it is probable that all four evangelists with or without their symbols appeared on the head of the cross. The liturgical interpretation of the cross put forward by Ó Carragáin (1986) would then still be valid. The figure with the bird is also physically separated from the rest of the figural panels on the cross by a lengthy runic inscription. The nature of the relationship (if any) between this image and the group of eighth-century *sceattas* noted by Bailey and Cramp (1988) is still in need of further clarification. The problems with the identification of this figure will be dealt with in a forthcoming paper by C. Karkov, "The John the Evangelist Panel on the Bewcastle cross; Problems of Interpretation," to be published as part of the 1991 Insular Conference in *American Early Medieval Studies* (1992).

[21] See H. Richardson, "Observations on Christian Art in Early Ireland, Georgia and Armenia," in M. Ryan, ed., *Ireland and Insular Art, A.D. 500–1200*, Dublin (1987), 129–137. But see also M. Ryan, "Aspects of Sequence and Style in the

sculpture at Ruthwell and Bewcastle so closely paralleled, as the other aspects of the crosses are. There has been a good deal of lively discussion in the literature in the past few years. Meyvaert has proposed to interpret the figure holding the lamb as a *Majestas Domini*.[22] He does so for a number of reasons. Dr. Duncan identified this figure as God the Father when it was unearthed; the iconography of the middle ages, Meyvaert tells us, is insufficiently fixed and conventionalized to make a John the Baptist an absolutely certain identification. The case Meyvaert makes must be read *in toto* for a full understanding, but the archaeological evidence does not support Meyvaert's major basis for his interpretation. Meyvaert proposes that the figure suffered particularly severe damage in the seventeenth century precisely because the iconoclasts reserved their greatest abhorrence for representations of divine figures. If the case presented here for the deconstruction of the cross is valid, and if an original Anglo-Saxon structural element joining the upper and lower monoliths caused the fragmentation of the sculpture just above the break, then the destruction of this figure was more probably effected by structural rather than doctrinal causes. At the very least, any interpretation of the imagery of the Ruthwell cross must deal with the archaeological evidence and also take into account the remarkably similar iconographic program that it shares with the cross at Bewcastle; a cursory dismissal of either of these questions will simply not suffice. While runes and letter forms are the proper concern of the palaeographer and philologist, I should like to register only one *caveat* about the inscriptions as well. Dr. Duncan had had an abiding interest in the Ruthwell cross for some thirty years when he read his paper to the Society of Antiquaries on 10 December 1832. However, interest is not to be equated with knowledge and experience, and although his account when published purported to provide a scrupulously accurate record of the runic inscriptions, its credibility is sorely undermined by the fact that he understood parts of the inscription to be written in Old Norse.

Conclusions

The current state of the Ruthwell cross, due to the many indignities it has suffered, leads to the inevitable conclusion that any credible assessment of its style, iconography and meaning must accept the sculpture *as it exists at present*, a much-battered, weathered, and worn partial record of a once magnificent monument. Early representations of the cross are no sure guide to its earlier appearance and, indeed, may be positively inaccurate and misleading.

Those engaged in early medieval studies are inclined to wish for more than they have; a case in point in the study of early English literature is the often expressed desire for a more satisfactory *Urtext* of *Beowulf*, one which is, for example, more appropriately pagan. Or to take a more directly analogous example, both literary critics and art historians often equate

Metalwork of Eighth- and Ninth-century Ireland," in M. Ryan, ed., *Ireland and Insular Art, A.D. 500–1200*, Dublin (1987), 73, who notes that the connections drawn by Richardson should be seen as "cognate developments from the common doctrinal, scriptural and spiritual bases of Christianity," rather than as instances of direct transmission of style and motif.

[22] Meyvaert (1982), and his paper in this volume.

the short series of *sententiae* inscribed in runes on the Ruthwell cross, in itself a cross poem, with the much more lengthy cross poem to which modern scholars have assigned the name *Dream of the Rood* that was written down some three centuries later in the Vercelli book.[23] In this context it was interesting to note that some literary critics at the colloquium at which these papers were delivered expressed acute displeasure because the discussions of a seventh- or eighth-century cross and its decoration did not deal with the cognate but distinct tenth-century poem.

Looked at in a hard, cold light, the Ruthwell cross is the equivalent of a manuscript with clear evidence of excised leaves and now illegible script. In fact, the cross is a far less reliable "text" than the charred manuscript of *Beowulf*. Wherever scholarly flights of fancy, plausible and seductive though they may be, depart from the hard evidence that only the cross as it survives can provide, the conclusions drawn from such ingenuity must be clearly distinguished as conjecture. On the other hand, the fact that the cross is damaged does not permit those who study it to ignore such very close parallels as the Bewcastle cross, and, for instance, to rotate the upper stone at will. Meyvaert's arguments for rearranging the upper monolith at Ruthwell are persuasive and learned and produce an extremely feasible and complex iconographic program, but the cross that he thereby creates is neither the Ruthwell cross as it exists at present nor, I suspect, as it was conceived and executed in the eighth century. Howlett's elegant and eloquent reconstruction of the gaps in the Ruthwell cross inscription depends to a considerable part on early representations of the cross, and on conjecture. It is to be hoped that the reader of this volume will approach all such learned and conjectural analyses with a full understanding of the ruinous state of the Ruthwell cross as it has come down to us.

[23] Neuman de Vegvar (1987), 206, for example, states that "The Ruthwell Cross is dated to the first half of the eighth century on the basis of the runes, the meter, and the language of the *Dream of the Rood*, the Anglo-Saxon poem inscribed on the borders around the inhibited vine scroll on the lateral face of the cross." The same mistake is also made by Ó Carragáin (1988), 1.

The Date of the Ruthwell Cross*

•

DOUGLAS MAC LEAN

DATING the the Ruthwell cross has a Celtic dimension which has been overlooked by Anglo-Saxon specialists. Stylistic, epigraphical and historical arguments have all been used by proponents of different dates for the Ruthwell cross and its smaller, if not necessarily younger brother at Bewcastle, but none of them has proven entirely satisfactory. Stylistic considerations necessarily defer to Mediterranean matters. Epigraphical and philological arguments produce imprecise conclusions. Historical studies limited to Anglo-Saxon sources fail to address the central question about the existence of the Ruthwell cross: what is the greatest Anglo-Saxon cross doing in the middle of a British Celtic kingdom? I shall review the stylistic and epigraphical nature of the problem before discussing the historical context for dating the Ruthwell cross.

THE ARGUMENTS FROM STYLE

W. G. Collingwood, the godfather of Anglo-Saxon sculpture studies, was originally inclined to date the Bewcastle cross to c. 670 on the basis of its runic inscriptions, a subject to which I shall return.[1] By 1918, Collingwood had decided that "in the north there were no skilled stonecarvers (after the Romans had gone) until the building of decorated churches" by St. Wilfrid at Hexham after 672 and by Benedict Biscop at Monkwearmouth c. 675. He identified the "Hunter relief" at Jarrow (Pl. 47) as architectural sculpture, but thought that there must have been an interval of "some years . . . between the introduction of this kind of ornament into ecclesiastical work in Northumbria and the invention of the tall cross," an event Collingwood dated to the end of the seventh century and ascribed to two sculptural centers in the valleys of the Tyne and Wear, one at Hexham and the other "more to the east," perhaps at one of Benedict Biscop's foundations. Collingwood drew a distinction between single-strand interlace on Northumbrian crosses, which he dated to the first half of the eighth century, and those with patterns of parallel lines, which he dated to the second half of the century

* I am most grateful to Mr. Paul Meyvaert and to Dr. Brendan Cassidy for inviting me to participate in the Princeton colloquium on the Ruthwell cross; to Dr. John T. Koch for his bibliographical advice and for asking me to read the paper again, in the Celtic Seminar Series at Harvard University on April 6, 1990; and to Mr. John Higgitt, who kindly prevented me from making a few mistakes.

[1] Collingwood (1904), 219–226.

by analogy with late Lombardic sculpture in Italy. The north and south faces of the Bewcastle cross (Pls. 51–52) feature doubled strands and Collingwood therefore dated both Ruthwell and Bewcastle to the second half of the eighth century.[2] Baldwin Brown, however, was to draw comparisons between the Bewcastle patterns and similiar designs in the Lindisfarne Gospels (London, British Library, MS. Cotton Nero D. IV, fols. 2v and 95r), which he dated to c. 700.[3]

Collingwood's dating of Ruthwell and Bewcastle to the later eighth century did not rest entirely upon his assessment of motif development, but depended largely upon the precedence he accorded the four fragments of a cross shaft at Hexham Abbey (Pl. 55), two of which were identified in 1861 as the remains of the cross erected c. 740 at the head of bishop Acca's grave. Symeon of Durham, writing in the early twelfth century, described two sculptured stone crosses placed over Acca's grave at Hexham, the one at his head with an identifying inscription, the other at his feet.[4] Traces of an inscription covering most of one face of the cross at Hexham are now virtually illegible and cannot be used to link the cross convincingly with Acca, although the label "Acca's cross" has remained customary. Collingwood accepted the identification and put the cross at the beginning of the series of Northumbrian stone crosses, concluding that Acca's cross gave rise to the Hexham school, which was characterized by uninhabited vine scrolls, while inhabited vine scrolls developed slightly later in another workshop based in "Benedict Biscop's foundations in County Durham." He attributed Ruthwell and Bewcastle, however, to an *atelier* at Hoddom, a few miles from Ruthwell in Dumfriesshire.[5] The finest Hoddom fragments disappeared in 1939, but in 1953 Ralegh Radford, using older photographs, dated the earliest of the Hoddom crosses no earlier than the mideighth century, a date since supported by Rosemary Cramp.[6]

In 1921, Baldwin Brown published the most complete study of the Ruthwell and Bewcastle crosses yet to appear, one which continues to provide support for those who favor a seventh-century date for both monuments.[7] But other than similarities he detected between Bewcastle's interlace patterns and those in the Lindisfarne Gospels, and between the lettering in the same manuscript and Ruthwell's Latin inscriptions, Baldwin Brown's discussion

[2] Collingwood (1918), 34–83, esp. 34–38, 51.

[3] Baldwin Brown (1921), 173n, pl. XXIII. Adcock (1974), 158–165, finds a closer correspondence between Bewcastle's interlace and the Cassiodorus manuscript, Durham Cathedral Library, MS. B.II.30, of the second quarter of the eighth century; Adcock's arguments are discussed in Bailey and Cramp (1988), 66.

[4] Cramp (1984), pt. 1, 15, 174–176, pt. 2, pls. 167–171, 172 (909); Symeon of Durham, *Symeonis Monachi Opera Omnia*, ed. T. Arnold, Rolls Series, London (1882–1885), II, 33. For the history of the attribution, see M. J. Swanton, "Bishop Acca and the Cross at Hexham," *Archaeologia Aeliana*, 4th ser., XLVIII (1970), 157–168.

[5] Collingwood (1925), 74–6, 78; Collingwood (1927), 29–32, 70–71, 114, 116–119; Collingwood (1932), 37–48.

[6] C. A. Ralegh Radford, "Hoddom," *Transactions of the Dumfriesshire and Galloway Natural History and Antiquarian Society*, 3rd ser., XXXI (1952–1953), 174, 184–187; Ralegh Radford, "Hoddom," *Antiquity* XXVII (1953), 153, 158–159; R. Cramp, "The Anglian Tradition in the Ninth Century," in *Anglo-Saxon and Viking Age Sculpture and Its Context: Papers from the Collingwood Symposium on Insular Sculpture from 800 to 1066* (British Archaeological Reports, British Series 49), ed. J. Lang, Oxford (1978), 7–8.

[7] Baldwin Brown (1921), 102–317.

of the stylistic antecedents of both crosses was so general that it has allowed considerable latitude to those who have since addressed the question of style. He dismissed the likelihood of the involvement of foreign craftsmen, saying of the Magdalene's hand on the Ruthwell cross (Pl. 16) that it "is a monstrosity when we compare it with the claws of the eagles on the upper panels An Italian or even a Gallic carver would have been more at home with the human hand than with the claw of a bird."[8] In 1924 Brøndsted expressed the entirely contrary opinion that the sculptured figures of both Bewcastle and Ruthwell were the work of foreign, "Oriental" artists, except for their inscriptions, and dated them shortly after 700.[9] Clapham sided with Baldwin Brown in attributing both crosses to Anglo-Saxon sculptors of the late seventh century.[10] In 1936, Kitzinger compared the Ruthwell vine scrolls to sixth-century carvings in Ravenna, and those at Bewcastle (Pl. 50) to Coptic wooden and ivory panels, but decided that the Ravenna and Coptic examples were too early to be relevant to Northumbrian sculpture. Instead, he proposed a generic relationship between Anglo-Saxon vine scroll ornament and the late seventh and early eighth-century mosaics in the Dome of the Rock in Jerusalem and the Great Mosque of Damascus, as well as the designs carved on the mid-eighth-century Mshatta facade. Kitzinger thought it unlikely that the eastern models for Northumbrian vine scrolls were imported later than the early eighth century, although he admitted that "some patterns might have come from a western late antique source unknown to us."[11] Baldwin Brown had traced the vine scrolls to Roman provincial sculpture and imported Samian ware, while finding Ruthwell's figure style "more Greek than Roman," and Cramp has suggested imported textiles, for which there is substantial textual evidence, as a possible source for vine scroll ornament.[12]

The relative dates of the Bewcastle and Ruthwell crosses remain a source of debate. In 1938, Kendrick found the style of Bewcastle "weaker" and later than Ruthwell and assigned Bewcastle a date of c. 700.[13] Saxl reversed the generally accepted sequence in 1943, when he made Bewcastle earlier than Ruthwell on the basis of drapery comparisons and dated both crosses to the last quarter of the seventh century.[14] Kitzinger subsequently repeated the late seventh-century date in his study of St. Cuthbert's coffin, but rejected Saxl's attempt to make Bewcastle the earlier of the two crosses.[15] In the process, Kitzinger identified a distinctive Northumbrian variant of classical drapery. The classical *pallium* was worn draped over the

[8] Baldwin Brown (1921), 136, 305–313.

[9] Brøndsted (1924), 35–36, 74–80, 88–89.

[10] Clapham (1930), 56–57, 64.

[11] Kitzinger (1936), 61–71; E. Kitzinger, "Byzantine Art in the Period between Justinian and Iconoclasm," *Berichte zum XI. Internationalen Byzantinisten-Kongress*, Munich (1958), IV.1, 33, 38 (reprinted in Kitzinger, *The Art of Byzantium and the Medieval West: Selected Studies*, ed. W. E. Kleinbauer, Bloomington and London [1976], 189, 194).

[12] Baldwin Brown (1921), 274–275, 284; Bailey and Cramp (1988), 20. For evidence of textile imports, see Dodwell (1982), 128–169.

[13] Kendrick (1938), 128–174.

[14] Saxl (1943), 8–10, 15–19.

[15] Kitzinger (1956), 224, 294n, 295, 298–299.

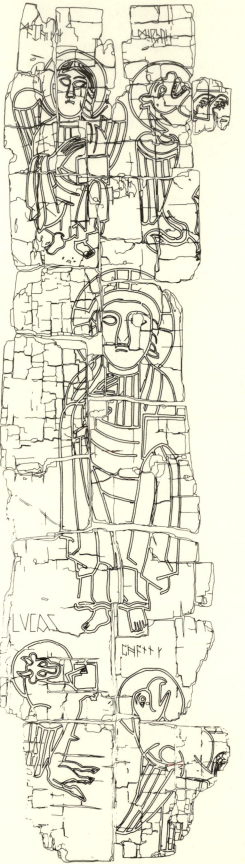

Fig. 1. Lid of St. Cuthbert's
Coffin (copyright: Dean and
Chapter of Durham Cathedral)

left shoulder so that it hung along the left arm. The remainder of the garment was then wrapped about the back and brought around to the front of the figure so that the other end could fall over the left arm also. The right shoulder was usually left uncovered, but not always. The Northumbrian *pallia* worn by the figures of Christ Adored by Beasts at Ruthwell (Pl. 23) and Bewcastle (Pl. 49) and by the Christ figure incised on Cuthbert's wooden coffin lid (Fig. 1) show something different. In each case, the *pallium* is draped over both shoulders, while one end hangs from each forearm with an illogical stretch of cloth drooping between them.[16] The clear depiction of the Northumbrian type of drapery on Cuthbert's coffin is securely dated by the translation of the saint's relics at Lindisfarne in 698. The Bewcastle version is also straightforward, while the Northumbrian nature of the Ruthwell drapery is more subtle and Cramp follows Saxl in making Bewcastle the earlier of the two.[17]

Rosemary Cramp has wrestled with the dates of Ruthwell and Bewcastle since at least 1960, when she was inclined to the mid-eighth century, a date she repeated in her 1965 Jarrow Lecture. On that occasion, Cramp began to associate the inhabited vine scrolls of the two crosses with two architectural fragments at Jarrow (Pls. 47–48), including the so-called "Hunter relief." The circumstances of the discovery of the two fragments make it impossible to link them unquestionably with the monastic church at Jarrow dedicated in 685, but Cramp would not date either of them later than the mid-eighth century. Recently, she has argued that the craftsmen who created Ruthwell and Bewcastle were "trained east of the Pennines, probably in the Jarrow workshops," although she admits that "the small hunter figure from Jarrow is an inadequate parallel for the figures on these crosses." By 1976, Cramp began to lean toward an early eighth-century date and most recently has dated Bewcastle to the first half of the eighth century.[18] In general, the development of Northumbrian relief sculpture in an architectural setting following the introduction of stonemasonry from Gaul by Wilfrid and Benedict Biscop in the 670s must have preceded the emergence of the freestanding sculptured stone cross, which, on the evidence of the Jarrow vine scroll fragments, is unlikely to have occurred before 685. There is no comparable Anglian architectural sculpture from Wilfrid's earlier foundations at Ripon or Hexham, nor from Benedict Biscop's own earlier foundation at Monkwearmouth, but vine scrolls of the Jarrow type are found on both the Ruthwell and Bewcastle crosses, which stand at the beginning of the Northumbrian series of sculptured stone crosses.[19]

[16] Kitzinger (1956), 292–297.

[17] Most recently in Bailey and Cramp (1988), 70–71.

[18] Cramp (1959–60), 12–13; Cramp (1965), 8–12: R. Cramp, "Mediterranean Elements in the Early Medieval Sculpture of England," in *Les relations entre l'empire roman tardif, l'empire franc et ses voisins*, Union Internationale des Sciences Préhistoriques et Protohistoriques, IX^e Congrès, Colloque XXX, Nice (1976), 268; Cramp (as in n. 6), 6–7; Cramp (1984), 27, 114–115; Bailey and Cramp (1988), 20–21, 71.

[19] The fragments of an inhabited vine scroll composition from Hexham Abbey are in much lower relief and lack the sinuous density of the Jarrow fragments or the vine scroll on the Ruthwell and Bewcastle crosses. Indeed, the Hexham vine scrolls are almost certainly Roman, although they could have been reused in the early medieval period. See Cramp (1984), pt. 1, 185–186, pt. 2, pls. 179 (960–961); 180 (965).

The Epigraphical Arguments

Cramp's original preference for an eighth-century date for Ruthwell and Bewcastle depended upon philological considerations.[20] Even Baldwin Brown, who dated Ruthwell to c. 675, conceded that some of the unusual linguistic forms of the runic inscriptions on both crosses pointed to a date in the eighth, rather than the late seventh century, although he was reassured by his colleague Blyth Webster that there was nothing about the forms of the runes themselves, or the language they were used to write, which would preclude the earlier date.[21] Page was originally disposed to date Ruthwell and Bewcastle between 750 and 850 on linguistic grounds, although he later accepted a possible date range between 650 and 750, a difference of a century indicative of the difficulty of dating the two crosses on the basis of their runic inscriptions.[22] He also has called attention to faked runic inscriptions produced in the Bewcastle neighborhood in the nineteenth century and runic enthusiasts who "did not hesitate to scrape away" at the Bewcastle inscriptions "with knives," although the "unusual runic and linguistic forms" on the cross "cannot always be traced back to nineteenth-century readings."[23]

Ruthwell's Latin inscriptions, which form an integral part of its iconography and were presumably part of the original design, offer only slightly more help. In an unpublished paper John Higgitt finds Ruthwell's Latin letters "more advanced" than the Roman capitals on the Jarrow dedication inscription of c. 685 or those incised on Cuthbert's coffin in 698. He prefers an early eighth-century date for Ruthwell, "before the increasingly fantastic forms found in the display script of manuscripts like the Lichfield Gospels or the Book of Kells," but concedes that a later date is "quite possible."[24]

The Arguments from History

Any attempt to date Ruthwell and Bewcastle must inevitably take into consideration the historical evidence, particularly in view of the equivocal results provided by stylistic, philological and palaeographical analyses. Cramp has recently indicated two possible historical contexts for Ruthwell and Bewcastle: one just before 685 and the other nearer the mid-eighth century.[25] There are, however, difficulties with the earlier date which have been omitted from the discussion. The problem is one of historical geography: Ruthwell stands in what was once the territory of Rheged, one of the kingdoms of the Celtic Britons which survived until some point in the seventh century. The Anglo-Saxon sources that are relied upon almost

[20] Cramp (1959–60), 12–13.

[21] Baldwin Brown (1921), 22, 203–272, 305.

[22] R. I. Page, "The Bewcastle Cross," *Nottingham Medieval Studies* IV (1960), 57; Page (1973), 148.

[23] Page (1960 [as in n. 22]), 50–53.

[24] John Higgitt's paper will appear in the collection of papers on the Ruthwell cross to be edited by Rosemary Cramp and Robert Farrell. I am most grateful to the author for a copy of his article.

[25] Bailey and Cramp (1988), 21–22.

exclusively to provide a historical context for the Ruthwell cross fail to do justice to the complexity of the historical situation.

When Baldwin Brown considered the historical context of the Ruthwell cross he did not recognize the problem posed by its location in a place that for some part of the seventh century belonged to the kingdom of Rheged (Fig. 2). Indeed, he did not mention Rheged at all. For him the cross stood within the territory of a single British kingdom comprising Strathclyde and Cumbria, which, he thought, stretched from *Alt Clut*, the modern Dumbarton at the mouth of the Clyde, to the Derwent in Cumbria (Fig. 3).[26] He made the mistake of conflating two quite distinct British kingdoms: Strathclyde, with its capital at Dumbarton, and Rheged, which centered on Carlisle. He further believed, on the basis of Bede's remark that Ethelfrith "ravaged the Britons more extensively than any other British ruler" and "subjected more land to the English race," that Ethelfrith, the first Northumbrian king to rule both Deira and Bernicia (see Fig. 2), had conquered the area around Carlisle before his death in 617.[27] Bede, however, does not specify which lands of the Britons the Northumbrians secured.[28]

The period of disruption after the death of Ethelfrith's successor Edwin c. 633 was followed by another period of Anglian expansion under Oswald and Oswiu, but it is not clear that Carlisle was in Northumbrian hands until 685, when Ecgfrith died fighting the Picts at the battle of Dunnichen, Symeon of Durham's *Nechtanesmere*.[29] Baldwin Brown was mistaken in supposing that the neighborhood of Carlisle, including Ruthwell, was Northumbrian throughout most of the seventh century.

[26] Baldwin Brown (1921), 291–292.

[27] *Venerabilis Baedae Opera Historica*, ed. C. Plummer, Oxford (1896), I, 71; *Bede's Ecclesiastical History of the English People*, ed. B. Colgrave and R. A. B. Mynors, Oxford (1988), 116: *qui plus omnibus Anglorum primatibus gentem uastauit Brettonum Nemo enim in tribunis, nemo in regibus plures eorum terras, exterminatis uel subiugatis indigenis, aut tributarias genti Anglorum aut habitabiles fecit.* As far as Rheged is concerned, there is no archaeological or place-name evidence for Anglo-Saxon occupation of the area in the pagan period. See K. H. Jackson, *Language and History in Early Britain: A Chronological Survey of the Brittonic Languages First to Twelfth Century A.D.*, Edinburgh (1953), 215–216.

[28] Baldwin Brown also placed Britons on the losing side at the battle of Degsastan, when Aedán mac Gabráin of Scottish Dál Riata was defeated by Ethelfrith c. 603, somewhere in northern England. However, the earliest source to connect the Britons with Aedán's defeat is the unreliable fourteenth-century chronicler John of Fordun; see Baldwin Brown (1921), 292. For the sources, see A. O. Anderson, *Early Sources of Scottish History*, Edinburgh and London (1922), I, 123–124; discussed in J. Bannerman, *Studies in the History of Dalriada*, Edinburgh and London (1974), 86–88. The earlier sources indicate a certain ambivalence in Aedán's relationship with the Britons. Although he had a son or grandson with the British name Artúr and his mother and at least one of his wives were Britons, the Welsh sources recall his attacks on the Celtic Britons in Strathclyde and Rheged, and accord him the epithet *bradawc*, the "wily" or "treacherous." If the Welsh tradition is reliable it would make it unlikely that he would render assistance to the Britons by going to war against Ethelfrith of Northumbria; see Bannerman, 83–84, 88–89; K. H. Jackson, "The Britons in Southern Scotland," *Antiquity* xxix (1955), 83. For a different interpretation of Degsastan, which has gained little support, see A. A. M. Duncan, "Bede, Iona and the Picts," in *The Writing of History in the Middle Ages: Essays Presented to Richard William Southern*, eds. R. H. C. Davis and J. M. Wallace-Hadrill, Oxford (1981), 16–19. T. F. O'Rahilly, *Early Irish History and Mythology*, Dublin (1946), 362, notes that Aedán had two other grandsons with British names.

[29] Baldwin Brown (1921), 292–295; Symeon of Durham (as in n. 4), I, 32. For the name of the battle, see F. T. Wainwright, "Nechtanesmere," *Antiquity* xxii (1948), 82–97. The English name, *Nechtanesmere*, does not appear before Symeon of Durham, writing in the early twelfth century. The only contemporary sources are Irish and call the battle *Duin Nechtain*, while Dunnichen is the name of the place today.

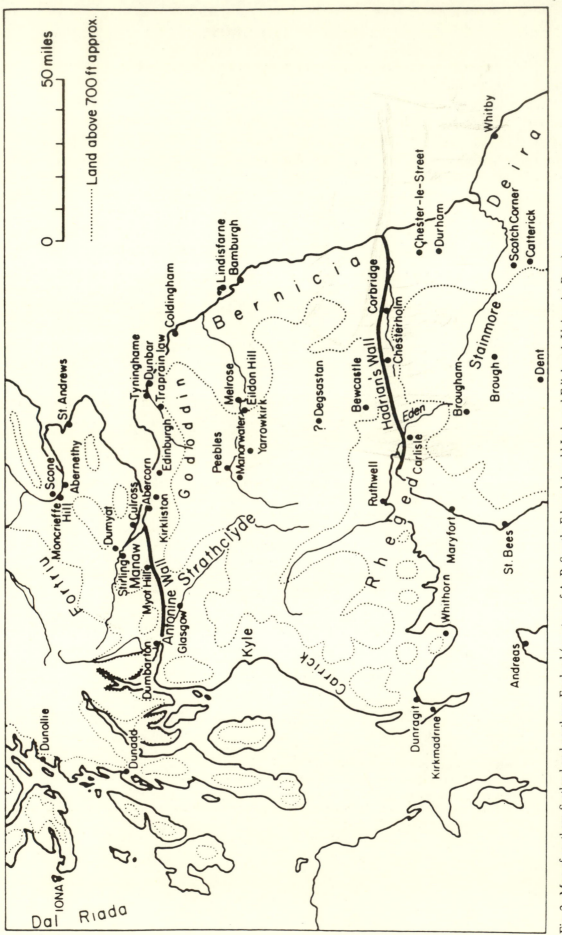

Fig. 2. Map of southern Scotland and northern England (courtesy of A. P. Smyth, Edward Arnold Ltd., and Edinburgh University Press)

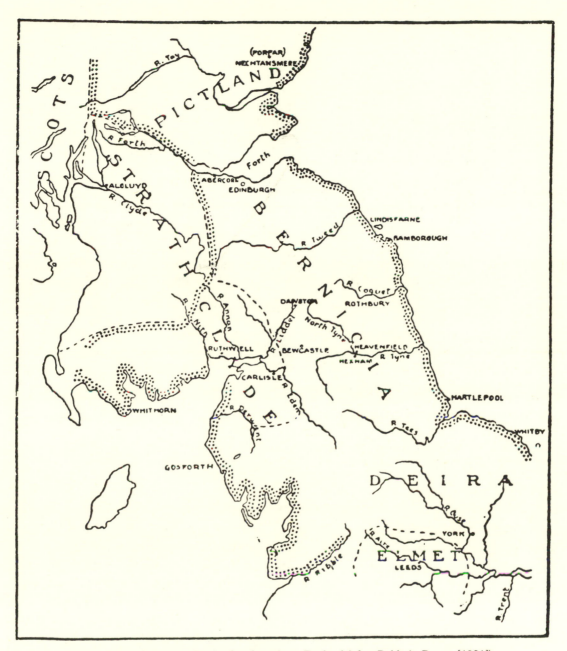

Fig. 3. Map of southern Scotland and northern England (after Baldwin Brown [1921])

He was confirmed in this historical error by another misapprehension concerning the runic inscriptions of the Bewcastle cross. If Ruthwell and the surrounding area had belonged to Northumbria during the reigns of Oswald, Oswiu and Ecgfrith, there would be little historical difficulty in accepting an interpretation of Bewcastle's runes that links them with Alhfrith, the sub-king of Deira and the son of Oswiu of Northumbria (Fig. 4). The runic

NORTHUMBRIAN KINGS **British House of Rheged**

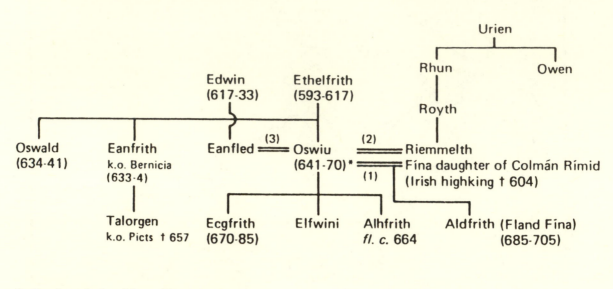

* Oswiu ruled as king of Bernicia only
 until 655 and as king of Northumbria
 thereafter

(1) Various marriages of Oswiu
 (chronological sequence uncertain)

Fig. 4. Genealogical chart of the kings of Northumbria and the British house of Rheged (courtesy of A. P. Smyth, Edward Arnold Ltd., and Edinburgh University Press)

inscription between the two lowest panels on Bewcastle's north face (Pl. 51) bears the still-legible Anglo-Saxon female name *Cyneburh*.[30] Although not uncommon, Cyneburh was the name of the wife of Alhfrith.[31] By itself, the appearance of her name would be insufficient evidence to connect it with Alhfrith, but *his* name was also found by nineteenth-century runologists in the principal inscription on Bewcastle's west face (Pl. 49).[32] Page, however, has been unable to discover Alhfrith's name there: he reads: "This token of victory . . . set up in memory of . . . ," and attributes the several different readings made by the Rev. John Maughan, the rector of Bewcastle church in the 1850's, to recutting by runic forgers or damage caused by over-enthusiastic cleaning.[33] Baldwin Brown, on the other hand, had no hesitation in identifying the Bewcastle cross as a monument to Alhfrith of Deira and the latter's close relations with Bishop Wilfrid seemed to provide an appropriate ecclesiastical

[30] R. I. Page in Bailey and Cramp (1988), 63, 65, now accepts this reading.
[31] Bede, *Opera Historica* (as in n. 27), I, 170: Bede, *Ecclesiastical History* (as in n. 27), 278–279.
[32] This reading was corroborated by Baldwin Brown's collaborator Blyth Webster (Baldwin Brown [1921], 245–246, 255–256, 268–270).
[33] Page (1960 [as in n. 22]), 38–39, 42–43, 44–47, 50–54, 56–57.

context for the commissioning of the cross.[34] Alhfrith received religious instruction from Wilfrid, evicted Eata and Cuthbert from Ripon to give it to Wilfrid instead, had the visiting Frankish bishop Agilbert ordain Wilfrid priest, engineered the Synod of Whitby, and then sent Wilfrid to Gaul to be ordained bishop by Agilbert, who was now bishop of Paris.[35] Bede refers in passing to Alhfrith attacking his father Oswiu, who was succeeded c. 670 by another son, Ecgfrith (Fig. 4). We hear no more about Alhfrith after his apparent rebellion.[36] These circumstances suggested to Baldwin Brown that the expansionist Ecgfrith had Ruthwell erected in formerly British territory as "an imposing monument of Anglian Christianity" around 675, while Bewcastle served a more private purpose and was set up later by Alhfrith's adherents, possibly over his grave.[37] Following Baldwin Brown, Kendrick connected Bewcastle to Wilfrid or one of his cohorts and Stone has argued that the cross cannot be later than Wilfrid's death in 709.[38] But the considered inability of Page to find Alhfrith's name in the Bewcastle inscription renders the Alhfrith issue the biggest red herring in the history of dating the Ruthwell and Bewcastle crosses.[39]

Another set of historical circumstances, surrounding the career of Alhfrith's half-brother Ecgfrith, is adduced to support a pre-685 date for Ruthwell, but it, too, fails to take the kingdom of Rheged into account. Baldwin Brown's separation of the historical context for the creation of Bewcastle, which he associated with Alhfrith, from that of Ruthwell, which he linked to Ecgfrith, served as the basis for the subsequent elaboration of Baldwin Brown's dating scheme by Kendrick, Stone and Schapiro. Ecgfrith's father Oswiu had found for Wilfrid at the Synod of Whitby, but after Ecgfrith came to the throne, he quarreled with Wilfrid, drove him from his see and imprisoned him upon his return, only releasing the bishop at the request of the abbess of Coldingham, who was the king's aunt.[40] The patronage of Wilfrid by Alhfrith, whom Ecgfrith apparently displaced in the succession, was thus used by Baldwin Brown, Kendrick and Stone to connect Bewcastle with Wilfrid and Alhfrith, rather than with Ecgfrith, but we have seen that the nineteenth-century reading of Alhfrith's name in one of the Bewcastle inscriptions is no longer acceptable. Further, Baldwin Brown made Ecgfrith the patron of Ruthwell, a suggestion for which there is no evidence, and one which ignores Ruthwell's location in Rheged territory. Ecgfrith was, however, a benefactor of the

[34] Baldwin Brown (1921), 119, 132, 314, 317.

[35] Bede, *Opera Historica* (as in n. 27), I, 182–183, 194, 325; Bede, *Ecclesiastical History* (as in n. 27), 296–299, 314–315, 521–523; *Life of Bishop Wilfrid by Eddius Stephanus*, ed. B. Colgrave, Cambridge (1927), 14–21; discussed in H. Mayr-Harting, *The Coming of Christianity to Anglo-Saxon England*, London (1972), 107–108.

[36] Bede, *Opera Historica* (as in n. 27), I, 154, 214; Bede, *Ecclesiastical History* (as in n. 27), 254–255, 348–349, 564–565. Ecgfrith is named in the Romanizing dedication inscription at Jarrow in 685, see Cramp (1984), 113–114; J. Higgitt, "The Dedication Inscription at Jarrow and Its Context," *Antiquaries Journal* LIX (1979), 343–374.

[37] Baldwin Brown (1921), 313–317.

[38] Kendrick (1938), 133–134; Stone (1955), 13.

[39] Runic letters were composed of straight lines originally intended to be cut in wood and, even if the Bewcastle inscription once mentioned Alhfrith, the extant stone cross may have replaced an earlier wooden monument, a possibility which argues against a direct connection between Alhfrith's dates, or Wilfrid's, for that matter, and the dates of the Bewcastle and Ruthwell crosses.

[40] *Life of Bishop Wilfrid* (as in n. 35), 48–49, 70–71, 88–89; Bede, *Opera Historica* (as in n. 27), I, 229, 326; Bede, *Ecclesiastical History* (as in n. 27), 370–371, 522–523.

Northumbrian church: he was instrumental in the appointment of Cuthbert as bishop of Lindisfarne and endowed Benedict Biscop with the lands of Monkwearmouth and Jarrow.[41] Still, the similarities between the vine scroll ornament on architectural sculpture at Jarrow and the Ruthwell and Bewcastle crosses are insufficient, in themselves, to make Ecgfrith Ruthwell's patron. But Schapiro's historical misinterpretation, which compounded Baldwin Brown's, referred to Ecgfrith's military activities. Ecgfrith apparently inherited some sort of overlordship of the southern Picts and put down a Pictish revolt early in his reign.[42] Bede reproved him for sending an army into Ireland in 684, when various Irish annals record the depredations of the "Saxons" on the Plain of Brega in east Meath. Ecgfrith then attacked the Picts again in 685, against Cuthbert's advice, and fell at the battle of Dunnichen.[43]

The battle of Dunnichen or *Nechtanesmere* was fought in Pictish territory in Angus, north of the Firth of Tay and some considerable distance to the north of Ruthwell (see Fig. 3). But Schapiro's misunderstanding of historical geography, the conflicts between Northumbria and the Celtic kingdoms in the seventh century and particularly the events surrounding the momentous battle in 685 affected his dating of Ruthwell and has unfortunately received deferential treatment from art historians. According to Schapiro,

> the Northumbrians, at first under Oswald and then under Oswiu (641–670) conquered Strathclyde; but the Northern Picts and Britons rose against the latter's son and successor, Ecgfrith, and slew him at the battle at Nechtanesmere in 685. This was the end of Northumbrian power in that region and marks the beginning of the general decline of the kingdom. Since the Ruthwell cross is in form an object of Northumbrian type, and is inscribed with a poem in an early Northumbrian dialect, it must precede that date.[44]

Schapiro's account is erroneous on several crucial points. First, he follows Baldwin Brown in dismissing the existence of Rheged, making it part of the British Celtic kingdom of Strathclyde during the reigns of the Northumbrian kings Oswald and Oswiu. Second, Schapiro mistakenly places Britons on the winning side at Dunnichen, although there is no evidence that there were. Bede merely reports that, as a result of the battle, Northumbrian overlordship was overthrown by the Picts, the Scots of Dál Riata and some of the Britons, although characteristically he neglects to tell us which Britons he had in mind.[45] Bridei son of Bili, the Pictish king who triumphed at Dunnichen, was himself the son of the British king of Strathclyde and any Britons liberated by the battle are likely to have been ruled by his Strathclyde

[41] Bede, *Opera Historica* (as in n. 27), I, 268, 272–273; Bede, *Ecclesiastical History* (as in n. 27), 430–431, 437–439; Bede, *Historia Abbatum* in *Opera Historica* (as in n. 27), I, 370; *Two Lives of Saint Cuthbert: A Life by an Anonymous Monk of Lindisfarne and Bede's Prose Life*, ed. B. Colgrave, Cambridge (1940), 110–111.

[42] *Life of Bishop Wilfrid* (as in n. 35), 41–43; discussed in I. Henderson, *The Picts*, London (1967), 52–55; A. P. Smyth, *Warlords and Holy Men: Scotland A.D. 80–1000*, London (1984), 62.

[43] Bede, *Opera Historica* (as in n. 27), I, 266–267; Bede, *Ecclesiastical History* (as in n. 27), 426–429; Anderson (as in n. 28), I, 191–195.

[44] Schapiro (1944), 241.

[45] Bede, *Opera Historica* (as in n. 27), I, 267; Bede, *Ecclesiastical History* (as in n. 27), 428: *Brettonum quoque pars nonnulla.*

relations, who still enjoyed a strong Celtic polity.[46] The same can no longer be said by 685 of Rheged, which had survived the reigns of Oswald and Oswiu, but had only recently ceased to exist, as is shown below. Third, Dunnichen did not ultimately affect the newly-acquired Northumbrian control of the former territory of Rheged. Carlisle, at least, remained in Northumbrian hands after the battle. Cuthbert, recently made bishop of Lindisfarne, was being taken on a tour of Carlisle's Roman ruins by Waga, the city's Anglian reeve, when the saint had a vision of Ecgfrith's death at Dunnichen. According to Bede, Eormenburg, Ecgfrith's queen, was in Carlisle at the time. Cuthbert then left Carlisle to dedicate a monastic church nearby and returned to the city afterwards to conduct the widowed Eormenburg into a nunnery.[47] Carlisle thus continued to be Northumbrian although conditions may have remained unsettled in the area for some time. Fourth, Ruthwell's runic inscriptions can no longer be seen as evidence of an early Northumbrian dialect no later than the seventh century. Despite Schapiro's series of mistakes, Stone improved upon them by assigning Ruthwell to the exact decade between the building of Monkwearmouth and the battle in 685.[48]

The fundamental problem, however, remains the failure to recognize the importance of the history of Rheged to the dating of the Ruthwell cross.[49] Urien of Rheged is a major figure in the oldest surviving stratum of Welsh literature.[50] Poems attributed to Taliesin in the later sixth century describe Urien as prince of Rheged and lord of *Catraeth*, or Catterick in Yorkshire, which may have been the easternmost extension of his kingdom. Dunragit ("Fortress of Rheged") is at the head of Luce Bay on the eastern side of the Rinns of Galloway and suggests the western reaches of Rheged (Fig. 2), while Rochdale in Lancashire is called *Recedham* in *Domesday Book*.[51] The *Historia Brittonum* briefly discusses Urien's career. He was assassinated by a jealous confederate while besieging the Bernician Angles in the island of *Metcaud* or Lindisfarne in the late sixth century and his death seems to have created a power

[46] Anderson (as in n. 28), I, 193; M. O. Anderson, *Kings and Kingship in Early Scotland*, rev. ed., Edinburgh and London (1980), 167, 170–172; Smyth (as in n. 42), 72–77.

[47] Baldwin Brown (1921), 294–297; *Two Lives of Saint Cuthbert* (as in n. 41), 122–123, 242–245, 248–249.

[48] Stone (1955), 13.

[49] *Rheged* seems to have meant "givers of gifts" or "the generous ones." I. Williams, "Wales and the North," *Transactions of the Cumberland and Westmorland Antiquarian and Archaeological Society*, n.s. li (1952), 84 (reprinted, with additional notes, in *The Beginnings of Welsh Poetry: Studies by Sir Ifor Williams*, ed. R. Bromwich, 2nd ed., Cardiff [1980], 84).

[50] R. Bromwich, "The Character of the Early Welsh Tradition," in *Studies in Early British History*, ed. N. K. Chadwick, Cambridge (1954), 84–87; M. Dillon and N. Chadwick, *The Celtic Realms*, London (1967), 270–273.

[51] W. J. Watson, *The History of the Celtic Place-Names of Scotland*, Edinburgh and London (1926), 156, 168; A. W. Wade-Evans, "Prologomena to the Study of the Lowlands," *Transactions of the Dumfriesshire and Galloway Natural History and Antiquarian Society*, 3rd ser., xxvii (1950), 76–78; D. P. Kirby, "Strathclyde and Cumbria: A Survey of Historical Development to 1092," *Transactions of the Cumberland and Westmorland Antiquarian and Archaeological Society*, n.s. lxii (1962), 79; K. H. Jackson, *The Gododdin: The Oldest Scottish Poem*, Edinburgh (1969), 8–9, 83–84; N. K. Chadwick, *The British Heroic Age: The Welsh and the Men of the North*, Cardiff (1976), 81–82; J. T. Koch, "Mor Terwyn," *Bulletin of the Board of Celtic Studies* xxx (1983), 301–303; Williams (1952 [as in n. 49]), 83–84; reprinted in Williams (1980 [as in n. 49]), 82–83. J. MacQueen, *St. Nynia, with a translation of the Miracles of Bishop Nynia* by W. MacQueen, Edinburgh (1990), 60–76, proposes an east coast location for Rheged which has not been generally accepted.

vacuum in the area of Catterick, where the British Gododdin of southeastern Scotland were overwhelmingly defeated by the Northumbrians c. 600.[52]

Later Welsh tradition fondly remembered Urien's son Owein as a hero,[53] but Owein's brother Rhun is more of an historical figure (Fig. 4). According to the c. 1100 Harley 3859 manuscript (London, British Library) of the texts of both the *Historia Brittonum*, written in the early ninth century, and the *Annales Cambriae*, originally compiled in the mid-tenth century, Rhun son of Urien of Rheged baptized Eanfled, daughter of Edwin of Northumbria, at Pentecost c. 626, only to baptize Edwin himself the following Easter.[54] If Bede knew the story, he suppressed it, no doubt because of his antipathy to the schismatic Britons, and instead credited Paulinus, the first archbishop of York, with the baptism of Edwin and his infant daughter. The twelfth-century *Life* of the royal St. Oswald by Reginald of Durham and later Welsh tradition, however, place Edwin while in exile at the court of Gwynedd in north Wales and Bede himself discusses Edwin wandering "as a fugitive for many years through many places and kingdoms," some of which were apparently those of the Celtic Britons.[55] It has been assumed that Rhun son of Urien, known as a "famous warrior" in his youth, must have subsequently entered the church, but Smyth suggests that Rhun may only have acted as sponsor at a baptism performed in the court of Rheged during Edwin's exile,

[52] *Historia Brittonum cum Additamentis Nennii*, ed. T. Mommsen, *Monumenta Germaniae Historica, Auctores antiquissimorum* XIII, Berlin (1898, reprint 1961), 206; Anderson (as in n. 28), I, 13; Jackson (as in n. 27), 707–708; P. Hunter Blair, "The Bernicians and Their Northern Frontier," in Chadwick (as in n. 50), 151–155; K. H. Jackson, "On the Northern British Section in Nennius," in *Celt and Saxon: Studies in the Early British Border*, ed. N. K. Chadwick, Cambridge (1963), 31–32; Jackson (as in n. 51), 9, 11–12. L. Alcock, "Gwŷr y Gogledd: An Archaeological Appraisal," *Archaeologia Cambrensis* CXXXII (1983), 14–17, has cast doubts on the historicity of the literary account, in view of archaeological evidence for Anglian settlement in the area of Catterick before 600. T. M. Charles-Edwards, "The Authenticity of the *Gododdin*: An Historian's View," in *Astudiaethau ar yr Hengerdd (Studies in Old Welsh Poetry) cyflwynedig i Syr Idris Foster*, ed. R. Bromwich and R. B. Jones, Cardiff (1978), 44–71, accepts the historicity of the *Gododdin* poem and suggests that its author Aneirin flourished between c. 550 and c. 640. D. N. Dumville, "Early Welsh Poetry: Problems of Historicity," in *Early Welsh Poetry: Studies in the Book of Aneirin*, ed. B. F. Roberts, Aberystwyth (1988), 1–16, advises that the case for historicity "is not proven," although another paper in the same volume, J. T. Koch, "The Cynfeirdd Poetry and the Language of the Sixth Century," 17–41, presents linguistic arguments in favor of sixth-century elements in the language of the surviving texts attributed to Taliesin and Aneirin.

[53] Bromwich (as in n. 50), 87–88; Chadwick (as in n. 51), 112–116. Owein was to evolve into the Yvain of Chrétien de Troyes.

[54] *Historia Brittonum* (as in n. 52), 206–207; Anderson (as in n. 28), I, 13–14, 150. The sources are discussed in N. K. Chadwick, "Early Culture and Learning in North Wales," in *Studies in the Early British Church*, ed. N. K. Chadwick, Cambridge (1958), 37–58, 72–73, 114; K. Hughes, "The Welsh Latin Chronicles: *Annales Cambriae* and Related Texts," *Proceedings of the British Academy* LIX (1973), 233–258; D. N. Dumville, "'Nennius' and the *Historia Brittonum*," *Studia Celtica* X–XI (1975-6), 78–95; D. N. Dumville, "On the North British Section of the *Historia Brittonum*," *Welsh History Review* VIII.3 (June 1977), 345–354.

[55] Bede, *Opera Historica* (as in n. 27), I, 99, 107, II, 93; Bede, *Ecclesiastical History* (as in n. 27), 164–167, 176: *per diuersa occultus loca uel regna multo annorum tempore profugus uagaretur*; Chadwick (as in n. 54), 72. B. Colgrave, "The Earliest Life of St. Gregory the Great, Written by a Whitby Monk," in *Celt and Saxon: Studies in the Early British Border*, ed. N. K. Chadwick, Cambridge (1963), 137, loyally maintained that the tradition of Edwin's sojourn in Gwynedd and his baptism by Rhun were "later Welsh inventions" and that the only reason Bede failed to mention them was that he was "ignorant of them." But see, in the same volume, N. K. Chadwick, "The Conversion of Northumbria: A Comparison of the Sources," 138–166. See also T. M. Charles-Edwards, "Bede, the Irish and the Britons," *Celtica* XV (1983), 42–52.

although it might have been politically expedient to undergo a second baptism by Paulinus after Edwin assumed the Northumbrian throne.[56]

The *Historia Brittonum* records the marriage of Edwin's eventual successor, Ethelfrith's son Oswiu, to Riemmelth, daughter of Royth, son of Rhun, who is accepted as Rhun son of Urien of Rheged. (Fig. 4). Riemmelth's name is also listed among the queens of Northumbria in the Durham *Liber Vitae*. Neither source assigns the marriage a date, which depends instead upon modern scholarship. Kirby identifies Riemmelth as the mother of Wilfrid's patron Alhfrith of Deira, who was old enough to fight alongside his father against Penda of Mercia in 655. Jackson therefore dates the marriage to c. 635, while Kirby dates it to c. 638 "at the latest." Riemmelth was probably Oswiu's first wife (*contra* Fig. 4); his second wife, Eanfled, the daughter of Edwin baptized by Riemmelth's grandfather Rhun, was the mother of Ecgfrith, became abbess of Whitby and was still living after 685, according to Bede.[57] Rheged must have still enjoyed viable political status for Riemmelth to have made a suitable wife for Oswiu but Jackson, Kirby and Bailey follow Wade-Evans's suggestion that Northumbria gained Rheged as a result of the marriage.[58] Indeed, Kirby's suggested date for the marriage of c. 638 has achieved almost canonical certainty. Laing has used it in reference to the firing of the mote of Mark, the Rheged hill-fort in Kirkcudbrightshire, although Graham-Campbell and Close-Brooks argue for the possibility of a later date on archaeological grounds, while Bailey tentatively dates the end of the kingdom of Rheged to c. 638.[59] As Smyth pointedly remarks, however:

> Anyone who has studied Celtic polity knows that kingdoms did not passively change hands as dowries, and that even if royal lines were reduced to sole surviving daughters, there were myriads of rival segments in the tribal aristocracy who would not sit idly by and see a Germanic warlord usurp their patrimony.[60]

The marriage of Riemmelth and Oswiu shows that Northumbria considered Rheged worthy of a marital alliance, not that Rheged lost both a daughter and itself in the form of her dowry.

[56] Wade-Evans (as in n. 51), 82; Chadwick (as in n. 54), 72; Jackson (as in n. 52), 32–33; Smyth (as in n. 42), 22–23.

[57] *Historia Brittonum* (as in n. 52), 203; Anderson (as in n. 28), I, 15n; Jackson (as in n. 52), 21, 41–42, 50, 53; Kirby (as in n. 51), 80, 81n; Bede, *Opera Historica* (as in n. 27), I, 267; Bede, *Ecclesiastical History* (as in n. 27), 428–431. Wade-Evans (as in n. 51), 82–83, would make Riemmelth the mother of Ecgfrith's successor Aldfrith, but Aldfrith was Oswiu's son by the Irish Uí Néill princess Fína and Bede describes Aldfrith as illegitimate. See Bede, *Opera Historica* (as in n. 27), II, 263–264; Anderson (as in n. 28), I, 210; *Two Lives of Saint Cuthbert* (as in n. 41), 238–239; F. J. Byrne, *Irish Kings and High-Kings*, London (1973), 111.

[58] Wade-Evans (as in n. 51), 82–83; Jackson (as in n. 28), 82; Jackson (as in n. 52), 42; Kirby (as in n. 51), 81; Bailey and Cramp (1988), 3.

[59] Bailey and Cramp (1988), 3; L. Laing, "The Mote of Mark and the Origins of Celtic Interlace," *Antiquity* XLIX (1975), 98–102; J. Graham-Campbell and J. Close-Brooks, "The Mote of Mark and Celtic Interlace," *Antiquity* L (1976), 48–53; although Graham-Campbell also accepts the 638 date for "the Anglian advance into SW Scotland." The fifth-century date obtained by radiocarbon readings in D. Longley, "The Date of the Mote of Mark," *Antiquity* LVI (1982), 132–134, refers to the construction, not the destruction of the rampart; but Alcock (as in n. 52), 5–6, argues for a construction date not earlier than c. 600, on the basis of the stratigraphy.

[60] Smyth (as in n. 42), 23.

It was Ecgfrith of Northumbria who seems to have annexed Rheged piecemeal until it ceased to exist shortly before Dunnichen. Ecgfrith attended the dedication ceremony at Ripon some time between 671 and 678, when Wilfrid read out a list of apparently recent royal grants of lands taken from fleeing British clergy. Some of the place names in question, including Dent (Fig. 2), Catlow and the River Ribble, are in Lancashire and the West Riding of Yorkshire. Jackson additionally notes that Ecgfrith granted Cuthbert the land of Cartmell in Lancashire (North-of-Sands) and *omnes Brittanos cum eo*, concluding that Rheged's remaining territories only fell to Northumbria around the third quarter of the seventh century.[61] But all of the place names in question are in the southern part of Rheged's territory; the northern area may have clung to its independence for a few years more. While Wilfrid's biographer Stephen depicts him newly exultant over the seizure of the ecclesiastical holdings of the Celtic Britons in southern Rheged, neither Stephen nor Bede mentions any Anglian churches around the Solway Firth outside the immediate area of Carlisle, and those around Carlisle only at the time of Dunnichen.[62] At any rate the Anglian takeover of Rheged was an ongoing process under Ecgfrith. Continued armed conquest, rather than a peaceful transfer as the result of a royal marriage, is also suggested by the burnings of the Rheged hill-forts at the Mote of Mark and Trusty's Hill, to the west of Ruthwell.[63]

The presence of a Pictish symbol stone at Trusty's Hill (Fig. 5) has been used to argue for an early Pictish population in the area, an interpretation that would argue against the lingering independence of northern Rheged until the eve of Dunnichen.[64] Charles Thomas would not make the Picts local residents, but attributes to a late sixth- or early seventh-century Pictish raid the Pictish Double Disc and Z-rod symbol incised on a rock outcrop and the vitrifaction at the hill-fort site on Trusty's Hill near Anwoth in Kircudbrightshire, some thirty-five miles west of Ruthwell.[65] Thomas dates the raid by the symbol stone, which he sees as early. But Henderson has identified as signs of lateness the curlicues flowing the wrong way on its Z-rod and the penetration by the Z-rod of the Double Disc symbol, an

[61] *Life of Bishop Wilfrid* (as in n. 35), 36–37, 164; P. Hunter Blair, "The Northumbrians and Their Southern Frontier," *Archaeologia Aeliana*, 4th ser., xxvi (1948), 122–126; Jackson (as in n. 27), 215–217; K. H. Jackson, "The British Language during the Period of the English Settlements," in Chadwick (as in n. 50), 64–65. Jackson reconciles his apparently contradictory view in Jackson (as in n. 52), 42. Ecgfrith's grant of Cartmell to Cuthbert, *et omnes Brittani cum eo* (the emendation is Jackson's), is recorded in the tenth-century *Historia de Sancto Cuthberto*, printed in Symeon of Durham (as in n. 4), I, 200.

[62] Smyth (as in n. 42), 24–25; *Life of Bishop Wilfrid* (as in n. 35), 26–27. For the correct name of the author of the *Vita Wilfridi*, see D. P. Kirby, "Bede, Eddius Stephanus and the 'Life of Wilfrid'," *English Historical Review* xcviii (1983), 101–114. A solitary Anglian outpost is indicated by Cuthbert's hermit friend who gave his name to St. Herbert's Isle in Derwent Water in Cumbria; see Bede, *Opera Historica* (as in n. 27), I, 274; Bede, *Ecclesiastical History* (as in n. 27), 440–441. For Celtic British place-name evidence in the territory of Rheged, see W. F. H. Nicolaisen, *Scottish Place-Names: Their Study and Significance*, London (1976), 160–162. See also I. N. Wood, "Anglo-Saxon Otley: An Archiepiscopal Estate and Its Crosses in a Northumbrian Context," *Northern History* xxiii (1987), 24.

[63] A. C. Thomas, "Excavations at Trusty's Hill, Anwoth, Kircudbrightshire in 1960," *Transactions of the Dumfriesshire and Galloway Natural History and Antiquarian Society*, 3rd ser., xxxviii (1961), 58–70 attributes the vitrifaction at Trusty's Hill to a late sixth or early seventh-century Pictish raid. Excavations at the two sites are summarized in L. Laing, *The Archaeology of Late Celtic Britain and Ireland c. 400–1200 A.D.*, London (1975), 32–36.

[64] MacQueen (as in n. 51), 40–41.

[65] Thomas (as in n. 63); C. Thomas, *Christianity in Roman Britain to A.D. 500*, London (1981), 288–290.

Fig. 5. Pictish symbol stone from Trusty's Hill, Anwoth, Kircudbrightshire (after Romilly Allen and Anderson [1903])

observation which supports Ralegh Radford's association of the Trusty's Hill carving with a Pictish raid in the wake of Dunnichen in the late seventh century, and makes far more sense than any appeal to late-medieval legends about the spurious "Picts" of Galloway.[66]

[66] I. Henderson, "The Origin Centre of the Pictish Symbol Stones," *Proceedings of the Society of Antiquaries of Scotland*, XCI (1957–1958), 50n; Henderson (as in n. 42), 114; C. A. Ralegh Radford, "The Pictish Symbols at Trusty's Hill, Kirkcudbrightshire," *Antiquity* XXVII (1953), 237–239 also dates to the period following Dunnichen the Pictish symbol stone found in Princes Street Gardens below Edinburgh Castle, see Romilly Allen and Anderson (1903), III, fig. 438; Bede, *Opera Historica* (as in n. 27), I, 267; Bede, *Ecclesiastical History* (as in n. 27), 428–429, records a Pictish military incursion in the neighborhood after Dunnichen, when the Anglian bishop Trumwine hastily abandoned his recently founded seat at Abercorn on the Firth of Forth and fled to Whitby. Support for Ralegh Radford's dating of the Edinburgh symbol stone is offered by the wide angles of its Z-rod, a feature identified as late in the symbol stone series in I. Henderson, "The Silver Chain from Whitecleugh, Shieldholm, Crawfordjohn, Lanarkshire," *Transactions of the Dumfriesshire and Galloway Natural History and Antiquarian Society*, 3rd ser., LIV (1979), 24. A. C. Thomas, "Abercorn and the Provincia Pictorum," in *Between and beyond the Walls: Essays on the Prehistory and History of North Britain in Honour of George Jobey*, ed. R. Miket and C. Burgess, Edinburgh (1984), 327, dates the Edinburgh stone to the sixth century, which would place it early in the symbol stone series. There is some evidence in support of an early Pictish presence along the south shore of the Firth of Forth, outside the traditional Pictish area. Individual Picts are described allies of the Gododdin at *Catraeth* c. 600; see Jackson (as in n. 51), 6, 78–79, 103, 108, 119–121. John T. Koch has pointed out to me that friendly relations between the Picts and the Gododdin are also suggested in the fifth century or earlier by late medieval Welsh genealogies of Cunedda, the legendary founder of Gwynedd, who is said to have come from Gododdin, in which the names of some of Cunedda's forebears include the prefix *Guor-*, equivalent to Pictish *Uur-*; see P. C. Bartrum, *Early Welsh Genealogical Tracts*, Cardiff (1966), 9, 44, 108. K. H. Jackson, "The Sources for the Life of St. Kentigern," *Studies in the Early British Church*, ed. N. K. Chadwick, Cambridge (1958), 292–293, argues that place names on the south shore of the Firth of Forth beginning in *Aber-*, such as Aberlady (and Abercorn) are more likely to be Pictish than Brittonic. Various kinds of evidence therefore may be drawn upon to infer a Pictish presence in Gododdin territory before and after the Anglian takeover. Bede, however, makes it clear that Abercorn was in Anglian territory in 685, whatever may have been the origins of its name; see Bede,

The British Celtic sources for the later history of Rheged fail us after the marriage of Riemmelth to Oswiu. At the end, Rheged had no Aneirin, the poet who wrote the lament for the Gododdin who died at *Catraeth* c. 600. The great poets of Rheged belonged to the same generation: Taliesin sang the praises of Riemmelth's great-grandfather Urien, while another cycle of poems is associated with Llywarch Hen, who emerges as Urien's first cousin in the Welsh genealogies.[67] A similar British failure characterizes the collapse of Gododdin. We learn of the fall of the Gododdin capital not from a British source, but from the Irish *Annals of Ulster* and the *Annals of Tigernach*.[68] The final demise of Rheged may also be reflected in the same Irish sources.

Five events described in the Irish annals between 682 and 709, when marauding bands of Britons were active in eastern Ireland, are relevant to the later history of Rheged and the dating of the Ruthwell cross.[69] In 682 Britons killed Cathasach of Dál nAraide in Antrim, directly across the North Channel from Rheged. After a fifteen-year silence, they appeared again in 697, now allied with the Ulstermen, laying waste to Mag Muirthemne in County Louth. In 702 Britons slew Írgalach of North Brega on Ireland's Eye, north of Dublin. A year later, Britons were defeated in the Wicklow mountains, apparently fighting as mercenaries alongside Cellach Cualann of the Leinster Uí Máil, father-in-law of the Írgalach slain by Britons in 702.

The *Annals of Ulster* entry for 682, the first in the series, includes an additional detail not found in the *Annals of Tigernach*: the battle involving Britons in Antrim is associated with the killing of *Muirmin in Mano*. Chadwick interpreted *in Mano* to mean "in the isle of

Opera Historica (as in n. 27), I, 267; Bede, *Ecclesiastical History* (as in n. 27), 428: *Aebbercurnig, posito quidem in regione Anglorum sed in uicinia freti, quod Anglorum terras Pictorumque disterminat.* Having prepared my own typology of the Double Disc and Z-rod symbol in D. Mac Lean, *Early Medieval Sculpture in the West Highlands and Islands of Scotland*, Ph.D diss., 2 vols., University of Edinburgh (1985), I, 82–91, I am convinced that the Trusty's Hill and Edinburgh stones are both typologically and chronologically late, and thus concur with Ralegh Radford that their find-spots are most probably to be explained by a Pictish raid after Dunnichen.

[67] In British Library, MS. Harley 3859, the late thirteenth-century *Bonedd Gwŷr y Gogledd* ("Descent of the Men of the North"), which may originally have been compiled in the twelfth century, and the fourteenth-century Jesus College, Oxford MS. 20, see Bromwich (as in n. 50), 92–94, 119–121; Chadwick (as in n. 54), 74, 79–82, 86–90; Jackson (as in n. 51), 21–22, 50; Dillon and Chadwick (as in n. 50), 273–275. For *Bonedd Gwŷr y Gogledd* and Harley 3859, see also M. Miller, "Historicity and the Pedigrees of the Northcountrymen," *Bulletin of the Board of Celtic Studies* XXVI (1975), 256–257, 258–259. The genealogies are published in Bartrum (as in n. 66), 10, 46, 48, 73. The verses attributed to Llywarch Hen are not thought to be earlier than the early ninth century. For their original text, see I. Williams, *Canu Llywarch Hen*, 2nd ed., Cardiff (1953). P. K. Ford, *The Poetry of Llywarch Hen*, Berkeley (1974), gives the verses in a standardized Modern Welsh spelling, with English translation.

[68] *The Annals of Ulster (to A.D. 1131)*, ed. S. Mac Airt and G. Mac Niocaill, Dublin (1983), 120–121; W. Stokes, "The Annals of Tigernach: Third Fragment. A.D. 489–766," *Revue Celtique* XVII (1896), 184; Anderson (as in n. 28), I, 163–164; discussed in K. H. Jackson, "Edinburgh and the Anglian Occupation of Lothian," in *The Anglo-Saxons: Studies in Some Aspects of their History and Culture Presented to Bruce Dickins*, ed. P. Clemoes, London (1959), 35–42.

[69] G. Mac Niocaill, *Ireland before the Vikings*, Dublin (1972), 110–114; M. Miller, "Hiberni reversuri," *Proceedings of the Society of Antiquaries of Scotland* CX (1978–1980), 310; Smyth (as in n. 42), 25–6. For the individual entries, see *Annals of Ulster* (as in n. 68), 146, 158, 160, 162, 165–167; Stokes (as in n. 68), 206–207, 215, 217–218, 221. Miller would also include a garbled entry for 678 in the Annals of Tigernach, but M. O. Anderson (as in n. 46), 38, has shown that the "text has suffered a manifest dislocation" at this point. The sequence therefore begins in 682 in both the Annals of Ulster and the Annals of Tigernach.

Man" and identified *Muirmin* as the Merfyn Mawr named as an ancestor, in the female line, of Merfyn Frych, founder of the Second Dynasty of Gwynedd in north Wales, who died in 844.[70] A verse interpolated in the entry in the *Annals of Ulster* of the death in 878 of Merfyn Frych's son Rhodri Mawr calls him "Rhodri of Man." At this point, the Welsh records reassert themselves. Jesus College MS. 20 and the probably thirteenth-century *Hanes Gruf-fudd ap Cynan* trace the descent in the male line of Rhodri Mawr son of Merfyn Frych back to Llywarch Hen, the cousin of Urien of Rheged.[71] Merfyn's father's name is given as Gu-riat, who has been connected with the CRUX GURIAT inscription on the edge of a cross slab from Maughold in the Isle of Man.[72] The later medieval Welsh genealogies were subject to fashionable schematization, but the belief that the Gwynedd family was traceable through Man to Rheged was a strong one. In a Celtic context, such beliefs are not lightly dismissed.

A summary is in order. Rampaging Britons appear in 682 in Antrim, due west of Rhe-ged. In the same year, Merfyn Mawr, a forebear of the ninth-century Merfyn Frych of Gwynedd, died in the Isle of Man. Merfyn Frych claimed descent from Llywarch Hen, a cousin of Urien of Rheged. Military activities by Britons in Ireland are only mentioned five times in the twenty-seven years between 682 and 709 and it seems likely that the British raiders were based in the Isle of Man, having moved there after the destruction of Rheged.[73] The Northumbrian raid Ecgfrith sent into Ireland in 684 has been explained in terms of Ecgfrith's strained relationship with his illegitimate half-brother Aldfrith, yet another son of the prolific Oswiu, this time by an Irish princess (Fig. 4). Aldfrith spent some time in Ire-land, where he was remembered as a poet in Old Irish and was accorded the privilege, rare for an Anglo-Saxon, of an Irish nickname, *Fland Fína*. Aldfrith did, in fact, succeed Ecgfrith after Dunnichen, as Cuthbert had foretold. Smyth credits Ecgfrith with an additional motive: the threat posed by the "dispossessed warriors" who were the "élite of the house" of Rheged.[74]

[70] H. M. Chadwick, *Early Scotland: The Picts, the Scots and the Welsh of Southern Scotland*, Cambridge (1949), 146. *Annala Uladh: Annals of Ulster*, I, ed. W. M. Hennessy, Dublin (1887), 132–133, makes no attempt to translate *in Mano*. The modern editors of the *Annals of Ulster* (as in n. 68), 146–147, translate the phrase "while captive (?)," but give no reasons for doing so. Chadwick's translation fits best with the other evidence. Merfyn Mawr's genealogy is expressly linked to *Ynys Manaw* (the Isle of Man) in London, British Library, MS. Harley 3859; Oxford, Jesus College MS. 20 makes Merfyn Frych of Gwynedd the great-grandson of Celeinion, the great-granddaughter of Merfyn Mawr; Celeinion is Merfyn Mawr's granddaughter in the probably fifteenth-century *Achau Brenhinoedd a Thywysogion Cymru*; see Bartrum (as in n. 66), 10, 46, 100. Additional discussion in Miller (as in n. 69), 310–311; D. P. Kirby, "British Dynastic History in the Pre-Viking Period," *Bulletin of the Board of Celtic Studies* XXVII (1978), 97, 102, 110–111, 114.

[71] *Annals of Ulster* (as in n. 68), 332; Bartrum (as in n. 66), 36, 46; Chadwick (as in n. 54), 79–81.

[72] The lack of a patronymic in the inscription renders the identification incapable of certainty, but the slab stylistically predates the colonial Viking-period Manx crosses. P. M. C. Kermode, *Manx Crosses*, London (1907), 121–123, fig. 49, pl. XV, no. 48; C. A. Ralegh Radford, "The Early Church in Strathclyde and Galloway," *Medieval Archaeology* XI (1967), 125; A. M. Cubbon, *The Art of the Manx Crosses* (Manx Museum and National Trust), 3rd. ed., Douglas (1983), 10–11. Bede says that Edwin of Northumbria brought under Anglian rule the *Meuanias Brettonum insulas*, which are taken to be Anglesey and Man, although Plummer found "no authority for applying this name to Man." If so, Edwin's conquests were lost after his death at the hands of Cadwallon of Gwynedd and Penda of Mercia c. 633. See Bede, *Opera Historica* (as in n. 27), I, 89, 97, 124–125, II, 94: Bede, *Ecclesiastical History* (as in n. 27), 148–149, 162–163, 202–205.

[73] Smyth (as in n. 42), 25–26; Mac Niocaill (as in n. 69), 112–113; Byrne (as in n. 57), 111–112.

[74] Smyth (as in n. 42), 26, 129; and H. Moisl, "The Bernician Royal Dynasty and the Irish in the Seventh Century," *Peritia* II (1983), 120–124; *Two Lives of Saint Cuthbert* (as in n. 41), 104–105, 236–237.

The later history of the Irish Wild Geese and Scottish Jacobites serving in their French and
Spanish regiments against the day when they could restore the king across the water provides
a modern parallel to the warriors of Rheged lurking in the Isle of Man and hiring themselves
out as mercenaries in Ireland while nursing a similar forlorn hope. The description in the
Lives of Cuthbert of the saint inspecting the Roman walls of Carlisle and an ancient fountain
in the city carries the sense of newly discovered wonders.[75] Carlisle may only recently have
passed to Northumbria. Rheged had been an L-shaped polity, running east from the Rinns of
Galloway past Carlisle, then turning south through Cumbria into Lancashire. The Ruthwell
cross is about twenty miles west of Carlisle. The story of the last days of Rheged, retrieved
from the Celtic sources, makes it unlikely that so conspicuously Anglian a monument was
erected much before 682.

Typological Development of Northumbrian Sculpture

The typological sequence outlined by Cramp argues against its antedating 685.[76] In Phase I,
Gaulish stonemasons built stone churches at the behest of Wilfrid and Benedict Biscop. Ar-
chitectural sculpture evolved in Northumbria as a result, but the Jarrow vine scroll frag-
ments cannot be shown to have been part of the monastic church of 685 and may well belong
to a secondary structure of the late seventh or early eighth century. Inscribed slabs bearing
crosses in relief were also produced at Monkwearmouth and Jarrow in the same period, at
the beginning of Cramp's Phase II. Higgitt has advanced excellent reasons for dating the two
finest examples to the early eighth century. Levison established that the inscription on a slab
at Jarrow, now partly defaced, was *In hoc singulari signo vita redditur mundo* and that it
derives from the Latin version of the inscription on the statue erected in honor of Constan-
tine's vision, which is given in Rufinus's Latin translation of Eusebius's *Ecclesiastical His-
tory*, a work known to Bede.[77] Higgitt relates the Jarrow inscription to the return from Rome
after 701 of Hwaetberht, who succeeded Ceolfrith in the abbacy in 716 and was also known
by the monastic nickname of Eusebius, which suggests his interest in Rufinus's text of Euse-
bius and may account for the text of the Jarrow inscription.[78] The inscription on a relief cross
slab at Monkwearmouth (Pl. 56) reads *Hic in sepulcro requiescit corpore Herebericht p̄r̄b*
and the last line has been altered to make room for Herebericht's name. The rest of the
inscription is original and echoes the epitaph on Wilfrid's tomb at Ripon, which is recorded
by Bede. Higgitt therefore proposes that the original carving of the HEREBERICHT slab
may date after 709 and suggests that Ceolfrith or Hwaetberht may have commissioned it
shortly thereafter as a memorial to abbots Eosterwine or Sicgfrid of Monkwearmouth, whose
remains were translated in 716, which would then have left the slab free for reuse. Alterna-
tively, the slab "might have been a monument prepared before his death for Ceolfrith, who

[75] *Two Lives of Saint Cuthbert* (as in n. 41), 122–123, 242–245.

[76] Cramp (as in n. 6), 6–7.

[77] W. Levison, "The Inscription on the Jarrow Cross," *Archaeologia Aeliana*, 4th ser., xxi (1943), 121–127.

[78] Higgitt (as in n. 35), 364. For Hwaetberht, see Bede, *Opera Historica* (as in n. 27), I, xiv–xvii, cxlvii, 382–400.

unexpectedly left Jarrow in old age to travel to Rome," dying "on the way at Langres in 716,"[79] which would also explain the change of the name inscribed on the Monkwearmouth memorial. In any event, the inscribed relief cross slab, a typological predecessor of the sculptured stone cross, became established as a Northumbrian monumental form by the early eighth century.

In 1978, Cramp dated the Northumbrian evolution of the "large standing cross" to the "very end" of her phase II, shortly before the mid-eighth century. A decade later, she suggested two possible historical contexts for the Ruthwell and Bewcastle crosses, one c. 684, just before the battle of Dunnichen, the other nearer the mid-eighth century.[80] But she is still leery of the earlier date, in view of the "insecurity of Northumbria's hold in the region" and she is as fond of the mid-eighth-century date now as she was in 1960.

Conclusion

Mercer has collected the historical evidence in favor of the mid-eighth-century date. Bede completed his *Historia Ecclesiastica* in 731 and refers in it to a recently established Anglian bishopric at Whithorn, near the old Rheged hill-fort at Trusty's Hill. Eadberht became king of Northumbria in 737 and in 750 seized Kyle in Ayrshire (Fig. 2), which belonged to the British Celtic kingdom of Strathclyde based at Dumbarton. In 756, he took Dumbarton in alliance with the Picts, but the Britons savaged his army on its march home. In 758, Eadberht retired to religious life at York, where his brother Ecgberct was archbishop. In later years, Ecgberct's pupil Alcuin would recall Eadberht's reign as something of a golden age. For Cramp, this is "a convincing context for an English monument at Ruthwell."[81]

One might, however, argue for a date nearer 731 than 750. According to Bede, the "number of believers" at Whithorn had "so increased" that the new bishopric was a necessity.[82] Whithorn had long been an ecclesiastical center, whenever St. Ninian may have lived, but we can be certain of the sort of "believers" Bede had in mind. The implied collapse of the

[79] Higgitt (as in n. 35), 365, also suggests Benedict Biscop as the possible commemoratee of the Monkwearmouth slab, but Biscop died c. 689, "rather too soon for the lettering in relation to the Jarrow dedication inscription and perhaps also for the form of the cross," Bede, *Opera Historica* (as in n. 27), I, 385, II, 369. The emergence of the relief cross slab in Northumbria before the erection of freestanding stone crosses parallels the situation in northern Scotland, where the Pictish evolution of cross slabs carved in relief preceded the Gaelic experimentation at Iona which led to the development of the Celtic cross. The geographical distinction between Northumbria and northern Scotland may be somewhat misleading: Pictish cross slabs depended upon their predecessors at Jarrow and Monkwearmouth, while Iona derived the cross form from Northumbria, not the Picts.

[80] Cramp (as in n. 6), 7; Bailey and Cramp (1988), 20–22.

[81] Mercer (1964), 268–276, esp. 271; Bede, *Opera Historica* (as in n. 27), I, 351, 362–363, II, 346; Bede, *Ecclesiastical History* (as in n. 27), 559–561, 572–575; Jackson (as in n. 28), 85; Bailey and Cramp (1988), 22.

[82] Bede, *Opera Historica* (as in n. 27), I, 351; Bede, *Ecclesiastical History* (as in n. 27), 259–261: *quae nuper, multiplicatis fidelium plebibus, in sedem pontificatus addita ipsum primum habet antitistitem.* A MacQuarrie, "The Date of Saint Ninian's Mission: A Reappraisal," *Records of the Scottish Church History Society* XXIII.1 (1987), 1–25, marshals evidence for placing Ninian's floruit in the first half of the sixth century; for a summary of the Whithorn problem favoring an earlier date, see C. Thomas (as in n. 65), 275–294; for further discussion see MacQueen (as in n. 51), 22–31.

local nonconformist church of the Celtic Britons would not have been accomplished overnight. Eadberht must have felt quite secure about old Rheged at his rear when he made his grab for Kyle in the kingdom of Strathclyde in 750. By then, the few remaining warriors of Rheged who had removed themselves to the Isle of Man and served as mercenaries in Ireland had nothing left but their memories and their rheumatism. Northumbrian stone churches housed architectural sculpture at the latest by the early eighth century, when cross slabs carved in relief made their appearance at Monkwearmouth and Jarrow. Sculptured stone crosses were erected over Acca's grave at Hexham c. 740. The Ruthwell cross was a near contemporary.

Of the two suggested historical contexts for dating the Ruthwell and Bewcastle crosses, the earlier date of c. 684 is untenable. The British Celtic kingdom of Rheged had only recently fallen to Ecgfrith of Northumbria and Carlisle was still being explored by its new Anglian masters. Conditions in the area were unstable after Dunnichen and Northumbrian sculpture had not yet developed to the point of producing freestanding crosses. The second possible historical context, between the period of the establishment of the Anglian bishopric at Whithorn and Eadberht's acquisition of Kyle in 750, allows time for Northumbrian sculptors to have liberated the cross from its slab after detaching the slab from the church building. That was the period, early in the second quarter of the eighth century, when a dusty band of stonemasons, trained at Jarrow, trudged along Hadrian's Wall to the headwaters of the Solway Firth and set up their masterpiece at Ruthwell, whether they made the Bewcastle cross along the way, or instead while returning home.

Inscriptions and Design
of the Ruthwell Cross

•

DAVID HOWLETT

THE RUTHWELL CROSS, one of the most glorious relics of Anglo-Saxon culture, exhibits an extensive program of sculpture, the longest extant series of Anglo-Latin inscriptions, the longest Old English runic inscription, and the most beautiful poem in the Old Northumbrian dialect. The cross of native red sandstone has stood since 1887 in a specially constructed apse in the parish kirk of Ruthwell in Dumfriesshire. The earliest modern reference to the cross is an annotated drawing, made between 1599 and 1601 by Reginald Bainbrigg, of the runes on the upper border of the east face of the main shaft (Pl. 33).[1] Within the next half century the cross was thrown down and shattered in compliance with an act of the General Assembly of the Kirk of Scotland of 1642. During the following 150 years, when various pieces of the demolished cross lay embedded in the floor of the kirk or buried in the yard outside, portions of it were drawn at least three times by men who did not recognize it as a cross and could not read its runic inscriptions (Pls. 34–38).[2] After discovery of a fragment during excavation for a grave between 1799 and 1802 the Rev. Henry Duncan erected the lower portions of the main shaft as a pillar in the garden of his manse. In 1823 he tried to reconstruct the cross, supplying a transverse beam and setting the headstone back to front. On 10 December 1832 he read a paper about the cross, which he published with a drawing of the reconstructed cross in 1833 (Pl. 39).[3] Thereafter, four other detailed drawings appeared in print, but each of these has shortcomings. The first, by J. Basire in Kemble's article about the runes, merely reproduces earlier drawings (Pls. 42–43).[4] The second, by the notoriously unreliable D. H. Haigh, fills gaps in the text of inscriptions with readings which earlier drawings either lack or contradict (Pl. 44).[5] The third, by A. Gibb in John Stuart's work for the Spalding Club, reproduces some texts upside down (Pl. 45).[6] The fourth, in Stephens's famous publication about runic monuments, misplaces the entire east and west faces (Pl. 46).[7]

[1] The drawing is to be found in a manuscript in the British Library, Cotton Julius F VI, fol. 352, published by Page (1959b), pl. XXVI.

[2] These were published by Hickes (1703), *Pars* III, *tabella* iv; Gordon (1726), pl. 57; Gough (1789), II, pls. 54, 55.

[3] Duncan (1833), pl. XIII.

[4] Kemble (1840), pls. XVII, XVIII.

[5] Haigh (1861), pl. II.

[6] Stuart (1856–67), II, pls. XIX, XX.

[7] Stephens (1866–67), I, pl. opp. p. 405, pp. 416–417.

The basis of design of the Ruthwell cross is Biblical style,[8] comprising statement and restatement, Old Testament prefiguring antetype and New Testament fulfilling type, antiphonal repetition and variation of image and word. The reliefs, languages, words, meters, and scripts, roman and runic, have been arranged by parallelism and chiasmus, ordered by measure and number and weight to communicate a message for all seasons.

The design of the Ruthwell cross may formerly have included twenty-four panels, ten each on the north and south faces and two each on the east and west faces. The sequence begins at the base of the south face with the panel which I shall call S1, an almost obliterated Crucifixion (Pl. 19). Christ rather stands than hangs on the Cross, bearded and wearing only a loin cloth. Traces of the sun and moon remain near the top of the panel, and traces which may have represented one figure on each side of the cross (presumably St. John and the Virgin Mary) remain further down. There is no inscription on this panel now, and probably there never was.[9]

To reconstruct the inscriptions let us begin with the text as it appears today, recorded by Elisabeth Okasha, whose conventions and readings I follow.[10]

Panel S2 depicts the Annunciation with the Archangel Gabriel, winged and nimbed, beside the Virgin Mary, also nimbed (Pl. 18). Okasha gives the remaining inscription as:[11]

> *INGRESSVSA[NG]—*

Collation of Duncan's drawing with Luke 1:28 suggests that originally it read:

Top	+ ET INGRESSVS ANGELVS
Right	AD EAM DIXIT HAVE GRATIA PLENA DNS
Left	TECVM BENEDICTA TV IN MULIERIBVS

> + And having entered, the angel said to her, "Hail, full of grace, the Lord [is] with you. You [are] blessed among women."

Panel S3 (Pl. 17) depicts Christ cross-nimbed, reaching toward a blind man. Okasha gives the remaining inscription as:[12]

> *+ ETPRAETERIENS:VIDI[...]T[...]R[....]*
> *ANATIBITATE:ETS[...]*

Collation with John 9:1 suggests that originally it read:

Left	+ ET PRAETERIENS: VIDIT HOMINEM CAECVM
Right	A NATIBITATE: ET SANAVIT EVM AB INFIRMITATE:

[8] For further discussion see my *British Books in Biblical Style* (forthcoming).

[9] See below, p. 91.

[10] Okasha (1971), 45, uses the following conventions when transcribing inscriptions: "Ligatures ... appear as 'A/B' Deliberate spaces between letters in the text are indicated by spaces. Ends of lines of text and ends of complete texts are shown by ' I' 'A': a letter damaged but legible. '[A]': a damaged letter where the restoration is fairly certain. '[A]': a legible and undamaged letter of unusual form, probably A. '[...]': three letters lost, the number varying according to the number of dots. '[...]': an indefinite number of letters lost in the text. '—': a complete loss of text at beginning or end."

[11] Ibid., 110, Sv.

[12] Ibid., 110, Siv.

Arrangement in the following manner illustrates the rhythm and assonance of this inscription.

+ ET PRAETERIENS:
VIDIT HOMINEM CAECVM A NATIBITATE:
ET SANAVIT EVM AB INFIRMITATE:

+ And passing by He saw a man blind from birth, and He healed him from [his] infirmity.

Panel S4 (Pl. 16) depicts Christ cross-nimbed, holding a book in His left hand and blessing with His right hand. Below a woman wipes His feet with her hair. Okasha gives the remaining inscription as:[13]

+A[. . V]B[.]
STRVM:V[NGVE]NTI:
&S[T]AN[SR]E[TR]OSECVSPEDES:
EIVSLACRIMIS:C/OEPITRIGARE:PEDESEIVS:&CAPILLIS:
CAPITISSVITERGEBAT

Collation of early drawings with Luke 7:37–38 allows one to restore it as:

Top	+ ATTVLIT ALABA
Right	STRVM : VNGVENTI : & STANS RETRO SECVS PEDES
Left	EIVS LACRIMIS : COEPIT RIGARE : PEDES EIVS : & CAPILLIS
Bottom	CAPITIS SVI TERGEBAT

+ She brought an alabaster box of ointment and standing behind beside His feet she began to wash His feet with her tears, and she wiped [them] with the hairs of her head.

Panel S5 (Pl. 15) depicts two women embracing. Most scholars have referred to it as the Visitation and identified the women as Elizabeth and the Virgin Mary. From collation of various independent attempts to decipher the surrounding inscription,[14] one infers that originally it read:

Left	marþa
Top	maria mr
Right	dominnæ

To interpret this as "Martha [and] Mary, Mother of the Lord" would raise two epigraphic difficulties. It would force one to infer that the designer or carver confused Martha with Elizabeth and *dominae* with *domini*, although nothing on the Ruthwell cross suggests that he could be guilty of such solecisms. To identify the panel as a Visitation would also raise two

[13] Okasha (1971), 110, Siii.

[14] Black (1887b), 225, "m..rþa|ma.....r|ma..isnæ" or "a." Vietor (1895), 11, "m..rþa|ma.....r|ma..isnæ" or "a." Baldwin Brown (1921), V, pl. 196, 246 fig. 18 (2) 7, "martha|mariamr|dominn(æ)." Dickins and Ross, eds. (1934, ed. 1967), 3–4, "m|m..i . . . r|dominnæ." Elliott (1959, repr. 1971), 94, "mmir|dominnæ." M. Swanton, ed. (1970), 18, "m[a]r þa|ma[riam]|. . . dominnæ." Okasha (1971), 111, "—m[.]r[.]a|m[. . . .]er|dominnae—."

iconographical difficulties. It would interrupt the sequence of scenes and require one to explain why the Visitation should follow the Annunciation, not directly, but after two panels depicting Jesus as a grown man. It would also require one to explain why the Virgin Mary appears with a nimbus in the Annunciation panel but without one in the Visitation panel. Both epigraphic and iconographical difficulties disappear by reading *marþa maria mr* [sc. *merentes*][15] *dominnæ*, "Martha [and] Mary, meritorious ladies," and identifying the women as the sisters of Lazarus.[16]

Panel S6 (Pls. 11–12) depicts a crouching archer who aims upward to the right. The surrounding inscription is obliterated.

The transverse beam of the cross, which is now missing, probably contained three panels: one to the right, S7, one in a central roundel, S8, and one to the left, S9. If the cross had been correctly reconstructed the panel which now appears atop the north face (Pl. 20) would be S10, depicting a bird perched on a fruit-laden branch. The surrounding runic inscription —*œfauœþo*—[17] which has so far defied interpretation, should stand above the runic inscription around panel S5.

The next sequence begins at the base of the north face. Panel N1 is now wholly obliterated but may formerly have depicted the Deposition. There is no inscription on this panel now, and probably there never was.[18]

Panel N2 (Pl. 25) depicts the Virgin Mary, who seems to have been nimbed, bearing the infant Jesus and riding a donkey. At the left traces remain of Joseph leading the donkey during the Flight into Egypt or the Return from Egypt. Okasha gives the remaining inscription as:[19]

> + *MARIA:E*TIO[.....]
> T*V*[*O* ...]

Originally the inscription may have read:

		or	
Top	+ MARIA : ET IOS		+ MARIA : ET IOS
Right	EPH IN AEGYP		EPH EX AEGYP
Left	TVM PER DESERTVM		TO PER DESERTVM
Bottom	RECESSERVNT		RECESSERVNT

+ Mary and Joseph withdrew into Egypt through the desert.

or

+ Mary and Joseph withdrew from Egypt through the desert.[20]

[15] R. Cagnat, *Cours d'Épigraphie Latine*, 2nd ed., Paris (1890), 399.

[16] For another example see the back panel of the Franks Casket, "*HIC FUGIANT HIERUSALIM afitatores.*" The last word, a pronunciation spelling of "*habitatores*," is carved in runes. See Elliott (1959, repr. 1971), 101; and Page (1973), 179.

[17] Okasha (1971), 111.

[18] See below, p. 91.

[19] Okasha (1971), 110, Nv.

[20] See Matthew 2:14 and 2:19. The return from Egypt would accord more literally with the prophecy of Hosea 11:1, *ex Aegypto vocavi Filium Meum*, than the Flight into Eygpt. The direction in which the donkey is heading, right, might

Panel N3 (Pl. 24) depicts the hermit saints Paul and Anthony breaking bread. Okasha gives the remaining inscription as:[21]

> \+ SCS:P*AVL*VS:
> *ET*:*A*[...]
> *F*REG*E*R[.. *T*]:PA*NEM*INDESERTO:

Originally this may have read:

Top	+ SCS : PAVLVS :
Right	ET : ANTONIVS : DVO EREMITAE :
Left	FREGERVNT : PANEM IN DESERTO :

 + Saints Paul and Anthony, two hermits, broke bread in the desert.

Panel N4 (Pl. 23) depicts Christ cross-nimbed, holding a scroll in His left hand and blessing with His right hand. Beneath His feet are two beasts with crossed forepaws. Okasha gives the remaining inscription as:[22]

> [.]*IHS*X[. *S*]
> I*VD*[.]*X*[∴]*E*Q*V*[*IT*]A[*TI*]S:
> *B*EST*IAE*:*ET*:DRACON[*ES*]:*COGNOUERVNT*:*INDE*:
> *SERT*O:*SALVA*[. *O*]REM:MVNDI:

Originally this probably read:

Top	+ IHS XPS
Right	IVDEX : AEQVITATIS :
Left	BESTIAE : ET : DRACONES : COGNOUERVNT : IN DE :
Right	SERTO : SALVATOREM : MVNDI :

 + Jesus Christ the Judge of Justice. Beasts and dragons acknowledged in the desert the Saviour of the world.

Panel N5 (Pl. 21) depicts St. John the Baptist nimbed and standing on two globes, bearing the Lamb of God in his left hand. Okasha gives the remaining inscription as:[23]

> — *DORAMV*S
> [...]

The oldest drawing of this portion of the cross (Pl. 38) gives the inscription along the bottom of this panel as TNONEVM.[24] In the lower left corner between the *S* and the *T* is a long diagonal line with a perpendicular stroke from its centre to the right, perhaps the remains of

suggest return from Egypt, as distinct from left, which might suggest flight into Egypt. But as there is little from this period with which to compare the Ruthwell cross one interpretation should not be affirmed to the exclusion of another.

[21] Okasha (1971), 110, Niv.
[22] Ibid., 109, Niii.
[23] Ibid., 109, Nii.
[24] Gough (1789).

an *E* (Pl. 21). On the basis of the few surviving characters any reading must be highly conjectural, but it may have originally read:

Left + AGNVM DEI ADORAMVS
Bottom ET NON EVM
Right SINGILLATIM TOTAM VERO
Top TRINITATEM

+ We adore the Lamb of God, and not Him singly, but the whole Trinity.

Panel N6 (Pl. 20) depicts two men. The surrounding inscription is obliterated.

The transverse beam of the cross, which is now missing, probably contained three panels: one to the left, N7, one in a central roundel, N8, and one to the right, N9. If the cross had been correctly reconstructed the panel which now appears atop the south face (Pl. 11) would be N10, depicting a bird and a man. The surrounding inscription, which in Okasha's style would read:[25]

INP[.]INC —
VE[.]BVM

should stand above the Latin inscription around panel N5.

Panels N6-7-9-10 almost certainly depicted the four evangelists. As St. John faces his eagle in N10 (Pl. 11) and St. Matthew stands beside his man in N6 (Pl. 20), one infers that St. Mark appeared with his lion to the left in N7 and St. Luke with his ox to the right in N9. The following inscriptions would have fitted into the borders surrounding these panels.

N6 LIBER GENERATIONIS IHV XPI Matthew 1:1
N7 INITIVM EVANGELII IHV XPI Mark 1:1
N9 FVIT IN DIEBVS HERODI REGIS Luke 1:5
N10 IN PRINCIPIO ERAT VERBVM John 1:1

These inscriptions would include twenty-three, twenty-two, twenty-three, and twenty-one letters respectively.

The designer's plan may now begin to emerge. Deferring consideration of the obliterated panel N1, the supposed Deposition, one notes two sequences of four panels, N2-3-4-5 and N6-7-9-10. Each has at least one textual source in the Old Testament and one in the New Testament. Panel N2 (Pl. 25) shows the prophecy of Hosea 11:1 fulfilled in Matthew 2:13–15, *ex Aegypto vocavi Filium Meum*. Panel N3 (Pl. 24) shows a miraculous breaking of bread, for which the Old Testament antetype is I Kings 17 and the New Testament type Luke 24:35, *cognoverunt eum in fractione panis*. Panel N4 (Pl. 23) derives from a parallelism in Psalm 9:9: *ipse iudicabit orbem terrae in aequitate, iudicabit populos in iustitia* ("He will judge the orb of the world in equity; He will judge peoples with justice"); and from a chiasmus in Psalm 91 (90):13:

[25] From unpublished photographs lent by C. J. E. Ball.

a super aspidem
b et
c basiliscum
d ambulabis
e et
d' conculcabis
c' leonem
b' et
a' draconem

Upon the asp and the basilisk will you walk, and you will tread on the lion and the dragon.

The New Testament reflexes of these texts are Acts 17:31 and Mark 1:13:

eo quod statuit diem in qua iudicaturus est orbem in aequitate
a et erat in deserto quadraginta diebus et quadraginta noctibus
b et temptabatur a Satana
a' eratque cum bestiis
b' et angeli ministrabant illi;

because He has fixed the day on which He will judge the world in equity; and He was in the desert for forty days and forty nights, and He was tempted by Satan, and He was with the wild beasts, and the angels ministered to Him.

The source of N5 (Pl. 21) is the prophecy of Isaiah 53:6–7:

ai omnes nos quasi oves erravimus
 ii unusquisque in viam suam declinavit
b et Dominus posuit in eo iniquitatem omnium nostrum
b' oblatus est quia ipse voluit
a'i et non aperuit os suum
 ii sicut ovis ad occisionem ducetur
 ii' et quasi agnus coram tondente obmutescet
 i' et non aperiet os suum.

All we like sheep have gone astray; each one has turned aside into his own way; and the Lord has placed upon Him the iniquity of us all. He was offered as He Himself wished, and He did not open His mouth; as a sheep will be led to the slaughter, and as a lamb will become silent before the shearer, He also will not open His mouth.

The New Testament reflex of this text is John 1:29, *ecce Agnus Dei qui tollit peccatum mundi*. The symbolism of panels N6-7-9-10 (Pls. 20, 11) derives from Ezekiel 1:10:

similitudo autem vultus eorum facies hominis
et facies leonis a dextris ipsorum quattuor
facies autem bovis a sinistris ipsorum quattuor
et facies aquilae ipsorum quattuor.

But the likeness of their countenances: [four] faces of a man [in front], and four faces of a lion on their right sides, but four faces of an ox on their left sides, and four faces of an eagle on their [back sides].

The following verses contain Ezekiel's description of the accompanying wheel within a wheel, *et aspectus earum et opera quasi sit rota in medio rotae* (1:16). The New Testament reflex of this passage is Revelation 4:6–10:

> quattuor animalia plena oculis ante et retro
> et animal primum simile leoni
> et secundum animal simile vitulo
> et tertium animal habens faciem quasi hominis
> et quartum animal simile aquilae volanti . . .
> et requiem non habent die et nocte dicentia
> "Sanctus Sanctus Sanctus Dominus Deus Omnipotens
> qui erat et qui est et qui venturus est" . . .
> procident viginti quattuor seniores ante sedentem in throno.

> four animals filled with eyes before and behind, and the first animal like a lion, and the second animal like a calf, and the third animal having a face as of a man, and the fourth animal like a flying eagle . . . and they do not have rest by day and by night, saying, "Holy, Holy, Holy, Lord God Omnipotent, Who was and Who is and Who is to come" . . . twenty-four elders will fall down before the One sitting on the throne.

These texts from Ezekiel and Revelation support the suggestion that panel N8 was a roundel which may have borne the text *SANCTVS* or *SCS SCS SCS*.

Several recurrent themes unite panels N2-3-4-5 (Pls. 25, 24, 23, 21). First, the Holy Family fled into Egypt and returned from Egypt through the desert. Sts. Paul and Anthony lived *on Egypta westenne*[26] and broke bread *in deserto*. The beasts and dragons recognized Christ *in deserto*. All four evangelists identified St. John the Baptist as the *vox clamantis in deserto*.[27] Second, each of the panels involves beasts. The Virgin Mary appears on a donkey, and according to the Gospel of Pseudo-Matthew, when she dismounted in the desert dragons emerged from a cave to worship Jesus.[28] Devils attacked St. Anthony disguised as bulls and wolves: *hi hine bylgedon on swa fearras ond ðuton eallswa wulfas*.[29] St. Paul the Hermit lived among howling lions and wolves in the desert, where a raven fed him daily with half a loaf of bread until St. Anthony arrived, when the raven brought a whole loaf:

> he næfre naht oþres ne geseah ne ne gehyrde butan leona grymetunge ond wulfa gerar, ond æt þæs westenes æppla ond ð æt wæter dranc of his holre hand. Ond ða ætnehstan fedde hine an hræfn sextig geara, se him brohte æghwelce dæge healfne

[26] *Das altenglische Martyrologium*, ed. G. Kotzor, Munich (1981), II, 18.
[27] Matthew 3:1–3, Mark 1:1–3, Luke 3:2–4, John 1:23.
[28] M. R. James, trans., *The Apocryphal New Testament*, Oxford (1924), 74–75.
[29] *Das altenglische Martyrologium* (as in n. 26), II, 18.

hlaf. Ond ða hwæne ær his ende com him to sanctus Antonius se ancra, ond ða sona brohte him se hræfn gehalne hlaf.[30]

He never either saw or heard anything other than lions' raging and wolves' roaring, and he ate fruits of the desert, and he drank water from his hollowed hand. And then at last a raven fed him for sixty years, which brought him each day a half loaf. And then when before his death St. Anthony the anchorite came to him, then immediately the raven brought him a whole loaf.

Beasts and dragons acknowledged Christ the Saviour of the world, and St. John the Baptist proclaimed Him the Lamb of God. This theme of beasts continues into the evangelists' panels above. Third, each of the stories depicted in panels N2-3-4-5 involves angels. An angel advised Joseph to flee into Egypt and to return from Egypt. When St. Paul the Hermit died St. Anthony saw his soul ascend to heaven *betweoh engla preatas*.[31] When St. Anthony died his disciples saw that *hine openlice englas læddon to heofenum*.[32] After Christ's temptation *angeli ministrabant illi*. St. John the Baptist fulfilled the prophecy of Malachi 3:1: *ecce ego mittam angelum meum et praeparabit viam ante faciem meam*.

Panels N2 and N3 (Pls. 25, 24) are specially linked by their allusion to the Egyptian desert. Panels N4 and N5 (Pls. 23, 21) are specially linked by their allusion to the desert near the Jordan River. They are also linked compositionally by the similar stances of the Baptist, who stands on globes, and Christ, who stands on a beast and a dragon.

The order of panels N2-3-4-5 follows the order of the liturgical year. The story of the Flight into Egypt is the Gospel for Innocents' Day, 28 December, anticipating the day of its occurrence after Epiphany, celebrated on 6 January. St. Paul the Hermit is commemorated on 10 January and St. Anthony on 17 January. The story of Christ's Temptation in the desert is the Gospel for Quadragesima, the first Sunday in Lent. The Nativity of St. John the Baptist is celebrated on 24 June, and his Decollation is commemorated on 29 August.

Each of these panels is related to one of the evangelists' panels above. The story of the Flight into Egypt is related only by St. Matthew. The type of the hermits' *fractio panis* is the story of the road to Emmaus, related only by St. Luke. The presence of beasts at the Temptation is mentioned only by St. Mark. Only St. John discusses the *Agnus Dei*.

The plan of the south face is no less remarkable. Deferring consideration of the almost obliterated panel S1, the Crucifixion, one notes a sequence of four panels, S2-3-4-5. The key to the sequence is found in Bede's commentary *In Lucae Evangelium Expositio*, which derives from the period 709–715. Bede wrote of the Annunciation, depicted in S2, as the sinless beginning of salvation:[33]

"Ecce concipies in utero et paries filium et vocabis nomen eius Iesum." Iesus salvator sive salutaris interpretatur. Cuius sacramentum nominis alloquens Ioseph angelus

[30] Ibid., II, 14.
[31] Ibid., II, 14.
[32] Ibid., II, 18.
[33] *Bedae Venerabilis Opera Pars II, Opera Exegetica*, ed. D. Hurst, *Corpus Christianorum Series Latina* (hereafter *CCSL*) CXX, Turnhout (1960), 31–33.

exposuit "Ipse enim" inquiens "salvum faciet populum suum a peccatis eorum
Non virili" inquit "quod non cognoscis semine sed Spiritus Sancti quo impleris opere
concipies. Erit in te conceptio, libido non erit."

"Behold, you will conceive in your womb, and you will bear a son, and you will call
His name Jesus." "Jesus" is interpreted "saviour" or "salutary." The angel speaking
to Joseph explained the mystery of His name, saying, "For He will make His people
safe from their sins." He says, "You will conceive not by the seed of a man, which you
do not know, but by the work of the Holy Spirit, with which you will be filled. There
will be conception in you; there will not be lust."

Of the healing of the man born blind he wrote:[34]

Agnosce igitur magnae modum medicinae et gaude quia per hanc illuminari meruisti
. . . quia "verbum caro factum est et habitavit in nobis, et vidimus gloriam eius" quam
prius tenebris arcentibus comprehendere non poteramus.

Know therefore the form of the great medicine and rejoice that you have merited to be
illuminated by it . . . because "the Word was made flesh and dwelt among us and we
have beheld His glory," which we were not able to comprehend before in the imped-
ing shadows.

Of the woman who was a sinner he wrote:[35]

cum primo accedens cum humilitate et lacrimis remissionem meruit peccatorum . . .
non iam peccatrix sed casta sancta devotaque Christo mulier.

when first approaching with humility and tears she merited the forgiveness of sins
. . . no longer a sinner but a woman chaste, holy, and devoted to Christ.

Of Martha and Mary he wrote:[36]

"Factum est autem dum irent et ipse intravit in quoddam castellum, et mulier quae-
dam Martha nomine excepit illum in domum suam, et huic erat soror nomine
Maria." Haec lectio superiori pulcherrima ratione conectitur quia videlicet illa dilec-
tionem Dei et proximi verbis et parabolis haec autem ipsis rebus et veritate designat.
Duae quippe istae Domino dilectae sorores duas vitas spiritales quibus in praesenti
sancta exercetur ecclesia demonstrant Martha quidem actualem qua proximo in ca-
ritate sociamur Maria vero contemplativam qua in Dei amore suspiramus.

"It happened then while they were going He also entered into a certain hamlet, and a
woman, Martha by name, received Him into her house, and her sister's name was
Mary." This reading is connected to the one above by a most beautiful explanation,
that is that the former woman designates the love of God and neighbor in words and
comparisons, but the latter in the things themselves and in truth. For the two sisters

[34] Ibid., 105–106.
[35] Ibid., 166–167.
[36] Ibid., 225.

beloved by the Lord represent the two spiritual lives by which the Holy Church is exercised at the present day, Martha the active, by which we are joined to a neighbor in charity, but Mary the contemplative, by which we breathe in the love of God.

Each panel is related to the panel directly above it. S2 and S3 (Pls. 18, 17) contrast the sinless birth of Jesus with that of the man *caecum a natibitate*. Panels S3 and S4 (Pls. 17, 16) depict two anointing scenes, Christ washing the eyes of a sinner and a sinner washing Christ's feet. Panels S4 and S5 (Pls. 16, 15) portray Mary Magdalene as the type of both penitence and righteousness: *ibi quippe rudimenta paenitentium hic iustitiam perfectarum designat animarum.*[37] In the former panel she is a repentant *peccatrix*, in the latter a *casta sancta devotaque Christo mulier*. Panel S5 (Pl. 15) depicts Martha and Mary as *merentes dominnæ*, who represent the active life and the contemplative life.

Each panel is related also to the panel directly opposite. Panels N2 and S2 both depict the Virgin Mary. Panel N3 depicts a miracle of feeding and panel S3 a miracle of healing. Panel N4 depicts a beast and a dragon worshipping Christ and panel S4 a woman worshipping Christ. Panel N5 depicts St. John the Baptist, whom Ælfric, expressing a patristic commonplace, described as the type of the ascetic life: *Iohannes astealde þa stiðan drohtnunge.*[38] Panel S5 depicts Martha and Mary the types of the active and the contemplative life.

This parallelism extends to the upper portions of the north and south faces (Pls. 20, 11). Panel N6, depicting St. Matthew and his man, stands opposite panel S6, depicting the seated man with a bow. Panel N10, depicting St. John with his eagle, stands opposite panel S10, depicting a bird, probably an eagle, perched on a branch. Panel N7, presumably depicting St. Mark and his lion, stood opposite panel S7, presumably depicting some wild beast like a lion, and panel N9, presumably depicting St. Luke with his ox, stood opposite panel S9, presumably depicting some domestic beast like an ox. The wild beast in S7 would be the object at which the seated archer in panel S6 aims. The central roundel, panel N8, presumably containing the text *SANCTVS*, stood opposite the central roundel, panel S8, presumably containing a text something like *BENEDICTVS*. In most ancient liturgies the *Benedictus qui venit* immediately follows the *Sanctus*, as it does in the Canon of the Mass. The word *benedictus* suggests a text which panels S6-7-9-10 may have illustrated. One of the best known Canticles, the *Hymnus Trium Puerorum* or *Benedicite*, contains the following verses:

> Benedicite volucres caeli Dominum
> Benedicite bestiae et universa pecora Dominum
> Benedicite filii hominum Dominum;
>
> Bledsiað fuglas heofenes Dryhten
> Bledsiað wilddeor 7 all netenu Dryhten
> Bledsiað bearn monna Dryhten.

[37] *Bedae Venerabilis Opera Pars III, Opera Homiletica*, ed. D. Hurst, *CCSL* CXXII, Turnhout (1955), 209–210.

[38] *Ælfric's Lives of the Saints*, ed. W. W. Skeat (Early English Text Society, Original Series 76), London (1881), I, 344.

Bless the Lord, birds of heaven.
Bless the Lord, wild beasts and all domestic beasts.
Bless the Lord, sons of men.

This yields in ascending order a man, one of the *bearn monna*, for panel S6; a wild beast, one of the *wilddeor*, for panel S7; a domestic beast, one of the *netenu*, for panel S9; and a bird, one of the *fuglas heofenes*, for panel S10. The concluding verse of the Canticle is *Benedictus es in firmamento caeli et laudabilis et superexaltatus in saecula*.

The design of the east and west faces (Pls. 27–32) is simpler than that of the north and south faces, a vine scroll inhabited by birds and fantastic quadrupeds and bipeds, surrounded by borders containing an inscription in Old English runes. In the accompanying drawing of the east and west faces of the cross (Fig. 1) the 268 runes which appear without distinguishing marks are considered by Page and Okasha to be clear or only slightly damaged.[39] The sixty-odd runes and other inscribed marks enclosed in square brackets are supplied from collation of the cross with six old drawings.[40] The thirty-odd runes which appear in round brackets are supplied from collation with the text of "The Dream of the Rood" in the *Vercelli Book*.[41]

Collation of Readings from Old Drawings

The Arabic numerals refer to the lines of runes in Fig. 1. The Roman numerals in the tables refer to the following drawings.

> I = Bainbrigg (Pl. 33)
> II = Hickes (Pl. 34)
> III = Gordon (Pl. 35)
> IV = Gough (Pl. 37)
> V = Duncan (Pl. 40)
> VI = Stuart (Pl. 45)

East Side, South Border (Southeast)

> 1 I
> 2 II indistinct *x* and two stems, III three stems, the first with a lateral ascending left, IV *ie*, perhaps the right stem of *h* and the lower part of *of*, V *r*, perhaps the lower part of *o*
> 7 IV, V, VI
> 10 II, III, IV, V, VI *t*
> 16 II, III, IV, VI lower part
> 17 II, III *a* and two stems, IV *a* and two stems, V, VI *æd*

[39] Page (1973), 150–151; Okasha (1971), 111–112.

[40] See above notes 1, 2, 3, and 6. I accept from these drawings the etymologically correct readings *bismæradu* and *blodi*. See Howlett (1974), 1–5. For collation see also Howlett (1976), 54–58.

[41] *The Anglo-Saxon Poetic Records*, II, 61–65. M. Foerster, *Il Codice Vercellese* (facsimile), Rome (1913), fols. 104v–106r. *The Vercelli Book*, ed. K. Sisam, Early English Manuscripts in Facsimile, XIX, Copenhagen (1976).

SOUTHEAST	NORTHEAST		NORTHWEST	SOUTHWEST

The figure consists of four columns of runic characters (SOUTHEAST, NORTHEAST, NORTHWEST, SOUTHWEST), numbered 1–31 on the left side and 1–30 on the right side.

Fig. 1. The runic inscription of the Ruthwell cross; runes in square brackets are collated from various drawings; those in round brackets are from collation with the Vercelli book

18 III, V Duncan drew *u* as *e*
22 III stem with a right ascending lateral, IV stem with a right ascending lateral, VI
23 II *ei*, III *ei*, IV *ei*, V *i*, VI *id*
25 IV right stem, V right stem, VI
26 IV *i*, V *i*, VI *æ*
28 IV right stem, V right stem, VI
29 VI right stem
30 IV *t*, perhaps the upper right end of *g* and the stem and broken lateral of *o*, VI
31 VI right stem of *e* and *hof*

EAST SIDE, NORTH BORDER (NORTHEAST)

10 III, IV, V, VI
23 II *are*, III, IV, V laterals of *æ* and *re*
24 two stems and a lateral, perhaps the stem of *a*, the lateral of *l*, and the stem of the second *l*,
 VI four stems
26 IV *ug*, VI all except the bottom of *b* and *ug̅*
29? IV two broken laterals and *e*

WEST SIDE, NORTH BORDER (NORTHWEST)

1 II, III, IV, V *l*, VI *t/æ* as a bind rune
2 II, III, IV, V, VI
4 II *i*, III *i*, IV *i*, V *i*, VI *t*
5 II, III, IV, V, VI upper part
19 II, III, IV, V upper part, VI top of stem
20 IV
21 V two stems, VI lower parts of two stems
23 IV right broken lateral of *êa*, V upper part of *l*?, VI upper part of *êa*
25 IV right stem, V right stem, VI all except left stem
26 IV, V stem, VI all except left stem
27 IV *d*, V two stems, VI all except left stem
28 IV, V > only, VI
29 IV *l*

WEST SIDE, SOUTH BORDER (SOUTHWEST)

3 VI Gibb drew as if a chip of stone were missing here and mistook the *i* in *rodi* for *l*. He
 may have been misled by a small point about eight millimeters from the top of the *i* rune
 and to the right, perhaps a punctuation mark. Page (1959), 288, has suggested that similar
 marks after *alme3ttig.* and *k̂yniŋc.* may be punctuation marks.
9 II *o*, III, IV, V, VI stem and lower lateral of *æ*
12 II, III, IV, V *a*?, VI
13 II, III, IV, V *l*, VI
19 II, III left stem, IV left stem, V left stem, VI *u*, perhaps the lower part of *h*
20 IV stems of *êa* and *l*
21 IV two stems, probably rather of *sa* than of *ræ*, VI one stem

22 VI
24 IV *o* and the stem and lateral stem of *r*, V *a* and part of the stem of *r*, VI
25 IV *w*, perhaps the left half of *m*, V *æ*, perhaps the left half of *m*, VI left stem
27 IV stem, VI two stems

The text established by collation of the cross and drawings suggests that the source of the Ruthwell poem was similar to, but distinct from, lines 39–65 of "The Dream of the Rood" in the *Vercelli Book*. Lines 2–15 on the east side, south border yield one and a half nearly complete lines of normal four-stressed alliterative verse almost identical with lines 44b–45b of the Vercelli text.

> *Ruthwell, east side, south border, 2–15:*
> . [hof] ic riicnæ kyniŋc hêafunæs h[l]afard hælda ic ni dorstæ

> *Vercelli 44b–45b:*
> ahof ic ricne cyning heofona hlaford hyldan me ne dorste

On the west face lines 1–20 of the upper and south borders yield two and a half nearly complete lines of normal verse similar to lines 56b–58b of the Vercelli text.

> *Ruthwell, west side, upper and south border, 1–20:*
> kri[s]t wæs on rodi hweþræ þer fus[æ] fêarran kw[o]mu [æ]þþilæ til anum ic þæt al bi[hêal].

> *Vercelli 56b–58b:*
> crist wæs on rode hwæðere þær fuse feorran cwoman to þam æðelinge ic þæt eall beheold

On the east face again the upper and north borders yield one quarter of a hypermetric six-stressed alliterative line identical with the beginning of line 39a of the Vercelli text.

> *Ruthwell, east side, upper and north border:*
> [ond]geredæ hinæ

> *Vercelli 39a:*
> ongyrede hine

Lines 16–23 on the east side, south border yield half of a hypermetric line very similar to line 48a of the Vercelli text.

> *Ruthwell, east side, south border, 16–23:*
> [b]ismær[ad]u uŋket men ba æt[ḡ]ad. [e]

> *Vercelli 48a:*
> bysmeredon hie unc butu ætgædere

Lines 10–24 on the north border of the west face yield more than three quarters of a hypermetric verse almost identical with line 63 of the Vercelli text.

Ruthwell, west side, north border, 10–24:
alegdun hiæ hinæ limwœrignæ gistoddu[n] him .. [h] . . . [li]cæs . [êa]f .. m

Vercelli 63:
aledon hie ðær limwerigne gestodon him æt his lices heafdum

Despite the differences between early Northumbrian and late West Saxon dialects, these correspondences are so striking that they allow restoration of the incomplete verses as *ahof ic riicnæ ǩyniŋc, ic þæt al bihêald, bismæradu uŋǩet men ba ætḡadre,* and *gistoddun him æt his licæs hêafdum.* They also suggest that the remaining gaps in the Ruthwell text may be filled from the Vercelli text.

Bruce Dickins and A. S. C. Ross have estimated that space remains for thirty runes on the east border, north side after *buḡa,* forty runes on the east border, south side after *bi-,* eighteen runes on the west border, south side after *hnaḡ,* and forty runes on the west border, north side after *þer.*[42] Verses similar to hypermetric half lines 42b, 43b, and 59b of the Vercelli text would fill the spaces after *buḡa* and *hnaḡ:*

Ruthwell:	*Vercelli 42b, 43b, 59b:*
buḡa (ic ni dorstæ	ne dorste ic hwæðre bugan to eorðan
ac scêalde fæstæ standa)	ac ic sceolde fæste standan
hnaḡ (ic þam secgum til handa)	hnag ic hwæðre þam secgum to handa

The former reading would need twenty-nine additional runes. The latter would need nineteen, but as five of the runes are slender, *nyd, is, tyr,* and *lagu,* it would fit the available space. Verses similar to hypermetric lines 49 and 64 of the Vercelli text would fill the spaces after *bi-* and *þer:*

Ruthwell: bi(ḡoten of þæs ḡuman sida siþþan he his ḡastæ sendæ)

Vercelli: begoten of þæs guman sidan siððan he hæfde his gast onsended

Ruthwell: bihêaldun hiæ þer (hêafunæs dryctin ond he hinæ þer hwilæ restæ)

Vercelli: beheoldon hie ðær heofenes dryhten ond he hine ðær hwile reste

The former reading would need forty runes. The latter would need thirty-six; four additional runes in *amen* would bring the total to forty if one were eager to fill all the estimated space. All these restorations would involve only runes attested clearly in other parts of the poem. None of them would entail any philological anomalies. The spelling *dryctin* is found in the oldest manuscripts of "Cædmon's Hymn,"[43] which record from the second quarter of the eighth century a poem composed about 660–680. The adverbial ending *-æ* in *fæstæ* is found in *uidæ* in the "Leiden Riddle"[44] and probably also in the poem in *sar[æ].* The spelling *gastae*

[42] Dickins and Ross (1934, ed. 1967), 25 n. 42, 27 n. 49, 28 n. 59, 29 n. 64.

[43] Dobbie (1942), 105–106. *Three Northumbrian Poems,* ed. A. H. Smith, London (1933, corr. repr. 1968), 38–41.

[44] Dobbie (1942), 109. *Three Northumbrian Poems* (as in n. 43), 44–47. The copy of this riddle in Old Northumbrian dialect is in a hand of the ninth century, but it may well have been translated soon after Aldhelm composed the original Latin riddle toward the end of the seventh century.

is found in "Bede's Death Song,"[45] for which the *terminus post quem non* is Ascension Day, Thursday 26 May 735. The accusative ending -*æ* in *hwilæ* appears in the feminine *o*-stem noun *aerigfaerae* in the "Leiden Riddle." With the third person preterite ending -*æ* in *restæ*, compare *ondgeredæ*. The Ruthwell form of *hæfde onsended* may have been *sendæ*.[46] The Ruthwell form of *sceolde* may have been *scêalde*.[47] Loss of terminal -*n* in *sida* may be compared with that in *g̅alg̅u*. Loss of terminal -*n* in the infinitive *standa* may be compared with that in *gistig̅a* and *hælda*.

Collation of the drawings supports the philologically correct readings *bismæradu* and *mi þ blodi*. The only other alleged error, *on rodi*, where one might expect *on rodæ*, illustrates the analogical introduction of the locative -*i* inflection from the paradigm of *a*-stem nouns into that of *o*-stem nouns.[48] The same phenomenon is illustrated by the form *romæcæstri* on the left panel of the Franks Casket[49] and by *gitiungi* in the *Épinal Glossary*.[50]

Here are lines 39–65 of the Vercelli text. Words and ideas incorporated into the Ruthwell Crucifixion Poem are italicized.

> *Ongyrede Hine* þa geong Hæleð , þæt wæs *God Ælmihtig*,
> strang ond stiðmod, *gestah* He *on gealgan* heanne,
> *modig on manigra gesyhðe*, þa He *wolde* mancyn lysan.
> Bifode ic þa me se Beorn ymbclypte. *Ne dorste ic* hwæðre *bugan* to eorðan,
> feallan to foldan sceatum. *Ac ic sceolde fæste standan.*
> Rod wæs ic aræred. *Ahof ic ricne Cyning*,
> *Heofona Hlaford*, hyldan me ne dorste.
> Þurhdrifan hi me mid deorcan næglum. On me syndon þa dolg gesiene,
> opene inwidhlemmas. Ne dorste ic hira ænigum[51] sceððan.
> *Bysmeredon hie unc butu ætgædere.* *Eall ic wæs mid blode bestemed*,
> *begoten of þæs Guman sidan*, *siððan* He *hæfde His gast onsended*.
> Feala ic on þam beorge gebiden hæbbe
> wraðra wyrda. Geseah ic weruda God
> þearle þenian. Þystro hæfdon
> bewrigen mid wolcnum Wealdendes hræw,
> scirne sciman; sceadu forðeode,
> wann under wolcnum. Weop eal gesceaft,
> cwiðdon Cyninges fyll. *Crist wæs on rode.*
> *Hwæðere þær fuse* *feorran cwoman*
> *to þam Æðelinge.* Ic þæt eall beheold.
> *Sare ic wæs mid sorgum gedrefed*, hnag ic hwæðre þam secgum to handa,
> eaðmod, elne mycle. Genamon hie þær Ælmihtigne God,

[45] Dobbie (1942), 108. *Three Northumbrian Poems* (as in n. 43), 42–43.

[46] Campbell (1959, repr. 1964), 476. Compare *cendae* in the "Leiden Riddle." M. B. Parkes, "The Manuscript of the Leiden Riddle," *Anglo-Saxon England* I (1972), 208.

[47] Campbell (1959, repr. 1964), 156.

[48] Howlett (1974), 2–3.

[49] Elliott (1959, repr. 1971), 103; Page (1987), 177–178.

[50] *Old English Glosses in the Épinal-Erfurt Glossary*, ed. J. D. Pheifer, Oxford (1974) §§ 42, 57.3, 59.3, 79.

[51] MS. *nænigum*, but alliteration on a vowel is required.

ahofon Hine of ðam hefian wite. Forleton me þa hilderincas
standan steame bedrifenne; eall ic wæs *mid strælum forwundod.*
Aledon hie ðær limwerigne, gestodon him æt His lices heafdum,
beheoldon hie ðær Heofenes Dryhten, ond He Hine ðær hwile reste,
meðe æfter ðam miclan gewinne.

Here is the reconstructed Ruthwell text:

East Side

I. North border

 + Ondgeredæ Hinæ Ḡod Alme3ttig. Þa He walde on ḡalḡu gistiḡa
 modig fore allæ men
 buḡa ic ni dorstæ
 ac scêalde fæstæ standa.

II. South border

 Ahof ic riicnæ K̄yniŋc.
 Hêafunæs Hlafard hælda ic ni dorstæ.
 Bismæradu uŋk̄et men ba ætḡadre; ic wæs miþ blodi bistemid,
 biḡoten of þæs Ḡuman sida siþþan He His ḡastæ sendæ.

West Side

III. South border

 + Krist wæs on rodi.
 Hweþræ þer fusæ fêarran kwomu
 æþþilæ til anum: ic þæt al bihêald.
 Saræ ic wæs miþ sorḡum gidrœfid; hnaḡ ic þam secgum til handa.

IV. North border

 Miþ strelum giwundad
 alegdun hiæ Hinæ limwœrignæ; gistoddun him æt His licæs hêafdum;
 bihêaldun hiæ þer Hêafunæs Dryctin; ond He Hinæ þer hwilæ restæ.

I. God Almighty stripped Himself. When He wished to ascend on to the gallows, brave before all men, I dared not bow down, but had to stand fast.

II. I raised up a powerful King. I dared not tilt the Lord of Heaven. Men mocked us both together. I was drenched with blood issued from the Man's side after He sent forth His spirit.

III. Christ was on the Cross. But hastening nobles came together there from afar. I beheld it all. Sorely was I with sorrows afflicted. I bent to the men, to their hands.

IV. Wounded with arrows they laid Him down weary in limb. They stood for him at the head of His corpse. They beheld there Heaven's Lord. And He rested Himself there for a time.

The designer of the Ruthwell poem made his quotations conform with Biblical style. Parts I and II on the east face make a chiasmus.

a Ḡod Alme3ttig
b modig fore allæ men
c buḡa ic ni dorstæ
d ac scêalde fæstæ standa
d' ahof ic riicnæ K̄yniŋc
c' hælda ic ni dorstæ
b' bismæradu uŋḱet men
a' Ḡuman

One notes in a and a' Jesus' two natures as God and Man, in b and b' what men saw and what men did, in c and c' what the cross dared not do, and in d and d' what the cross did. Parts III and IV on the west face also make a chiasmus.

a Krist
b fusæ kwomu æþþilæ til anum; ic þæt al bihêald
c miþ sorḡum gidrœfid hnaḡ ic þam secgum til handa
c' miþ strelum giwundad alegdun hiæ Hinæ limwœrignæ
b' gistoddun him æt his licæs hêafdum; bihêaldun hiæ þer
a' Hêafunæs Dryctin

One notes in a and a' Jesus' titles, in b and b' the movements of the disciples and the verb "behold," in c and c' the actions of the cross and the disciples. In each chiasmus the outer members allude to the Lord, the next to sight, and the central to specific deeds. In the former chiasmus the crux is the Crucifixion. In the latter chiasmus the crux is the Deposition.

The designer made his quotations conform further with Biblical style by linking the east face to the west face with parallelism.

a + ondgeredæ Hinæ Ḡod Alme3ttig
b þa He walde on ḡalḡu gistiḡa
c modig fore allæ men
d buḡa ic ni dorstæ
e ac scêalde fæstæ standa
f miþ blodi bistemid
g biḡoten of þæs Ḡuman sida
h siþþan He His ḡastæ sendæ
a' + Krist wæs
b' on rodi
c' hweþræ þer fusæ fêarran kwomu æþþilæ til anum
d' ic þæt al bihêald
e' hnaḡ ic þam secgum til handa
f' miþ strelum giwundad
g' alegdun hiæ Hinæ limwœrignæ
h' ond He Hinæ þer hwilæ restæ

One notes in a and a' crosses and divine titles, in b and b' references to the cross, in c and c' allusions to the heroism of Jesus (*modig*) and His disciples (*fusæ æþþilæ*), in d and d' the

cross' first mention of itself (*ic*), in e and e' the cross' report of its resistance among hostile men and its compliance among sympathetic disciples, in f and f' references to wounds, in g and g' allusions to Jesus' body, in h and h' mention of the period after His death.

The designer quoted words and phrases which recall the Passion narratives of Matthew and John as well as the Benedictine Office. Later Old English translations of these Latin texts afford remarkable echoes of words and phrases in the Ruthwell poem.[52]

RUTHWELL CROSS	NORTHUMBRIAN GOSPELS AND BENEDICTINE OFFICE	
ondgeredæ Hinæ	ungeredun Hine	Matthew 27:31
on ḡalḡu gistiḡa	Domine Iesu Christe qui sexta hora pro nobis in cruce ascendisti	Sext Collect
modig fore allæ men	þa þæs gerœfe kæmpe genoman Hælend in gemote gesomnadun to Him ealne þone þreat	Matthew 27:27
ahof ic riicnæ kyniŋc	þis is Hælend Crist Cyningc	Matthew 27:37
bismæradu men	hiæ Hine bismeradun	Matthew 27:31
miþ blodi bistemid	sona ofeode blod	John 19:34
siþþan He His ḡastæ sendæ	asende His gast	Matthew 27:50
	syððan His gast asende	Ad Nonam
Krist wæs on rodi	Crist wæs on rode	De Officio Sexte Hore
þer fêarran	werun þonne þær wif monige gesægun feorran	Matthew 27:55
fusæ kwomu æþþilæ til anum	cwom sum monn wælig	Matthew 27:57
miþ strelum giwundad	mið spere sido His untynde	John 19:34
alegdun hiæ Hinæ	alægde in his byrgenne neowe	Matthew 27:60
gistoddun æt His licæs hêafdum	genoman þæs Hælendes lic	Matthew 27:59
He Hinæ þer hwilæ restæ	ðær His lichaman on gereste swa lange swa His willa wæs	De Completorio

The reconstructed Ruthwell Crucifixion Poem contains six half lines, three normal lines, and six hypermetric lines. The unit of composition is the half line. There are twenty-four of these, twelve on the east face and twelve on the west.[53] The outer parts of the poem, I and IV, arranged back to back on the north borders, each contain five half lines, which form a metrical chiasmus of hypermetric-half-half-hypermetric lines. The inner parts of the poem, II and III, also opposite each other on the south borders, each contain seven half lines, which form a metrical parallelism of half-normal-hypermetric, half-normal-hypermetric lines. The Ruthwell poem contains 104 words, fifty-two on the east face and fifty-two on the west. The east face contains 233 runes, one cross, and two punctuation marks, or 236 inscribed marks.

[52] *The Holy Gospels*, ed. W. W. Skeat, Cambridge (1871–77). *The Benedictine Office*, ed. J. M. Ure, Edinburgh (1957), 97–100.

[53] The number may have been determined by the program of twenty-four panels on the entire cross, that suggested in turn by the twenty-four elders of Revelation 4:10. The division of half lines into groups of seven and five may have been determined by extreme and mean ratio. The Golden Section of 12 falls at 7 and 5.

The west face contains 234 runes, one cross, and one punctuation mark, or 236 inscribed marks.[54]

Each part of the poem relates a specific period of the Passion: I from Jesus' disrobing to the raising of the cross, II from the Crucifixion to Jesus' death, III from Jesus' death to the Deposition, and IV from the Deposition to the Sepulture. The inner parts of the poem, II and III, alluding to the Crucifixion at the crux of their chiasmus, run down the south borders, making a frame for the Crucifixion panel, S1. The outer parts of the poem, I and IV, alluding to the Deposition at the crux of their chiasmus, run down the north borders, making a frame for what may formerly have been a Deposition panel, N1.

The vine scroll motif surrounded by the runic poem continues into the upper panels of the east and west faces. These were formerly surrounded by runes arranged not in horizontal rows like the runes below, but like the inscriptions on the north and south faces. The inscription on the upper border of the west face has been wholly obliterated, but on the upper east face the runes –dægisgæf[.] remain.[55] At the crux of the passage of the Vercelli version of "The Dream of the Rood" quoted above stand the verses 52b–55b:

> þystro hæfdon
> bewrigen mid wolcnum Wealdendes hræw,
> scirne sciman; sceadu for ðeode,
> wann under wolcnum. Weop eal gesceaft.

In Old Northumbrian dialect they would read:

> Þystru hæfde
> bewrigen miþ wolcnu Waldendæs hræw;
> scêadu forþeode
> wann under wolcnu wœpdæ gisgæft.

They make a perfect parallelism. The first half comprises seven words, fourteen syllables, and forty-one runes; the second half comprises seven words, fourteen syllables, and forty runes.

The design of the entire Ruthwell cross consists of groups of four panels: the parallel sequences S2-3-4-5 and N2-3-4-5, the four evangelists' panels N6-7-9-10 and their parallel panels S6-7-9-10, the four parts of the Crucifixion Poem, and the four remaining panels, the presumably parallel roundels S8 and N8, and the presumably parallel Crucifixion and Deposition, S1 and N1. All the elements of the design—parallelism and chiasmus of word, phrase, meter, and sculpture; Biblical allusion; rhyme, rhythm, and the counting of everything[56]— belong to the common culture of the Anglo-Latin and Old English traditions. Yet the designer reveals himself as no common man. Who was he, and when did he work?

[54] For consideration of punctuation marks see Page (1959), 288 and Howlett (1976), 56.

[55] Okasha (1971), 111.

[56] Is there a calendrical aspect to this? There are twenty-four half lines in the poem, for hours of the day; seven half lines on the left border of the east face and the right border of the west face, for days of the week; fifty-two words on both east and west sides, for weeks of the year; twelve half lines on both east and west sides, for months of the year; 236 inscribed marks on each face plus 40 on the upper part equals 276, the number of days from the Annunciation to the Nativity. But this may be merely coincidental.

The apparent influence of Bede's *In Lucae Evangelium Expositio* implies that the designer worked after 709–715, and there are other independent indications of this. First, *hêafunæs*, with its back-mutation of *e* to *êa*, suggests development from the forms *hefen*, *hefaen*, and *heben* recorded in the oldest manuscripts of "Cædmon's Hymn." Second, the Ruthwell runemaster's *fuþorc* is expanded from the more primitive *fuþorc* used by the runemaster of the Franks Casket. The form of *dæg* used by the Franks carver, ⋈, is more archaic than that used by the Ruthwell carver, ⋈. The digraph *ea* on the Franks Casket is apparently earlier than the *ear* of the Ruthwell cross. The Franks carver used only *giefu* to represent *g* and only *cen* to represent *c*, but the Ruthwell carver tried to distinguish *giefu* (as in *ondgeredæ* and *giwundad*) from *ḡar* (as in *ḡod* and *ḡalḡu*) and *cen* (as in *ic* and *riicnæ*) from *calc* (as in *krist* and *kwomu*) and from *k̄ (as in k̄yniŋc* and *uŋk̄et*). Most authoritative philologists agree about the date of the Ruthwell inscription. Campbell ascribes it "to the eighth century without hazard"[57] and Dickins and Ross to "the first half of the eighth century."[58] One might suppose more precisely that it belongs to the second quarter of the eighth century.

During this period there were only four episcopal sees in Northumbria: York, Lindisfarne, Hexham, and, closest to Ruthwell, St. Ninian's foundation, *Candida Casa*, Old English *Hwit Ærn*, Modern English Whithorn, where, Bede says, the Church had grown so wonderfully that only recently (*nuper*) Pecthelm had become its first English bishop.[59] A work like Bede's commentary on Luke could easily have come into Pecthelm's hands soon after composition, for the two men communicated. Bede acknowledged Pecthelm as the source of his story about the unrepentant Mercian thane and his report of miracles performed at Bishop Haeddi's tomb.[60] Bede's reliance upon him implies that Pecthelm had a reputation for learning and judgement. So does a letter from Wynfreth seeking Pecthelm's advice about a matter of kindred and affinity not mentioned among the ancient canons.[61] Wynfreth may have met Pecthelm when both men were still in Wessex, for Bede states that the latter remained a deacon and monk for a long time with Aldhelm.[62] Of the chronology of his life we know only that he lived *multo tempore* at Malmesbury and that in 731 he had become Bishop of Whithorn *nuper*. He died in 735.

Tentative ascription of the Ruthwell cross to Pecthelm's episcopate would raise another possibility. "The Dream of the Rood" is generally acknowledged the finest extant Old English Christian poem, and there are indications that the Anglo-Saxons also regarded it highly. The only other Old English poems which survive in many copies owe their transmission either to Bede (e.g. "Cædmon's Hymn" and "Bede's Death Song") or to the *Anglo-Saxon Chronicle*. Yet without any similar single aid verses from this poem appear in runes in early eighth-century Northumbrian and in insular minuscule script in late West Saxon (with some

[57] Campbell (1959, repr. 1964), 4 n. 2.

[58] Dickins and Ross (1934, ed. 1967), 13.

[59] Bede, *Historia Ecclesiastica*, V:XVIII.

[60] Ibid., V:XIII, XVIII.

[61] *Die Briefe des Heiligen Bonifatius und Lullus, Monumenta Germaniae Historica, Epistolae Selectae*, ed. M. Tangl, I, 2nd ed., Berlin (1955), 55–56.

[62] Bede, *Historia Ecclesiastica*, V:XVIII.

earlier Alfredian forms) in the tenth-century *Vercelli Book*. There are apparent echoes of its language in the tenth-century Northumbrian gloss of the *Rushworth Gospels* and the late tenth- or early eleventh-century West Saxon inscription on the Brussells cross. In the *Gesta Pontificum Anglorum* V § 190 William of Malmesbury reported from the *Encheridion* or *Liber Manualis* or *Handboc* of Alfred the Great the king's opinion that in English poetry *nulla umquam aetate par ei* [sc. *Aldhelmo*] *fuerit quisquam*: "in no age ever was anyone equal to him [sc. Aldhelm]." In Corpus Christi College, Cambridge MS. 326, a tenth-century manuscript, probably from Christ Church, Canterbury, a macaronic poem in Old English and Latin praises the

> sanctus et iustus
> beorn boca gleaw, bonus auctor,
> Ealdelm, æþele sceop[63]

the holy and righteous man, wise in books, the good author, Aldhelm, the noble poet.

Might "The Dream of the Rood" be one of the works which supported the reputation of Pecthelm's mentor and Alfred's kinsman and the Canterbury encomiast's hero, Aldhelm, as the supreme Old English poet?

[63] Dobbie (1942), 97–98.

A New Perspective on the Ruthwell Cross:
Ecclesia and Vita Monastica

•

PAUL MEYVAERT

ALL EXISTING studies of the Ruthwell cross rest on the premise that the present align-ment of the panels on the cross is the original one.[1] Is this assumption valid? When Reformation iconoclasts toppled and dismembered what they considered an idolatrous monu-ment, they intended that it should never rise again. What were the chances that an accurate restoration would be achieved by Ruthwell's minister when, in 1802, he erected an obelisk in his garden from fragments that for the most part had been lying about, in and outside the church, for more than 150 years? The iconography of the cross has been much discussed in recent years, but these basic questions have never yet been raised. Only a thorough exami-nation of all available evidence will enable us to hazard a guess as to how they should be answered.

THE CROSS FROM 1642 TO 1824: FROM RUIN TO RECONSTRUCTION

The cross was still intact, its panels visible in their original order, when Reginald Bainbrigg visited the church at Ruthwell, formerly dedicated to St. Cuthbert, in or about the year 1599.[2] Unfortunately, the note concerning "the cross of wonderful height" that he sent to William Camden after this visit failed to mention any details, and alluded only in general terms to "pulchris imaginibus Christi historiam referentibus."[3] The cross, originally con-structed from two pieces of sandstone, was pulled down on order of the General Assembly of the Church of Scotland in 1642.[4] Subsequent accounts allow us to conclude that when the

[1] Including my own earlier essay, Meyvaert (1982).

[2] The Cuthbert dedication is proved through the pre-Reformation act of James IV, King of Scotland, dated 17 February 1507, establishing Ruthwell as a burgh of Barony. The act grants permission for the holding of two yearly fairs on the two feasts, including their octaves, of St. Cuthbert (20 March and 4 September), "nundinas publicas annuatim diebus festivis sancti Cuthberti et per octavas earundem." We know the act through its confirmation of 8 May 1509; see *The Acts of the Parliaments of Scotland (1424–1566)*, Edinburgh (1814), 275, col. a. One can probably conclude that at Ruthwell, as at Bewcastle, Cuthbert was the patron saint of the parish from its foundation in the period of Northumbrian dominance of this region. (See also below at nn. 211–212).

[3] Meyvaert (1982), 3.

[4] Meyvaert (1982), 4–5.

cross was toppled, its long twelve-foot shaft broke into two pieces (Fig. 1: #1 and #2),[5] both of which remained lying inside the church. The cross-head (#3–#6), measuring in all over six feet, evidently splintered on impact, and its numerous pieces were thrown outside the church. The iconoclasts defaced many of the panels with hammer and chisel, and the piece they considered the most obnoxious and sacrilegious (#4), because to them it represented the Deity with the Lamb in His bosom, they buried deep in the ground. It came to light again only a century and a half later during the time when the Reverend Henry Duncan was minister at Ruthwell. The transom or cross-beam (#5) has never been recovered, and may likewise have been buried somewhere nearby.

The survival of the fragments of the cross still extant was due mainly to the great interest taken by early antiquarians in the runic characters used in some of the inscriptions. As word spread of the presence of these strange characters, travellers and antiquarians chose to pass by the place to see and examine them. These visitors, obviously believing Ruthwell to be a place of interest, must have played some part in persuading the local authorities to preserve the fragments of the cross that lay strewn about. It is important for our present purpose to examine all the early accounts that mention the monument, with a view to determining when and how the various fragments came to be identified and related, one to another.

William Nicolson, canon and later bishop of Carlisle, visited Ruthwell in 1697 and again in 1704 to examine the runic inscriptions.[6] The account he gives, both in his diary and in his letters, makes it clear that the two sections of the shattered shaft lay within the church itself. The largest piece, forming the lower part of the long shaft (#1), lay embedded in the ground of what was called "Murray's Quire" (later called Murray's Aisle), and was too heavy to move. Nicolson was able to view only its upper surface. He describes it as displaying scenes of both the Crucifixion and the Annunciation. He says it would have needed "Crows and Levers" to prize it loose from the ground in order to examine its three other surfaces. The upper section of the shaft (#2), "about five feet in length," was obviously more manageable, since it could be turned over and all its four surfaces seen. In his diary account of 1704 Nicolson wrote that "some lesser pieces . . . we found thrown under Through-stones in ye Church-yard." His narrative clearly implies that only two pieces were to be found within the church itself, the others lay strewn on the ground outside.

Nicolson's data basically agree with those given us by George Archibald (1646–1715) in his *Account of the Curiosities at Dumfreis*: "Here is also in this County, St. Ruths Church [!], called Ruthwall, where lyes a Monument broken in two pieces, which was a Pillar quadrangle of stone, reaching from the bottom of the Church unto the roof."[7] The brief description that follows obviously relates to the upper section of the shaft (#2), which, as we noted, could be turned over and examined on all four sides. Another very short note by Mr.

[5] Fig. 1, to which section numbers have been added to facilitate the discussion in the following pages—reproduces the drawing made by Henry Duncan to accompany his article on the cross which appeared in vol. 4 of *Archaeologia Scotica* in 1833. The folds in the sheet bearing Duncan's illustration—and not any break in the monument—account for the two straight lines extending across the page.

[6] On Nicolson see Meyvaert (1982), 5.

[7] See Mitchell and Clark (1906–8), III, 187–188.

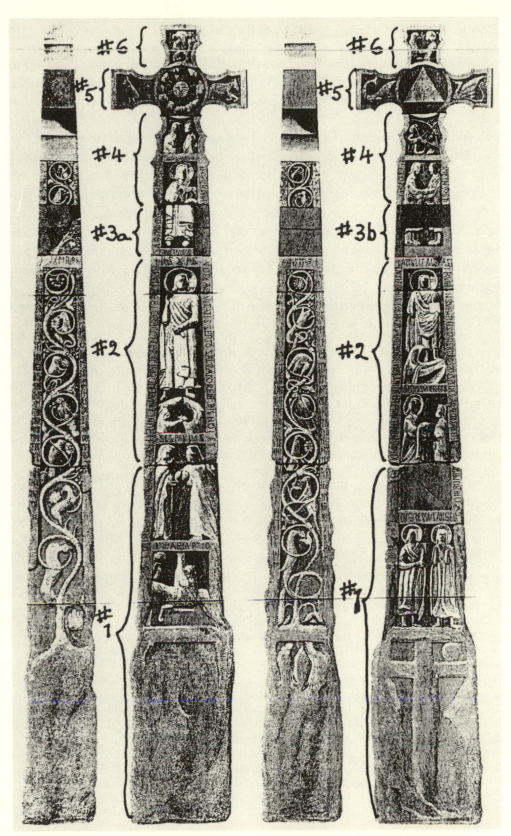

Fig. 1. Engraving of Ruthwell cross, after Duncan (1833), with sections numbered by Paul Meyvaert

W. Hamilton of Orbeston, dated 1695, provides further confirmation: "A Broken Cross in Revel Church The Length 4 foot and three Inches (#2) The Pedestal (#1), in Murray's Quire, hath the bottome of the Inscriptions with some few more Images on the Latin side."[8]

With Alexander Gordon's *Itinerarium Septentrionale*, published in 1726, the number of parts within the Ruthwell church has increased to three: "It lies flat on the Ground, within the Church of Ruthvel This Obelisk, some think, was originally of one intire Stone, but is now broke into three Parts."[9] Gordon proceeds to give a full description of section #2, and it is this section only that is depicted in the plates that accompany the account (reproduced here as Pls. 35 and 36). He likewise describes the "base" (#1), but in a manner that makes it clear that only one surface was visible, namely that illustrating the Crucifixion.[10] Gordon gives no description of the third piece that now lay with the two others: it must have been either #3a or #6.

The report of Thomas Pennant, who visited Ruthwell in 1772, deserves close attention:

> The church of Ruthwell contains the ruins of a most curious monument; an obelisk once of a great height, now lying in three pieces It originally consisted of two pieces; the lowest [namely the shaft], now [broken] in two, had been fifteen feet long; the upper had been placed on the other by means of a socket The pedestal lies buried beneath the floor of the church: I found some fragments of the capital, with letters similar to the others; and on each side an eagle, neatly cut in relief [#6]. There was also a piece of another, with Saxon letters round the lower part of a human figure, in long vestments, with his foot on a pair of small globes [#3a]: this too seemed to have been the top of a cross.[11]

Once again, Pennant's fullest description has to do with the part that could be turned over and examined on all four sides. He is the first to note the use of a socket to hold the two parts of the monument together; this must mean that the top of section #2 contained a hole meant to receive a tongue or tenon to hold the "capital" or cross-head in place.[12] Pennant correctly identified the fragment with an eagle on each side as part of this "capital" or cross-head. He had doubts, however, about the relationship with the others of the remaining fragment (#3a),

[8] Ibid., 255.

[9] Meyvaert (1982), 6.

[10] Gordon (1726), 161, describes the panel showing the healing of the man born blind as containing "two rude Figures, one of whose Heads is also encircled with a Glory: These seem to represent Joseph and the Virgin Mary."

[11] Pennant (1774, ed. 1796), part I, 96–98.

[12] This is fully confirmed by Mr. J. W. Dods, the stone mason from Dumfries who dismantled and then re-erected the cross inside the church in 1887 (see also n. 231 below), also see Hewison (1914), 29. Mr. Dods characterizes the technique as "the most approved masonic form." Dods' letter to Hewison (dated 14 Feb. 1913), which survives among Hewison's papers in Edinburgh, has a drawing showing the shaft as containing the mortise meant for the tenon projecting from the upper stone (see Fig. 1 in R. Farrell's essay in this volume). In the more recent literature it is argued that the use of mortise and tenon represents the transfer to stone of techniques first developed for carpentry, see R. Cramp, "The Artistic Influence of Lindisfarne within Northumbria," in *St. Cuthbert, His Cult and His Community to A.D. 1200*, ed. G. Bonner, D. Rollason and C. Stancliffe, Woodbridge, Suffolk, (1989), 223; D. Mac Lean, "The Origins and Early Development of the Celtic Cross," *Markers (Journal of the Association for Gravestone Studies)* VII, Needham, Mass. (1990), 233–275; R. Stalley, "European Art and the Irish High Crosses," *Proceedings of the Royal Irish Academy* XC (1990), section C, 154 n. 75. Stalley raises some interesting points concerning the links between working in wood and in stone.

showing "the lower part of a human figure . . . on a pair of small globes." His suggestion that "this too seemed to have been the top of a cross" may well reflect the presence of some feature at its base, like the remnant of a tenon, suggesting that it was meant to be fitted into another piece containing a socket.

We next come to the description of Richard Gough and the illustrations by Cardonnell, which serve to show that by the end of the century the Ruthwell cross was receiving recognition as a "national" monument. A sumptuous series, *Vetusta Monumenta ad rerum Britannicarum memoriam conservandam*, had been launched in 1747 by the Society of Antiquaries of London; later the Society decided, on the basis of the two drawings in Gordon's *Itinerarium septentrionale*, together with his description and that of Pennant, to include the Ruthwell monument. They commissioned Adam Mansfeldt de Cardonnell-Lawson, whose *Picturesque Antiquities of Scotland* (1788) had just appeared, to go to Ruthwell and make new drawings of all the pieces to be seen there. The engravings produced from these drawings, together with Richard Gough's commentary, were published in volume 2, which appeared in 1789 (Pls. 37, 38).[13] We may assume that Cardonnell accompanied his drawings with a letter providing additional information, which would be worth trying to locate. In any case, it is important to remember that Gough did not personally visit Ruthwell and that his comments and deductions are based on the material Cardonnell sent to the Society.

Thus we learn from Gough that only recently had the lower part of the shaft been prized loose from the clay floor of Murray's Quire, where it had lain embedded for so long. It is not clear whether this was done to allow the making of Cardonnell's drawings, or whether the artist found all the pieces already outdoors in the churchyard, having been moved out of the church to allow the installation of a new flagstone floor; extensive alterations and improvements were being made to the Ruthwell church between the years 1772 and 1790.[14] John Craig, minister from 1783 to 1798, states in his account of the parish that at the time he was writing (prior to 1794) the fragments were lying outside the church, "In the churchyard of Ruthwell, a very curious monument appears, although now broken into two or three fragments, which, however, have all been preserved."[15]

With the arrival of Henry Duncan, minister from 1799 to 1843, a new chapter, which might well be headed "The resurrection of the Ruthwell cross," begins. It required a man with his "ingenious and sentimental turn of mind," as his son describes him, to conceive the idea of re-erecting the cross.[16] The project may well have received its impetus from an event

[13] Gough (1789), vol. 2, plates LIV and LV (the last in the volume) with three pages of commentary, numbered 1–3, signed by R[ichard] G[ough]. The same initials are found elsewhere in this volume.

[14] See the account of Dinwiddie (1927), 98. The later revised and abridged edition of Dinwiddie's booklet leaves out some important data for the purposes of the present study.

[15] See Craig's account of the parish in Sinclair (1794), 226–227.

[16] Duncan (1848), 5–6, relates how his father, as a young man, erected a monument to his pet nightingale: "he built over its grave a mausoleum of brick and mortar. This erection was constructed by the side of the church road, and adjoining to, or rather surrounded by, the gurgling water of a tiny stream. In the lower part of this erection, and looking down the stream, he inserted an engraved stone, chiselled by himself, representing the face of a man in the very extremity of grief, having the eyes bored so as to give vent for the constant flow of a small portion of water intended to represent the mourner's tears. A channel was made to the eyes from behind, by means of the necks of bottles, so disposed as to make, with the ever-flowing water, a

that occurred sometime between 1799 and 1802, when a crucial fragment of the cross emerged from the ground. Duncan himself describes the episode in a paper on the cross which he read to the Scottish Antiquarian Society in 1832:

> A poor man and his wife having died within a day or two of each other, it was resolved that they should be buried in the same grave, which, on that account, required to be made unusually deep. The gravedigger in the course of his labour came to a fragment of sand-stone of considerable bulk, which was found, on one of its sides, to contain the upper part of the image of the Supreme Being, with the Agnus Dei in his bosom, and, on the reverse, a representation of two human figures in the act of embracing. On applying this fragment to the monument, it was found to coincide with that portion of it which Pennant mistook for the top of a cross, the limbs and flowing robes of the image of the Deity being that which he describes as 'the lower part of a human figure in long vestments, with his feet on a pair of small globes' [#3a].[17]

When this key piece (#4) came to light it became apparent that of the major pieces, only the transom or cross-beam (#5) was still missing. Duncan retained the hope, throughout his tenure at Ruthwell, that it too would one day emerge from the earth.

This development then led Duncan to identify, in the detritus of the churchyard, another fragment of the cross. The reverse side of the newly discovered section #4 showed the upper part of a scene in which two women embraced each other. This prompted Duncan to identify a fragment showing the feet of two facing figures, together with the lower edges of their garments (#3b), as belonging to the same panel. As Robert Farrell has rightly stressed, a glance at this particular piece, now integrated into the cross, is enough to persuade us that something is out of order.[18] The fragment with the feet looks out of place, mainly because the size of the border below the feet clashes so markedly with the borders enclosing all the other panels (see Pls. 11, 15). A satisfactory explanation for the discrepancy may, however, be available in a striking feature that has so far escaped notice.

Let us return for a moment to the drawing furnished to the Society of Antiquaries by Cardonnell (Pl. 38). Referring to the reverse side of section #3a, as depicted in his drawing, Gough remarked: "the top of the stone on this side is broken, but shews a mark like a cavity for inserting the transverse bar." We can dismiss the idea of a "transverse bar," which Gough presumably thought to be intended, somehow or other, to support the cross-beam. What the drawing shows is actually very clear evidence of a repair made to the cross at an earlier stage of its history, for it seems legitimate to interpret this feature as representing some sort of cavity, carefully shaped, and requiring the services of a stonemason.[19] We can only speculate

moaning sound, which a slight stretch of imagination might construe into a funereal wail." An epitaph, in Latin verse was placed over the monument. Such a story helps to bring the character of Henry Duncan into focus; a man fully prepared, when the time came, to invent his own new transom for the Ruthwell cross.

[17] See Meyvaert (1982), 7.

[18] See the section entitled "An Incongruous Fragment" in Farrell (1986), 365–368, and now his essay in this volume.

[19] A comparison of the side view of this fragment in Cardonnell's drawing (Pl. 37) with what actually was there (see Pls. 31, 32) shows that the artist took some liberties in making his sketch. We must visualize the cavity as present at the back of the stone whose breadth is seen in Pls. 31 and 32.

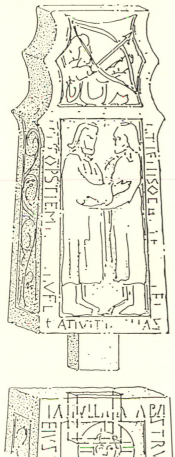

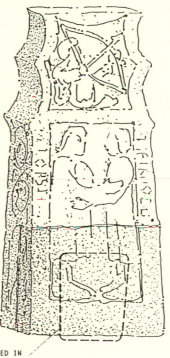

SURVIVING FRAGMENT USED IN
HENRY DUNCAN'S RECONSTRUCTION

SHADING INDICATES AREA PRESUMABLY INVOLVED IN MEDIEVAL REPAIR

ORIGINAL CONSTRUCTION, EIGHTH CENTURY

Fig. 2. Drawing showing the original construction of the join between the shaft and cross-head of the Ruthwell cross according to Paul Meyvaert (drawing by Richard Joslin)

as to the nature of the repair: was this a mortise destined to hold a correspondingly shaped tenon on another stone? Or was it not rather a cavity to be matched with a similar cavity in another stone, so that the two might be joined by the pouring in of molten lead along a channel carved into the new, inserted piece?[20] Fig. 2 shows how shaft and cross-head were

[20] There is a fascinating story in Symeon of Durham about a stone cross in the Durham cemetery, whose top had been broken,being very skillfully mended through the pouring in of lead (*infuso plumbo*) to hold the two parts together, see *Historia Dunelmensis Ecclesiae* I.12, ed. T. Arnold, London (1882), 39 "De Ethelwoldo episcopo, et cruce lapidea quam fecit." Symeon has almost certainly misidentified the Ethelwold who caused the cross to be erected at Durham with his name inscribed on it, with an earlier and better-known Ethelwold, one of the early successors of St. Cuthbert as bishop of Lindis-farne. Symeon imagined that the heavy stone cross had been broken by the Vikings and then carried around together with

originally joined and how the mend was probably effected through the insertion of a new piece of stone to replace a damaged part.[21] Needless to say, we have no written source to tell us what sort of accident occurred, or when it happened; whether at the time when the cross was first erected, or more likely, as we shall see later on, at some later date.[22] All we possess is the physical evidence, no longer visible, but depicted in Cardonnell's drawing, to show the existence of an anomaly within the very structure of the cross. This mend, moreover, helps not only to account for the rather ill-fitting insertion containing the two feet (#3b), but also to explain why this section of the monument became so badly fragmented when the cross was pulled down in 1642.[23] Having been mended, section #3 had become the most fragile part of the whole monument.[24]

In 1802 Duncan decided to erect all the existing pieces, in the form of a single pillar, in the garden he had just designed for the manse. The very fragmentary nature of the pieces making up section #3 required the use of several new stones to form a kind of platform for the much more massive part (#4), that had emerged from the ground. The series of views in Pls. 11–15, 20–22, 28–32 present a complete survey of this part of the monument. In the form this restoration gave it the cross stood in the manse garden for twenty years (Pls. 7, 8).[25] Finally, with his hope of recovering the missing cross-beam fading, Duncan designed one himself and had a local mason carve and install it in 1823, thus completing the restoration and transforming an obelisk into a true cruciform monument.[26] In this form it was moved into its present place in the parish church in 1887.

AN ALTERNATIVE ARRANGEMENT AND ITS THEMES

In erecting his obelisk from the surviving fragments of the cross, Duncan simply accepted the alignment of panels that by 1800 had acquired a quasi-official status, especially through

Cuthbert's relics during their long peregrination. Of the repair Symeon writes, "Cuius summitatem [crucis] . . . pagani fregerunt, sed post artificis ingenio reliquae parti infuso plumbo, ipsa fractura est adjuncta." I thank Douglas Mac Lean for drawing my attention to this text.

[21] I am very grateful to my architect friend, Richard Joslin, of Cambridge, Mass., for providing me with these drawings.

[22] See below at n. 228.

[23] In viewing this fragment we must remember that Duncan's mason must have chiselled away a considerable portion of the stone, both at the top and at the sides, to make it fit within the space between the new stones that were being used to prop up the newly discovered section (#4) of the cross.

[24] It has been conjectured that the St. John's cross on Iona also suffered damage and was repaired, though not with lead; see *The Royal Commission on the Ancient Monuments of Scotland, Argyll*, vol. 4, *Iona* (1982), 201. I again thank Douglas Mac Lean for this information.

[25] Pl. 7 is from Dinwiddie (1927), opposite p. 107, Pl. 8 from Baldwin Brown (1924), pl. XV.

[26] It must remain an open question whether the Ruthwell cross-head was formed from a single piece, or from three separate pieces of sandstone. Judging from Cardonnell's drawing, the base of the uppermost stone (#6) was flat. The top of #4 is similarly shown as flat. Would the shattering of the cross in 1642 have resulted in such very neat fractures, right along the lines of the transom, if indeed the whole upper section was originally a single stone? Or do these breaks suggest that the transom was a separate piece, joined to the others through mortices and tenons? Any surviving evidence of such features— recalling the way some of the Iona crosses were constructed (see the volume mentioned above in n. 24)—may well have been obliterated by Duncan's mason when he erected the monument in 1802. If the cross were again to be dismantled, some new evidence might nevertheless be found.

Cardonnell's depiction; the Ruthwell cross today retains the structure Duncan gave it. We now recognize that the small stone at the top of the cross (#6) is displayed backwards; it needs to be reversed, so that John and his symbol, the eagle, will appear above Matthew and his symbol, *imago hominis*, thus reuniting at least two of the four evangelists who originally encircled the central roundel of the cross-head, the other two, with their symbols, being lost with section #5. Can we rest assured, however, that with this simple and obvious correction, we have restored the original arrangement of figures and panels on the Ruthwell cross? The documentation just reviewed offers no such assurance. On the contrary, it appears that early attempts to make sense of the monument's fragmented remains yielded questionable results. It seems more likely than not that when the parish gravediggers unearthed section #4, section #3a was still in place above section #2, as in Cardonnell's drawing. But how did it come about that it was the face showing Christ upon the beasts with which #3a had been lined up, rather than the other face, with the woman anointing Christ's feet?

If the pieces were lined up in this way only after Cardonnell's arrival, and for his benefit, then he himself may certainly have played a part in their arrangement, and one may then point to artistic considerations: the figure of Christ upon the beasts is larger and more imposing than the Christ with the woman at his feet, and no panel is left partly blank, like the one showing the healing of the man born blind, appearing directly below the scene of the anointing of Christ's feet on this face of the shaft. If the present arrangement predates Cardonnell, other considerations come to the fore. As long as section #1 remained in the church, only one set of panels could be seen; it was always those showing the Crucifixion and Annunciation that visitors described, the others being inaccessible, embedded face down in the clay of the floor. Those who moved it to the churchyard were then obliged to decide which face they would leave exposed to view, since the piece would remain too heavy to turn over, except in special circumstances (like those attending the visit of Cardonnell), and they may well have preferred to display the face that had been so long unseen by anyone.

When section #3a was put in place, the decision as to which of its two surfaces should be placed uppermost was never in doubt, since that showing part of a figure with long garments and feet resting on globes was the only one on which any carving had been done; the other had a blank surface exhibiting nothing but the evidence of an earlier repair. The present alignment was therefore determined by the placing of this broken piece above Christ upon the beasts. Did someone think that a fragment showing feet on globes was best placed above a figure whose feet were similarly supported, but by heads of animals? There was no inscription or literary text bearing witness to the original alignment, and it is doubtful whether an oral tradition on such a matter would have survived in the parish for well over a century. It also seems unlikely that theological or iconographic arguments could have played a part; in fact the matter of alignment of panels may have been determined entirely by happenstance. However it may have come about, this was the arrangement of panels that Cardonnell drew, and the arrangement that the cross displays today. It remains to be seen whether the new arrangement I now intend to propose makes more sense, theologically and culturally, within the period when the cross was first designed.

The arrangement I propose (Fig. 3) would reverse the upper part of the cross so that the cross-head (sections #3–6) would display its reverse face. The panel with the figure whose feet rest on globes (#3a) would thus appear above the panel showing the woman at the feet of Jesus, while on the opposite side the panel with the two women embracing each other would appear above that showing Christ upon the beasts, and likewise above the figures of Paul and Anthony, who also incline towards each other. Nothing in the cross' construction militates against such a change; the customary square (or rectangular) tongue or tenon could have been set in its socket either way. Furthermore the base of section #3a is so narrow (see the side view, Pl. 32) that it can have retained no more than a vestige of the original tenon, too little to support any conjecture as to how it once fitted into the socket in the shaft.

The fact that the present alignment of panels has an apparent parallel on the Bewcastle cross must not be allowed *a priori* to influence the argument. Section #4, showing the nimbed figure carrying the Lamb, and thus establishing a connection with Bewcastle, had not yet been discovered when section #3a was placed over #2, showing Christ upon the beasts, at Ruthwell; consequently it can hardly have influenced the juxtaposition, even if some visitor to Ruthwell had been familiar with the other monument. The Bewcastle figure appears, moreover, to lack the globes that might have suggested a connection. Nor does the juxtaposition of the panels on Bewcastle preempt the argument, for the simple reason that panels with figures appear on only one side of this cross. It would be a different matter if the Bewcastle cross were double-sided, with its arrangement of panels coinciding fully with the present arrangement at Ruthwell.

This is not to deny an obvious link between the two monuments, in addition to the fact that the parish churches at both Bewcastle and Ruthwell were dedicated to St. Cuthbert. As far as the Ruthwell cross is concerned we are justified in suspecting, however, that the juxtaposition of fragments, as shown in Cardonnell's engraving, almost certainly occurred fortuitously.

My proposed realignment brings about, moreover, as we shall see, a much greater thematic and theological unity for each of the two faces of this cross. The emphasis of side A is on the Church (*Ecclesia*) and Christian life; the emphasis of side B is more specifically monastic (*Vita Monastica*). Even visually we notice a greater unity, since the Crucifixion on side A now responds to the Apocalyptic Lamb, while on side B the two figures of Paul and Anthony inclining towards each other now respond to the mutual embrace of Martha and Mary, and to the embrace of the two beasts, whose feet are linked together. How the themes intertwined with these subjects are developed can best be understood if we approach the panels individually, having recourse, for their interpretation, to the commentaries and other literature in circulation in this region at the time when the cross was designed.

Ecclesia

Having proposed a different alignment of its panels, I will also propose a different location in the church for the Ruthwell cross. Certainly it was not sunk in a small apse specially made to

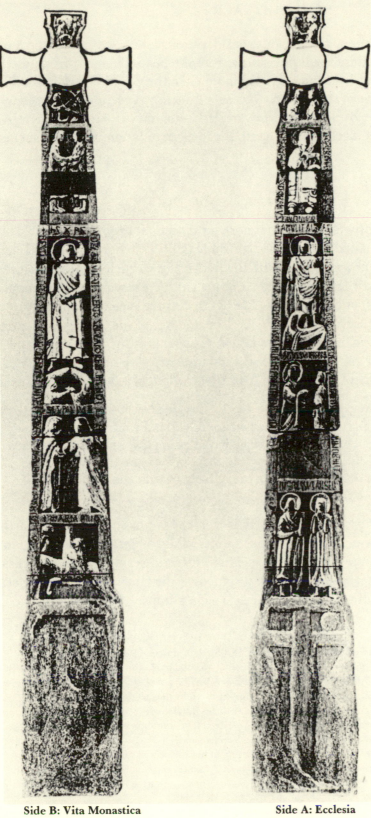

Side B: Vita Monastica **Side A: Ecclesia**

Fig. 3. Original arrangement of
the sections of the Ruthwell cross
according to Paul Meyvaert

accommodate it, as is the case now. The various considerations entering into a determination of its original position in the church will be dealt with in the last section of this study. Let it suffice to say, at this point, that I see the cross as placed (like the Great Cross on the Plan of St. Gall)[27] part way up the nave of the church, with side A facing West, toward the congregation of village folk, while side B faced East, toward the sanctuary occupied by Ruthwell's monks, these two communities together making up the local population in the days when the cross was first raised.

The Crucifixion

The village people of Ruthwell would therefore have seen, at ground level, a Crucifixion scene, now very badly mutilated, but still recognizable (Pl. 19).[28] For us, who have grown accustomed to viewing a cross as a Crucifix, with the figure of the crucified Jesus holding the central and dominant position, it may seem odd, at first sight, to discover the Crucifixion as a separate panel, placed at the foot of the shaft. The Ruthwell cross shares this feature with three other Anglian crosses, those at Alnmouth, Aycliffe and one of the crosses at Hexham.[29] This, by itself, may suggest the existence of a tradition proving that the Ruthwell panel is an original feature and not a later carving added to the monument, as some have thought. Lawrence Stone believed the placement of this panel to be best explained in terms of the barbarian character of the society that erected the cross:

> To a primitive people brought up on traditions where might and worldly success are the main criteria of morality, the Crucifixion is a bewildering example of shame and degradation At Ruthwell the Crucifixion is present, but hidden away on the bottom panel of the back face of the cross and transformed into a pagan contest by the contemporary explanatory poem carved in runes on the shaft.[30]

There is nothing in the literature of the period, however, to lead us to think that Northumbrian Christians were in any way ashamed of the manner of death Jesus had endured to save them.[31] We know that before the battle of Heavenfield Oswald set up a wooden cross and prayed on bended knees before it; possibly the first symbol of the Christian faith to be erected in the whole of Bernicia, according to Bede.[32] We also get a glimpse of the general veneration

[27] See n. 230 below.

[28] For other good photographs of the two bottom panels see pls. 1a and 1b in Farrell (1986), 359.

[29] See *Corpus of Anglo-Saxon Stone Sculpture in England*, vol. 1, pt. 1, 161 and pt. 2, pl. 156 (Alnmouth); vol. 1, pt. 1, 42 and pt. 2, pl. 7 (Aycliffe); vol. 1, pt. 1, 176 and pt. 2, pl. 173 (Hexham 2). The panel on the Auckland St. Andrew cross (cf. pt. 2, pl. 3) shows the crucifixion of St. Andrew, not of Jesus; this is proved by the fact that (1) the church is dedicated to St. Andrew; (2) what survives of the inscription refers to Andrew (*PASsio ANDreae*); (3) the mode of crucifixion is with ropes, and ropes are specifically mentioned in the account of Andrew's death ("levaverunt eum cruce et extendentes funibus corpus eius sicut iussum fuerat suspenderunt," see B. Mombritius, *Sanctuarium*, ed. Paris [1910], 105).

[30] Stone (1955), 10–11. Huppé (1970), 103, accepts this explanation in his analysis of *The Dream of the Rood*.

[31] See for example Bede in his commentary on the *Canticle of Canticles*, "sancta ecclesia non erubescit crucem Christi sed et ipsa gaudet in contumeliis ac passionibus pro Christo vexillumque crucis ipsius gestare solet in facie," *In Cantica Canticorum*, II.iv.3, *Corpus Christianorum Series Latina* (hereafter *CCSL*) CXIXB, 248.

[32] Bede, *Historia Ecclesiastica* III:2, ed. C. Plummer, Oxford (1896), 128.

in which the cross was held in contemporary England from a passage of Huneberc's *Life of St. Willibald* (700–786 A.D.):

> When [Willibald's] parents, in great anxiety of mind, were still uncertain about the fate of their [sick] infant son, they took him and offered him up before the holy cross of our Lord and Savior. And this they did, not in the church but at the foot of the cross, for on the estates of the nobles and good men of the Saxon race it is a custom to have a cross, which is dedicated to our Lord and held in great reverence, erected on some prominent spot for the convenience of those who wish to pray daily before it. There before the cross they laid him.[33]

If I am right in my opinion of the probable placement of the cross in Ruthwell church, and of its orientation, the Crucifixion was by no means hidden on the back face; it was prominent and in full view. The people, accustomed to praying "at the foot of the cross," would have found it natural to come and kneel before this panel, placed at ground level to make it close and accessible. In so doing they would also have been facing eastward, the traditional Christian position for prayer in the early centuries.[34]

Another, more symbolic factor may also have helped to determine the position given the Crucifixion panel, especially for the literate and sophisticated designers of the cross. Patristic writers were fond of linking a phrase from Paul's letter to the Ephesians (3:18) with the cross. Paul expressed the wish that his readers might "comprehend with all the saints what is the breadth and length and height and depth." Any set of terms implying these four dimensions was enough to evoke the image of the cross in the mind of the commentators.[35] Bede sees in Paul's words the "moral configuration of the cross" (*moralis sacrosanctae crucis figura*), explaining that by "depth" is here meant the section of the cross as it emerges from the ground.[36]

This part of the cross stands for the *inscrutabilia iudicia Dei*, the dispositions God has made from all eternity for man's redemption. Bede repeats the same idea in his commentary on the *Canticle of Canticles* 5:15 where there is question of "alabaster columns set upon bases of gold." The base, close to the ground, acts as the foundation for God's plan as it unfolds. It represents God's decisions for the salvation of the world, made from all eternity, as they

[33] See *The Anglo-Saxon Missionaries in Germany*, ed. and trans. C. H. Talbot, London (1954), 154–155.

[34] On the connection between the cross and orientation towards the east for prayer see E. Peterson, "La croce e la preghiera verso oriente," *Ephemerides liturgicae* XLIX (1945), 52–68; also L. Gougaud, *Dévotions et pratiques ascétiques du Moyen-âge*, Maredsous (1925), 44–46, for the positioning of the cross on the east walls of monastic buildings in the early middle ages.

[35] In reading the texts one needs to know whether the cross is being viewed as standing erect or lying flat on the ground. Cassiodorus, commenting on Psalm 21:18, mentions the symbolism of the standing cross and adds that when seen lying on the ground it indicates the four cardinal points, "iacens vero quatuor cardines orbis designat." Sedulius also views the cross as *iacens* in *Carmen Paschale*, V:190–194, *Corpus Scriptorum Ecclesiasticorum Latinorum* (hereafter *CSEL*), X, ed. J. Huemer, Vienna (1885), "Quattuor inde plagas quadrati colligat orbis." The east shines on Christ's head, and the west caresses his feet: this implies a cross lying flat on the ground, not standing erect.

[36] See Bede's comments on Luke 23:33 (*CCSL* CXX, 401–402), "in profundo, inscrutabilia iudicia Dei unde ista gratia in homines venit . . . in profundo, pars illa ligni quae in terrae abdita defixa latet sed inde consurgit illud omne quod eminet sicut ex occulta Dei voluntate vocatur homo ad participationem tantae gratiae." The idea is put more briefly in Bede's comment on Mark 15:24 (*CCSL* CXX, 631), "profundum autem quod terrae infixum est secretum sacramenti praefigurat."

emerge in time, namely "the Incarnation of our Savior and our predestined salvation in him." He goes on to quote I Peter 1:18, "You know that you were ransomed . . . with the precious blood of Christ, like that of a lamb without blemish or spot."[37] Incarnation and Passion are thus linked with the idea of depth or base: we see the two great Christian mysteries as it were emerging from the ground as from the eternal and hidden decisions of God.[38]

To find the sun and moon shown in the sky on either side of the cross, like at Ruthwell, was standard Crucifixion iconography going back to an early period.[39] A traditional iconography, however, can acquire new overtones in particular historical circumstances. Ó Carragáin has argued that a special meaning may be attached to them here because of the contemporary discussion concerning the date of Easter, particularly as this discussion was handled by Bede.[40] For Bede the association of the solar equinox with the paschal moon was of prime importance for calculating the correct date of Easter, and he was able to weave the relationship between these heavenly bodies into a symbol of the relationship between Christ and his Church: "the equinox must precede and determine the Easter full moon, because it is only when Christ [the sun] had died, risen and returned to heaven that the Church [the moon] was able to begin her ministry." Christ's death on the Cross begets the Church. This is the message Bede felt he could draw from Habacuc 3:11: "The sun was exalted and the moon stood in her order" (*Elevatus est sol, et luna stetit in ordine suo*).[41]

The Annunciation

The inscriptions around the next three panels leave no doubt about their subjects; here Luke 1:28 accompanies an Annunciation scene (Pl. 18). In view of its proximity on the cross

[37] *CCSL* CXIXB, 293–94, "Bases quippe aureae ipsa sunt consilia divinae provisionis quibus aeternaliter ante saecula dispositum est omne quod temporaliter in saeculo crearetur in quibus et ipsa salvatoris nostri incarnatio et nostra in illo salus praedestinata est teste apostolo . . . et apostolus Petrus redemptos esse nos dicit 'pretioso sanguine quasi agni inmaculati et incontaminati Iesu Christi praecogniti quidem ante mundi constitutionem manifestati autem novissimis temporibus.'"

[38] It is particularly unfortunate that we can no longer determine whether the panel on the other face of the cross, forming the counterpart to the Crucifixion, was a Nativity panel. If it was, then this would give added weight to the symbolic explanation drawn from Bede.

[39] See the many examples in G. Schiller, *Ikonographie der christlichen Kunst*, Bd. 2, Güterloh (1968), fig. 324 (6th c. Palestinian ampulla), fig. 327 (6th c. Rabbula Gospels), etc. As regards the literature see, among other studies, L. Hautecoeur, "Le soleil et la lune dans les scènes de la Crucification," *Revue archéologique* XIV (1921), 13–32; E. Becker, "Auferstehung oder Kreuzigung auf altchristlichen Sarkophagen," *Byzantinische-neugriechische Jahrbuch* I (1920), 151–157.

[40] Ó Carragáin (1987b), 121–122. In this article Ó Carragáin makes the ancient baptismal liturgy, with its adult catechumens, a principal basis for his interpretations of the various panels. Underlying such an approach is the assumption that the Anglian advance into Southwest Scotland was an advance into pagan territory, resulting in the mass conversion and baptism of adults. There is no echo, however, of such a situation in contemporary records like the *Lives of Cuthbert*, or the *Ecclesiastical History* of Bede. Infant baptism was the norm in Northumbria in Bede's day, and it was Northumbrian settlers who colonized the newly conquered territory and needed their own bishop. The Northumbrians were also advancing into lands that already had Christian communities, like the one at Whithorn, with their own traditions (British and Irish). We do not need a prototype among the catechumens of the early church to explain the short tunic of Christ on the Cross, since numerous earlier artistic models showed him thus garbed; this is the case, for instance, in the Crucifixion at Alnmouth, not far from Lindisfarne.

[41] The verse is quoted in abbot Ceolfrid's letter to King Nechtan of the Picts (Bede, *Historia Ecclesiastica* [as in n. 32], V:21), a document which Bede certainly had a hand in composing. Bede has a similar comment on this verse in his commentary on the *Canticle of Habacuc*, see *CCSL* CXIXB, 397, "soli Christum, ecclesiam lunae comparaverat."

to the Crucifixion, we should take note of the fact that in the Christian calendars of the period the date of the Crucifixion (Good Friday), like that of the Resurrection (Easter Sunday), changed from year to year, and a widely accepted tradition placed the actual date of Christ's Crucifixion on 25 March. Since the day of his birth was celebrated on 25 December, the date for his conception, nine months earlier, therefore also fell on 25 March, the day of the vernal equinox. Many calendars of the early Middle Ages have entries like "Dominus crucifixus et adnunciatio S. Mariae" or "Dominus crucifixus et conceptus" for 25 March, showing a widespread acknowledgment of this coincidence of dates.[42] Whether this calendrical feature explains the proximity of the two panels on the Ruthwell cross is unclear, since the link between the panels is more than sufficiently explained on the Scriptural level, "God sent forth his Son, born of a woman, born under the law, to redeem those who were under the law, so that we might receive adoption as sons" (Galatians 4:4–5). The Annunciation, in Bede's words, is "the beginning of our redemption" (*exordium nostrae redemptionis*) and the "fitting commencement of the restoration of mankind" (*aptum principium humanae restorationi*).[43] Christ's death on the Cross, through which man's redemption was wrought, fulfilled the mission initiated at the Annunciation.

In his message to Mary at the Annunciation the angel had said that the child to which she would give birth would reign for ever over the "House of Jacob" (*et regnabit in domo Iacob in aeternum*). On this Bede remarks:

> The House of Jacob signifies the universal Church [drawn from the Jewish race and all the other nations] He reigns in the Church in this life when, dwelling in the hearts of the elect through faith and love, he rules over them and guides them through his constant protection towards acquiring the eternal reward. He will reign over them in the future when after the period of this temporal exile He will bring them into the heavenly fatherland where, constantly inspired by the vision of his presence, their only task will be to rejoice in singing his praises.[44]

In his commentary on Luke, Bede notes that the traditional date for the Annunciation or conception of Christ, 25 March, coincided with the vernal equinox: "It was fitting that he 'who enlightens every man who comes into the world' [John 1:9] should be conceived at the time when daylight begins to increase."[45]

The Healing of the Man Born Blind

The panel immediately above the Annunciation shows Jesus "enlightening" the man born blind (John 9:1–6, quoted in this panel's inscription), who in the allegorical tradition is

[42] See, for example, B. Bischoff, "Das karolingische Kalendar der Palimpsesthandschrift Ambros. M. 12 sup," in *Colligere Fragmenta. Festschrift Alban Dold zum 70. Geburtstag*, Beuron (1952), 251, [25 March] "Adam a Deo de puluere plasmatur. Adam nomina cunctis animantibus ponit. Adnuntiatio (ad Mariam). Christus crucifigitur. Isaac immolatur." Also E. A. Loew, *Die ältesten Kalendarien aus Monte Cassino*, Munich (1908), 16–17: "Dominus crucifixus et conceptus," etc.

[43] Bede's homily (I, 3) for Advent, *CCSL* CXXII, 14, ll. 1 and 10.

[44] Ibid. 17, ll. 115–127.

[45] *CCSL* CXX, 30, ll. 444–445: "conuenit utique cum lucis incremento concipi uel nasci eum qui 'inluminat omnem hominem uenientem in hunc mundum.'"

taken to represent mankind (Pl. 17).[46] The figures of Christ and the blind man occupy only the upper half of this panel. The lower part remains blank, and was obviously blank from the beginning, a feature to which we will return later in this study. The healing of the man born blind was represented frequently in Christian art, and from an early date.[47] The motives that lie behind the choice of this subject are not always evident since Patristic sources can provide several explanations.[48] Augustine's well-known comment on these verses of John, which is echoed by Bede, remains the most likely source of inspiration:

> That blind man is the human race; for the first man incurred this blindness through sin, from whom we all draw our origin, not only with respect to death, but also to unrighteousness. For if unbelief is blindness and faith enlightenment, whom did Christ find a believer at his coming? . . . If evil has so taken root within us, every man is born mentally blind. For if he sees, then he has no need for a guide. But if he does need someone to guide and enlighten him, this shows he is blind from his birth Jesus sent him to the pool which is called Siloam . . . which is interpreted "Sent" (*quod interpretatur Missus*) You understand now who it is that was sent; for had he not been sent, none of us would have been set free from iniquity. Accordingly he washed his eyes in that pool which is interpreted "Sent"—he was baptized in Christ.[49]

The Christian tradition, following Paul, saw baptism as the act through which man was made to share in Christ's saving death on the Cross.[50] Those who were baptized constituted the *Ecclesia* or Church, the Body of Christ. On the allegorical level this ties in with the panel immediately above, depicting the woman who anoints the feet of Jesus.

Mary Anointing the Feet of Jesus

The inscription on its border, taken from Luke 7:37–38, identifies the subject of this panel (Pl. 16). Identifying the woman, on the historical level, presented some problems to the commentators. Jerome in his commentary on Matthew considered that the woman mentioned by Luke needed to be distinguished from the woman alluded to by Matthew (ch. 26) and Mark (ch. 14), who, close to the time of Jesus' passion, had anointed both his feet and his

[46] As in the text of Augustine cited below at n. 49.

[47] See Schiller (as in n. 39) Bd. 1, figs. 505–509, showing examples from the fourth to sixth century.

[48] Patristic literature contains traces of discussions about Christ's greatest miracle, centering on this episode. Thus Jerome, who delighted in disagreeing with the opinions of others, asserted in his comment on Matthew 21:15 that those who believed the greatest miracle of Christ to be the resurrection of Lazarus, or the healing of the man born blind, or the voice of the Father heard at his baptism, or even his Transfiguration, were all mistaken. In Jerome's view the greatest miracle was the expulsion of the vendors from the Temple. (On this see H. Sylvestre, "Le 'plus grand miracle' de Jésus," *Analecta Bollandiana* c [1982], 1–15). A sermon, probably from North Africa and from the time of Augustine, but preserved only in two Beneventam manuscripts, explains why the healing of the man born blind was Christ's greatest miracle (see R. Etaix, "Textes inédits tirés des homiliaires de la bibliothèque capitulaire de Bénévent," *Revue Bénédictine* XCII [1982], 340–342). It seems doubtful, however, that this sermon was known in Anglo-Saxon England and prompted the inclusion of this panel on the Ruthwell cross.

[49] *Tractatus 44 in Evangelium Ioannis, CCSL* XXXVI, 381–382.

[50] Romans 6:3 "in morte ipsius baptizati sumus."

head.[51] Ambrose, without a full discussion, was prepared to believe they might be the same person.[52] Bede made a careful study of all the passages involved, and firmly concluded—against Jerome—that the anonymous woman of Luke, Matthew and Mark, was the same person, who could, moreover, be identified also with Mary Magdalen and Mary, the sister of Martha and Lazarus.[53] This multi-faceted identification had important consequences for his allegorical interpretation of the scene.

Bede was prepared to admit that, on the historical level, the anointing of the head in Matthew (ch. 26) and Mark (ch. 14) had occurred at a different time from the anointing of the feet in Luke (ch. 7), but to think of the one always meant recalling the other. Thus to see Mary bending down to anoint the feet of Jesus summons up for him the image of Mary erect, anointing his head, as shown in the following passage from one of his homilies:

> The same woman there [in Luke], prostrate, anoints only the feet of Jesus, while shedding tears of penance, but here [in Mark, Matthew] she stands erect, rejoicing in her good conduct, and anoints both his feet and his head. There she signifies the beginning of those who are penitent, here she stands for the justice of those who are perfect The head she anoints stands for the sublimity of his divinity, his feet indicate the humility of his incarnation. We anoint his feet when we proclaim with praise the mystery of his incarnation, we anoint his head when we venerate the excellence of his divinity with worthy praise We anoint the Lord's head when we embrace with the true tenderness (*dulcedine*) of faith, hope and charity the glory both of his divinity and humanity, and proclaim praise to his name by living good lives. We anoint his feet when we succor the poor through comforting words, and urge them not to despair, despite the hardships they must endure. We dry his feet with our hair when from our superfluous possessions we give to the needy.[54]

In his commentary on Luke, which appears to depend in part on the homily quoted above, Bede again summarizes this views about Mary, representing both the Church and the individual Christian, as she anoints Jesus:

> Each individual faithful soul must first humbly prostrate self at the feet of the Lord and obtain forgiveness of sins, then, as with time its merits increase, through the ardor of a joyful faith, it bathes the Lord's head with the fragrance of sweet spices. And the universal church of Christ which here below celebrates the mystery of his incarnation, designated by his feet, hereafter will contemplate together both the glory of his humanity and the eternity of his divinity—for "the head of Christ is God" (I Corinthians 11:3)—glorifying him with genuine spikenard through the utterance of unending praise.[55]

[51] J.-P. Migne, ed., *Patrologia Latina* (hereafter *PL*) XXVI, 199A "Nemo putet [hanc mulierem] eamdem esse quae super caput effudit unguentum."

[52] *Expositio in Lucam VI* (*CCSL* XIV, 179): "Potest ergo non eandem esse, ne sibi contrarium euangelistae dixisse uideantur. Potest etiam quaestio meriti et temporis diuersitate dissolui, ut adhuc illa peccatrix sit, iam ista perfectior." In other words, the woman who as a sinner had washed the feet of Jesus, was later, after her conversion, found worthy to anoint his head.

[53] Bede, *In Lucam III* (*CCSL* CXX, 166–167).

[54] Bede, *Homilia II.4* (*CCSL* CXXII, 210).

[55] Bede, *In Lucam III* (*CCSL* CXX, 167).

Thus the image of Mary, seen at the feet of Jesus, conjures up for Bede the image of the Church—mankind redeemed through Christ's death on the Cross—struggling here below as she prepares herself for eternity and the life of unending praise when it will be seen that the "head of Christ is God." Bede's phrase *Universalis ecclesia Christi . . . perpetuis confessionum laudibus . . . glorificat* seems to evoke the *adoramus*—all that now survives of the lost inscription of the panel immediately above.

The Apocalypse Vision

The *[a]doramus* of its inscription is insufficient in itself to provide a clear identification of this panel's subject, except to suggest some image of the deity, to whom alone adoration is due (Pls. 20–22). The loss of the rest of the inscription opens the door, however, to debate about the main figure's identity, and the interpretation of the panel as a whole. Henry Duncan, as we have seen, concluded that it represented "the Supreme Being with the Agnus Dei in his bosom."[56] Daniel Henry Haigh seems to have been the first to link the Ruthwell panel with the one on the Bewcastle cross and declare that both contained "St. John the Baptist, with the Holy Lamb, to which he points with his right hand, resting on his left arm."[57] This interpretation remained unquestioned until 1982 when I published a paper arguing that the subject of the panel was not John the Baptist, but an Apocalypse vision; in other words, the image was based on the *Book of Revelation*, and could be fitted into the tradition of Apocalypse imagery.[58] In preparing this paper I had neglected the evidence available in some of the photographs, particularly that of the Bewcastle panel, published with the official report of 1920 (Pl. 53), and taken at a time when the cross—exposed for so long to the elements—was in slightly better condition than it is today (Pl. 54).[59] A close look at this photograph revealed that the Bewcastle figure was not pointing to the Lamb[60] but was holding a book in the right hand, with the fingers bent round the book.[61]

[56] See above p. 100.

[57] Haigh (1857), 167–168. His description of the Bewcastle panel (ibid., 151) reads: "in an oblong compartment is the effigy of St John the Baptist, pointing with his right hand to the Holy Lamb, which rests on his left arm." In her recent description of the Bewcastle cross Cramp (in Bailey and Cramp [1988], 68) echoes this tradition, deriving from Haigh, in stating that the bearded figure in the panel "points very clearly to the haloed Lamb."

[58] Meyvaert (1982).

[59] The original plate of this photograph has not survived among Baldwin Brown's negatives in the Department of Fine Arts of the University of Edinburgh, as I have learned through the kindness of John Higgitt of that Department. The same illustration, reproduced on a much smaller scale as plate XI, opposite p. 103, in Baldwin Brown (1921), is useless for purposes of comparison. Some of Brown's other negatives are preserved at Edinburgh but they represent photographs taken from a side angle of the monument and are of no real use for the present investigation.

[60] We must remember that when the Quinisext Council of 692 referred to the gesture of John the Baptist pointing to the lamb ("Agnus qui digito praecursoris monstratur" in the Latin rendering of Mansi, *Sacrorum Conciliorum Amplissima Collectio*, XI, 978), this was not our gesture of pointing; in the classical language of gesture—illustrated in the John the Baptist panel of the Maximian Chair at Ravenna—"pointing" requires a raised arm, and one or two fingers pointing upward: see Meyvaert (1982), pl. VII. This is not the gesture we see at Bewcastle or Ruthwell.

[61] I state this with little hesitation. By way of experiment, I presented the photographs to a series of seven scholarly friends, three of whom are art historians, and asked each one—without mentioning the point at issue—to give a description of the panel. They all pointed out that a book was being held with the right hand. If we pass from the 1920 photograph to the

Alerted by this new perception I then turned to the Ruthwell panel, whose upper portion suffered so much damage at the hands of the iconoclasts. The position of the Ruthwell figure's right hand corresponds closely to the right hand at Bewcastle, namely showing a gap between the thumb and the fingers. In Pls. 20–22 the outline of a rectangular object can be discerned; its outline goes straight up from behind the hand almost to shoulder level, then at a right angle across the figure's breast until it meets the head of the Lamb.[62] There seems good reason for concluding, therefore, that the Ruthwell figure, like the one at Bewcastle, held a book in an undraped right hand. That some object is present on the figure's right side can also be determined by studying the treatment of the drapery on the upper part of the body. We can begin by noticing the ribbed treatment of the folds of the outer garment in the panels showing Jesus standing on the animals, or with the woman at his feet where the folds are shown as a series of parallel grooved lines (Pl. 26). We can discern a similar pattern of folds on the figure's left side, the side with the lamb (Pls. 20, 21); they extend from the waist to the shoulder,

more recent one in Pl. 54, we can see that despite further deterioration the outlines of the book still remain visible. Willett (1956–57), states in his bibliography that the best photographs, made by F. W. Tassell of Carlisle and J. Gibson of Hexham, were to be found in A. S. Cook's work of 1912. Unfortunately these are rather small in size, although Cook's fig. 19 does suggest the presence of a book. Given their early date one wonders whether the plates from which these photographs were made have survived?

[62] This is also faintly visible in Farrell (1978), 97, pl. VIII Available photographs show that light focused from different angles can produce quite different impressions. This can be seen, for example, by simply examining the figure's face, or what remains of the face, as it appears in Pls. 20–22. Pls. 9 and 10 represent the beeswax model of the cross made by Henry Duncan whose skills as a modeller have already been touched upon (see n. 16). The model is still in the possession of Duncan's family from whom Mrs. Mary Martin, Curator of the Ruthwell Museum, kindly obtained an illustration for me. Duncan's modelling of the figure with the lamb suggests a hand holding some object. The line ascending vertically from the figure's right hand contrasts with the diagonal line indicating the edge of the garment on the opposite side. Being unable to visit Ruthwell myself, I asked Mrs. Martin to take a close look at the panel and describe what she saw. In her reply (8 August 1991) she wrote: "I have . . . looked again at that panel, in dim light, in sunlight, and with a torch focused on it, and in all cases have seen a 'something' in the hand. It is surely rectangular . . . and—I'm sure—is not visible only because you guide me to look for it."

Prompted by my enquiry, Mrs. Martin also asked the opinion of an Irish medievalist, Dr. Michael Haren, who was passing through Ruthwell. Dr. Haren later wrote me (16 August 1991): "I did examine carefully the figure at the point you had marked on the photocopy and would confirm that there is a ridge visible on the figure's extreme right which distinguishes the drapery from a 'panel.' There is also slight evidence of a ridge along the top of what I refer to, neutrally, as the 'panel.' It seems to me that the interpretation of this 'panel' must be a matter for comparative iconography."

Most recently Professors Brian Daley and Lloyd Patterson of Cambridge, Mass. visited the Ruthwell cross on my behalf. In a note (3 September 1991) Brian Daley writes: "On August 28, 1991, Lloyd Patterson and I visited the Church at Ruthwell and spent almost an hour examining the cross, looking at it and photographing it from all angles. We came back that night after dark to examine it again without daylight, and made a third visit the next morning. It seemed quite clear to both of us that the figure in the top panel of the north side of the cross is represented as seated, and that he is holding a rectangular object in his right hand that extends upward from this hand to just below the level of the shoulder. The front face of this rectangular object is flat—the lower folds of his robe are clearly not continued here—and there is a corner, faintly but clearly visible, at the seated figure's upper right, just in front of his shoulder. In our view the object certainly suggests a book. The lamb on the figure's left side is represented as walking towards this object. Both the seated figure and the lamb are haloed, and the seated figure's feet are resting on two globes. In the context, your identification of the panel as representing Apoc. 5:7 seemed to us to be completely convincing."

I am grateful to these correspondents for giving me an account of their visual impressions of a material aspect of the monument that, as far as I am aware, has never been mentioned in the literature of the Ruthwell cross, and obviously now deserves close attention.

but are interrupted by the body of the lamb.[63] A side view of the panel (Pls. 30, 31) also shows that the carving on this side is more deeply recessed than the corresponding surfaces on the figure's right side where we discover no similar pattern of folds. Just as the lamb hides part of the garment and its folds on the figure's left side, so another object, namely the book, stands in front of and therefore obscures the folds on his right side. The main difference between the Ruthwell and Bewcastle panels is the absence of globes under the feet at Bewcastle (Pl. 53). Likewise the head of Bewcastle's lamb appears a little to the left of the main figure, rather than in a central position, as at Ruthwell.

Despite these differences we are certainly dealing, both at Bewcastle and Ruthwell, with the same iconography, namely that of an imposing personage holding both book and lamb. The layout of these panels can be compared with the image found on fol. 88 of the *Liber Floridus* (Pl. 57), a page initially begun as an illustrated Apocalypse, but then discarded and later used for a different series of texts.[64] This iconography, of lamb and book together, obviously belongs to the Apocalypse tradition, and illustrates chapter five of Revelation, where an unnamed person, seated on a throne, holds in his right hand a book, "written within and without, and sealed with seven seals." A lamb then appears, in the middle of the throne, to take the book from the right hand of the one seated there.[65]

Within the tradition of Apocalypse imagery the action of the Lamb taking (or opening) the Book (*et accepit librum*) is illustrated by showing the animal with one of its front feet raised and resting on some part of a closed or open book.[66] Both the Bewcastle and Ruthwell

[63] See likewise Farrell (1986), 366, pl. 8a.

[64] Lambert of St. Omer is recognized to have drawn on numerous literary and pictorial sources for his work. The list of contents of the *Liber Floridus* includes, as chapter 13, an *Apocalypsis depictus*. Derolez, in his meticulous examination of the Ghent manuscript, has shown that the surviving illustrated Apocalypse—now available only in the copies of the *Liber Floridus*—was not the one originally chosen. Lambert first laid out the present bifolium 188–191 for an illustrated Apocalypse, but soon decided not to use it and turned to another model (the original chapter number, 13, is still visible, however, at the top of fol. 88). Later Lambert used the discarded bifolium (fols. 88–91) for his chapters 78–79 on the four elements, the constellations, etc. This explains the odd clash between the lay-out of these pages, and in particular of fol. 88, with its quotations deriving from the Apocalypse, and the other material that now occupies this same page: see A. Derolez, *Lambertus qui librum fecit. Een codicologische studie van de Liber Floridus autograaf*, Brussels (1978), 167–172. Anyone who compares fol. 88 with the copy of this folio in Wolfenbüttel, Cod. Guelf. 1 Gud. lat., reproduced in *Monumenta Anonis. Weltbild und Kunst in Hohen Mittelalter*, exh. cat., Cologne (1975), 90, will notice numerous changes. In the Ghent manuscript the figure is shown seated, although no throne is visible—a feature that links it to Ruthwell—while the raised leg of the Lamb touches the Book. In Wolfenbüttel the Book has been closed and transferred to the left hand—although the Lamb, with raised leg, still remains facing its right—and a throne has been supplied; Wolfenbüttel can obviously not be accepted as a faithful copy of the Ghent manuscript. The origins of Lambert's original model deserve attention. The type of floating drapery we see on fol. 88 is very reminiscent of what Francis Wormald called the early eleventh-century style of English drawing: see F. Wormald, *English Drawings of the Tenth and Eleventh Centuries*, London (1952), 37 with pl. 5b. One can also note that fol. 88v was first intended to depict the twenty-four elders who fall down before the Lamb. In his revised Apocalypse, as we know from the copy in Wolfenbüttel, Lambert distributed the elders over two pages. The strange series of names given to the twenty-four elders is found only in the *Textus Roffensis* (Rochester Cathedral Library, MS. A. 3. 5) which, again, suggests an English background for the Apocalypse model Lambert had to hand.

[65] Apocalypse 5:1, 6–7.

[66] One noticeable variant in Apocalypse imagery is the position assigned to the Lamb who takes the Book. The Ruthwell, Bewcastle and *Liber Floridus* images stay closest to the actual text of Revelation, where the seated figure and the Lamb

crosses are now so damaged and in such poor condition that it is no longer possible to ascertain whether this feature was present in the original design. It should be noted, however, that in both monuments the physical proximity of Lamb to the Book strongly suggests that this was the case. We also understand the attempt at Ruthwell to place the head of the lamb as centrally as possible (*in medio throni*), aligned with the head of the seated figure.

The treatment of the folds in the drapery immediately below the Lamb in the Ruthwell panel also deserves attention (Pl. 22).[67] An identical disposition of folds occurs in the eighth-century sculpture at Breedon-on-the-Hill, Leicestershire, showing a woman holding a book with her left hand (Pl. 58).[68] Other figures holding books with a draped left hand are easy to find: for example, at Ruthwell in the figure of Jesus with the woman at his feet (Pl. 16), on the Cuthbert coffin, in the Gregory image of the St. Petersburg (formerly Leningrad) Bede, in the *Majestas* figure of Codex Amiatinus, etc.—although in these other instances the stylized arrangement of folds, found at Ruthwell and Breedon, is lacking. Another monument with the same stylized arrangement of folds is the seventh-century sarcophagus of Bishop Agilbert, in the crypt at Jouarre (Pl. 59). Agilbert was the Frankish bishop who, after spending some time in Ireland, became bishop of Dorchester and took part in the synod of Whitby. Later he became bishop of Paris and in this capacity consecrated Wilfrid as a bishop. The point worth remembering here is that Wilfrid's building of stone churches at Ripon and Hexham postdates his consecration at the hands of Agilbert. Thus the link between the stylized folds at Jouarre—Agilbert's family estate, where he was buried—and at Ruthwell may be evidence for the diffusion of techniques in carving introduced by stone masons brought over by Wilfrid from Gaul to Northumbria in the late seventh century.[69] What light does this treatment of folds shed on the posture of the main figure? At Breedon the folds define a hand holding a book, while at Jouarre they define two knees and thus reinforce the image of a seated figure. At Ruthwell the folds occur only on one side; they are meant to suggest a support for the hind legs of the lamb.[70] If the sculptor had a knee in mind he obviously lacked the space—because of the narrowness of the shaft—to add a similar pattern on the other side to define the other knee. Perhaps we should not expect much realism from such a monument

occupy a central position with respect to the throne ("sedens in throno . . . [Agnus] in medio throni"). Elsewhere we find the Lamb shown to the right, both of the seated figure and of the Book, no doubt because of numerous New Testament texts, like Colossians 3:1 ("Christus est in dextera Dei sedens"), which speak of Christ being seated at the right hand of God.

[67] This illustration, from the Warburg Institute's photographic collection, was made specially for Saxl's study of 1943. It seeks to recapture the original alignment, lost in Duncan's reconstruction.

[68] Also shown in *The Anglo-Saxons*, ed. J. Campbell, E. John, and F. Wormald, Oxford (1982), 113, fig. 109, and D. M. Wilson, *Anglo-Saxon Art*, New York (1984), 82, fig. 88. See also A. W. Clapham, "The Carved Stones at Breedon-on-the-Hill, Leicestershire and their Position in the History of English Art," *Archaeologia* LXXVII (1928), 219–240.

[69] *The Anglo-Saxons* (as in n. 68), 46, fig. 47 shows a side of Agilbert's sarcophagus that includes a figure of the seated Christ with what appear to be similar stylized folds outlining the knees. In the note that accompanies this illustration Campbell laments the loss of other sculpture from this period in Gaul, since this loss deprived us of "the possibility of a full understanding of the origins of such sculpture in England." For this reason the link between Ruthwell and Jouarre deserves attention.

[70] I am very grateful to Professor Peter Fergusson of the Art Department of Wellesley College, for pointing out to me the unity of design thus achieved.

at this period.[71] The conjunction of book and lamb with a central figure is enough to point us in the direction of Apocalypse imagery, and away from John the Baptist.

Ruthwell's most distinctive feature appears at the bottom of the panel, in the globes placed under the figure's feet. To Henry Duncan, their meaning was clear; they represented the spheres subject to divine dominion, "probably the world which now is and the world which is to come."[72] Others have difficulties in determining their meaning, compounded by the fact that Ruthwell's presentation is unique and unprecedented, at least as far as extant sculpture is concerned; we can only surmise what else might have existed in northern Europe before the region was swept by the tide of Reformation iconoclasm. I myself believe that the missing link to a living tradition of Apocalypse imagery might well have been found in the series of paintings brought from Rome by Benedict Biscop, and installed on the north wall of the church at Wearmouth-Jarrow. Unfortunately these painted panels are long lost, their content recorded only as "images of the visions of the Apocalypse of the blessed John."[73] If we look beyond the early Anglian monuments to later times, we find a well-developed iconographic tradition in which single globes beneath a figure's feet abound, although double globes are more difficult to find.[74] An early tenth-century ivory in Darmstadt (Pl. 60), and an image on fol. 199 of Paris, Bib. Nat., lat. 8878 (the St. Sever Apocalypse) (Pl. 61), show semicircles under the feet of a seated Apocalypse *Majestas*.[75] The antecedent of these images is unclear. Could they perhaps originate from the tradition that shows Christ seated above the Cosmos, which has been personified and holds a cloth in semicircular shape above its head?[76]

In the Byzantine world an early iconographic tradition of the *Majestas Domini* was based on Ezekiel (1:10) where, in addition to the four animals or Living Creatures that surround the *Majestas*, there are also wheels (*rotae*): "Now as I looked at the living creatures, I saw a wheel upon the ground beside the animals" (*apparuit rota una super terram iuxta animalium*, Ezekiel 1:15). Above this apparition Ezekiel beheld "the likeness of a throne . . . and seated above the likeness of a throne the likeness as it were of a human form" (Ezekiel 1:26). Wheels are linked to the animals, below the figure of a standing Christ, in the well-known Ascension scene of the Rabbula Gospels.[77] We also find wheels constantly present in

[71] The quite different treatment of the drapery at Bewcastle (Pl. 53) leaves little doubt that the figure there is shown standing. A composition that bears some resemblance to Ruthwell is St. Dunstan's well-known drawing of Christ. It suggests a seated Christ where only one knee is defined, while the folds on the other side lead up to the place where a hand, holding a book, emerges. For a reproduction of this drawing see Campbell (as in n. 69), 186.

[72] Duncan (1833), 326.

[73] Bede, *Historia abbatum*, ed. C. Plummer, Oxford (1896), VI, 369: "imagines visionum apocalypsis beati Iohannis."

[74] Meyvaert (1982), 18.

[75] The Darmstadt ivory is also reproduced in Schiller (as in n. 39), Bd. 3, fig. 694.

[76] This interesting suggestion was made to me by Professor Ioli Kalavrezou of Harvard University. For a telling example see the seated Christ on the Vatican sarcophagus shown in A. Grabar, *Early Christian Art*, New York (1968), 249, fig. 276. With time the Cosmos figure could have been omitted while the semicircular arc was retained; such a tradition, however, would more normally have produced a single semicircle, rather than two.

[77] This image has often been reproduced: see, for example, K. Weitzmann, *Late Antique and Early Christian Book Illumination*, New York (1977), pl. 36; Schiller (as in n. 39) Bd. 3, fig. 459.

the early paintings at Bawît, Egypt.[78] This iconography maintained a long tradition, for we encounter it again on the famous *sakkos* or "dalmatic" of the Treasury of St. Peter's, Rome, once thought to have belonged to Charlemagne but now recognized to be a Byzantine embroidery of the thirteenth or fourteenth century (Pl. 62). Here we find a winged circle placed under each foot of the seated Christ. While it is unlikely that wheels with spokes, like those at Bawît, would have been mistaken for globes, it is conceivable that simple circles like those on the *sakkos*, particularly if they lacked wings, could have been misinterpreted as globes, given the fact that circles to indicate globes were such a constant feature of *Majestas* iconography.

Such an interpretation, of circles for globes, would have found confirmation in the tradition from which the illustrated Trier Apocalypse derives; on fol. 37r we see a woman standing on two globes, representing the sun and the moon (Apocalypse 12:1) (Pl. 63).[79] The remarkable thing here is that the original, uncorrected text, present on the facing page (fol. 36v) does not support this image, since it reads: *mulier amicta sole, et luna sub pedibus eius* ("a woman clothed with the sun and the moon under her feet"). Yet the textual history of the Latin (Vulgate) version of Revelation bears witness to a rare alternative reading: *mulier amicta, sol et luna sub pedibus eius.*[80] This is obviously the variant that underlies the Trier image, which must derive, therefore, from some earlier model based on the alternative text.[81] In this image the two globes represent sun and moon; in early Christian art heaven and earth were also represented as spheres.[82] The text on the Darmstadt ivory previously mentioned

[78] At Bawît the wheels—either two or four—remain at ground level in proximity to the feet and to the throne, and tend to impinge on the circumference of the mandorla. For a good example see the painting in chapel 42, easily accessible in the article "Baouît" by J. Clédat in the *DACL*, vol. 2, cols. 241–242, fig. 1280; also A. Grabar, *Christian Iconography. A Study of its Origins*, Princeton (1968), figs. 84 and 323.

[79] Also reproduced in Schiller (as in n. 39) Bd. 4/1, fig. 183. The identical image is found in the copy of Trier, Cambrai, Bibliothèque municipale, MS. 386, on fol. 27r: see *Trierer Apokalypse: Kommentarband*, ed. R. Laufner and P. Klein, Graz (1975), Taf. VIII, Abb.16. The similar illustration in the Valenciennes Apocalypse shows a double halo round the head and only one globe, the moon, under both feet: Schiller (as in n. 39) fig. 182.

[80] This reading is found in London, British Library, Harley MS. 1772 (fol. 144v): see E. S. Buchanan, *The Epistles and Apocalypse from the Codex Harleianus*, London (1912). Buchanan's opinion that the manuscript was Northumbrian, and could even have been in Bede's hands, must be set aside. According to B. Fischer, "Bibeltext und Bibelreform unter Karl dem Grossen," in *Karl der Grosse*, II, *Das geistige Leben*, Düsseldorf (1965), 89–190, Harley 1772 (Z in Wordsworth and White) belongs to the late eighth or early ninth century and probably comes from Cambrai, although the Reims area cannot be excluded. Another manuscript with the same variant for Apocalypse 12:1 is London, British Library, MS. Add. 11,852, fol. 204 (U in Wordsworth and White). This mid-ninth-century manuscript from St. Gall belongs to the time of Abbot Hartmut. U is recognized to contain a "typische St. Galler Lokaltext," but also to have links with S (= St. Gall, MS. 907), which depends on an Italian exemplar. It would need a minute textual study to evaluate a possible connection between U and this Italian model. I am grateful to Michelle Brown of the manuscript department, the British Library, for kindly verifying the two above manuscripts for me. She reports that in Z "the e of 'sole' is a contemporary or near contemporary suprascript correction, while in U the e is added but over what appears to be an erasure." Klein (as in n. 79), 134, in his discussion of the image on fol. 37r fails to take the textual history of the Latin version of the Apocalypse into account. A further clash between image and text occurs on fol. 63r of the Trier MS., where an angel is shown standing on the sun, while the text on the opposite page reads "stantem in sole" (Apocalypse 19:17). Here again one needs to know that there is support for this in the reading "supra solem" in the early commentary of Apringius on Revelation.

[81] How far back this variant goes is difficult to determine. Professor H. J. Frede, Director of the Vetus Latina Institute at Beuron, has kindly informed me that the files of the Institute provide no patristic evidence to support this variant. It seems to be connected with the Vulgate transmission.

[82] See Meyvaert (1982), 17.

reads: *data est mihi omnis potestas in caelo et in terra* (Matthew 28:18). Globes under the feet of a seated *Majestas* could be construed to have the same meaning. We can thus see that while the depiction of globes—perhaps also indicating that the figure is seated—is rather rare, it can be fitted into the surviving iconographic evidence that emanates from a tradition linked with Prophetic or Apocalypse visions.

Henderson, unconvinced by my previous arguments, has made a valiant attempt to explain the Ruthwell globes as possible attributes of John the Baptist.[83] He concedes that "neither God in Majesty, nor John the Baptist, normally have two globes or stones under their feet." John the Baptist, however, is sometimes shown baptizing Christ with one foot raised on a rock of the Jordan bank.[84] Henderson suggests that this feature, the Jordan rock, reshaped as a globe and multiplied by two, might have been used to exemplify Gospel concepts of John the Baptist. John has been shored up, as it were, as if on stilts, by "two blocks or globes" to illustrate his statement that he must diminish while Jesus increases (John 3:30).[85] The globe/rocks might suggest John's dictum that Jesus "comes from above and is above all" whereas others are "of the earth" (John 3:31),[86] or seek to contrast Jesus who "walks" while John "stands" (*Jesum ambulantem, Iohannes stabat*).[87] Henderson cannot point to actual instances of rocks appearing as globes, or to iconographic parallels for double globes or rocks intended to have the implications he suggests. These are *ad hoc* propositions, for which no evidence exists. It seems much simpler to accept the objects seen under the feet of the figure at Ruthwell for what they manifestly are, namely globes. Globes lead us toward the iconography of deity and sovereignty, or toward the Apocalypse, but not toward John the Baptist.

A constant element in Apocalypse illustrations is the presence of the four Living Creatures (Apocalypse 4:6–7, 5:8 etc.) resembling a lion, a calf, a man, and an eagle, that surround the central image (the throne, the one seated on the throne, the book and the lamb). Traditionally interpreted as the four evangelists, these animals are shown, sometimes with and sometimes without a book, but they seem never absent from an Apocalypse *Majestas*. What is peculiar to the Ruthwell cross is the addition of the human figures of the four evangelists to the animals symbolizing them. The very shape of the cross prevented placing these symbolic animals around the panel we have been discussing. But their position immediately above this panel, in the four arms of the cross-head, continues the relationship with Revelation and appears to guarantee that the central roundel of the cross-head, around which the animals radiate, but which is now lost, was also an Apocalypse image. This was probably the Lamb alone, perhaps with a cross staff or standing on the seven-sealed book, as shown in

[83] Henderson (1985).

[84] Schiller (as in n. 39) Bd. 1, has thirty-nine illustrations of the Baptism. In only five of these (350, 356, 358, 360–61) is John's foot raised on a rock (which never has the appearance of a globe). The presence of a rock is by no means a constant feature in the Western iconographic tradition of the Baptism.

[85] Henderson (1985), 9.

[86] Henderson (1985), 9–10. We read in John 3:27–31: "respondit Iohannes et dixit . . . illum oportet crescere me autem minui, qui desursum venit supra omnes est, qui est de terra de terra est et de terra loquitur."

[87] John 1:35: "altera die iterum stabat Iohannes et ex discipulis eius duo et respiciens Iesum ambulantem."

numerous surviving examples, including some cross-heads.[88] We must remember that chapter five of Revelation, which opens with the vision of the lamb receiving the book, culminates in the vision of the adoration of the Lamb before whom all fall prostrate:

> et cum [agnus] apperuisset librum quattuor animalia et viginti quattuor seniores ceciderunt coram agno . . . et vidi et audivi vocem angelorum multorum in circuitu throni et animalium . . . dicentium voce magna "dignus est agnus qui occisus est accipere virtutem et divinitatem et sapientiam et fortitudinem et honorem et gloriam et benedictionem" . . . omnes audivi dicentes sedenti in throno et agno "benedictio et honor et gloria et potestas in saecula saeculorum" et quattuor animalia dicebant "amen" et seniores ceciderunt et adoraverunt (Apocalypse 5:8–14).

Surely this text, combined with the Ruthwell imagery, provides a key to the general content of the inscription which once surrounded the Apocalypse panel, and only one word of which now survives, namely "[a]doramus." The two visions that compose chapter five of Revelation, or, to put it better, the two moments of the one vision as it unfolds, namely the taking of the book and adoration of the lamb, explain why the illustrated Apocalypses need two illustrations for this chapter. They are normally shown in sequence, but occasionally may occupy a single page, as, for example, in Paris, Bib. Nat., fr. 403, fol. 7 (Pl. 64). This image belongs to a later iconographic series but can serve as a useful reminder that tradition recognized the two-fold vision of Revelation 5. No objection should arise, therefore, to a similar sequence at Ruthwell, with the adoration of the Lamb placed at the top of the cross, above the panel showing the seated figure holding both Book and Lamb.[89]

As we know, this was the panel that so horrified the iconoclasts, causing them to bury it deep in the ground. Their outrage was yet another manifestation of the ancient tension between theological purists and those seeking to give visual reality to the ineffable through imagery and symbolism. Both in the Gospel (John 1:18) and the first Letter of John (I John 4:12) we read: "No man has ever seen God" (*Deus nemo vidit umquam*). Christian theology consistently taught that since God was pure spirit and invisible, he could never be represented visually as he is, in his essence. Christian theology also taught that in Jesus God had become man; there was never any artistic problem about representing the God-man, Jesus. And Scripture also recorded visions of God, granted to prophets and apostles, which they

[88] See, for example, two of the pre-Conquest cross-heads found in the foundations of the Chapter House of Durham: E. Coatsworth, "The Four Cross-Heads from the Chapter House, Durham," in *Anglo-Saxon and Viking Sculpture and its Context*, ed. J. Lang, Oxford (1978), 85–92; also the Hart cross-head in Cramp (1978), pl. XIII.

[89] Henderson (1985), 10 and n. 27 argues that in such a juxtaposition "the figure of the Almighty would be relegated to a position below that of the other majestas," the one figure, in fact, rendering the other "redundant." Anyone who reads through chapter 5 of Revelation may reach a different conclusion: a series of visions are presented in sequence, first the opening of the Book, in which the Lamb plays a key part, and then the adoration of the Lamb. Apocalypse visions, not dogmatic statements about the Godhead, are the basis of the imagery. An ivory panel at Tournai, Belgium, from about 900 A.D., deserves to be juxtaposed with this side of the Ruthwell cross. It shows at the bottom a Crucifixion, at the top a seated *Majestas*, and the Lamb in a central roundel: see Schiller (as in n. 39) Bd. 2, fig. 367.

described in terms that readily lent themselves to pictorial rendering. These visions, as Grabar has explained, lie at the root of a whole new development in Christian art.[90]

Theologians constantly feared that others, less sophisticated than they, might mistake the image for the reality. Cassiodorus, in his notes on the Apocalypse, begins with a warning:

> Remember that these [Apocalypse] and similar visions, which the Lord has granted to his servants, were shaped to meet certain needs of the time (*ad tempus pro qualitate rerum formatas*), yet all the while the exalted divine nature itself remained hidden. Moreover the divine nature, in its essence, has never been seen by any living man; we are promised that after the general resurrection those who are pure of heart will behold it.[91]

Bede, commenting on John 1:18, issued a similar warning:

> We need rightly to understand that in all such visions holy men contemplated God not in his very nature (*non per ipsam naturae suae speciem*) but only through certain images. So the saints saw God through some lower creature, for example fire, an angel, a cloud, electrum [a mixture of gold and silver]; nevertheless John could truly say that "no one has ever seen God." Truly God said to Moses: "man shall not see me and live." For while they are still held in the fragile shell of flesh, they can see—through the images of limited things—Him whom they are unable to see in the limitless light of his eternal being.[92]

In this passage Bede does not allude directly to the Apocalypse visions, nor does he explain how they are to be understood. His commentary on Revelation shows, however, that the accepted position in his day was to give all the visions of Revelation an allegorical or symbolic interpretation. We need, therefore, to be aware of the interpretations favored at the time, and to take note, in particular, of the shift in Apocalypse interpretation that had occurred towards the end of the fourth century. This shift is apparent in a statement Caesarius of Arles makes at the beginning of his commentary on Revelation:

> Some of the ancient Fathers considered that most, if not all, of the contents of Revelation belonged to the time of the last judgment or the coming of Anti-Christ. But others who have studied this Book more diligently see the contents as referring to what takes place between the passion of our Lord and Redeemer and that day of judgment, so that only a very small part has a direct bearing on the time of Anti-Christ. So when you read the text and encounter mention of the Son of Man, or the stars, or the angels, or the candlesticks, or the four animals, or the eagle flying through the heavens, or whatever else, understand all these as referring to Christ and being accomplished in the Church, or as being foretold to symbolize it (*in Christo intelligite et in ecclesia fieri, vel in typo eius praedicta esse recognoscite*).[93]

[90] Grabar (as in n. 78), 116: "since the theophany was accorded to these prophetic visionaries, their descriptions of it authorized its pictorial representation. It is thus that the images of visions of God by the prophets—and then by the author of the Apocalypse—were introduced into the repertory of Christian iconography. In contradiction also to the numerous affirmations of the theologians, who continued to deny the possibility of representing God in heaven pictorially, these images made their appearance soon after the year 400, and were never abandoned afterwards."

[91] Cassiodorus, *Complexiones in Apocalypsin* 3 (*PL* LXX, 1406B).

[92] Bede, *Homilia* I.2 (*CCSL* CXXII, 11).

[93] *Sancti Caesarii Opera Omnia*, ed. G. Morin, vol. 2, *Expositio in Apocalypsim*, IV, Maredsous (1942), 210.

As Yves Christe has pointed out in an important series of articles, it is essential to recognize this change in emphasis, and the variety of interpretations in circulation in a given period, when one seeks to interpret Apocalypse imagery.[94] The writer mainly responsible for the shift in emphasis, away from the "last days" and towards the on-going life of the Church, was Tyconius, the African Donatist whose commentary on Revelation, although now lost, exerted an enormous influence on later writers, including his fellow North African, Primasius, bishop of Hadrumetum in the sixth century.[95] Bede's commentary on Revelation was his first Biblical commentary, dating from about 703–709 A.D., and was written at a time when he was still heavily dependent on the works of others. Although in this commentary Bede mentions the name of Tyconius twelve times, and that of Primasius only once, a close comparison of his text with that of his sources shows beyond doubt that Primasius' work was the one he most constantly consulted and borrowed from. At times Bede's brief comments can only be fully understood if we turn to the parallel passage in the commentary of Primasius from which he is borrowing textually.[96] In other words, both Bede and Primasius, together with some others writers like Caesarius of Arles,[97] will be important witnesses in the attempt to recover the meanings invested in the Apocalypse imagery of the period.

We have already identified the Scriptural source for the Apocalypse images at Ruthwell in the fifth chapter of the Book of Revelation; it remains now to determine how this passage was interpreted at the time. The Biblical author describes the visions he saw as follows:

> And I saw (*et vidi*) in the right hand of him who was seated on the throne a book written within and without and sealed with seven seals, and I saw (*et vidi*) a strong angel proclaiming with a loud voice, "who is worthy to open the book and break its seals?" . . . and I saw (*et vidi*), in the middle of the throne (*in medio throni*) and of the four animals and the elders, a Lamb standing, as though slain, with seven horns and seven eyes, which are the seven spirits of God sent out to all the earth, and he came and took the book from the right hand of him who was seated on the throne. And when he had opened the book the four living creatures and twenty-four elders fell down before the Lamb, each holding a harp and a golden bowl full of incense, which are the prayers of the saints, and they sang a new song saying . . . "worthy art thou to take the book and to open its seals, for thou wast slain and hast redeemed us for God with thy blood out of every tribe and tongue and people and nation, and hast made them for our God a kingdom and priests, and they shall reign over the earth" (Apocalypse 5:1–10).

[94] See especially Y. Christe, "Traditions littéraires et iconographiques dans l'interprétation des images apocalyptiques," *L'Apocalypse de Jean. Traditions exégétiques et iconographiques, III^e–XIII^e siècles*, Geneva (1979), 109–134.

[95] For a lucid account of the works of Tyconius and Primasius and their relation to Bede, see G. Bonner, *Saint Bede in the Tradition of Western Apocalyptic Commentary*, Jarrow Lecture, Jarrow (1966).

[96] Bonner (as in n. 95) points out the insular links of the Primasius manuscript tradition. He knew how frequently Bede quoted Primasius verbatim, and looked forward to the edition of Primasius then (in 1966) in preparation by A. W. Adams for the *Corpus Christianorum*. This edition has since appeared (*CCSL* XCII, published in 1985). Unfortunately the editor has failed to catch all Bede's verbatim borrowings from Primasius. Perhaps the edition of Bede's Apocalypse commentary for *CCSL*, still in preparation, will remedy this deficiency.

[97] It is less certain that Caesarius was circulating in England at an early date, although British Library, Egerton MS. 874, of the ninth century is from St. Augustine's, Canterbury, and Oxford, Bodleian, Hatton MS. 30, of the tenth century, is from Glastonbury (Morin's A and H).

The Ruthwell Lamb remains within the earlier tradition of Apocalypse imagery, depicted as a simple lamb,[98] without the addition of the "seven horns and seven eyes" that give the animal such a strange appearance in later Apocalypse imagery.[99] By placing both heads in the center of the panel the designer has managed to combine the vision of the one seated on the throne, holding the book, with the vision of the lamb, who is also *in medio throni*, as it takes possession of the book. If we now turn to the commentaries on the Apocalypse being read at the time, we see immediately that all the elements composing the vision are viewed as charged with multiple spiritual meanings.

The Book held in the right hand, "written within and without" and "sealed with seven seals" stands for Sacred Scripture, comprising the Old and the New Testament.[100] The Old Testament, written "without," speaks of what is to come, but only in terms that are veiled or concealed, while the New Testament, written "within," unfolds and proclaims the mysteries of the Lord's Incarnation, only adumbrated in the Old Testament.[101] Both Testaments are at one (*unitas concors*) in their message: "do penance for your sins, seek the Kingdom of Heaven, flee the torments of hell."[102]

The Book is sealed with seven seals, meaning that the fullness of the divine mysteries remains hidden, awaiting the passion and resurrection of Christ. The seals of testaments are only broken at death, and then their contents are revealed. In like manner after Christ's death all the divine mysteries are revealed. The Lamb both "opens" the Book and "breaks the seals." He opens the Book when, in accomplishing his Father's will, he is conceived and born as man; he breaks the seals when he dies on the cross for the sake of the human race.[103]

The Lamb is presented "as it were slain." Each time the church proclaims the death of Christ, the Lamb is again seen to be slain for the sins of the world. Thus the ignorant are taught a new lesson, and the memory of this deed becomes etched ever more deeply in the soul of loving believers.[104] The Lamb is also an image of the Church, which in Christ has received all power;[105] the Lamb "as it were slain" signifies the Church together with Christ its head, since the Church dies for Christ, so that it may live with him. The Lamb can likewise betoken the Church's martyrs.[106]

[98] As in the representations of the Lamb in the mosaics (Rome and Ravenna) and on the sarcophagi, see Schiller (as in n. 39), Bd. 3, figs. 537, 538, 581, 583, 591, etc.

[99] The earliest example seems to be the illustration in the Trier Apocalypse, fol. 18v, accompanying Apocalypse 5, showing a lamb with "seven horns and seven eyes," but the lamb on fol. 23r lacks these features.

[100] A different punctuation in the Latin can result in a different interpretation, as is shown in the older Apocalypse commentary of Victorinus of Pettau, revised by Jerome. Here we read: "librum scriptum (de)intus, et foris signatum sigillis septem." The writing "within" becomes the Old Testament.

[101] Primasius, *CCSL* XCII, 61; Bede, *PL* XCIII, 145A; Caesarius (as in n. 93), 221.

[102] Bede: "Cuncta enim series Veteris et Novi Testamenti, poenitentiam pro peccatis agendam, regnum coeleste quaerendum, et fletus infernales praemonet esse fugiendos" *PL* XCIII, 145B.

[103] Caesarius (as in n. 93), 221–222.

[104] Primasius: "Quotiens enim occisus Christus in medio ecclesiae praedicatur, totiens idem agnus pro mundi crimine quasi immolari uidetur, quia et rudibus ignota panduntur, et fidelium memoria deuoto cultore sculpitur" (*CCSL* XCII, 85). This reads like an allusion to the Mass celebrated in the church.

[105] Bede: "Tychonius agnum ecclesiam dicit, quae in Christo accepit omnem potestatem" (*PL* XCIII, 145D).

[106] Caesarius (as in n. 93), 222: "agnus quasi occisus, ecclesia est cum capite suo, quae pro Christo moritur, ut cum Christo vivat. Possunt et martyres in ecclesia agnus quasi occisus accipi."

The throne is the Church.[107] The one seated on the throne is the Godhead—Father, Son and Holy Spirit—who dwells in the church.[108] The image of the Lamb receiving the Book from the right hand of the one seated on the throne must not be understood in a carnal or material way, as if the Father had some other right hand than the Son. The Son is the right hand of the Father. Receiving the Book means, therefore, accepting the design for salvation which they who inhabit the throne—Father, Son and Holy Spirit, together—have decreed.[109] The Lamb, signifying the Church, receives the Book from the Son, God's right hand, as the mission it is destined to accomplish, for he said "as the Father sent me so I also send you" (John 20:21).[110] And the Church can say, with Paul (Colossians 1:24), that it accomplishes in its flesh what is still lacking in the sufferings of Christ.[111] The right hand also stands for the joy of victory, because the Church is made victorious through him who is the right hand of the Father, and who said "Rejoice, for I have conquered the world" (John 16:33).[112]

The four animals and twenty-four elders who surround the throne and sing a new hymn represent the Church, gathered from all nations, that celebrates the mysteries (*sacramenta*) of the New Testament, fulfilled in Christ.[113] Their hymn is "new," since it is surely a new thing that God's Son should become man, should die, rise, ascend into heaven, and grant all men forgiveness for their sins. When the song of praise is completed, the four animals cry "Amen," and the twenty-four elders fall down in adoration—also a vision of the Church adoring its Lord after singing his praises.

From the foregoing we can see that in its own time Ruthwell's Apocalypse panel was richly endowed with meanings, one overlaid upon another, one merging into another, one complementing another, without any sense of contradiction. Where the modern mind sees conflicting ideas and interpretations, the commentators and their readers saw a transcendent reality requiring a multi-faceted exposition. Henry Duncan's view was thus inevitably incomplete and inadequate when, on seeing this panel emerge from the ground, he pronounced it to be "the image of the Supreme Being, with the Agnus Dei in his bosom." His reaction was, however, entirely natural; if the Lamb represented Christ, then surely the figure supporting the Lamb must be interpreted as another person, presumably the Father. Even a reading of Apocalypse 5:1 can leave this impression, as we see from the short notes on the Apocalypse by Cassiodorus: "inter haec vidit librum in dextera Patris sedentis in throno."[114] A more complex conception is depicted in the illustrated Apocalypse of St. Sever (Paris, Bib. Nat., lat. 8878, fols. 121v–122), where a seated figure holds in the right hand a lamb enclosed

[107] Primasius: "in throno, id est in Ecclesia" (*CCSL* XCII, 127), repeated by Bede (*PL* XCIII, 152D). In addition to there being no space to depict a throne on the Ruthwell panel, one wonders whether the presence of the monument in the church might also account for the missing throne?

[108] Primasius, *CCSL* XCII, 127 (on Apocalypse 7:10); Bede, *PL* XCIII, 152D–153A; Caesarius (as in n. 93), 222.

[109] Primasius, *CCSL* XCII, 86; Bede, *PL* XCIII, 145D–146A.

[110] Caesarius (as in n. 93), 122.

[111] Primasius, *CCSL* XCII, 87.

[112] Primasius, *CCSL* XCII, 86.

[113] Bede, *PL* XCIII, 146A–B.

[114] *PL* LXX, 1408D.

in a roundel, and in the left a staff terminating in a roundel enclosing a dove.[115] If Lamb and Dove are shown together we can recognize an effort to depict the Trinity. But in the tradition of illustrated Apocalypses, as for example in the image on fol. 88 of the *Liber Floridus* (Pl. 57), the seated figure with the lamb is almost certainly meant to be taken as Christ.

A theological Trinity as Godhead strains our normal human perceptions and reactions, especially in a visual presentation. Primasius, as we saw above, was at pains to stress that "the right hand of the one seated," and holding the book, was none other than Christ, Son of God and right hand of the Father. The commentators remained always mindful of Christ's saying in John's Gospel: "He who sees me, sees the Father." God, as God, remained invisible. For this reason the ability to give the image another dimension, like saying that the Lamb represented the Church—together with its head—who received its mission from Christ, as from God's right hand, in some sense diffused the danger; nevertheless, whether used in verbal discourse or in the wordless language of art, a vocabulary based in the human sphere will present pitfalls when used in reference to the divine. There is an interesting passage in Bede where, after quoting John's words (John 1:18) "No one has ever seen God; the only-begotten Son who is in the bosom of the Father, he has made him known," Bede remarks:

> In saying "in the bosom of the Father" he means "in the hidden depth of the Father" (*in secreto*). We are not to think of the Father's bosom in a childish way, after the manner of our own bosom, which is hidden by our clothes, nor are we to think of God, who is not structured with bodily members as we are, being seated as we are. But because our bosom is hidden within, Scripture—speaking after our manner—speaks of the Son as dwelling in the bosom of the Father, where the human gaze is unable to reach.

The bosom remains hidden whether one is seated or standing, and John's text had made no allusion to being seated. Had an image similar to that of the Ruthwell cross, perhaps present among the Apocalypse images on the north wall of St. Peter's church at Wearmouth, caused Bede to ponder this phrase?

Other panels at Wearmouth depicted the Virgin Mary and the twelve apostles, and scenes from the gospel story (*imagines euangelicae historiae*). We get a sense of the impact these images had on the local community from Bede's comment:

> So that all who entered the church, even the unlettered, no matter in what direction they turned, would be able to contemplate the loveable likeness of Christ and his saints, even though only through an image: or would more intently recall to mind the grace of the Lord's Incarnation; or, having as it were before their eyes the winnowing that would occur at the Last Judgment, would remember to keep a closer watch on their actions.

We may guess that some of the Apocalypse images, like the beast with ten horns and seven heads rising out of the sea (Apocalypse 13), or the disasters poured on the earth by the seven angels (Apocalypse 16) etc. would have generated fear in the beholders and guided their thoughts to the great judgment at the end of time. But the lessons to be drawn from the

[115] See the illustration in Meyvaert (1982), pl. X.

panels on this side of the Ruthwell cross would help to "recall to mind the grace of the Lord's Incarnation."

Primasius ends his comments on the adoration of the twenty-four elders with the words: "After this description of the Church and its duty of giving praise (*descripta ecclesia cum officiis debitae laudis*) we pass on . . . to the opening of the individual seals of the Book."[116] *Descripta ecclesia*: do these words not also sum up this side of the Ruthwell cross? Its message is simple and clear: God became incarnate, through Mary, to redeem man by his death on the Cross. Man shares in that redemption through baptism which makes him a member of Christ's body, the Church. As a member of this Church he struggles here below to lead a good Christian life so that he may, one day, enjoy the bliss of Heaven. His duty is to repent his sins, profess his faith in Christ, praise God and adore him.

Vita Monastica

If I am right in thinking that the Ruthwell cross, like the Great Cross in the St. Gall plan,[117] stood at a point in the nave indicating the demarcation between the portion of the church accessible to the lay congregation and that reserved for the monks, it would follow that side B would have remained continuously visible only to a more restricted audience (see Fig. 3). There seems, in fact, to be a contrast between the set of panels forming side A, which can be readily linked with the great central themes of Christian life, and those of side B, whose implications are less easily discernible; they evoke a more complex set of resonances, more specifically linked with the values of monastic life.

Christ upon the Beasts

The panel with the image of Christ standing upon two beasts (Pl. 23) is the largest and most impressive one on this side of the cross, and will provide a good introduction to the kind of thought determining the design. It is recognized that even if this image evolved iconographically from that of Christ treading upon the "asp and the basilisk" (Psalm 90:13, *super aspidem et basiliscum ambulabis*), the import of the Ruthwell panel is totally different. The two beasts—not easily identifiable zoologically (lions? dragons?)—are not being conquered or subdued but are here depicted in a position that can be interpreted as reverent, suppliant or adoring. This is confirmed, moreover, by the inscription that surrounds the panel: *Bestiae et dracones cognoverunt in deserto salvatorem mundi.*

What does this scene represent? If we consult a Latin Biblical concordance we discover that two words from the inscription occur close together in Mark 1:13: "et erat *in deserto* quadraginta diebus et quadraginta noctibus et temptabatur a Satana. *Eratque cum bestiis* et

[116] Primasius, *CCSL* XCII, 91.
[117] See n. 230 below.

angeli ministrabant ei." The other two synoptic Gospels, Matthew (4:1–11) and Luke (4:1–13), mention Christ's sojourn of forty days in the desert but make no allusion to beasts.

If we now return to our concordance we find that three of the words of the inscription occur together in a passage of the prophet Isaiah (43:20): "glorificabit me *bestia* agri *dracones* et strutiones quia dedi *in deserto* aquas flumina in invio ut darem potum populo electo meo." But it should be noted that this verse of Isaiah merely says that the wild beasts honor God for putting water in the desert and wastelands; it says nothing that could be construed as "Christ dwelling in the desert among the beasts."

A straightforward reading of Mark does not necessarily convey the idea that the beasts, like the angels, were docile and eager to minister to Christ. Indeed Bede, encountering this verse in his commentary on Mark, gives the beasts a quite negative interpretation:

> *Eratque cum bestiis, et angeli ministrabant illi.* As a man he dwelt among the beasts, but as God he used the help of angels. And so we, who dwell in the desert of monastic life (*in heremo sanctae conversationis*), if we endure the bestial conduct of men with unblemished minds, will deserve the help of the angels, who will transport us to the eternal joys of heaven when we are released from our bodies.[118]

This interpretation agrees with that of Jerome:

> Jesus was with the beasts and therefore (*ideo*) the angels ministered to him. For he said: "do not hand over to the beasts a soul that trusts in thee." These are the beasts on which the Lord trod with the foot of the Gospel (*evangelico pede*), for "he trod on the lion and the dragon" (Psalm 90:13).[119]

A very different interpretation of this verse is found, however, in the commentary on Mark composed by Cummian, abbot of Clonfert,[120] early in the seventh century:

> *Statim spiritus expullit eum in desertum . . . eratque cum bestiis et angeli ministrabant ei.* On the moral level (*moraliter*) we must follow the example of Christ Then the spirit casts us out into the desert to be tempted by Satan, so that "patience may beget endurance, endurance produce hope and hope give birth to love/charity" (Romans 5:4) since "our

[118] *CCSL* CXX, 445, ll. 315–320.

[119] *CCSL* LXXVIII, 460, ll. 9–19.

[120] The grounds for maintaining Cummian's authorship of the commentary have been strengthened by M. Walsh and D. Ó Cróinín in Appendix 1 to their edition of Cummian's Letter *De controversia Paschali*, Toronto (1988), 217–221. Further points could be added, moreover, to the ones they make. C. Stancliffe, "Early 'Irish' Biblical Exegesis," *Studia Patristica* XII, 365–366, argued against Bischoff's suggestion of Cummian's authorship, put forward in his famous "Wendepunkte in der Geschichte der lateinische Exegese im Frühmittelalter" in *Sacris Erudiri* (1954), 189–281 on the basis of Morin's "fundamental" article "Un commentaire romain sur S. Marc de la première moitié du V^e siècle," *Revue Bénédictine* XXVII (1910), 352–362. Morin had there maintained that this commentary on Mark was composed by a fifth-century Balkan refugee writing in Rome. There are numerous reasons militating against such a view; it is important also to remember that Morin was a pioneer worker, often given to hasty judgments he was later obliged to retract. On this see G. Ghysens and P.-P. Verbraken, *La carrière scientifique de Dom Germain Morin*, Steenbrugge (1986), 76–88: also P.-P. Verbraken, "Vingt-cinq notices liturgiques tirées des Rétractations inédites de Dom Germain Morin," in *Traditio et Progressio. Studi liturgici in onore del Prof. Adrien Nocent, OSB*, Rome (1988), 597–619. Morin should be cited as a "fundamental" authority only when it can be demonstrated that his conclusions have withstood the test of time.

wrestling is not against flesh and blood but against Principalities and Powers" (Ephesians 6:12). And then the beasts will be at peace with us, namely when in the inner chamber of our soul (*arca animae*) we, being cleansed, will grow gentle (*mansuescimus*) with the unclean animals, and like Daniel we will lie down with the lions, when the spirit will not be pitted against flesh and blood (Ephesians 6:12) and the flesh will not lust against the spirit (Galatians 5:17).[121]

The monastic and spiritual slant given to Mark's text shows that Cummian, unlike Bede, views the sojourn of Christ with the beasts in the desert as a very pacific one. The rather unusual word used by Cummian, *mansuescimus*, is important, for it almost certainly provides the key to his source, namely Pseudo-Matthew, or, to give it the title it bears in the early manuscripts, *De nativitate sanctae Mariae*,[122] a text which, in the version we know, was produced in a monastery[123] and, moreover, was known in Ireland from an early date.[124] The chapters (xviii–xix) where the word occurs—and behind which one senses the influence of texts like Isaiah 43:20—are the ones that describe the journey of Mary and Joseph through the desert on their way to Egypt:

> (xviii.2): Ammonitus est Ioseph his verbis ab angelo domini: "Tolle Mariam et infantem et per viam heremi perge ad Aegyptum" . . . ecce subito egressi sunt de spelunca *dracones multi* . . . Illi autem *dracones adoraverunt eum*

> (3): Sed Maria et Ioseph dicebant inter se: Melius est ut nos interficiant isti dracones quam infantem laedant. Quibus Iesus ait: *Nolite me considerare quia infantulus sum: ego enim semper vir perfectus fui et sum et necesse est ut omnia genera ferarum mansuescere faciam*

> (xix. 1): Similiter autem et leones et pardi adorabant et comitabantur eum in deserto quocumque ibat Maria cum Ioseph, atque antecedebant eos ostendentes viam *et obsequium exhibentes*

> (2): Prima autem die ut vidit Maria leones circa se venientes et pardos et varia ferarum monstra, vehementer expavit. In cuius faciem infans Iesus subrisit et consolationis eam voce aloquens dixit: Noli timere mater, non enim ad iniuriam tuam sed *ad obsequium* venire festinant, et his dictis amputavit timorem cordis eius.

[121] *PL* XXX, 594–595. This mention of Daniel may explain the presence of the prophet being licked by a pair of friendly lions, on a number of Irish stone crosses.

[122] On this work see J. Gijsel, *Die unmittelbare Textüberlieferung des sog. Pseudo-Matthäus*, Brussels (1981). Gijsel establishes the earliest recension (Textform A) as that which survives in Reims MS. 1395, fols. 3–17v, and he provides an insert giving the text of this manuscript. All quotations here are from this insert. For comments on the text of C. Tischendorf, *Evangelia Apocrypha*, Leipzig (1853), 53–84, see Gijsel, 8–9.

[123] Gijsel (as in n. 122), 13: "Von hervorrangender Bedeutung sind die Klosterideale, die den Hintergrund bilden, auf dem in Kapitel IV die Tugenden Marias Beschrieben werden. Es ist Amanns Verdienst, darauf aufmerksam gemacht zu haben. Diese Umbiegung auf das Klosterleben, zusamen mit den genannten Reminiszenzen an das Buch Tobias, ist kennzeichnend für die Einstellung des Verfassers, der sicherlich ein Mönch gewesen ist. In diesem Rahmen bekommt auch das zweifache Jungfräulichkeitsgelübde (VI 2 und XII 8), ein Element das im Protevangelium fehlt, eine klare Bedeutung." The reference is to E. Amann, *Le Protévangile de Jacques et ses remaniements latins*, Paris (1910), 106. Establishing a dependence of Cummian on Pseudo-Matthew would provide a terminus ante quem for the origins of this work, whose date is not yet firmly established: "ein noch unbekannter Verfasser, vermutlich zwischen 550 und 700" (Gijsel, 12).

[124] See M. McNamara, *The Apocrypha in the Irish Church*, Dublin (1975), 37–40 and 48, no. 41.

(3): Ambulabant ergo simul leones et asini et boves et sagmarii . . . *erant etiam mansueti arietes . . . qui et ipsi inter lupos ambulabant sine formidine.*

(4): Non timebat ullus ullum et nullus a nullo laedebatur in aliquo. Tunc adimpletum est quod Esaias ait: Lupi cum agnis pascentur et leo et bos simul paleis vescentur

A monastic community that accepted Pseudo-Matthew as authentic would have had no trouble composing the Ruthwell inscription: *Bestiae et dracones cognoverunt in deserto salvatorem mundi,* both on the basis of its content and on that of Mark: *et erat cum bestiis,* as interpreted in the Irish tradition of Cummian. We are even entitled to ask whether the panel depicting the Flight into Egypt (or possibly the Flight out of Egypt) (Pl. 25) was not deliberately included to establish a link with that of Christ upon the beasts, on the basis of Pseudo-Matthew. The imposing stature given to the figure of Christ in the central panel seems to reflect the saying from Pseudo-Matthew, xviii.3, italicized above: "Do not consider me a child, I was and am the perfect man and it is necessary that I make gentle (*mansuescere faciam*) all kinds of wild animals."[125]

An important piece of evidence that may have a direct bearing on the conjunction on the Ruthwell cross of the two panels—Christ upon the beasts and the Flight into Egypt—and may even perhaps provide an historical context for the origins of the monument, is found in codex Palatinus latinus 68 of the Vatican Library.[126] This manuscript, an incomplete copy of the Psalter (Psalms 39–151), with a Latin commentary and some Irish and Northumbrian glosses, is considered to belong to the early eighth century and to derive from a monastery that was part of the paruchia of St. Columba in Northumbria.[127] No one disputes that its Old English glosses and its script link it firmly with Northumbria, while the Irish glosses and the content of its Latin commentary link it equally firmly with a Celtic milieu. The Latin gloss on Psalm 148:7 (*Laudate dominum de terra, dracones et omnes abyssi*) reads as follows:

"Laudate Dominum de terra." id est hucusque de caelo canit et de mirabilibus eius; Nunc de terra incipit et de mirabilibus eius, per quae meruit laudari. "dracones et omnes [abyssi]." id est hoc genus terrenum dicit quod in aquis terrae nascitur quod inpletur cum fugit Ioseph in Aegiptum cum filio et Maria; dormientes in spelonca *venerunt dracones et laudaverunt pedes eorum.*[128]

Here at least is evidence of interest, contemporary with the making of the cross, in the sojourn in the desert described in Pseudo-Matthew, evidence linking this sojourn with the reverence shown by the animals at the feet of Jesus. What is most remarkable is that the expression

[125] Henderson (1985), 6, fails to note this important phrase when he writes: "The literary connection between this apocryphal Flight and the central scene of Christ with the beasts [suggested by Saxl] is convincing enough, *but the standing Christ is no child* and the central scene of Christ should have its own meaning, not merely by attraction to the subsidiary scene of the Flight" (emphasis mine).

[126] Recently edited by M. McNamara, *Glossa in Psalmos. The Hiberno-Latin Gloss on the Psalms of Codex Palatinus Latinus 68 (Psalms 39:11–151:7)*, Studi e Testi 310, Vatican City (1986).

[127] Ibid., 75–76.

[128] Ibid., 307–308 (correct the faulty "ner" to "per [quae]" at the beginning of line 2 on 308). I am grateful to the Vatican Film Library at Saint Louis University for providing me with a photocopy of the relevant folia of this manuscript.

laudaverunt pedes eorum is the author's interpretation of the behavior of the beasts as described in the narrative of Pseudo-Matthew, although the feet (*pedes*) are not specifically mentioned in this text. That the comment in the Psalter evokes the Ruthwell image hardly needs emphasis.[129]

The Return from Egypt

George Henderson has argued that the panel depicting Mary seated on the ass (Pl. 25) represents, not the Flight into Egypt, but rather the Return from Egypt. He states "in scenes of action and confrontation on the Ruthwell cross, the Annunciation by Gabriel to the Virgin, Christ healing the blind man, and Mary Magdalen prostrating herself before Christ, the normal western narrative impulse is maintained—as in reading a text, so in the reading of an image, the narrative, the action, moves from left to right."[130] It would not be a difficult matter to show, however, that artistic conventions that appear settled and established in the later Middle Ages had not yet solidified in the earlier period. Thus with respect to the Annunciation scene on the Ruthwell cross (Pl. 18), while it is true that the angel appears to the Virgin's left, one can point to fifteen examples of Annunciation scenes in Schiller's compilation, some of them quite early, where the angel is shown approaching Mary from the right.[131] It would need a far more extensive study of all the material available to determine when particular artistic conventions became permanent, and thus capable of being used securely to prove a point, like the one Henderson is trying to make.

There are other grounds, however, that would seem to support the Return through the desert from Egypt, helping furthermore to bring this panel into a monastic perspective. A series of early calendars bear witness to the celebration of a feast entitled *Eductio Christi de Egypto* both in Ireland and in Northumbria.[132] A marginal note to the metrical martyrology

[129] The particular part that friendly animals play in the Irish hagiographical tradition deserves to be noted here: see Sister Mary Donatus, *Beasts and Birds in the Lives of the Early Irish Saints*, Philadelphia (1934); H.-J. Falsett, *Irische Heilige und Tiere in mittelalterlichen lateinischen Legenden*, Bonn (1960). I owe these references to the kindness of Professor Jan Ziolkowski of Harvard University.

[130] Henderson (1985), 7.

[131] Schiller (as in n. 39) Bd. I, figs. 66–69, 71, 73, 78–79, 81, 85, 89–90, 101, 117, 122. The same experiment can be repeated with other themes—using Schiller's material—for example, the Magi approaching Mother and Child from the right or the left; John the Baptist baptizing Christ from the right or the left. Few early depictions of the travels of the Holy Family to and from Egypt seem available, although we know from a comment of Theodulf of Orléans in his *Libri Carolini* (Book IV, chapter 21) that these were popular artistic subjects in his time: "Pingitur etiam eadem beata virgo, qualiter aselli gestamine vecta puerum in ulnis ferens Ioseph previo in Aegyptum descenderit qualiterve ex Aegypto ad terram Israhel redierit—in pluribus namque materiis haec historia inditur et non semper in basilicis, sed interdum in vasis escariis sive potatoriis, interdum in sericis indumentis, plerumque tamen in stragulis" (ed. Bastgen, *MGH*, 213). A sequence of scenes, connected with the apocryphal narratives of the Flight into Egypt, would make the return journey more easily distinguishable. The mere orientation of the animal bearing mother and child, without an adequate inscription, in a single panel, does not allow a firm conclusion. In the twelfth-century Moissac relief (Schiller, fig. 320) the Flight into Egypt takes place from left to right. It is also worth recalling that numerous examples of riders, moving indifferently from right to left or from left to right, are found on Pictish stone slabs. This only adds a further note of caution.

[132] Numerous references could be given; see, for example, M. Schneiders, "The Irish Calendar in the Karlsruhe Bede," *Archiv für Liturgiewissenschaft* xxxi (1989), 42. It is interesting that Cambridge, Jesus College, ms. Q.B.6, which gives the

of Oengus asks: "What is the cause that Christ's coming out of Egypt is a festival and His going into it is not? The answer is easy for *Egyptus* means the same as *tenebrae* and fitter is happiness at one's coming out of them than at going into them."[133] In Jerome's *Liber interpretationis hebraicorum nominum*, a work that was constantly consulted at this period, we find *Aegyptus* rendered three times as *tenebrae*.[134] If the Flight into Egypt involved a passage through the desert, so did the Return from Egypt. Patristic writers, commenting on verses from Scripture, were less concerned with the geographical location of places than with the spiritual connotations of the words they encountered. Thus Bede meeting verse 5 of the Epistle of Jude: *Iesus populum de terra Aegypti salvans, secundo eos qui non crediderunt perdidit* (Jesus who saved the people from the land of Egypt, the next time destroyed those who did not believe) makes this comment:

> For as He first saved the humble who, from their affliction in Egypt, cried unto Him, so he likewise humbled the proud who murmured against Him in the desert. And so he teaches us that we should even now remember that as He saves believers through the waters of baptism—of which the Red Sea was an image—so he expects that after baptism we should continue to live a life of humility, cut off from the deformity of vices. And this aptly designates the secret monastic life of the desert (*qualem merito heremi secreta conversatio designabat*). If anyone violates this life either by straying from the true faith or by wicked behavior, his heart having turned aside, he will be led into Egypt and not into the promised land of the kingdom, and he will deserve to perish with the wicked.[135]

The image of the passage through the desert, on the return from Egypt, would therefore have been a pregnant one for a monastic audience. It was at once a reminder of the monastic life they were committed to, of the direction in which they were going, and of the dangers lurking before them if they faltered or turned aside.

As for the inscription around the panel, the only letters that now survive are the initial + MARIA ET IO[seph] at the beginning, and TU on the left side. It has been suggested that these last letters could be part of "AegypTUm" or of "TUlerunt," but they would fit equally well into an inscription like "MARIA ET IOseph/ . . . per deser/TUm tulerunt" that would reflect the vocabulary and themes of Pseudo-Matthew. The names "Maria et Ioseph" come three times in this section of Pseudo-Matthew, and we also read the phrase: "Tolle Mariam et infantem et per viam heremi perge in Aegyptum . . . commitabantur eum in deserto." Seen in the context of Christ with the beasts *in deserto*, and of Paul and Anthony breaking bread *in deserto*, a further mention of the desert in the panel of the Flight into Egypt seems quite possible on the basis of the text of Pseudo-Matthew. In the Gospel of Matthew itself at 2:13–14 there is no allusion to a passage through the desert; all we read is: "fuge in Aegyptum," "recessit in Aegyptum."

Durham tradition, has on fol. 2 for 9 January "Deductio Christi in egiptum" and for 10 January "Deductio Christi de egipto." This may reflect an earlier Northumbrian or Lindisfarne tradition. See F. Wormald, *English Benedictine Kalendars after A.D. 1100*, vol. 1, London (1939), 168.

[133] *The Martyrology of Oengus the Culdee*, Henry Bradshaw Society, vol. 29, London (1905), 43.

[134] See de Lagarde's edition, *Onomastica sacra*, reprinted in *CCSL* LXXII, at 66.28, 73.14 and 77.25.

[135] *CCSL* CXXI, 336.

Paul and Anthony

In a recent essay Kristine Haney has perceptively shown that Jerome's *Vita Pauli* must likewise be brought into the discussion of the panel showing Christ upon the beasts.[136] She quotes the passage from the Life where a desert creature appears to Anthony as he travels in search of Paul and, alluding to the various inhabitants of the desert, says, among other things: *Bestiae Christum loquuntur*.[137] It is worth pointing out, in addition to Haney's remarks, that Jerome's hagiographical novelette—for the *Vita Pauli* is no more than that[138]—introduces a pair of helpful lions, appearing "meek as doves," who dig a grave to help Anthony bury the body of Paul:

> *duo leones* ex interioris eremi parte currentes, volantibus per colla jubis, ferebantur. Quibus aspectis, primo [Antonius] exhorruit; rursusque ad Deum referens mentem, *quasi columbas videret*, mansit intrepidus. Et illi quidem directo cursu ad cadaver beati senis substiterunt; adulantibusque caudis *circa eius pedes accubuere*, fremitu ingenti rugientes, prorsus ut intelligeres eos plangere, quomodo poterant. Deinde haud procul coeperunt humum pedibus scalpere, arenamque certatim egerentes, unius hominis capacem locum foderunt, ac statim quasi mercedem pro opere postulantes, cum motu aurium cervice deiecta, ad Antonium perrexerunt, manus eius *pedesque lingentes*. At ille animadvertit, benedictionem eos a se precari. Nec mora, in laudationem Christi effusus, quod *muta quoque animalia Deum esse sentirent*, ait: Domine, sine cuius nutu nec folium arboris defluit, nec unus passerum ad terram cadit, da illis sicut tu scis. Et manu annuens eis, ut abirent, imperavit.[139]

The subject depicted in the panel itself (Pl. 24) is the breaking of bread by Paul and Anthony after their day-long struggle to see who would win the upper hand in the contest of humility. But the sight of the two beasts reverently placed at the feet of Christ, just above the heads of Paul and Anthony, must have recalled the story of the two helpful lions, who in addition to scooping out a grave, had also placed themselves reverently at the feet of the two desert fathers. The generations of early monks who accepted the historical veracity of all the miracle stories told in the Bible, including the one where God caused Balaam's ass to speak (Numbers 22:28), must have experienced little difficulty in accepting as true Jerome's story about the two lions and—where they did not reject it as an apocryphal work—the stories of Pseudo-

[136] Haney (1985), 215–231.

[137] Ibid., 219.

[138] De Labriolle and de Bruyne felt little hesitation in classifying the *Vita Pauli* as a romance or fairy-tale. E. Coleiro, "St. Jerome's Lives of the Hermits," *Vigiliae Christianae* xi (1957), 161–178, in an interesting analysis that showed how many details linked this Life with the romance literature of Late Antiquity, believed, nevertheless, that Jerome was merely embellishing a kernel of historical truth. This can be doubted, for, apart from Jerome's narrative, Paul the hermit remains a figure unknown to history. Whether Jerome hoped his non-sceptical readers—for there were some in his day who said it was all a tissue of lies—would accept his accounts as history is a different question. The *Vita Pauli* proved, in fact, a great success and came to be universally accepted as true. Like a present day best-seller it was also translated into a number of languages, including Greek, Coptic, Syriac, Ethiopic and Arabic.

[139] *PL* XXIII, 28A–B. See also *Studies in the Text Tradition of Jerome's "Vitae Patrum"*, ed. W. A. Oldfather, Urbana, Ill. (1943) 41, no. 16.

Matthew about the other animals.[140] One can even wonder whether Jerome's narrative did not also contribute to shaping the iconography of the panel showing Christ upon the beasts, as it did in the depiction of the two animals on the Nigg cross-slab (Pl. 66).

"In deserto" is still visibly part of two of the inscriptions. To the age of Bede this word did not primarily evoke the vision of a desert wilderness peopled by solitary hermits, but simply monastic life, as such, whether in its cenobitic or its eremitical form. The stories of Christ's withdrawal into the desert to fast for forty days, or into desert places during the course of his ministry, were interpreted in terms of the standard of Christian conduct a monk was called upon to maintain, not just for forty days, but for his whole life. Commenting on Mark 1:45 (*ille egressus coepit . . . foris in desertis locis esse*), and also playing on the connection between *desertum* and *deserere*, Cummian writes:

> Indeed Jesus does not manifest himself to all . . . but to those who . . . are in desert places, the places namely where the Lord chose to pray and to feed the people. They desert the pleasures of this world, they desert all their earthly possessions so that they can say: "The Lord is my portion" (Psalm 118:57). But the glory of the Lord is made manifest to those who gather together from many places, walking the lowly and difficult road (*per plana et ardua*). Nothing can separate them from the love of Christ.[141]

As we recall, Bede refers, in his commentary on Mark, to "the desert of monastic life" (*nos . . . in heremo sanctae conversationis*).[142] We encounter a similar thought in his commentary on Luke 4:1–2:

> Jesus was not led by an evil spirit into the desert, but he entered the place of contest, certain of his victory, moved through the will of his good Spirit. And there he exemplifies (*praemonstrat*) for us the form of monastic life (*ordinem recte conversandi*),[143] so that after receiving the remission of sins in baptism and the grace of the Holy Spirit, having girded our minds more strongly to meet the new attacks of the enemy, we should leave the world and hunger only for the joys of eternal life as for the manna given in the desert.[144]

[140] There is not a hint in Bede's commentaries on Luke and Mark—or in any of his other works—to suggest acceptance of Pseudo-Matthew's narrative. On the contrary, Bede regards apocryphal works with great suspicion. In a comment on Luke 2:39 he explains how one evangelist sometimes omits to mention an event which he knows another evangelist has told—or intends to tell ("uel ab aliis commemoranda in spiritu praeuiderint")—thus, for instance, Luke omits the flight into Egypt because he knows it is already in Matthew's Gospel. The idea that a non-scriptural or "apocryphal" text—or to put it differently, a text not evidently approved by the *auctoritas magnorum doctorum*—might be used to fill in the gaps of the Gospel narrative seems completely alien to his outlook. The treatment of the pacific animals on the Ruthwell cross, like the comment in Vat. Pal. lat. 68 cited above, suggests a different outlook that accepts Pseudo-Matthew. This point is important in establishing the nature of the monastic community that commissioned the cross, which cannot be assessed solely on the basis of the craftsmanship of the stone-cutting.

[141] *PL* XXX, 597C.

[142] See above, n. 118.

[143] On the specifically monastic connotations of the words *conversatio/conversare*, see A. de Vogüé's comments on the use of the words in the *Rule of St. Benedict*, Sources Chrétiennes, vol. 186, 1324–1326. Here one need only recall the opening words of the final chapter of Benedict's Rule: "Regulam autem hanc descripsimus, ut hanc observantes in monasteriis aliquatenus uel honestatem morum aut *initium conuersationis* nos habere demonstremus habere."

[144] *CCSL* CXX, 93.

In the Irish commentary on Luke, preserved in Codex Vindobonensis latinus 997, we read:

> The New Testament takes its origins from the desert, namely from John and from Jesus. It was a new event to fast and preach in the desert. And the holy monks followed this rule of the desert. Thus it behooves us to flee the crowds of vices and to enter the secrets of perfection.[145]

It is what Bede called the manna of the desert, the food that will nourish the monks, that is shown to us in the panel depicting Paul and Anthony.

Seen merely in the context of Jerome's *Vita Pauli*, a panel depicting Paul and Anthony breaking bread need not necessarily imply a eucharistic dimension.[146] According to Jerome's narrative the two ascetics, after greeting each other, sit down (*residens*) to have a talk. While thus engaged the raven that was accustomed to bring Paul his daily ration of bread arrives on the scene, but this time not carrying the usual half-loaf, but a full one. Both monks rise to thank God for his gift and then seat themselves again, this time "on the edge of the clear-flowing fountain," where they engage in a long debate, which lasts until evening, about who will divide the loaf (*quis frangeret panem oborta contentio*).[147] Neither Paul, the host, nor Anthony, his junior, is willing to deny the other the privilege of breaking the bread. Finally they agree to perform the action jointly. Each will hold fast to one side of the loaf and, pulling together, break it. After eating the portion each is left with, they bend over to drink some water from the fountain. Their meal accomplished, "they spent the night 'offering to God the sacrifice of praise' (Psalm 115:17)." This expression, in itself, implies a night spent in prayer rather than a eucharistic celebration. Jerome's allusion to breaking the bread (*quis frangeret panem*) undoubtedly would recall to the mind of some of his readers the breaking of the eucharistic bread. Even so, it cannot be taken for granted that every representation of Paul and Anthony breaking bread goes beyond Jerome's straightforward narrative. For example, the scene on the twelfth-century capital at Vézelay shows the two saints standing and breaking a large loaf that rests on a cupboard containing two drinking bowls (Pl. 65). A couple of jars, presumably intended for filling the bowls, stand on the floor in front of the cupboard. The image this capital suggests is that of a monastic refectory meal rather than a liturgical celebration.[148]

[145] *CCSL* CVIIIC, 29.

[146] Kingsley Porter (1929), 25–38, unaware of the textual history of the *Vita Pauli*, concluded that the "earlier" Greek text, which omits the incident of the breaking of the bread, was known in Ireland before Jerome's Latin version. He thought this accounted for the iconography of Paul and Anthony on some of the Irish crosses where they do not appear to be breaking bread. F. Henry, *La sculpture irlandaise pendant les douze premier siècles de l'ère chrétienne*, Paris (1932), 133 accepted Kingsley Porter's conclusion. In fact there is no "earlier" Greek text: see K. Tubbs Corey, "The Greek Versions of Jerome's Vita Sancti Pauli," in *Studies in the Text Tradition of St. Jerome's "Vitae Patrum"*, ed. W. A. Oldfather, Urbana, Ill. (1943), 143–250. All the known translations are dependent on Jerome's Latin text, and it is more than doubtful that a Greek version, circulating in Ireland, could explain differences in iconography on the crosses.

[147] Coleiro (as in n. 138), 165, 177–178 has noted the somewhat unseemly nature of this literary embellishment devised by Jerome.

[148] The drawing of the Vézelay capital printed by F. Henry, *Irish Art during the Viking Invasions (800–1020 A.D.)*, London (1967), 202, Fig. 40c is very misleading; vegetation replaces the cupboard and the jars.

A totally different impression is given by the representation on the cross-slab at Nigg (Pl. 66) in Rosshire, Scotland, a monument that is firmly set in Columban territory.[149] The triangular apex of the slab, where the scene occurs, has caused the figures of Paul and Anthony to seem somewhat distorted; they appear to be bent over in reverence. Each holds a book that seems to rest on the back of a lion (no doubt the two lions mentioned in Jerome's tale). The conjunction of the lions, facing each other, recalls the two animals on the Ruthwell panel at the feet of Christ. The raven is depositing the loaf on a circular platter. What immediately catches the eye is the well defined depiction of a missing segment on the left side of the loaf. The eucharistic and symbolic implications, here, are unmistakable, particularly if we consult the Irish tract on the Mass found in the Stowe Missal:

> The Host on the Paten is Christ's Flesh on the tree of the Cross. The fraction on the paten is the breaking of Christ's Body with nails on the Cross. The meeting wherewith the two halves join after the fraction is a figure of the wholeness of Christ's Body after His resurrection. *The particle that is cut off from the bottom of the half which is on the [priest's] left hand* is the figure of the wounding with the lance in the armpit on the right side; for westwards was Christ's face on the Cross, to wit, "contra civitatem," and eastwards was the face of Longinus; what to him was the left, to Christ was the right.[150]

The Nigg slab is unique in its symbolic emphasis, and in its inclusion of the two animals. Paul and Anthony are normally shown seated, placing their hands on the round loaf the raven has brought. In two instances—the Market cross at Kells and Muiredeach's cross at nearby Monasterboice—they are shown standing, holding staves that are crossed, possibly to denote their contention. In addition to the raven who descends with the bread, a chalice (or is it merely a pitcher, as at Vézelay?) is placed on the ground between them.[151] The standing position, together with the chalice, again recall a eucharistic celebration. These last instances are of particular interest, because Kells places us in the tradition of Iona, and also recalls a story told in Adamnan's Life of Columba that reflects the liturgical usages of his monastery:

> At another time, there came to the saint [on Iona] . . . a stranger who humbly kept himself out of sight, as much as he could, so that no one knew that he was a bishop. But yet that fact could not remain hidden from Columba. For on the next Lord's-day, when the stranger was bidden by the saint to prepare, according to custom, the body of Christ, he called the saint to

[149] I am grateful to Douglas Mac Lean for providing me with the photograph, made by his brother, Cameron. On the Nigg cross-slab see I. Henderson, *The Picts*, New York (1967), 147–149 and pl. 61. Both in this work and especially in her "Pictish Art and the Book of Kells," in *Ireland in Early Medieval Europe*, ed. D. Whitelock, R. McKitterick and D. Dumville, Cambridge (1982), 85–89, Henderson has argued for a close relationship between the Nigg slab and the Book of Kells. Elsewhere I have tried to show that there are grounds for viewing Iona as the home of the Book of Kells ("The Book of Kells and Iona," *Art Bulletin* LXXI [1989], 6–19). Establishing close links between Iona and other parts of the Columban *paruchia* may provide grounds for arguing that liturgical practices which originated in Columba's monastery were also adopted elsewhere.

[150] *Thesaurus Palaeohibernicus* 2, ed. W. Stokes and J. Strachan, Cambridge (1903), 253–254, nos. 11–13, 15.

[151] See H. M. Roe, *The High Crosses of Kells* (1959), 43–44; idem, *Monasterboice and its Monuments* (1981), 36. At Kells the scene is found at the end of the arm and at Monasterboice at the gable end of the housecap. Roe states that the object on the ground between the figures is a chalice. Schapiro (1944), 239, n. 64, suggests that the staves are crossed to indicate contention. If this was the intention the eucharistic dimension could be doubted.

assist him, *so that they should, as two presbyters, together break the Lord's bread.* There-upon the saint, going to the altar, suddenly looked upon his face, and thus addressed him: "Christ bless you, brother: break this bread alone, according to the episcopal rite, for we know you are a bishop. Why until now have you tried to conceal yourself, so that the rever-ence due to you was not paid by us?"[152]

Dom Louis Gougaud, in his study of the rites of consecration and fraction in the Celtic mass, stressed the unique nature of the Iona rite, which he termed *confractio*, namely that of two priests *jointly* breaking the eucharistic bread: "c'était là l'usage d'Iona. Rien n'autorise à généraliser cette coutume. Aucun monument liturgique ne la mentionne."[153] Speaking in more general terms, Gougaud was at pains to underline "le particularisme religieux des Celtes," which obtained in liturgical matters as well as in those of private devotion and ascetic practice, not to mention church organization.[154] In other words, local customs abounded, and it becomes hazardous for us to make generalizations. Nevertheless, given the paucity of the documentation that survives for this period, the question of the extent to which Iona practice was followed elsewhere within the domain of the Columban *paruchia* is a legitimate one. The Iona rite of fraction was almost certainly directly inspired by Jerome's text, and the intent of its symbolism seems equally obvious, namely to strengthen monastic concord and humility. This provides the background for viewing the panel depicting Paul and Anthony on the Ruthwell cross. The raven bringing the bread is omitted, and the two saints are shown standing as they break the bread together. Although no chalice is shown, and the poor condi-tion of the monument does not allow us to determine whether a portion of the bread is mis-sing as at Nigg, the absence of the raven together with the upright posture of the two saints (which contradicts Jerome's account) strongly suggest a liturgical context for the action, and underline the central place of the eucharistic sacrifice in a monastic context. But given the restricted usage of the Iona *cofractio* rite, this panel, with its Celtic elements, once again raises—together with that displaying the "pacific animals"—the question of what particular monastic milieu helped to shape the design of the Ruthwell cross.

Christus Iudex Aequitatis

Cummian, as we saw above, spoke of those who in the monastic desert walk the lowly and difficult road (*per plana et ardua*).[155] It is perhaps in this perspective that we should un-derstand the arresting title given Christ as he appears upon the beasts: *Iesus Christus Iudex Aequitatis* (Pl. 23). Unfortunately, since we live in an age that customarily uses "equity" in quite a different sense, the implications of the word *aequitas* in patristic times may not be

[152] *Adomnan's Life of Columba*, ed. A. O. and M. O. Anderson, Edinburgh (1961), 304–305.

[153] L. Gougaud, "Les rites de la consécration et de la fraction dans la liturgie celtique de la messe," in *Report of the Nine-teenth Eucharistic Congress*, London (1909), 353. It must be pointed out that the term *confractio* in the early documents relating to the Roman Mass has a totally different meaning. For the texts see B. Capelle, "Le Rite de la fraction dans la messe romaine," *Revue Bénédictine* LIII (1941), 11–13: here the term means that the bishops and priests, all *individually*, perform their fraction (*confrangant hostias*) at the same time that the *pontifex* performs his.

[154] Gougaud (as in n. 153), 348.

[155] Above at n. 141.

clear to us. The word has a long history, not all of whose ramifications, particularly for the Latin patristic period, have yet been charted. Several studies have dealt with Cicero's use of the term.[156] The antithesis he perceives between *ius* and *aequitas* (translating *epieikeia*) belongs to the tradition of Aristotelian rhetoric rather than to that of strict Roman jurisprudence, but it exercised a strong influence on later writers.[157] *Aequitas* likewise plays a part in the development of Canon Law and this history has also been studied.[158] Our concern here, however, is to try to discover what *aequitas* might have meant for the generation that erected the cross and composed the title, a generation that was more familiar with the Bible and its commentators than with the writings of Cicero.

To begin with, are we to interpret the genitive *aequitatis* in the title *Iesus Christus Iudex Aequitatis* in a subjective or an objective sense? Does it qualify the *iudex*, or is he judge of *aequitas* in others? The two possibilities must be kept in mind, since texts can be quoted in support of both views. The title of *aequitas* befits both God and Christ: "quia deus aequitas et iustitia est: ipse sibi lex est" writes Eusebius Gallicanus.[159] Commenting on Job 23:7, Gregory the Great remarks: "Quis enim alius nisi mediator Dei et hominum, homo Christus Iesus aequitatis nomine designatur."[160] Christ exercises divine *aequitas* when at the end of time judgment is pronounced on both the just and the unjust. In the words of Chromatius of Aquileia, commenting on Matthew 3:12:

> Tali uentilabro ecclesiae suae aream in futuro est iudicio purgaturus, cum iustos suos quasi incorrupta tritici grana uelut in horreis, id est in caelesti mansione recondet. Peccatores autem quasi paleas inextinguibili igne tradit urendos, ille qui *aequitatis* et iustitiae *iudex* est, cui est laus et gloria in saecula saeculorum.[161]

The same idea is sufficiently present elsewhere to make us doubt that Chromatius himself was being put to use here, although he supplies the very words that appear on the cross. Cassiodorus commenting on Psalm 9:9 (*Ipse iudicabit orbem terrae in aequitate*) writes:

[156] See the studies listed under *aequitas* in H. J. Sieben, *Voces. Eine Bibliographie zu Wörtern und Begriffen aus der Patristik (1918–1978)*, Berlin (1980), 230: also the comment on *aequitas* in F. Schulz, *History of Roman Legal Science*, Oxford (1946), 74–75, from whom the following citations of Cicero are borrowed: "pueri apud magistros exercentur omnes, cum . . . alias scriptum [the law] alias aequitatem defendere docentur" (*De oratore* I.57.244); "multaque pro aequitate contra ius dicere" (ibid., I.56.240); "ius Crassus arguebat . . . aequitatem Antonius" (*De officiis* 3.16.67). *Aequitas* sought to apply the law equally to all.

[157] Early Christian writers exploited this theme for their own purposes. Thus Lactantius in his *Divinae Institutiones*—leaning heavily on Cicero—shows that *aequitas* is an essential part of justice: "se cum ceteris coaequandi, quam Cicero 'aequabilitatem' vocat . . . ubi enim non sunt universi pares, aequitas non est" (*Divinae Institutiones* V. xiv: Sources Chrétiennes, vol. 204, 202–205). Julianus Pomerius in his *De vita contemplativa* devotes a chapter (Book III.22: *PL* LIX, 505–507) to Christian *aequitas*, arguing that *aequitas*, which flows from justice, makes us believe that we are born not for ourselves alone but also for mankind in general ("aequitas facit . . . ut omnium necessitates hominum nostras esse dicamus"). It is obvious however that the rhetorical opposition between *ius* and *aequitas* is difficult to maintain on the theological level: since *deus sibi lex est* all his actions are law and must be seen as issuing from *aequitas*. It is the treatment of this aspect that would deserve further exploration in patristic writings.

[158] E. Wohlhaupter, *Aequitas canonica. Eine Studie aus dem kanonischen Recht*, Paderborn (1931). A very short and unsatisfactory section (27–32) deals with the patristic period.

[159] *CCSL* CI, 258.

[160] *CCSL* CXLIIIA, 820.

[161] *CCSL* IXA, 242.

"Ipse" utique Dominus *Christus*, qui hic patiendo iniustitiam, ab impiis ueraciter dicitur demonstrare iustitiam. "Orbem terrae" sanctos viros debemus accipere, qui de universali Ecclesia, quasi de coronae circulo congregantur. Isti *in aequitate iudicandi* sunt, quibus propter fidei et humilitatis suae bonum misericordia copiosa praestabitur, qui audituri sunt "Venite, benedicti Patris etc."[162]

The Ruthwell title can therefore be seen as a reminder to those who beheld it that they must constantly bear in mind the judgment that the *Iudex aequitatis* would pronounce on their conduct when the day of final reckoning arrived.

Another angle, however, also deserves to be explored. In III Kings 9:4 we read that God promised Solomon to consolidate his throne on condition that "you will walk before me, as David your father walked, *with integrity of heart and uprightness*, doing according to all I have commanded you" ("si ambulaveris coram me . . . *in simplicitate cordis et in aequitate* et feceris omnia quae praecepi tibi"). Again in Deuteronomy 9:5 the Israelites are told that their entry into the chosen land is due to God's decision and not to their own merits: "Not because of *your righteousness or the uprightness of your heart* are you going in to possess their land" ("*non propter iustitias tuas et aequitatem cordis tui*"). The Book of Proverbs begins with the wish that men may receive "iustitiam et iudicium et aequitatem" (Proverbs 1:3) and Bede's comments on these words should be noted:

> Iustitia est in eis quae secundum regulam ueritatis bene operamur, iudicium in illis quae recta discretione cum proximis agimus, *aequitas in eo cum sincera intentione Deo soli in his quae recte gerimus uel iudicamus placere contendimus*.[163]

Man's *aequitas* then is displayed when, in whatever he does, he seeks to please God alone. A little later, in a comment on Proverbs 4:11–12 (*ducam te per semitas aequitatis*), Bede returns to the idea in an excursus that has a very monastic tone:

> The "paths" are the right actions (*actiones aequitatis*) which to beginners seem restricted and hard (*artae et angustae*), but, through continuous practice, as they grow in strength, they become easier and broader. The psalmist testifies to this when he says (Psalm 16:4) "Because of the words from your lips I have kept to the hard ways," but later, when he had made progress, he chanted (Psalm 118:32) "I will run the way of your commandments as you widen my heart." So although when you begin to enter the paths of righteousness (*semitas aequitatis*), they may seem narrow, once you are engaged on this road the heart's footsteps no longer suffer from constriction but you discover, as the Lord said, that his yoke is sweet and his burden light (Matthew 11:30).[164]

[162] *CCSL* XCVII, 99.

[163] *CCSL* CXIXB, 24.

[164] Ibid., 46: "Semitae, id est actiones aequitatis, dum inchoantur artae uidentur et angustae, dum uero profectum capiunt iam ex consuetudine spatiosae uidentur et latae psalmista testante qui cum incipiens domino dixisset: 'Propter uerba labiorum tuorum ego custodiui uias duras,' postmodum iam proficiens canebat: 'Viam mandatorum tuorum cucurri dum dilatares cor meum.' Etsi ergo semitas aequitatis cum egredi coeperis artae tibi uidentur, cum tamen eas ingressus fueris non artabuntur gressus mentis tuae sed iuxta quod dominus ait 'iugum' eius 'suave et onus leue' repperies."

This brings us close to the *plana et ardua* through which, according to Cummian, as we saw above, the monk who lived the "desert life" must tread so that he could, with God's help, achieve that inner peace which allowed him to lie down with the beasts "when the spirit will not be pitted against flesh and blood and the flesh will not lust against the spirit." This also brings us close to the thought expressed at the end of the Prologue of Benedict's Rule:

> But as we progress in our monastic life and in faith, our hearts shall be enlarged and we shall run with inexpressible sweetness of love in the way of God's commandments (*processu vero conversationis et fidei, dilatato corde, inenarrabili dilectionis dulcedine curritur via mandatorum Dei*).[165]

Aequitas, when it occurs in the Psalms, is generally rendered as *rehtwisnisse* (righteousness) in the Old English gloss that accompanies the Vespasian Psalter.[166] This was perhaps the word which the makers of the cross (for whom Latin was not a native tongue) had in mind; Judge of Righteousness—a title intended more to inspire adherence to their monastic commitment, to cleave to the straight and narrow path that would bring them to their goal, than as a grim reminder of the awful judgment that awaited all men at the end of time.

Martha and Mary

The panel immediately above the central panel with Christ upon the beasts shows two women who appear to be greeting or embracing each other (Fig. 1 and Pls. 11–15). Visually this panel responds to the encounter of Paul and Anthony on the level below, where we likewise see two figures facing each other. The manner in which the women embrace recalls the embrace of Mary and Elizabeth in the Magdeburg antependium ivory.[167] In both instances the figures also lack halos. This therefore suggests that the Ruthwell panel must be a Visitation. Nevertheless what survives of the inscription—which appears to be original—presents the names of Martha and Mary, written in Latin but with runic characters.[168] This has caused some perplexity about how the image should be interpreted. To suppose, as does Baldwin Brown, that the carver, in a moment of distraction, put down Martha's name instead of that of Elizabeth does not carry much conviction.[169]

The names of the sisters, Martha and Mary, occur together both in Luke 10: 38–42 and in John 11. In Luke's story *Mary sat quietly at the feet of Jesus* while Martha busied herself serving their guests. Upon being appealed to by Martha for her sister's help, Jesus replied that Martha was preoccupied with many things and that Mary had chosen the better part.

[165] *CSEL* LXXV, 9.

[166] *The Vespasian Psalter*, ed. S. M. Kuhn, Ann Arbor (1965), 8 (Psalm 10:8), 48 (Psalm 51:5), 59 (Psalm 64:5), 61 (Psalm 66:5), 93 (Psalm 95:10), 111 (Psalm 110:8), 118 (Psalm 118:40), 120 (Psalm 118:75), 124 (Psalm 118:144), 141 (Psalm 142:11).

[167] See Schiller (as in n. 39) Bd. 1, fig. 130 (dated 962–975); in the Genoels-Elderen ivory (Schiller, fig. 75) of the eighth century both figures are shown nimbed.

[168] On the inscription see Howlett (1974), 334. The only name that can be securely read, it seems, is that of "Martha," but this would be enough to identify the meaning of the panel.

[169] Baldwin Brown (1921), 196.

John's account concerns the raising of Lazarus, the brother of these sisters, but it begins by noting that Mary, Martha's sister, was the one who had *anointed the feet of Jesus* and dried them with her hair. On its other face the Ruthwell cross shows Mary in the position described by Luke, namely at the feet of Jesus. If no iconographic precedents were at hand for portraying Martha and Mary together, perhaps a Visitation image, since it depicted two women, might have been considered a suitable model.[170]

In the later Middle Ages the busy Martha and the quiet Mary came to symbolize different forms of religious life within the church, differentiating the religious orders dedicated to external works of charity from those that embraced a cloistered life of worship and prayer. Initially, and for the period that interests us here, the figures of the two sisters did not symbolize groups with separate religious ideals but rather the tensions that existed within the monastic life as such, which every monk, whether cenobite or anchorite, had to face and resolve. The classic statement is that given by Cassian near the beginning of his *Conferences*:

> This should be our main effort: and this steadfast purpose of heart we should constantly aspire after, namely that the soul may ever cleave to God and to heavenly things. Whatever is alien to this, however great it may be, should be given the second place, or even treated as of no consequence, or perhaps as hurtful. We have an excellent illustration of this state of mind and condition in the gospel in the case of Martha and Mary: for when Martha was performing a service that was certainly a sacred one, since she was ministering to the Lord and His disciples, and Mary being intent only on spiritual instruction was clinging close to the feet of Jesus which she kissed and anointed with the ointment of a good confession, she is shown by the Lord to have chosen the better part, and one which would not be taken from her He makes the chief good consist not in practical work, however praiseworthy and rich in fruits it may be, but in the contemplation of Him, which indeed is simple and "but one" (*unicum necessarium*).[171]

The tension between the active part and the contemplative part of every monastic life was stressed even more by Gregory the Great in several passages, some of which were borrowed by Bede:

> These two sisters, beloved of the Lord, represent the two spiritual lives which the church in its present condition exercises, Martha is the *actualis vita* in which we are bound to our neighbor by love, Mary is the *contemplativa vita* which we yearn after in our love of God. [What follows is quoted by Bede from Gregory.] The active life (*activa vita*) is to give bread to the hungry, to instruct the ignorant with wise words, to correct the one who errs, to recall our proud neighbor to humility, to look after the sick, to provide for the needs of each, to

[170] With so much material lost it becomes difficult to say what models may or may not have been available to those who designed the cross. The panel showing Christ upon the beasts suggests a real sense of originality, with earlier models of Christ triumphant over "asp and basilisk" being altered to suit a very different viewpoint. The Apocalypse image with a figure whose feet rest on globes could theoretically have been derived from one representing John the Baptist with the Lamb, but the presence of a whole series of Apocalypse image—none of which survive—in the church at Wearmouth suggests a more likely alternate source.

[171] Quoted from *A Select library of Nicene and Post-Nicene Fathers*, XI, 298. Note how closely Cassian's statement "that the soul may ever cleave to God and to heavenly things" agrees with Bede's interpretation of *aequitas*.

give guidance to those committed to our care. The contemplative life (*contemplativa vita*) is while loving God and our neighbor with our whole heart to withdraw from external activity, to yearn so strongly only for our Maker that all other action pales. Then the soul treads all cares underfoot, and burns so strongly with the desire to see the face of its Creator that it grieves to have to continue to bear the weight of this corruptible flesh. All it longs for is to join the angelic choirs, to be part of the heavenly citizenry, and to rejoice that it will live incorruptibly forever in the sight of God.[172]

Because the contemplative ideal cannot be fully achieved in this life, but only in the beatific vision of heaven, Isidore of Seville chose to identify Martha with the church in this world and Mary with the church of the world to come.[173] This formulation of the theme, using the expressions *actualis vita* and *theoretica* [or *theorica*] *vita* to designate the active and the contemplative life, had a wide currency in early Irish exegesis.[174] Thus in an anonymous Irish commentary on Luke we read:

> Martha, who received Jesus, stands for the *actualis vita* for we first receive God through good works. Mary stands for the *theorica vita*, she always sits near the Lord's feet and listens to the words he speaks; she is anchored without interruption in heaven in the contemplation of the Trinity.[175]

Recalling Cummian's comments on Christ in the desert with the pacific animals, we can easily see how well his exegesis harmonizes with the theme of Martha and Mary. Only in the life of contemplation could the monk reach the state when "the spirit no longer warred against the flesh nor the flesh rebelled against the spirit"—that is when, like Daniel who could lie down with the lions, he would grow meek (*mansuescimus*) together with the unclean beasts. All these texts, which were in wide circulation at the period, provide insights into the ideas which helped to shape the cross, and which remained implicit in the lessons it offered to those who first gazed upon it.

The Archer

The figure of the archer appears above that of Martha and Mary (Pls. 11, 12). Unless and until the cross-beam is recovered, the program of the top portion of the cross, on this side, must remain problematical. The uppermost panel of the cross, directly above the archer, were it properly arranged, should contain the figure of the eagle (Pl. 20). It has been claimed that the archer is aiming his arrow at this eagle, but if this were so the archer would normally

[172] This is taken from Bede's commentary on Mark (*CCSL* CXX, 225). It is interesting to see Bede himself here using the term *actualis vita*, since this reflects the terminology of the Irish tradition (*actualis* as opposed to *theoretica/theorica*) rather than that of Gregory, who consistently uses *activa* versus *contemplativa*.

[173] *Allegoriae quaedam sacrae Scripturae*: *PL* LXXXIII, 124D–125A "Martha . . . significat Ecclesiam, in hac vita Christum in corde excipientem, et in opere iustitiae laborantem. Maria . . . demonstrat eamdem Ecclesiam, in futuro saeculo ob omni opere cessantem, et in sola contemplatione sapientiae Christi requiescentem."

[174] B. Bischoff, "Wendepunkte in der Geschichte der lateinischen Exegese im Frühmittelalter," *Sacris Erudiri* VI (1954), 208, has shown how characteristic this is of the Irish exegesis.

[175] *CCSL* CVIIIC, 77.

be shown, as he is on the ivory pectoral or devotional cross from the Victoria and Albert Museum (and also on the cross shafts from St. Andrew Auckland and Bradbourne), aiming his shaft right up the center at the bird.[176] It is probable, therefore, that if a target for the archer were included in the design it must have occupied the panel to the right on the lost cross-beam. The eagle at the summit of the cross is not within the archer's aim and should be treated as a separate and independent image.

No inscription is now discernible on the borders around the archer, and this fact has led to a multiplicity of interpretations. Shapiro, following Baldwin Brown, thought that the archer had no theological significance; he was merely a secular figure ornamenting the extremity of a religious monument.[177]

Saxl argued that the archer might stand for "the enemies by whom the Roman Church in Northumbria was surrounded, pagans and heretics alike"—this on the basis of linking Psalm 90:5 ("You shall not fear the terror of the night nor the arrow that flies by day") with what he believed might have been the central panel on the lost cross-beam, namely St. Peter holding the keys of the Church.[178] Saxl's reasons for bringing in St. Peter rested on what is almost certainly a misinterpretation of a scene depicted at the center of three pre-Conquest crosses now preserved in the chapter-house at Durham cathedral.[179] Besides, one needs first to make sure that the Ruthwell cross does not contain elements that are more at home in a Celtic monastic rather than a strictly "Roman" milieu, before proposing this kind of argument.[180] One needs also to see what other religious meanings can be attributed to the figure of the archer.

Kantorowicz believed the archer represented Ishmael (Abraham's son by his Egyptian bondwoman, Hagar), who is spoken of in Genesis as a *sagittarius* (Genesis 21:20).[181] Kantorowicz refers to John Chrysostom's commentary on Genesis, where Ishmael is spoken of as a

[176] For illustrations of both pieces Farrell (1978), 101–103.

[177] Schapiro (1944), 238, n. 57: "I do not believe that the archer and the bird . . . have a definite religious sense It is one of the oldest mediaeval examples of secular imagery at the terminal point of a religious monument." If significant texts that support a religious meaning for the archer can be produced, how is one to demonstrate that they are irrelevant in this instance? One could imagine reaching Schapiro's position once other possibilities had failed to produced results.

[178] Saxl (1943), 6–7.

[179] For illustrations of these crosses see Coatsworth (as in n. 88), figs. 3A, 3B and 4A to pp. 85–92. Saxl (1943), 6 had interpreted the scene as "Christ holding a large key over the bent figure of St. Peter, a symbol of the institution of the Church of Rome." Coatsworth wonders whether, as some earlier writers had suggested, the scene does not represents John the Baptist holding a crook while he baptizes Christ. The scene is enigmatic. In all scenes of the Baptism Christ is shown standing upright and occupying a central position, with the Baptist positioned either on the right or left. The object held by the central figure resembles less a crook than a long handled *patera* like the one shown on a Roman altar now in the Museum of Antiquities at Newcastle, see J. C. Coulston, *Hadrian's Wall West of the North Tyne and Carlisle*, Corpus of Sculpture of the Roman World, Great Britain, vol. 1, fasc. 6, Oxford (1988), pl. 25 (92). This volume shows numerous other examples of *paterae*. Could the scene in question be the Baptism of King Edwin? According to Bede, *Historia Ecclesiastica*, II.13, Edwin was baptized in the church of St. Peter's at York. At the time the Ruthwell cross was carved numerous Roman monuments must still have been visible. It is worth asking whether their existence influenced the Northumbrian carvers. One is struck by similarities between the treatment of the parallel ribbed folds at Ruthwell and some of the examples shown in the Corpus volume mentioned above, see, for example, pls. 4 (15), 25 (93), 57 (202–203).

[180] The great merit of Schapiro's article of 1944 is to have perceived that the cross contained elements linking it with "the older native Celtic Christianity" (243) of the region.

[181] Kantorowicz (1960).

pious man living in the desert. There is no evidence, however, that a Latin version of this work was produced and circulated in the West. One has only to read the end of Bede's own commentary on Genesis to see Hagar and Ishmael presented as the image of those who are "carnal by intention" (*per intentionem animi carnalis*), to see that Ishmael does not fit into the scheme of the cross.[182]

The figure of the archer, with his bow stretched, aiming an arrow, evokes the numerous verses in Scripture that allude to *arcus* or *sagitta* or *sagittarius*, and the patristic commentaries on these verses. The literature is vast, and worth exploring if only to see what choices confront us and whether reasons exist to prefer one choice over another. As Gregory the Great frequently points out, the images of Scripture can often be interpreted, on the allegorical level, either in a good or a bad sense. Readers familiar with allegorical commentaries know only too well how a skilled player, with a vivid imagination, can play almost any tune he wants to on the allegorical organ. Gregory himself was a highly adept in this role. He tells us in his *Moralia* (Book 19) that a bow can sometimes signify the attacks of the wicked (as in Psalm 63:4), or the final day of judgment (as in Psalm 59:5), or even Scripture itself (as in Psalm 7:13).[183]

Both Shapiro and Saxl, in commenting on the archer, alluded to Psalm 90:5 (save me "from the arrow that flieth by day": *a sagitta volante per diem*). Farrell, in an interesting article on the Ruthwell archer, explored the implications of this Psalm in many directions—its liturgical use in the Roman Lenten liturgy, its connection with the theme of Christ in the desert, patristic comments made on the verse in question—and concluded that an "interpretation of the archer and his arrow as a force for evil seems likely."[184] If one accepts Psalm 90 as the only basis for comments on the Ruthwell archer, this may be true. Farrell quotes a text from Jerome in which we read: "the arrow of the devil that flies I interpret as the teaching of heretics and philosophers."[185] Obviously this involves placing the devil or some figure of evil on the triumphal Cross of Christ—*victoriosissima crucis arbor*, as Bede calls it.[186] This may seem somewhat incongruous, and it is therefore worth asking whether another, more positive, interpretation is not more likely. Bede, in his commentary on the Canticle of Habacuc, explains that this canticle was sung every Friday, to commemorate the death of Christ, and that it was the canticle that most loudly proclaimed the *sacramenta dominicae passionis*. Verse 9 of the Canticle, in the pre-Vulgate (*Vetus Latina*) text that was current in England in Bede's time, reads: "You will stretch your bow over all scepters" (*Tendens extendes arcum tuum super sceptra*).[187] Bede comments:

[182] *CCSL* CXVIIIA, 242.

[183] *CCSL* CXLIIIA, 999–1002, nos. 54–56.

[184] Farrell (1978), 105.

[185] Ibid., 109.

[186] *In Cant. Cant.* V.vii.8 (*CCSL* CXIXB, 330).

[187] For the different versions and the diffusion of the liturgical Canticles see H. Schneider, *Die altlateinischen biblischen Cantica*, Beuron (1938): on the Insular versions, 46–50, 75–80.

The bow here means the unexpected coming of the divine judgment, when all the scepters, that is, all the kingdoms of the earth are to be judged.[188]

Here at least we have a positive meaning that can be paired with the Apocalyptic vision on the other face of the cross, which also alludes to the end of time and the beginning of God's eternal kingdom. Yet this explanation still lacks a clearly discernible monastic emphasis to bring it into context with the other panels on this side of the cross.

God accomplishes his most powerful victories not by conquering his enemies but by conquering the human heart. He pierces hearts with his words and with his love. A vein on this theme in patristic literature deserves to be quarried. Here are Augustine's comments on Psalm 119:4, *sagittae potentis acutae*:

> "the sharp arrows of the powerful one" are the words of God. They are aimed and they pierce the heart. But when hearts are transfixed by the arrows of God's words, death does not result; instead, love is enkindled. God knows how to shoot his arrows to cause love. No one can do it better than he, whose shafts are words. Indeed he aims at the heart of the one who loves in order to help increase his love: he takes aim to engender love.[189]

Augustine is again worth quoting on verse 6 of Psalm 44:

> "Your arrows are sharp and most powerful" (*Sagittae tuae acutae, potentissimae*): Your words pierce the heart, provoking love. Hence it is said in the Canticle of Canticles "I am wounded by love." In saying she is wounded by love she means that she loves, yearns for, longs for the bridegroom from whom she receives the arrow of the word. "Your sharp and powerful arrows," transfixing, provoking. "Peoples fall down before you" (*Populi sub te cadent*). Who succumbed? Those who were smitten and fell down. We see peoples subject to Christ, yet we do not see them falling. The Psalmist explains where they fall: "in the heart" (*in corde*). It is both there that they rise up against Christ, and there that they fall down before Christ. When Saul was blaspheming Christ he was standing erect; he besought Christ, he fell, he lay prostrate. The enemy of Christ was slain so that the disciple of Christ could live. Then the arrow was sent from heaven. Saul, not yet Paul, was wounded in his heart; he was still upright, not prostrate. When he received the arrow he fell down in his heart O sharp and most powerful arrow.[190]

It is particularly interesting to consult the Psalm commentary of Cassiodorus on this same verse (Psalm 44:6) since we know that it was circulating in England at this period. This is what he writes:

[188] *CCSL* CXIXB, 394: "Arcum dicit improuisum diuini examinis aduentum, quo etiam sceptra, id est regna mundi examinanda esse praeuidit." Ó Carragáin (1986), 383–387 seeks to link the central panel with verse 2 of this same Canticle (*In medio duorum animalium innotesceris*). Quite apart from the fact that the desert theme, stressed in the inscription, is absent from the Canticle, it is difficult to see this verse prompting a depiction where Christ appears above and not between (*in medio*) the animals.

[189] *CCSL* XL, 1781.

[190] *CCSL* XXXVIII, 504.

The sharp arrows are the words of our Lord Savior, which pierce human hearts in a health-giving way; they wound so that they may cure, they strike so that they may set free, they lay low so that they may help to raise up. But let us examine by what kind of comparison this arrow is likened to the word of God. The wood of the arrow is armed with an iron spike and its tip is feathered: *so the word of God proceeding from the wood of the cross has power to penetrate, and speed enough to reach its goal.* Above [verse 4] he mentioned the sword which wounds the neighbor; here the psalmist alludes to arrows aimed from a distance, so as to underline by this image God's immeasurably far-reaching power. "Sharp" refers to the arrows' penetrating velocity, "most powerfully" indicates that no material, however hard, can resist them, possessing as they do the capacity to fulfill His will. "Peoples fall before Thee" indicates the conversion of men, when believers who first stood tall in the sin of pride happily prostrate themselves in humility. This happened to the apostle Paul who was pierced with the arrow of the Lord's voice; the persecutor fell down but the right hand of the Lord immediately raised him up to be an apostle. "In the heart" explains what was said above. "They fall," not with the feet that support the human body, but with the heart, namely the place where the soul's wickedness had stood erect. *For he who falls down penitent at heart rises again, toppled from his iniquity, and committed to the Lord's command-ments.*[191]

Note in particular the direct allusion to the arrows aimed from the cross. We are close here to the monastic ideal of contemplation, and Gregory the Great was inclined to develop the theme in this direction:

hearts are wounded so that they may be healed, for God strikes unfeeling minds with his shafts of love and through the warmth of charity renders them feeling again Smitten with the darts of his love, they are wounded in their innermost self. They burn with the desire of contemplation. In a wonderful manner, those who before, in full health, lay dead, now through being wounded are made to live.[192]

In his commentary on Ezekiel we find a similar development that again has a very monastic tone:

What are the bridal chambers in the church if not the hearts of those who through love are joined to the invisible bridegroom? They burn with desire for him, they long after nothing in this world, they view the length of their earthly life as a penalty, their desire is to depart and rest in the embrace of the heavenly spouse. A soul of this nature can take no pleasure from the present life, but yearns and longs only for the one it loves. It even feels contempt for its own bodily health, because it is pierced with the wound of love. Hence the Canticle of Canticles says: "I am wounded with love" [*Vetus Latina* Canticle 2:5]. The heart that does not know the pain of this love is not in good health. But as it pants after its heavenly desire and begins to feel the wound of love, the soul which formerly had lain sick in health grows healthier from its wound.[193]

[191] *CCSL* XCVII, 406–407.
[192] *Moralia* 6.42 (*CCSL* CXLIII, 315).
[193] *In Ezechielem* II.iii.8 (*CCSL* CXLII, 242).

For those who had read Augustine, Cassiodorus, or Gregory, the figure of an archer poised to release his shaft must have appeared as a powerful and even moving image. We shall never be able to prove, beyond doubt, that it was texts such as the ones quoted above that caused the figure of the archer to be placed on the Ruthwell cross, although the quotation from Cassiodorus, which explicitly alludes to the arrow launched from the cross, seems a very telling one. It should be obvious, however, that this is a theme that cannot be neglected. As Gregory so eloquently explains, the theme of *caritate vulneratus* is fully in keeping with the contemplative ideal—and this ideal is symbolized by Mary in the panel immediately below the archer. The true monk yearned for the full *theorica vita*, to pass beyond the veil, where he would no longer see *per speculum et enigmate* but *facia ad faciem* (I Corinthians 13:12). The eagle, occupying the uppermost panel of the cross on this side, seems to point again in the same direction.

The Eagle

The image of the eagle looms large, though the centuries, in Christian art.[194] It first appears as a symbol of Christ's resurrection, and, by extension, of the resurrection that awaited all Christians. A telling monument is a Christian sarcophagus now in the Lateran Museum.[195] It shows a cross with two sleeping soldiers placed beneath its arms. Above the cross is a laurel wreath with the monogram of Christ, the stem of the "P," as it were, extending the shaft of the cross. An eagle, with wings outstretched, and flanked on either side by personifications of sun and moon, holds this wreath in its beak, while two other eagles, standing on the cross-beam, feed on the wreath's berries. Christian art has here borrowed from classical art; the imperial eagle, assimilated to Christ, holds the wreath, a symbol of his victory over death through his resurrection, and other eagles, namely Christians, share in this same victory. Elements of this rich symbolism persist in the following period. Three manuscripts, dating from the sixth to the mid-eighth century, present crosses with a pair of eagles standing on the cross-bar,[196] while a mid-eighth-century Augustine manuscript, from Laon, has a cross with a single eagle standing at its apex and an inscription that clearly identifies this eagle with Christ.[197] A single eagle, flanked—as in the Lateran sarcophagus—by sun and moon (but not personified), forms the uppermost panel of at least one of the pre-Conquest crosses now in the Chapter house at Durham.[198]

While the resurrection-victory of Christ seems to provide the origin for the iconography, the exegetical literature, with its reflections on the flight of the eagle to the uppermost heaven,

[194] The most satisfying study is that of L. Wehrhahn-Stauch, "Aquila-Resurrectio," *Zeitschrift des Deutschen Vereins für Kunstwissenschaft* xxi (1967), 105–127; she also wrote the article on "Adler" (Eagle) for the *Lexikon der christlichen Ikonographie*, I (1968), cols. 70–76.

[195] Wehrhahn-Stauch, "Aquila-Resurrectio" (as in n. 194), 115, fig. 10.

[196] Ibid., 106 (fig. 1), 107 (fig. 2), 108 (fig. 4).

[197] Ibid., 107 (fig. 3); a color plate of this folio is also found in J. Porcher, "La peinture provinciale," *Karl der Grosse*, III, *Karolingische Kunst*, Düsseldorf (1965), pl. XXI.

[198] Coatsworth (as in n. 88), crosshead 20 (fig. 3A); what appears to be the tail of a similar eagle also seems discernible on crosshead 22 (fig. 4A).

comes to see the eagle as a symbol of Christ's Ascension.[199] A dichotomy is thus introduced into the iconographic tradition. A pair of eagles standing on the cross-beam of a cross—whether on a monument of the fourth or the thirteenth century—will be interpreted as a symbol of Christian resurrection. But a single eagle at the apex of a cross will normally be interpreted as a symbol of Christ's Resurrection or, more probably, of his Ascension (Pl. 20).

The uppermost panel on the other face of the Ruthwell cross contains an eagle, together with John the Evangelist (Pl. 11). The letters still discernible around this panel show that the inscription gave the opening words of John's Gospel: *In principio erat Verbum*. The uppermost panel on this face of the cross presents a bird perched on what seems to be a vine branch, and the clear outline of its curved beak shows it to be an eagle. Traces of letters are found around the border but they add up to no recognizable words.[200] Saxl, in his comment on this panel, noted that it "must undoubtedly be interpreted as a symbol of the Ascension."[201] But it is worth asking whether there is not still more to be said, and whether the image does not also have a monastic dimension—particularly in view of the long excursus on the eagle which is to be found in the *Moralia* of Gregory the Great.

In one of his homilies on Ezekiel, commenting on Ezekiel 1:10 (*facies aquilae desuper ipsorum quatuor*), Gregory states that the proper place for the eagle is "above" (*desuper*)—not to the right or the left—because the eagle stands either for Christ's Ascension or for the fact that the evangelist John excelled all the other evangelists in contemplation, since he alone began his Gospel by proclaiming the Word of the Father present as God with the Father from all eternity.[202] In his excursus on the eagle in the *Moralia*,[203] Gregory explains that the eagle can stand for many things: for the evil spirits which destroy souls (Lamentations 4:19), for earthly rulers (Ezekiel 17:3–4), for the Incarnate Lord, who after descending here below, like an eagle soars back to the heavens. But the particular verses of Job (39:27–30) concerning the eagle, on which he is commenting, suggest to him rather the theme of monastic contemplation. The text of Job had alluded to the eagle soaring (v. 27), making its nest on a high rock (v. 28), spying out its prey from afar (v. 29), letting its young lap up blood, and speedily hastening to wherever there was a corpse (v. 30). Gregory has no difficulty integrating all these aspects into his theme. The whole development is too long to give here but some telling passages can be quoted. Latchen, the Irish scholar who excerpted Gregory's *Moralia* in the mid-seventh century, noted some of the passages of this section, so it seems clear that Gregory's sayings were widely pondered:

[199] Psalm 102:5 reads: "Renovabitur sicut aquilae iuventus tua." Augustine frequently refers to this verse, but not as an image of outright resurrection: "Resurrectionem enim quamdam significauit nobis. Et quidem renouatur et iuuentus aquilae, sed non ad immortalitatem." The whole exposition (*CCSL* XL, 1459 and elsewhere) rests on the bird lore, current in his day, that an old eagle found a way to keep sharpening its beak so that it could continue eating, and thus renewing its strength.

[200] For the various readings and interpretations of this pane see Swanton (1970), 20 n. 5.

[201] Saxl (1943), 6.

[202] *CCSL* CXLII, 48.

[203] For all the following see *Moralia* XXXI, nos. 94–104, *CCSL* CXLIIIB, 1614–1623.

The eagle soars at the Lord's bidding when the life of the faithful, fulfilling God's commands, cleaves to what is on high. It nests in a high place because, despising earthly desires, it is already nourished, through hope, with heavenly things. It places its nest on high, because it does not build its mental abode in lowly and dishonorable behavior.

This eagle which lifts the eyes of its heart to the rays of the true sun abides in the rocks because the firmness of its mind is planted in the sayings of the ancient and mighty fathers When it silently considers their words and deeds and compares these with the tawdry and transient glory of the present life, then it can, as it were, from its high abode look down upon this lowly earth.

When a holy man, therefore, despises the things of earth, he raises himself like an eagle to higher things; and, elevated by the spirit of contemplation waits for the eternal glory of the angels; being a stranger in this world, by seeking after the things he beholds, he is already fixed on things above And whoever, by the grace of contemplation, is fixed on things above, will not be content beholding the glory of the angelic brightness, unless he is able to behold Him also, Who is above the angels. For His vision alone is the true refreshment of our mind.

Those who find their true nourishment in contemplation have a powerful incentive to perform pastoral service towards the less privileged members of the Christian body.

Throughout his long excursus Gregory constantly returns to the figure of Paul. Above, in the comments on the panel with the archer, we saw Paul presented as the one who had been struck and cured through the wound inflicted by the divine arrow. Here Gregory can propose Paul as the one who, though rapt in contemplation to the third heaven, remained constantly concerned for the pastoral needs of all his Christian flocks. The eagle flies to where there is a corpse, and corpse, for Gregory, means sinner:

All who have fallen into the death of sin can appropriately be considered corpses. For the one who lacks the spirit of vivifying uprightness lies inanimate like a corpse. But every holy preacher flies with concern like an eagle to the spot where he perceives there are sinners so that he can present spiritual life to those dead through sin.

Viewed in the light of Gregory's teaching, the uppermost panel of the Ruthwell cross with its eagle (Pl. 20), beckoning to contemplation (but a contemplation that will nourish pastoral concern), can therefore be seen as linked to the other face of the cross, exemplifying the life of the Church, to which not only monks but all Christians are called.

THE PHYSICAL AND CULTURAL SETTING OF THE CROSS

When and for whom was the Ruthwell cross made? No one disputes that it is an Anglian monument—in other words, that it belongs to the period when Northumbria had control over this part of Scotland, along the Solway Firth. The Lives of St. Cuthbert testify to Northumbrian expansion through the Tyne-Solway gap into Cumbria in the seventh century, and

Bede's Life, in particular, portrays Carlisle as part of the diocese of Lindisfarne; he writes of Cuthbert dedicating churches and ordaining priests there.[204] Bede could assert in 731, as he was ending his *Ecclesiastical History*, that an Anglian episcopal see now existed at Whithorn, or *Casa Candida*, which had formerly been the see of St. Ninian.[205] I agree with John MacQueen that Bede's phrase (*cuius sedem episcopatus . . . iam nunc Anglorum gens obtinet*) does not imply that the Northumbrians had only very recently conquered Whithorn, but rather that their colonization of the whole region was now so well established that the *Gens Anglorum* residing there could now pride itself on having its own bishop.[206] The man appointed was Pecthelm, who as monk and deacon had spent many years with bishop Aldhelm of Sherborne,[207] and who was personally known to Bede.[208] The Northumbrian conquest and colonization of southwest Scotland must have begun several decades, if not several generations, earlier. Northumbrian, or to use Bede's more precise terminology, Bernician dominance in this region did not decline until the mid-ninth century.[209]

Where, within the time of Anglian dominance, should the erection of the Ruthwell cross be placed? Elsewhere in this volume Douglas Mac Lean has presented a good survey of the various dates that have been proposed, with particular attention to the statements of Rosemary Cramp, our preeminent archaeological authority on this period.[210] Cramp has tended to oscillate between a date in the seventh century, around 684 A.D., and one in the middle of the following century, around 750 A.D. She seems, on the whole, to prefer the later date. Mac Lean provides reasons, based on some lingering military skirmishes in the area, and on the archaeological evidence for the development of free-standing crosses, for excluding the seventh century and choosing a date around 730 A.D.

There is a further consideration that should totally exclude any date in the seventh century. We find that in the territories conquered by the Northumbrians a whole series of churches, including those of Bewcastle and Ruthwell, were dedicated to St. Cuthbert (see Fig. 4);[211] these churches most probably date from the early period when the saint's cult was

[204] Bede, *Vita Cuthberti*, ed. B. Colgrave, Cambridge (1940), 244: "Ego . . . crastina die ad uicinum monasterium [i.e., close to Carlisle] ob dedicandam ibi aecclesiam, uenire rogatus sum; (28) (ibid., 248) ad eandem Lugubaliam ciuitatem [Carlisle] rogatus aduenit quatinus ibidem sacerdotes consecrare"

[205] Bede, *Historia Ecclesiastica* (as in n. 32), III.4, 133.

[206] J. MacQueen, *St. Nynia. A Study based on Literary and Linguistic Evidence*, Edinburgh (1961), 25–26.

[207] Bede, *Historia Ecclesiastica* (as in n. 32), V.18, 320.

[208] Bede, *Historia Ecclesiastica* (as in n. 32), V.13, 313: "sicut a venerabili antistite Pecthelmo didici." One may conjecture that Pecthelm had paid a visit to Bede's monastery.

[209] A comprehensive survey specifically aimed at studying the Anglian penetration into Southwest Scotland, and based on all the historical, archaeological and linguistic sources and evidence is still needed. For some brief overviews see D. Kirby, "Strathclyde and Cumbria: a Survey of Historical Development to 1092," *Transactions of the Cumberland and Westmorland Antiquarian and Archaeological Society*, n.s. LXII (1962), 81–84; W. R. Kermack, "Early English Settlement, Southwest Scotland," *Antiquity* XV (1941), 83–86.

[210] See above pp. 49–70.

[211] The map concentrates on Dumfriesshire and Ayrshire. Sources used were *The Royal Commission on Ancient and Historical Monuments and Constructions of Scotland, Seventh Report*, Edinburgh (1920); A. Hamilton Thompson, "The MS. List of Churches Dedicated to St. Cuthbert, attributed to Prior Wessyngton," *Transactions of the Architectural and Archaeological Society of Durham and Northumberland* VII (1936), 151–177; A. Penrose Forbes, *Kalendars of Scottish*

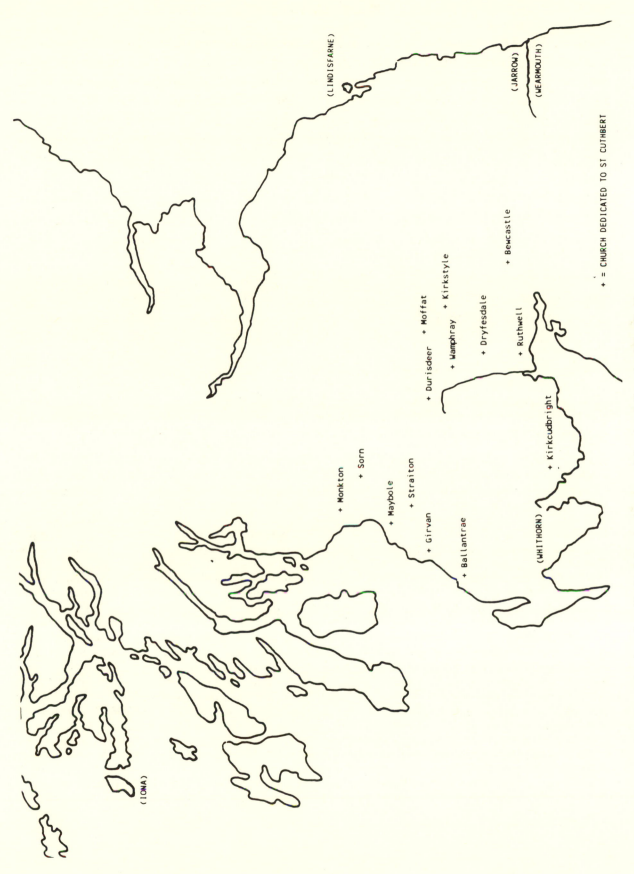

Fig. 4. Map of southern Scotland and northern England showing locations of churches dedicated to Saint Cuthbert

being very actively promoted.[212] But this promotion presupposes the elevation of Cuthbert's relics in 698, and the circulation of his Lives—or, at the very least, of the Anonymous, Lindisfarne Life, written probably within a year or two of the opening of Cuthbert's tomb, namely around 700 A.D. Bede's verse Life, but more especially his prose Life, which dates from about 720 A.D., must have done much to further the spread of the cult. The numerous dedications of churches to Cuthbert at this time may even suggest that Bede, in writing his Life, was trying to meet a growing demand for texts. Alan Thacker has provided a perceptive analysis of the tensions present in the Northumbrian church at this period, which help us to understand why the cult of St. Cuthbert was being so actively pursued.[213] The implications with regard to the Ruthwell cross, a cross erected within a church dedicated to St. Cuthbert, are simply that, on historical grounds alone, the erection of this monument cannot be earlier than the opening decades of the eighth century.

Who was responsible for the making of the Ruthwell cross? The question contains several layers of meaning that need to be distinguished. The cross is obviously the work of one or several skilled stonemasons. Building churches in stone and working in stone was a new skill introduced into Northumbria from the Continent in the 670s, in the days of Wilfrid and

Saints, Edinburgh (1872), 319; J. Murray Mackinlay, *Ancient Church Dedications in Scotland. Non-Scriptural Dedications*, Edinburgh (1914), 243–258; J. Gammack, "The Patron Saints of Scotland with Dedications," *Scottish Notes and Queries*, 3rd ser., I (1923), 102–104. To sort out what may be later medieval dedications from the earlier ones would require a more refined study. All the above publications are in one way or another deficient. Thus the *Seventh Report of the Royal Commission* in the section on Durisdeer (59–68) nowhere mentions that Cuthbert had been the Pre-Reformation patron of the parish; we know this from the list published by Hamilton Thompson. Mackinlay (252) provides no supporting evidence for his statement that Cuthbert was the patron of Ruthwell; the evidence is found in the act establishing Ruthwell as a burgh of Barony (see above, n. 2). The group of churches that were dedicated to the saint in the eighth century, at the time when his cult was being actively promoted, needs to be separated from the group of churches that may have acquired his name because his relics rested there during the long itinerary from Lindisfarne to Durham after the Viking invasion. L. Butler, "Church Dedications and the Cults of Anglo-Saxon Saints in England," in *The Anglo-Saxon Church. Papers on History, Architecture, and Archaeology in Honour of Dr. H. M. Taylor*, ed. L. A. S. Butler and R. K. Morris, London (1986), 44, makes the point that churches dedicated to Anglo-Saxon saints, even when no pre-conquest remains are visible, are most likely to be the earliest.

[212] The dedication and, more particularly, rededication of churches in the Middle Ages is a topic that has not received all the attention it deserves. On the level of hagiographic texts connected with a given saint, a pattern of flow and ebb is often discernible. A saint's cult is actively promoted in a given region, and then spreads to other regions, resulting in church dedications here and there. But later new cults develop, become popular, and supplant the earlier ones, resulting occasionally in the rededication of churches. Much research may be necessary to untangle all the threads before one has the assurance that a particular church dedication is, in fact, the original one. Those who wish to pursue the complexities of the problem will do well to consult the series of articles by A. Van Gennep published in book form with the title *Culte populaire des saints en Savoie*, Paris (1973); I thank Giles Constable for kindly drawing my attention to this work. As regards the Cuthbert dedications in Scotland, there can be little doubt that his cult was most actively promoted during the period of Anglian domination. Strong competition by Irish, Pictish and Cymric saints in the period that followed the decline of Anglian power makes it appear less likely that dedications to Cuthbert belong to this time. For regions closer to Lindisfarne, the relationships with that abbey of particular Scottish monasteries or Scottish lords would need investigation. I myself have been unable to uncover any historical evidence to suggest that the spread of the cult of Cuthbert along the Solway Firth belongs to a later century than the eighth.

[213] A. Thacker, "Lindisfarne and the Origins of the Cult of St Cuthbert," in *St. Cuthbert, His Cult and Community to A.D. 1200*, ed. G. Bonner, D. Rollason and C. Stancliffe, Woodbridge, Suffolk (1989), 103–121.

of Benedict Biscop. One can assume that the *cementarii* whom Wilfrid or the abbot of Monk-wearmouth brought back from Gaul were lay craftsmen, and that the Northumbrians whom they trained were likewise not monks.[214] King Nechtan's request for stonemasons who could build churches, sent around 710 A.D. to abbot Ceolfrid, shows that by then Wearmouth-Jarrow was a recognized source for such masons.[215] Rosemary Cramp considers some sculptured panels at Jarrow to be the closest parallels to the inhabited vinescrolls of the Ruthwell and Bewcastle crosses, and she accepts this as evidence that the masons involved received their training at Bede's monastery.[216] On the other hand John Higgitt, in analyzing the Latin inscriptions on the Ruthwell cross, finds more affinity between their letter forms and the Lindisfarne Gospels than with anything attributable to Wearmouth or Jarrow.[217] While the training a stonemason received might have equipped him to carve both letter forms and vinescrolls, it is unlikely that he would have been responsible for the overall program of so complex a monument as the Ruthwell cross. We need therefore to explore more fully the population and the region that provided the setting for the cross.

The Bewcastle cross is considered to have stood in the open from the beginning, and to have carried an inscription—now no longer readable, because of severe weathering—that commemorated either a person or an event. The condition of the Ruthwell cross, on the other hand, suggests that despite later vicissitudes it was originally housed within a church, and thus protected from the elements.

What sort of church did Anglian masons build, and what relationship does the present structure have to the original building? Here we advance into unexplored territory. Yet despite the lack, so far, of any archaeological investigation of the present building, some suggestions can be made. The *Imperial Gazetteer of Scotland* refers to the Ruthwell church as "a patch-work edifice of various dates."[218] John Craig, minister at Ruthwell from 1783 to 1798, wrote an account of the parish for publication in John Sinclair's *Statistical Account of Scotland*, referring to his church as "an ancient fabric, perhaps now the most so of any in this part of the country; *it is a long building, remarkably narrow*, and has a projecting aile [sic] or wing joined to it, which was formerly the burial place of the Murrays of Cockpool, and is now of the family of Stormont."[219]

[214] For a possible connection between the stone carving at Ruthwell and at Jouarre see above at n. 69. Because Bede's is the only explicit account of masons and glass makers being brought from Gaul (by Benedict Biscop, one year after the foundation of Wearmouth, i.e., ca. 674/75), there is a tendency to forget that Wilfrid must have done the same; one could even argue that Benedict Biscop was only imitating Wilfrid. Wilfrid's consecration took place in Paris in 664, a decade before Biscop set out on his mission to Gaul. According to Eddius (*Vita Wilfredi*, c. 16), Wilfrid was glazing the windows at York and renewing the masonry about 669–671. The building of stone churches at Ripon and Hexham, enclosing splendid stone work (*politis lapidibus*), followed not long after (ibid., c. 17). Wilfrid should also be given his due.

[215] In Bede, *Historia Ecclesiastica* (as in n. 32), V.21. Bede calls them *architecti*. According to Isidore (*Etymologia*, ed. W. Lindsay, 2 vols., Oxford [1911], 19:8:1) "architects" were stone masons who could lay out the foundations of a building ("architecti autem caementarii sunt, qui disponunt in fundamentis").

[216] Cramp (1965), 10–11.

[217] Higgitt (1990).

[218] *The Imperial Gazetteer of Scotland. Topographical, Statistical and Historical*, ed. J. M. Wilson, Edinburgh (1854–), vol. 4, 688. The entry states that the church could seat about 420.

[219] Sinclair (1794), 220.

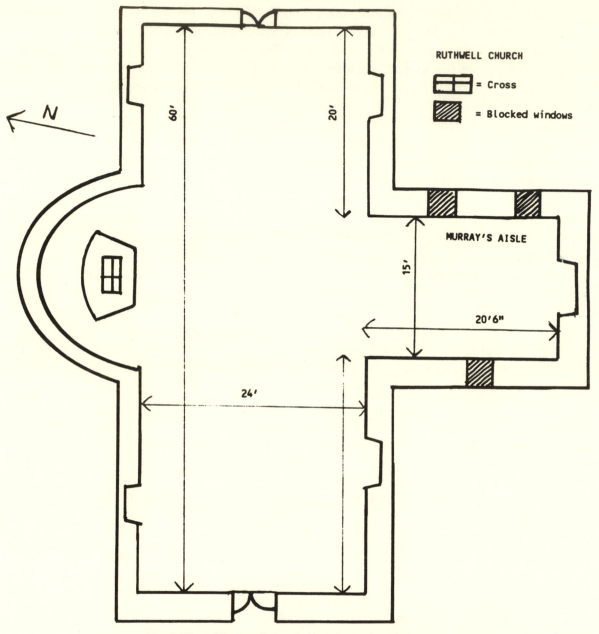

Fig. 5. Plan of Ruthwell church (drawing by Paul Meyvaert)

"A long building, remarkably narrow" would certainly not be an accurate description of today's church (Fig. 5). According to the explicit testimony of John L. Dinwiddie, the church was extensively remodeled by Henry Duncan, Craig's successor as minister from 1799 to 1843; Duncan reshaped the building by cutting back the east end by thirty feet, and widening

the nave, on its north side, by ten feet.[220] The inside length of the present nave is 60 feet and its width—ignoring the rounded apse added in 1887—is 24 feet. We do not know whether the figures furnished by Dinwiddie are rounded-off figures, nor whether they take into account the three-foot thickness of the walls. We could be dealing with a church whose earlier length (including a chancel? added later?) was about 84 feet, with a width of about 15 feet.[221] The resulting plan (see Fig. 6) can certainly be described as "a long building, remarkably narrow."[222] On the face of it this plan fits better into our picture of Anglo-Saxon than of Norman or later medieval architecture. Since this long narrow church was the one that formerly housed the tall cross, over eighteen feet in height, it was obviously somewhat higher than the present building, which required the digging of a pit about five feet deep in order to reinstall the cross in 1887.

Dinwiddie adds an interesting detail that may help to confirm the much narrower dimensions of the earlier nave. He writes: "there has quite recently been discovered, in the western gable, the outline of a much earlier type of window. Its dimensions on the outside of the wall are found to be 51 inches in height by 17 inches in width. *With a single stone for its*

[220] Dinwiddie (1927), 142: "The chief structural alteration, which was effected during the incumbency of Dr. Duncan, consisted in reducing the length of the building from east to west by thirty feet and adding ten feet to its width. The north wall was taken down and set back ten feet; while the wall, forming the eastern Gable, was brought forward ten yards." Elsewhere (140) Dinwiddie, himself minister of Ruthwell for nearly fifty years (1890–1936), informs us that "The Murray Aisle, the belfry, and the south walls, as well as nearly the whole of the western gable end, all belong to the ancient part of the edifice. Here, the average thickness of the walls is three feet. The eastern gable and the north wall, which were rebuilt rather more than a century since (that is, in Duncan's time), are less substantial. They are, in general, two feet in thickness." I have been unable to determine Dinwiddie's basis for these statements. He twice mentions a Church Improvement Scheme, one for Duncan's day, and one for his own (1906). This raises the question of whether such schemes were officially filed for approval with the Church of Scotland, and may therefore still exist. The need for repairs to the church during his own long incumbency may have brought evidence of structural changes to light, and must certainly have taught him something about the thickness of the various walls of the building. *The Memoir of the Rev. Henry Duncan*, written by his son, George John C. Duncan, Edinburgh (1848), is chiefly concerned with Duncan's moral physiognomy, and the part he played in establishing the Free Church and initiating the Savings Bank movement. Indeed it is only in two chapters (16 and 19), contributed by other writers—a fellow minister and an anonymous correspondent—that any mention is made of Duncan's involvement with the "runic" monument, i.e., the Ruthwell cross. George Duncan's *Memoir* (pp. 84–86) does establish the fact that his father's total renovation of the manse and grounds—the whole house was figuratively turned around, back becoming front, new avenues were opened and gardens planted, etc.—occurred immediately upon his arrival in the parish. The renovation of the church probably also belongs to this early period.

[221] The nave at Beechamwell is 15 x 60 (with a ratio of 4.0), that at Thornage is 20 x 70 (with a ratio of 3.5): see H. M. Taylor, *Anglo-Saxon Architecture*, III, Cambridge (1978), 1033. Regarding the orientation of churches see E. A. Fisher, *The Greater Anglo-Saxon Churches*, London (1962), 49. The orientation of the Ruthwell church, like that of many other Northumbrian churches, is pronouncedly to the north of east: see C. Crowe, "Excavations at Ruthwell, Dumfries, 1980 and 1984," *Transactions of the Dumfriesshire and Galloway Natural History and Antiquarian Society*, 3rd ser., LXII (1987), 41, fig. 2. The chancel at Hoddom is considered a later addition (see n. 248 below).

[222] I sincerely thank Mrs. Mary Martin, custodian of the Henry Duncan Savings Banks Museum at Ruthwell, for providing me with the measurements of the present church. If Henry Duncan did reduce the length of the nave on its east end, an excavation of the ground lying beyond the present east wall might immediately provide dramatic data regarding the original plan of the church. On a recent visit to Ruthwell Dr. Brendan Cassidy was able to ascertain that no graves earlier than 1817 lie within thirty feet of the present east wall. This already provides some confirmation of Dinwiddie's statement. A more thorough examination of all the church's architectural features would no doubt reveal additional data.

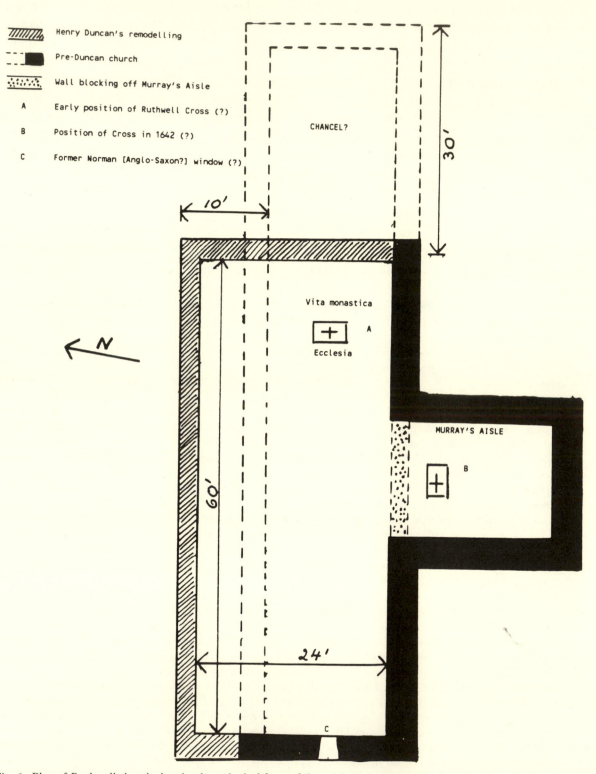

Fig. 6. Plan of Ruthwell church showing hypothetical form of the original church and the location of the Ruthwell cross according to Paul Meyvaert

semicircular head, it is clearly of the early Norman type."[223] The apparently off-center position of this window suggested to Dinwiddie that it must have stood at the midpoint of the old gable, that is, of the west end of the church, before the church was widened and the roof lowered.[224]

Windows with semicircular heads made from a single stone also happen to be a feature of Anglo-Saxon architecture.[225] What we need is a more up to date and accurate appraisal of this and every other architectural feature of the Ruthwell church. A date for the construction of the south aisle, known as "Murray's Quire," would seem absolutely essential. We need to know whether this aisle was part of the original church plan—corresponding to a former similar aisle on the north side?—or whether it was a later addition. We have the explicit testimony both of W. Hamilton and of Bishop Nicolson that the heavy pedestal of the cross lay in "Murray's Quire."[226] Its shaft obviously lay, too heavy to move, where the cross had

[223] Dinwiddie (1927), 141. It would seem that the minister had occasion to point out this window to the bishop of Durham, for he adds: "So high an authority as the Bishop of Durham, on his attention being called to it, at once pronounced it perfectly true to type, and of a very early form There can be little doubt that this single Norman window was not the only one in the pre-Reformation building. The others were doubtless replaced by the plain square-headed openings for light which would be more in keeping with the plainness of the parish Kirks built subsequent to the Reformation" (141). Dinwiddie's testimony concerning the windows of the church deserves notice: "The external outline of the earlier windows, which have been built up, reveals pretty clearly the changes which the building has undergone. The present windows, with the exception of the one in the Murray aisle [south wall] under the belfry, were put in twenty years ago, when a Church Improvement Scheme was carried through, in 1906. The windows which they superseded were larger and of the so-called 'heritors' Gothic' type. These were in all probability built during the incumbency of Dr. Duncan, as part of the Church Improvement Scheme carried out in his day. The windows which they replaced were of the ordinary oblong and square-headed domestic type. Their size and shape can easily be noticed in the parts of the southern wall where they have been built up." Despite Dinwiddie's opinion, it is possible that the "square-headed" windows that were built up were part of the earlier medieval church. For this reason a more professional study and dating, both of the "Norman" window and of the "square-headed" windows, would seem desirable.

[224] To a query by the present writer Mrs. Martin replied, in a letter dated 8 August, 1990: "the Norman window is not at present visible. The exterior of the Church was, about three years ago, pointed and repainted, and this work has hidden traces of the old window. Perhaps we shall have to wait for wind and weather to do their worst before it can be seen again." The fascinating article by C. J. Brooke, "Ground-based Remote Sensing for the Archaeological Study of Churches," in *The Anglo-Saxon Church. Papers on History, Architecture, and Archaeology in Honour of Dr H. M. Taylor*, ed. L. A. S. Butler and R. K. Morris, London (1986), 210–217, provides hope that new and speedier methods may be available for determining the position of the "Norman" window on the west wall of the Ruthwell church.

[225] The round-headed windows at the Anglo-Saxon church of Avebury have an outside dimension of 48 inches by 17 inches, which comes close to the outside dimensions recorded by Dinwiddie: see H. M. Taylor and J. Taylor, *Anglo-Saxon Architecture*, I, Cambridge (1965), 34. For a general discussion of Anglo-Saxon church windows see Taylor (as in n. 221), 836–868.

[226] See above at n. 6 and n. 8. The narrative in Nicolson's diary suggests that the upper fragment of the shaft, which could be turned over, was in the nave of the church, or at least not together with the lower part, which remained embedded in the clay: "(July 5, 1704) . . . I went directly to the Church, whither the parish-Clerk quickly brought me ye Key; and haveing my Former Draughts of both ye Latine and Runic Inscriptions, I compared my Transcripts (once more) with the Original The Characters (especially the Runic) are much larger on ye Stone itself than can be here express'd; But these are the Faces of ye four Sides so far as yr Legends goe. Besides these, there are some little Fragments of ym [i.e the characters] on ye heavy pedestal of this Cross; wch lyes in Murray's Quire." Henry Duncan, who found all the pieces of the cross outside the church when he arrived at Ruthwell in 1899, was obviously unaware of Nicolson's testimony when he wrote his famous Account of the monument (see Duncan [1833], 318): "The column was indeed thrown down, and broken into several pieces,

stood at the time it was toppled. This must mean that in 1642 the cross was standing *within* the projecting aisle. Theoretically a position at the juncture of this aisle with the nave might seem possible, but should be discarded if there is any truth to Dinwiddie's statement:

> It is known that extensive alterations and improvements upon the internal structure of the church building took place, between the years 1772 and 1790. These included *the removal of the wall which had inclosed the part of the building described by Archdeacon Nicolson as "the ancient Burial Place of the Murrays, Earls of Annan."* This part, which is still called "the Murray Aisle," was then added to the main building, giving it the shape of the letter T.[227]

Any evidence that this projecting south aisle is of a later date than the original nave would prove that the position of the cross, within the church, had been changed at some point during the Middle Ages, and probably at the time when this aisle was created. Such a move might easily explain the accident that required the mend to the upper stone previously discussed.[228] The crude quality of the mend suggests some lapse of time between the period when the cross was so skillfully carved and the time when the repair was done.[229] If this was indeed the sequence of events, there remains the problem of locating the cross within the original Anglo-Saxon nave, and determining how this early position related to the local worshipping community. If the original position of the cross was not in "Murrays' Quire," it presumably stood in the long nave, and probably in a position that marked the division between the portion of the church reserved for the monastic community, and the part to which the lay congregation had access. We know rather little about the interior arrangement of the early Anglo-Saxon minsters. Bede's report of Cuthbert's words, spoken near his end, when he gave permission for his body to be brought back from his island hermitage to Lindisfarne, provides some indication of divisions maintained within churches:

> If you wish to set aside my plans [to be buried on the island] and take my body back there, it seems best that you entomb it in the interior of the church, so that while you yourselves can visit the tomb when you wish, it may be in your power to decide whether any of those who come thither should approach it.

it should seem, by the fall It was allowed to lie within the church, beside the ancient site of the altar, on the spot where it fell, and probably served for more than a century as seats to part of the congregation."

[227] Dinwiddie (1927), 98.

[228] See above at n. 19 and n. 20.

[229] Knowing Henry Duncan's "feats of manual and artistic dexterity" (the *Memoir* by his son, George, records that he was adept with clay and plaster-of-Paris and that he made several models of the Ruthwell cross), one might be tempted to wonder whether the pair of feet inserted under the figures of Martha and Mary were of his making. In his account of the monument (Duncan [1833], 320) Duncan clearly implies that this was not the case: "The lower block is broken in two . . . and the upper stone is in several fragments. On its re-erection it was found necessary to fill up deficiencies, by the insertion of several new pieces of stone, which was done without any attempt to supply the place of the lost sculpture, except in the transverse limbs of the cross, already mentioned." Duncan's fondness for the Freemasons emerges from his son's *Memoir*, and explains the presence of Masonic symbols on the "transverse limbs" which he himself designed for the cross.

The place for the Ruthwell cross indicated on the plan (Fig. 6) is purely conjectural.[230] It makes the *Ecclesia* side, with its Crucifixion scene (and its renewable list of liturgical feasts) face west, towards the lay congregation. This would have been in keeping with the notions of the period; the Irish tract on the Mass in the Stowe missal, already cited earlier, states that "westward was Christ's face on the Cross, to wit, *contra civitatem*." On a more practical level, since section #1 (Fig. 1) of the shaft has a nine inch square tenon or tongue meant for insertion into a heavy stone plinth, we must wonder whether this plinth was moved, together with the cross, when its position within the church was altered.[231] If a new base for the cross was provided in "Murray's Quire," evidence beneath the floor of the present church may some day reveal both the original position of the cross and the place where it stood when the iconoclasts set about demolishing it in 1642.[232]

What can be said about the Christian community for which the cross was erected? That it had a monastic component can hardly be doubted, given the themes of Paul and Anthony, and Martha and Mary, that are present on the cross. Additional evidence on this point is, moreover, close at hand. The name of the locality, Ruthwell, deserves attention.[233] Earlier writers (from the last century to the 1930s) suggested that the name combined the Old English word "rode" (cross) with "well." James Johnston gave the same meaning to "Rothwell" in England and "Ruthwell" in Scotland, namely, "well of the rood or cross."[234] If this were

[230] The well-known Plan of St. Gall shows an altar surmounted by a very large cross, with the rubric *Altare sancti Saluatoris ad crucem*, situated at a point midway between the east and west ends of the church and lying along its central axis. W. Horn, *The Plan of St. Gall*, I, Berkeley (1979), 135–36 interprets the position of this altar as marking "the place of worship for laymen," and points to other monastic churches which had altars of the cross in a similar position. On these altars see especially J. Braun, *Der christliche Altar in seiner geschichtliche Entwicklung*, Munich (1924), 400–406, 'Heiligkreuzaltar.' The St. Gall cross did not stand, as at Ruthwell, at ground level. This fact makes it difficult—in the absence of other evidence—to determine the precise relationship between the tall standing cross and an altar placed in its vicinity.

[231] Dinwiddie (1927), 90: "There is, the writer has been informed on reliable authority, a tongue of stone about nine inches square projecting from the bottom of the shaft and now securely fixed in the cement floor of the cross chamber. The monumental mason who carried through the work of re-erecting the cross within the Church, in 1887, saw and noted this at the time. He is the authority for the statement." The same measurement is found in the entry for 25 August 1887 in Mr. McFarlan's pocket-book: "The cross completed in its new site by Mr Dods, Dumfries—Complete height, 18 feet 1 inch. In socket, 9 inches." quoted in Hewison (1914), 28.

[232] The comments of Dinwiddie (1927), 100, about the church floor are worth repeating: "It is in the highest degree probable that it was during the ministry of Dr. Andrew Jaffray, between 1760 and 1782, that the floor of the church was covered with flagstones. These were simply laid upon the surface of the floor of clay. A wooden floor was placed upon the top of both—during the period of Dr. Duncan's incumbency—similar to that which is in use at the present time. The reflooring of the building—about 1780—necessitated the removal of the pieces of the cross, which had lain there since 1642." Repairs made during Dinwiddie's long incumbency must have made him aware of what lay beneath the wooden boarding of his church, which he then tried to attribute to one or another of his predecessors.

[233] A great diversity of spellings is found in the documents: Revel, Rewell, Rivel, Ryvel, Rovell, Rowelle, Ruvell, Ruvale, Ruthvill.

[234] J. B. Johnston, *The Place-Names of England and Wales*, London (1915), 422; idem, *The Place-Names of Scotland*, London (1934), 289. A similar explanation is found in numerous other works, for example, W. C. Mackenzie, *Scottish Place-Names*, London (1931), 243; Sir H. Maxwell, *Scottish Land-Names*, Edinburgh (1894), 214; Sir E. Johnson-Ferguson, *The Place-Names of Dumfriesshire*, Dumfries (1935), 110–111, who includes another possible derivation: "from Norse 'rudh vollr,' 'fields of the clearing in the forest.'"

the true derivation of the name, we might be entitled to ask whether the Ruthwell monument had originally stood on its own, in the open, and near a well or spring. More recent research into the study of English place-names, recorded in the many volumes of the English Place-Name Society, suggests a different explanation. Some early spellings for Rothwell in the West Riding of Yorkshire (Rowelle, Rovell), have their parallel in some early spellings of Ruthwell (Rovell, Rowell). This is taken to indicate an Anglo-Norman loss of medial -th, and to show that we have to start with an Old English Roð(a)wella meaning "spring or stream or well by the clearing."[235] Indeed, it is now accepted that such names probably go back to the colonization of a given region: "the settlement at the spring in the clearing."[236] The name thus loses its specific link with the cross, but through its Old English derivation, continues to bear witness to the former Anglian presence in this region.[237]

Anyone who consults the Ordnance Survey sheet (85) for Carlisle and Solway Firth will be struck by seeing in the immediate vicinity of Ruthwell the names "Priestside Bank," "Priestside," "Priestside Flow."[238] They are found, furthermore, in documents of the sixteenth and seventeenth century that allude to Ruthwell, in addition to other names like "Priestdyke" and "Priestwoodside." The persistence of place-names down the centuries is well known. If we continue further down the bank of the estuary, we encounter "Abbey Burn Foot" and "Abbey Head."[239] These present-day names still refer to the time when the Cistercian monks of Dundrennan Abbey, situated a mile and a half inland, kept their fleet of ships at this location on the Solway Firth. We are therefore entitled to ask what significance attaches to the names incorporating "priest," close to Ruthwell. Do they testify to the original presence of an Old English "preost" (priest) and, if so, does it have a singular or collective meaning? It is recognized that names like Preston can indicate "places set aside for the endowment of priests or monks,"[240] and, indeed, again on the Solway Firth, in the vicinity of Southerness on the coast, just off Mersehead sands, we encounter Preston Merse, Preston Mill, East and West Preston—names that have an Old English ring and again suggest an ecclesiastical or monastic connection.[241] In other words, when such names occur near Ruthwell, are they not a strong indication that a monastic community once resided close by?

[235] See A. H. Smith, *The Place-Names of the West Riding of Yorkshire*, Cambridge (1961), 143–144 (Smith indicates that derivations from ON rauðr 'red' are to be rejected); ibid., *English Place-Name Elements*, pt. 2, Cambridge (1956), 88–89, 251–253; also J. E. B. Gover, A. Mawer and F. M. Stenton, *The Place-Names of Northamptonshire*, Cambridge (1933), 118–119.

[236] See G. Copley, *Early Place-Names of the Anglian Regions of England*, British Archaeological Reports, British Series 185, Oxford (1988), 10, 123; idem, *English Place-Names and their Origins*, Newton Abbot (1987), 90.

[237] It may also be worth noting that the church with its cross stands, isolated, over one-half mile away from the village that bears the name.

[238] Duncan (1833), 317 attests to the remains of an ancient road, founded on piles of wood and leading through a morass to "Priestwoodside," which was still visible in the latter part of the eighteenth century. Duncan (ibid.) likewise relates that in his predecessor's day it was rumored in the village that "Priestwoodside," near the coast, was the place where the cross had first been erected after having been cast on the shore through a shipwreck.

[239] See OS 84:7744.

[240] See A. H. Smith, *English Place-Name Elements*, pt. 2, Cambridge (1956), 73.

[241] See OS 84:9555.

A further question then deserves our attention. What were the cultural affiliations of the monastic community located at or near Ruthwell? Did the Northumbrians, as they gained firm possession of their new territory, set up new Anglian monasteries, or was it a case, at least here and there, of Anglian penetration into monastic communities already existing that had either a British or a Celtic past? Nothing is more difficult than to try to develop a picture of the monastic situation in Dumfriesshire and Galloway in the time of the Anglian take-over.[242] We are dealing with an area, close to Ireland, that had originally been British, but had also been subject to Irish colonization. Since in Ireland the monastery was the normal center for Christian missionary and pastoral activity in the surrounding area, it would be natural to assume that Celtic monasteries became established in the wake of an Irish colonization.

It might be useful to review a few sites, to give some sense of the very fragmentary nature of the surviving evidence. We can begin with Whithorn, where recent major archaeological excavations have greatly increased our knowledge, bringing to light signs of Anglian occupation.[243] The physical and literary evidence for the continuity of the cult of St. Ninian through this period (and right into Alcuin's time) favors the hypothesis that the Northumbrians took over an already existing Celtic monastery. John MacQueen's analysis of literary texts concerning Nynia also favors such a conclusion, since he has shown that an earlier Celtic *Vita* of Nynia received modifications and additions from Northumbrian hands.[244] This may be the place to recall the mention earlier in this essay of Vatican codex Palatinus latinus 68, a manuscript in which a similar blend of Celtic and Northumbrian features can be discerned, suggesting that it, too, might belong to this period and to this general region.[245]

Charles Thomas has interpreted the archaeological data at Ardwall Isle, Kirkcudbright ("Kirk of Cuthbert"), as further evidence of Irish influence, antedating the Northumbrian takeover.[246] The site, thought to have been a hermitage at one stage of its development, was possibly linked with a former Celtic monastery close to Kirkcudbright, for which there may be some literary evidence in the life of St. Aelred.[247] Hermitages linked to monasteries were also part of the Northumbrian monasticism of Lindisfarne which had its roots, through Iona, in the Irish tradition.

[242] Southwest Scotland is completely absent from the section entitled "Celtic foundations surviving into the medieval period" of D. E. Easton's, *Medieval Religious Houses, Scotland*, London (1957), 190–193. On some of the problems see A. Macdonald, "Major Early Monasteries: Some Procedural Problems for Field Archaeologists," in *Studies in Scottish Antiquity Presented to Stewart Cruden*, ed. D. J. Breeze, Edinburgh (1984), 69–86; also, C. A. Ralegh Radford, "The Early Church in Strathclyde and Galloway," *Medieval Archaeology* xi (1967), 105–126.

[243] For a good brief survey of the recent work see P. Hill, "Whithorn," *Current Archaeology*, no. 110 (1988), 85ff.

[244] MacQueen (as in n. 206), 4–6.

[245] Above at n. 126 and n. 128.

[246] C. Thomas, "An Early Christian Cemetery and Chapel on Ardwall Isle, Kirkcudbright," *Medieval Archaeology* xi (1967), 127–188. This article also deals with linguistic evidence showing Irish presence in the region.

[247] It occurs in Reginald of Durham's account of the visit in 1164 of Aelred of Rievaulx to Kirkcudbright, when as part of the local celebrations of St. Cuthbert's feast he disapprovingly watched a ferocious bull being chased around the cemetery grounds by "Scollofthes," young clerics belonging to the church of St. Cuthbert (*Libellus de admirandis beati Cuthberti virtutibus*, Surtees Society 1, chapters 84–85, [1835], 177–180). The "Scollofthes" have been interpreted as putative remnants of a Celtic community attached to the church of St. Cuthbert.

Closer to Ruthwell we have Hoddom, situated near the old Roman Fort of Birrens, less than ten miles both from the coast and from Ruthwell. Hoddom's name (*Hodelme*) occurs in the Inquisitio of Earl David, a document drawn up about 1124 A.D., which lists the lands in Cumbria to which the episcopal See of Glasgow laid claim (*regio inter Angliam et Scotiam sitam*).[248] Proof that Hoddom had once been an Anglian monastery rests on the archaeological evidence of a stone church, recognizably Anglo-Saxon in construction,[249] combined with fragments of an impressive series of stone crosses locally produced.[250] We do not know to whom the church was dedicated, nor whether any of the crosses had originally been housed within its walls. Their date is uncertain and their design may reflect links with centers other than the ones from which the Ruthwell and Bewcastle monuments derive.[251]

It was once thought that evidence for the existence of a monastic site at Hoddom prior to the arrival of the Northumbrians could be found in the story of St. Kentigern, but Jackson's meticulous analysis of the literary sources has shown that the allusions to Hoddom, as the episcopal see of St. Kentigern, are quite likely the invention of the saint's twelfth-century biographer, Jocelyn of Furness;[252] both Lives of Kentigern date from this period, when the cult of the saint was being very actively promoted. What these *Vitae* do show is how the production of saints' Lives and the promotion of the saint's cult went hand in hand, as was suggested earlier in connection with St. Cuthbert.[253] In the case of Cuthbert, however, the monk of Lindisfarne and Bede were much better informed about Cuthbert's doings than were the two twelfth-century writers about their sixth-century hero. Other evidence, however,

[248] See Sir A. C. Lawrie, *Early Scottish Charters Prior to A.D. 1153*, Glasgow (1905), 46.

[249] All that now remains above ground is a churchyard. Traces of the early church were first discovered in the course of digging a grave: see *The Royal Commission on Ancient and Historical Monuments and Constructions of Scotland, Seventh Report*, Edinburgh (1920), 93–94. Later it was ascertained that the chancel was not original but an added feature: see C. A. Ralegh Radford, "Hoddom," *Transactions of the Dumfriesshire and Galloway Natural History and Antiquarian Society*, 3rd ser., xxxi (1952–53), 174–197; idem, "Hoddom," *Antiquity* xxvii (1953), 153ff. Ralegh Radford (1952–53), 181, reports that all the stones of the nave wall represented reused Roman material from nearby Fort Birrens, and that "the megalithic quoins and the consistent reuse of Roman stones set in courses is typical of a number of early Northumbrian churches, such as Jarrow and Escomb, both dating from ca. A.D. 700. The nave at Hoddom should belong to the same period." The length of this Anglian nave is unknown but its width was 18 feet, 6 inches, a figure that can be used for comparison with that of Ruthwell (see above at n. 221).

[250] Apart from some small fragments in the Dumfries Museum only a photographic record of the main pieces of the Hoddom crosses survives. A. M. T. Maxwell-Irving, "Hoddom Castle: a Reappraisal of its Architecture and Place in History," *Proceedings of the Society of Antiquarians of Scotland* cxvii (1987), 213 n. 1, records that "the finer pieces, including parts of more than one great preaching cross were tragically buried under the east drive at Hoddom Castle during its occupation by the army in World War II. According to the testimony of Walter Bell, who actually drove the road roller, the Pioneer Corps delivered a lorry load of stones, including 'stones bearing strange symbols and writing,' and these were used to add about a yard to the north side of the drive prior to the arrival of a vast number of Churchill tanks. The carved stones were buried 'about 150 yards before the drawbridge'."

[251] See the comments of R. Cramp in her General Introduction, *Corpus of Anglo-Saxon Stone Sculpture in England*, II, London (1988), 20.

[252] K. H. Jackson, "The Sources for the Life of St. Kentigern," in *Studies in the Early British Church*, ed. N. K. Chadwick et al., Cambridge (1958), 320–321: "This shows plainly that the story does not come down as a genuine tradition from Kentigern's own time, and supports the view that the whole concept of Kentigern's see at Hoddom is a later and spurious invention."

[253] See above at n. 212.

supports the existence of a monastic settlement of the Celtic type at Hoddom, although—since it involves the presence of a stone church—it is not clear whether it predates the Anglian occupation, or simply reflects the Celtic aspect of the Northumbrian monastic community that settled there in Anglian times.[254]

Let us now consider Ruthwell itself. An aerial photograph taken in 1978 showed a large ring enclosure close to and including part of the present churchyard. Limited excavations carried out in 1980 and 1984 revealed what may be a large Dark Age site, or an enclosure used for iron-working, connected with the Roman occupation of the Wall.[255] Evidence for a Christian presence at Ruthwell in the post-Roman period may be found in a cross-incised slab[256] and in some white quartz pebbles that were found in the excavations; similar white pebbles have been found on the Isle of Man in early Christian contexts.[257] In his report on Christian burials at Whithorn,[258] Peter Hill states that "almost all the graves have produced white quartz pebbles and cattle teeth which seem to have been included as symbols of purity or lucky charms." In this connection we should note that Apocalypse 2:17 reads: "To him who conquers I will give some of the hidden manna, and I will give him a white stone, with a new name written on the stone, which no one knows except him who receives it." Bede appears to be alluding to the practice of Christians using white pebbles, in a context which he does not clarify, when he writes: "although you may write the name of the devil on a white stone, nevertheless he [the devil] signifies the uttermost darkness." Whether these elements would suffice to establish the existence of a Celtic community at Ruthwell prior to the arrival of the Northumbrians is unclear. A much wider archaeological exploration of the area would no doubt produce further evidence.

Because the style in which the stone was carved evoked Mediterranean rather than Celtic art, Saxl was prepared to see in the Ruthwell cross a monument set up by the "Roman" church, aiming—in the image of the archer—a warning to all its enemies, Celts and heretics alike.[259] Cramp echoes this theme, since she writes of the Ruthwell cross as having a

[254] C. Crowe, "Looking for a Monastery at Hoddom," *Popular Archaeology* IV (1982), 34–36, discusses the significance of the ring ditch and the results of the resistivity survey conducted in 1981. We can dismiss the argument for a Celtic background put forward by Ralegh Radford (1952–53) (as in n. 249), 183 based on Uduard of Hoddom's surrender of his rights to Hoddom, in 1202, *per librum*. Radford thought this phrase should "inevitably recall the illuminated Gospels of the early Celtic church, which were closely associated with the founder." But other documents in the *Registrum Episcopatus Glasguensis*, ed. C. Innes, Edinburgh (1843) not noticed by Radford, show that the renunciation of rights by placing the hand on a Gospel book was the common practice of the period (see, for example, *Registrum* 112, document 131).

[255] See C. Crowe, "Excavations at Ruthwell, Dumfries, 1980 and 1984," *Transactions of the Dumfriesshire and Galloway Natural History and Antiquarian Society*, 3rd ser., LXII (1987), 40–47.

[256] C. A. Ralegh Radford, "An Early Cross at Ruthwell," *Transactions of the Dumfiesshire and Galloway Natural History and Antiquarian Society*, 3rd ser., XXVIII (1949–50), 158–160.

[257] C. Crowe, "A Note on White Quartz Pebbles Found in Early Christian Contexts on the Isle of Man," *Proceedings of the Isle of Man Natural History and Antiquarian Society* VIII (1982), 413–415. Crowe states that he had found similar pebbles during the excavation at Ruthwell in 1980.

[258] Cited above at n. 243.

[259] Saxl (1943), 7. Schapiro (1944), 240–245, takes a diametrically opposite view: for him the cross represents monks celebrating the Celtic eremitical ideal in defiance of Rome. Both views lack a sound historical basis. The Northumbrian monastic communities associated with the Anglian penetration into this part of Scotland were rooted in the Celtic monastic

"propaganda" value for the "Roman" church in Northumbria.[260] In what aspect of the cross does the "propaganda" value lie? As regards its sculptural style, there seems agreement that Ruthwell belongs to the very initial stages of free-standing stone crosses. We are therefore still close to the beginning of carved stone work done by masons whose only training was in a "Mediterranean" idiom. Style, by itself, can provide a message if there exist a variety of styles from which to choose, and if one style is deliberately chosen over others. Comparing the manuscript production of Lindisfarne and other Insular houses with that of Wearmouth-Jarrow, one is justified in saying that Bede's monastery preferred the Mediterranean "Roman" script and style, and that therefore some "propaganda" value attaches to this choice. If, at the time the Ruthwell cross was shaped, the ecclesiastical landscape had been dotted with Iona or Irish-type stone crosses, there might be grounds for a value judgment. But if all the other stone carving is later, no such conclusion can be reached. In other words the "Mediterranean" style, viewed in this historical context, can hardly possess a "propaganda" value.

There is one element, perhaps, in the physical design of the Ruthwell cross that may have a bearing on the "Roman" issue. As we have noted,[261] the figures of Christ and the man born blind on the *Ecclesia* side occupy only the upper half of their panel; the lower half has been left blank, as if intended to carry an inscription of some kind. This can hardly have been a commemorative or dedicatory inscription, meant to endure as a permanent record; such an inscription, like the one on the Bewcastle cross, would surely have been incised in the stone. It looks rather as if the space were intended to hold a piece of parchment or a wooden panel that needed to be periodically renewed. At this time, and in this region, what aspect of religious practice could have been of greater concern than the celebration on their proper dates of major feasts, especially Easter, since this was the most obvious and painful of the issues on which those following Rome and Whitby differed from others whose allegiance was to Columba and Celtic practice?

We have no written source testifying to the ecclesiastical or liturgical allegiances of the region. But both in Bede's *Ecclesiastical History* and in his *Vita Cuthberti* there are telling comments. In the *History*, in the summation given at the end, he writes (immediately after mentioning Pecthelm):

> The Picts at this time are in alliance and at peace with the English people, and rejoice in being united in peace and truth with the universal church. The Irish who inhabit Britain are satisfied with their own territories, and plot no treachery or guile against the English people. The British, although they are, for the most part, averse to the English people through native hatred, and although they oppose, wrongfully and from wicked custom, the appointed Easter of the whole Catholic church, can in neither case prevail as they desire; for both Divine and human power entirely withstand them. For although in part they

traditions and ideals of Lindisfarne. Yet no doubt they too adhered to the "Roman" date of Easter decreed at Whitby. The Ruthwell cross is neither a monument erected as an act of defiance of Rome, nor a Roman monument set up to defy the Celtic tradition. It simply reflects the rich and complex Christian monastic traditions of the period and the community that gave it birth.

[260] See R. Cramp, "The Bewcastle Cross and its Context," in Bailey and Cramp (1988), 21.

[261] See p. 110.

are their own masters, yet to some extent they have been brought under subjection to the English.[262]

The Northumbrians were obviously meeting pockets of resistance to the decisions of Whitby in their newly conquered territories. This seems confirmed by the words Bede's Life puts into the mouth of the dying Cuthbert. In Bede's scenario Cuthbert is warning his own community, but it is obvious that Bede has the wider audience in mind among whom he knows his work will circulate:

> Have no communion with those who depart from the unity of the catholic peace, either in failing to celebrate Easter at the proper time, or in evil living. And you are to know and remember that if necessity compels you to choose one of two evils, I would much rather you should take my bones from the tomb, carry them with you and departing from this place dwell wherever God may ordain, than that you should consent in any way to iniquity, and put your necks under the yoke of schismatics.[263]

Was Bede aware that monks from the Lindisfarne communities were moving into new territories, perhaps taking a few relics of their patron with them? One can understand the decision to set up new Anglian monastic communities, in addition to establishing a new see at Whithorn, particularly if there were Christian communities in the newly conquered territories that were indifferent or hostile to the decisions of Whitby on the date of Easter. The figure of the man born blind who was healed and saw the light must have seemed an apposite image below which to insert a panel that, each year, would remind the local community of the day on which the universal, catholic, and Roman church celebrated the Lord's resurrection.

For the rest, too much stress should not be laid on the word "Roman" at this period. King Oswiu's decision at Whitby to opt for Peter rather than Columba in establishing the date of Easter should not be equated with the policy later adopted by Carolingian rulers imposing uniformity of Roman-liturgical and Benedictine-monastic usage within their realm, in the interest of unity. It would be anachronistic to consider that Whitby changed Lindisfarne from a Celtic-Northumbrian into an Italo-Northumbrian house, and resulted in giving the contemporary church in Northumbria an "ultramontane" bent that imbued it with a strong desire to implement at home every liturgical innovation the bishop of Rome might decree for his own city. We do not need Pope Sergius' injunction to his clergy on singing the *Agnus Dei* at Mass to explain the Apocalypse image of the Lamb on the Ruthwell cross, any more than we need it to explain the Apocalypse Lamb in the vault of San Vitale at Ravenna. Apocalypse imagery had been in circulation for centuries, and we know it was present—as a model from which to borrow—in Northumbria, on the north wall of St. Peter's church at Wearmouth. The Anglian advance into Dumfriesshire and Galloway was more Northumbrian than "Roman"; the churches erected were dedicated not to St. Peter but to St. Cuthbert. Heaven, in the person of St. Michael, had objected to the number of churches Wilfrid was dedicating to St. Peter and St. Andrew in Northumbria and had pleaded that he not forget to

[262] Bede, *Historia Ecclesiastica* (as in n. 32), V.23, 351.
[263] Bede, *Vita Cuthberti* (as in n. 204), 284–285.

dedicate one to the Virgin.[264] But there is no evidence that the heavenly bureaucracy was dissatisfied with the numerous dedications to Cuthbert, or wished to eliminate any of them in favor of Peter.

It seems safe to assert that the Ruthwell cross was conceived by a Northumbrian monk, brought up in the Lindisfarne tradition, who was familiar with the works of Bede. From the chronological point of view this presents no problem, since Bede died in 735 A.D., and the cross, as noted above,[265] can hardly be much earlier. It would be surprising, moreover, if the Lindisfarne community, or some of its offshoots in Northumbria, were not in possession of Bede's works by this date, and prepared to treasure his sayings. On the other hand, one must remember that the picture could also be reversed. For, in addition to drawing on earlier patristic works, much of what Bede writes must reflect, not only his own personal thoughts, but also a store of meditations on Scripture, orally transmitted, and circulating among the monasteries of his day. Bede's sayings, in this case, would be less a direct source than a valid witness to what he had heard others say—either at Wearmouth, Lindisfarne, Hexham or elsewhere.

It would be difficult, nevertheless, to think of Bede as the main designer of the Ruthwell cross, principally because of the panel—with its inscription—depicting Christ upon the beasts. This panel with its pacific beasts, seen in association with the panels immediately above and below it, places us in a line of Irish exegetical tradition of which Bede can hardly have been unaware, but which he chose not to adopt. Do we need to look beyond the Lindisfarne tradition, so closely linked, through Iona, to Ireland to explain these panels? Or should we envisage a Celtic monastic community absorbed, like that of Whithorn, by the Anglian advance along the banks of the Solway Firth? No firm answer can be given, since we lack the basic materials to inform us. It would be particularly helpful to know more about the library contents and the liturgical traditions of the Lindisfarne houses. What works of Augustine, Gregory and Cassiodorus did they possess? Did any of these monasteries share the rite of *cofractio*, which was practiced at Iona down into Adamnan's day?

As regards the runic verses—linked to the Old English *Dream of the Rood*—that are incised around the borders enclosing the inhabited vine-scroll, and that loom so large in the literature on the Ruthwell cross, nothing has been said in the preceding pages. This is only because I consider these verses to be a later addition, which did not influence the original design and iconography of the cross.[266] I have encountered no new evidence, or serious criticism of

[264] Eddius, *Vita Wilfridi* c. 56, ed. B. Colgrave, Cambridge (1927), 122–23.

[265] See above pp. 147–150.

[266] See Meyvaert (1982), 23–26. To the comments made there on p. 25 I would only add that since the original plan included borders on the two sides with Latin inscriptions, the need for symmetry in the overall design of the cross would have called for similar borders on the sides with the inhabited vine-scroll. The runic carver saw his opportunity to add the Old English verses on these blank borders. The runic inscription that once occupied the upper stone of the cross, of which now only a few runes remain (see Pls. 31–32), was laid out in exactly the same manner as the Latin inscriptions, thus indicating that it belongs to the original carving, done before the cross was erected. The problem is to explain how the runes on the shaft came to be incised so differently. Ó Carragáin (1987–88), 9, has recently suggested that the new procedure was intended to facilitate reading and prevent the Ruthwell community from getting the crick in the neck that would have resulted, had the runes been incised in the same way as the Latin letters. But anyone who peruses the numerous illustrations of runic

the argument I presented in 1982, to prompt me to change my opinion on this point. On the contrary, an even broader survey of the manner in which runic inscriptions were displayed through the centuries, always with a view to legibility, has kept me convinced that the lay-out at Ruthwell is a total anomaly demanding a very different kind of explanation. The explanation put forward in 1982—which has since been accepted by others[267]—still seems to me the most logical and reasonable one, namely, that the cross was no longer lying flat, in sections, in the stonemason's workyard, but was standing erect in the church, when the runes came to be incised upon it.

The presence of these verses, however, has a close link with the cultural context of the cross. They must have been added within the period during which Northumbria maintained its ascendancy in the region. The very use of runes for such a long inscription—"the most sustained piece of runic carving in Anglo-Saxon England" according to R. I. Page—suggests, moreover, a period of "runic literacy" before the adaptation of the Latin alphabet to writing Old English had reached its mature stage.[268] A date in the eighth century seems more likely than one in the ninth, but this is a question that is best left to the experts in linguistics.

The Ruthwell cross remains a monument ready to challenge all who seriously wish to study it. Does the present reconstruction reproduce its structure and appearance in 1642 when the iconoclasts pulled it down, or does an alternative arrangement better express the original design? How can the ideas that helped to shape this original design be recaptured? We are presented, for the most part, with images or words drawn from Scripture. Anyone who has spent much time with the Scriptural commentaries of the patristic period—and I include Bede's commentaries in their number—is aware of the overwhelming amount of material they contain. When so many possibilities of interpretation present themselves, one can never be sure that the interpretation appearing most attractive is actually or necessarily the operative one. If so many possibilities seem open to us as we read through the volumes of Augustine, Gregory, Cassiodorus or Bede, should we perhaps conclude that all these meanings were pertinent for those who planned the cross? For some time it has seemed to me that this was unlikely; that it was more natural to suppose that a simple and straightforward idea commanded the choice of the panels on each face. Once I had rearranged the order of the panels by reversing the cross-head, I discovered that a new unity had emerged on each of the

monuments—some with very long inscriptions—shown in E. Moltke, *Runes and their Origin, Denmark and Elsewhere*, Copenhagen (1985) will have to conclude that the runes on the Ruthwell shaft represent a complete anomaly, demanding some explanation unrelated to legibility or twisted necks. My own explanation was to suggest that the tall cross was already standing when the decision was made to add the runic verses.

[267] See Stanley (1987).

[268] See the interesting article by R. Derolez, "Runic Literacy Among the Anglo-Saxons," in *Britain 400–600: Language and History*, ed. A. Bammesberger and A. Wollmann, Heidelberg (1990), 397–436. Derolez raises the question of whether surviving inscriptions are transliterations into runic of texts originally written in Old English with the roman alphabet: "Thus the relations between the Dream of the Rood and the runic 'quotation' from it on the Ruthwell cross depends also on whether one believes the Urtext to have been written in runes or in roman; and if one believes the latter is more likely, one will have to explain why the runic transcript approximates the phonology of Old English more closely than was customary in roman (e.g., as far as distinguishing palatal and velar c and g goes)" (402–403). For an analysis of the Ruthwell runes see King (1986).

cross' two faces. A series of texts linked the images on one face with the theme *Ecclesia*, while another series of texts linked the images on the other face with *Vita monastica*. Have I found the key to the Ruthwell monument, solving all its enigmas and anomalies? It would be foolhardy to make such a claim. I hope at least to have presented a new perspective on this justly famous monument, which I now submit to the scrutiny of others.

A Bibliography of the Ruthwell Cross

•

COMPILED BY

BRENDAN CASSIDY AND KATHERINE KIEFER

T HIS BIBLIOGRAPHY does not make claims to be comprehensive; in particular there is an extensive literature on "The Dream of the Rood," much of which mentions the cross in passing. Not all of this literature has been surveyed. Page numbers in parentheses refer to specific pages in an article in which reference to the cross may be found. Items marked with an asterisk are those we have not seen. We should like to thank the following for drawing our attention to works we might otherwise have missed: Paul Meyvaert, Éamonn Ó Carragáin, and Christopher Moss.

| Åberg, N. (1943) | *The Occident and the Orient in the Art of the Seventh Century*, vol. I, *The British Isles* (Kungliga Vitterhets Historie och Antikvitets Akademiens Handlingar, 56:1), Stockholm: 48–50. |

| Adcock, G. (1974) | *A Study of the Types of Interlace on Northumbrian Sculpture* (M. Phil. thesis, Durham University).* |

| Ålund, E. (1904) | *Runorna i Norden*, Stockholm: 17.* |

| Amos, A. C. (1980) | *Linguistic Means of Determining the Dates of Old English Literary Texts* (Medieval Academy Books, no. 90), Cambridge, Mass.: 105–106. |

| Anderson, G. K. (1935) | "Some Irregular Uses of the Instrumental Case in Old English," *Publications of the Modern Language Association of America* L (no. 4), 946–956 (951). |

| Anderson, G. K. (1949) | *The Literature of the Anglo-Saxons*, Princeton: 140–141, 152nn, 202nn; revised ed. (1966). |

| Anderson, J. (1881) | *Scotland in Early Christian Times*, second series (The Rhind Lectures in Archaeology for 1880), Edinburgh: 232–246. |

| [Anon.] (1887) | "Antiquarian Intelligence: The Runic Cross at Ruthwell, Dumfriesshire," *Journal of the British Archaeological Association* XLIII, 414. |

| [Anon.] (1921) | "Early Northumbrian Art" (review of: G. Baldwin Brown [1921], *The Arts in Early England*, vol. V, *The Ruthwell and Bewcastle Crosses, the* |

Gospels of Lindisfarne, and Other Christian Monuments of Northumbria), in *The Times Literary Supplement* xx (no. 1005) 21 April 1921, 253.

Arntz, H. (1935) — *Handbuch der Runenkunde* (Sammlung kurzer Grammatiken germanischer Dialekte, supplemental series, no. 2, ed. K. Helm), Halle: 147, 149, 208, 227; 2nd ed. (1944): 124, 210.

Arntz, H. (1938) — *Die Runenschrift. Ihre Geschichte und ihre Denkmäler*, Halle: 76–77.

A[stley], H. J. D. (1921) — Review of: G. Baldwin Brown (1921), *The Arts in Early England*, vol. V, *The Ruthwell and Bewcastle Crosses, the Gospels of Lindisfarne, and Other Christian Monuments of Northumbria*, in *The Journal of the British Archaeological Association*, new ser., xxvii, 238–244.

Baecker, L. de (1857) — *Sagas du Nord*, Paris: 225ff., appendix 1.*

Baeksted, A. (1943) — *Runerne. Deres Historie og Brug*, Copenhagen: 45.

Bailey, R. N. (1980) — *Viking Age Sculpture in Northern England* (Collins Archaeology), London: 46, 77, 81, 83, 263.

Bailey, R. N. and R. Cramp (1988) — *Corpus of Anglo-Saxon Stone Sculpture*, vol. II, *Cumberland, Westmorland and Lancashire North-of-the-Sands*, with contributions by R. I. Page and D. L. Schofield, Oxford: 11, 15, 17, 19–21, 65, 67–71, 128.

Baird, J. L. (1984–86) — "'Natura plangens', the Ruthwell Cross and 'The Dream of the Rood'," *Studies in Iconography* x, 37–51.

Baldwin Brown, G. (1916) — "Was the Anglo-Saxon an Artist?" *Archaeological Journal*, 2nd ser., lxxiii, 171–194 (172, 187, 189–194).

Baldwin Brown, G. (1918–19) — "The Hartlepool Tombstones and the Relations between Celtic and Teutonic Art in the Early Christian Period," *Proceedings of the Society of Antiquaries of Scotland* liii (5th ser., v), 195–228 (195, 228).

Baldwin Brown, G. (1921) — *The Arts in Early England*, vol. V, *The Ruthwell and Bewcastle Crosses, the Gospels of Lindisfarne, and Other Christian Monuments of Northumbria*, with philological chapters by A. Blyth Webster, London: 102–305.

Baldwin Brown, G. (1937) — *The Arts in Early England*, vol. VI, part 2, *Anglo-Saxon Sculpture*, prepared for press by E. H. L. Sexton, London: 100, 122, 132–133, 135–136, 151, 169, 174–175, 182, 187, 191, 196, 198–200, 207–209, 278.

Baldwin Brown, G. and W. R. Lethaby (1913) — "The Bewcastle and Ruthwell Crosses," *Burlington Magazine* xxiii, 43–49.

[Baldwin Brown, G. and A. Blyth Webster] (1920) — "Report on the Ruthwell Cross," *The Royal Commission on Ancient and Historical Monuments and Constructions of Scotland, Seventh Report with Inventory of the Monuments and Constructions in the County of Dumfries*, Edinburgh: appendix, 219–286.

Ball, C. (1991) "Inconsistencies in the Main Runic Inscription on the Ruthwell Cross,"
 in *Old English Runes and Their Continental Background*, ed. A. Bam-
 mesberger, Heidelberg: 107–123.

Barbour, J. (1899–1900) "Regarding the Origin of the Ruthwell Cross," *Transactions and Jour-
 nal of the Proceedings of the Dumfriesshire and Galloway Natural His-
 tory Society* xvi, 28–31.

Baum, J. (1930) *Die Malerei und Plastik des Mittelalters*, vol. II, *Deutschland, Frank-
 reich und Britannien* (Handbuch der Kunstwissenschaft), Potsdam:
 61–64, 119, 167.

Baum, J. (1937) *La sculpture figurale en Europe à l'époque mérovingienne*, Paris: 36, 43,
 105–106.

Bazell, C. E. (1940) "Caseforms in –i in the Oldest English Texts," *Modern Language Notes*
 lv (no. 2): 136–139 (136–137).

Beckwith, J. (1966) "A Rediscovered English Reliquary Cross," *Victoria and Albert Mu-
 seum Bulletin* ii, 117–124 (118).

Beckwith, J. (1969) "Reculver, Ruthwell and Bewcastle," in *Kolloquium über frühmittelal-
 terliche Skulptur*, ed. V. Milojčić (Institut für Ur- und Frühgeschichte,
 Universität Heidelberg, Vortragstexte 1968), Mainz: 17–19.

Beckwith, J. (1972) *Ivory Carvings in Early Medieval England*, London: 13 and figs.

Bennett, J. A. W. (1950–51) "The Beginnings of Runic Studies in England," *Saga-Book of the Viking
 Society for Northern Research* xiii (no. 4): 269–283 (270, 272, 276–277,
 281–282).

Bennett, J. A. W. (1982) *Poetry of the Passion. Studies in Twelve Centuries of English Verse*, Ox-
 ford: 1, 4, 18, 183, 201, 231 nn.

Björkman, E. (1917–18) Review of: A. S. Cook (1912), "The Date of the Ruthwell and Bewcastle
 Crosses" and A. S. Cook (1914b), *Some Accounts of the Bewcastle Cross
 between the Years 1607 and 1861*, in *Englische Studien. Organ für eng-
 lische Philologie unter Mitsberucksichtigung des englischen Unterrichs
 auf höheren Schulen* li, 74–80.

Black, G. F. (1887a) "The Ruthwell Cross," *Transactions and Journal of the Proceedings of
 the Dumfriesshire and Galloway Natural History and Antiquarian Soci-
 ety* iv, 123–133.

Black, G. F. (1887b) Letter: "The Ruthwell Cross," *The Academy. A Weekly Review of Lit-
 erature, Science, and Art* xxxii (no. 804), 225.

Bradley, H. (1884) Review of: G. Stephens (1866–67), *The Old-Northern Runic Monu-
 ments of Scandinavia and England*, vol. III, and G. Stephens (1884),
 *Handbook of the Old-Northern Runic Monuments of Scandinavia and
 England*, in *The Academy. A Weekly Review of Literature, Science, and
 Art* xxvi (no. 636), 30–31.

Bradley, S. A. J. (1982) *Anglo-Saxon Poetry. An Anthology of Old English Poems in Prose Translation* (Everyman's Library), London, Melbourne and Toronto: 4–5.

Brandl, A. (1905) "Zum ags. Gedichte 'Traumgesicht vom Kreuze Christi'," *Sitzungsberichte der Königlich Preussischen Akademie der Wissenschaften, Philosophisch-historische Klasse*, part 2, 716–723 (716–717, 719); reprinted in *Forschungen und Charakteristiken, von Alois Brandl zum 80. Geburtstag*, Berlin (1936): 28–35 (28–29, 31).

Brandl, A. (1908) *Geschichte der altenglische Literatur. I Teil. Angelsächsische Periode bis zur Mitte des zwölfen Jahrhunderts* (Pauls Grundriss der germanischen Philologie, II), 2nd ed., Strassburg: 947, 1030–1032.

Brandl, A. (1912) "On the Early Northumbrian Poem, 'A Vision of the Cross of Christ'," *Scottish Historical Review* IX, 139–147 (139–140, 143). English translation and revision of Brandl (1905).

Brandl, A. (1917) "Zur Zeitbestimmung des Kreuzes von Ruthwell," *Archiv für das Studium der neueren Sprachen und Literaturen* CXXXVI (new ser., XXXVI), 150–151.

Brandt-Förster, B. (1978) *Das irische Hochkreuz: Ursprung, Entwicklung, Gestalt*, Stuttgart: 140–142.

Branston, B. (1957) *The Lost Gods of England*, London: 65, 165–169; reprinted (1974).

Brate, E. (1886) "Runologiska spörsmål," *Kongl. Vitterhets Historie och Antiqvitets Akademie, Månadsblad* nos. 169–174, 1–25, 49–84 (24).

Bréhier, L. (1904) *Les origines du crucifix dans l'art religieux*, 53–54; 3rd ed. (1908).

British Museum (1923) *A Guide to the Anglo-Saxon and Foreign Teutonic Antiquities in the Department of British and Mediaeval Antiquities*, London: 13.

Brøndsted, J. (1920) "Nordisk og fremmed Ornamentik i Vikingetiden, med særligt Henblik paa Stiludviklingen i England: en arkaeologisk Afhandling," *Aarboger for Nordisk Oldkyndighed og Historie* III (no. 10): 174, 176–177, 186–187.

Brøndsted, J. (1924) *Early English Ornament: The Sources, Development and Relation to Foreign Styles of Pre-Norman Ornamental Art in England*, trans. A. F. Major, London and Copenhagen: 38–42, 74–81.

Brooke, S. (1892) *The History of Early English Literature: Being the History of English Poetry from Its Beginnings to the Accession of King Alfred*, London: vol. II, 143–146, 287–289.

Browne, G. F. (1885a) "Early Sculptured Stones in England, 1," *Magazine of Art* VIII, 78–82 (78–80).

Browne, G. F. (1885b) "'Scandinavian' or 'Danish' Sculptured Stones Found in London; and Their Bearing on the Supposed 'Scandinavian' or 'Danish' Origin of the Other English Sculptured Stones," *Archaeological Journal* XLII, 251–259 (256).

Browne, G. F. (1890) Letter: "The Date of the Ruthwell Cross," *The Academy. A Weekly Review of Literature, Science, and Art* XXXVII (no. 931) 8 March 1890, 170–171.

Browne, G. F. (1893) *Lessons from Early English Church History*, London: 104–109.

Browne, G. F. (1897) *Theodore and Wilfrith* (Lectures Delivered in St. Paul's in December 1896), London: 235–254.

Browne, G. F. (1899–1901) "Runic and Ogam Characters and Inscriptions in the British Isles," *Notices of the Proceedings at the Meetings of the Members of the Royal Institution of Great Britain* XVI, 164–187 (167–169).

Browne, G. F. (1906) *The Conversion of the Heptarchy. Seven Lectures Given at St. Paul's*, London: 189, 206; revised ed. (1914).

Browne, G. F. (1908) *Alcuin of York. Lectures Delivered in the Cathedral Church of Bristol in 1907 and 1908*, London: 297.

Browne, G. F. (1915) *The Recollections of a Bishop*, London: 215–216.

Browne, G. F. (1915–16) "The Ivory Chair of Maximianus at Ravenna," *Proceedings of the Society of Antiquaries of London*, 2nd ser., XXVIII, 260–261.

Browne, G. F. (1916) *The Ancient Cross Shafts at Bewcastle and Ruthwell* (Enlarged from the Rede Lecture Delivered before the University of Cambridge on 20 May 1916), Cambridge.

Browne, G. F. (1917) "On the Early Lapidary Art and Inscriptions of the English the Irish and the Caledonians," *Journal of the British Archaeological Association*, new ser., XXIII, 141–142 (141).

Bugge, S. (1881–89) *Studier over de nordiske Gude- og Heltesagns Oprindelse*, Christiania: part 1, 42–43, 461–467.

Bugge, S. (1889) *Studien über die Entstehung der nordischen Götter- und Heldensagen*, trans. O. Brenner, Munich: 44–45, 490–491, 493–496. German translation of Bugge (1881–89).

Bugge, S. (1891–1924) *Norges Indskrifter med de ældre Runer* (Norges Indskrifter indtil Reformationen, part 1), Christiania: introduction: 32, 217; vol. I: 118–119, 143, 145–146, 148.

Bülbring, K. D. (1898) Review of: W. Vietor (1895), *Die northumbrischen Runensteine*, in *Anglia. Beiblatt: Mitteilungen aus dem gesamten Gebiete der englischen Sprache und Literatur* IX, 65–78 (65–67, 74–77).

Bülbring, K. D. (1900) Review of: U. Lindelöf, "Glossar zur Altnorthumbrischen Evangelien-übersetzung in der Rushworth-Handschrift," in *Anzeiger für Indogermanische Sprach- und Altertumskunde. Beiblatt zu den Indogermanischen Forschungen* XI, 118–120 (119).

Bundi, A. (1979) "Per la ricostruzione dei passi frammentari dell'iscrizione runica della Croce di Ruthwell," *Annali Istituto Universitario Orientale, Naples (Filologia germanica)* XXII, 21–58.

Burlin, R. B. (1968) "The Ruthwell Cross, *The Dream of the Rood* and the *Vita Contemplativa*," *Studies in Philology* LXV (no. 1), 23–43.

Burrow, J. A. (1959) "An Approach to the *Dream of the Rood*," *Neophilologus* XLIII, 123–133 (130).

Burton, J. H. (1867) *The History of Scotland from Agricola's Invasion to the Revolution of 1688*, Edinburgh and London: vol. I, 161.

Burton, J. H. (1899) *The History of Scotland from Agricola's Invasion to the Extinction of the Last Jacobite Insurrection*, Edinburgh and London: vol. I, 152–153; new edition of J. H. Burton (1867).

Bütow, H. (1935a) *Das altenglische 'Traumgesicht vom Kreuz': Textkritisches, Literaturgeschichtliches, Kunstgeschichtliches* (Anglistische Forschungen, 78), Heidelberg: 19–38, 171–176.

Bütow, H. (1935b) Review of: B. Dickins and A. S. C. Ross, eds. (1934), *The Dream of the Rood*, in *Beiblatt zur Anglia. Mitteilungen über englische Sprache und Literatur und über englischen Unterricht* XLVI, 161–165.

Calverley, W. S. (1883) "The Sculptured Cross at Gosforth, West Cumberland," *Archaeological Journal* XL, 143–158 (156, 158).

Calverley, W. S. (1899) *Notes on the Early Sculptured Crosses, Shrines and Monuments in the Present Diocese of Carlisle*, ed. W. G. Collingwood (Cumberland and Westmorland Antiquarian and Archaeological Society, Extra Series, XI), Kendal: 23–24, 41–43, 163.

Camden, W. (1695) *Camden's Britannia: Or a Chorographical Description of Great Britain and Ireland Together with the Adjacent Islands, Newly Translated into English, with Additions, by Edmund Gibson*, London: 910; 2nd ed. (1722) and 3rd ed. (1753): vol. II, 1195; 4th ed. (1772): vol. II, 268. Facsimile: *Camden's Britannia, 1695*, with introduction by S. Piggott, "William Camden and the Britannia," (reprinted from *The Proceedings of the British Academy* XXXVII [1951], 199–217), New York (1971): 910.

Camden, W. (1789) *Britannia: Or, A Chorographical Description of the Flourishing Kingdoms of England, Scotland, and Ireland, and the Islands Adjacent from the Earliest Antiquity*, enlarged by Richard Gough, London: vol. III, 322ff.; 2nd ed. (1806): vol. IV, 60–61.

Campbell, A. (1959) *Old English Grammar*, London: 4; corrected reprint, Oxford (1964).

Campbell, J., ed. (1982) *The Anglo-Saxons*, Oxford: 74–75, 80–81, 89, 91, 148.

Casieri, S. (1956) *Poemi, frammenti ed iscrizioni anglosassoni*, Varese and Milan: 123–127, 180–181.

Casson, S. (1932) "Byzantine and Anglo-Saxon Sculpture, I," *Burlington Magazine* LXI, 265–274 (267).

Chadwick, H. M. (1894–99) "Studies in Old English," *Transactions of the Cambridge Philological Society* IV (part 2), 118, 174–177, 179; reprinted (1977).

Chalmers, G. (1807) *Caledonia: Or a Historical and Topographical Account of North Britain*, London: 466–467; new ed. (1887).

Champneys, A. C. (1910) *Irish Ecclesiastical Architecture with Some Notice of Similar or Related Work in England, Scotland and Elsewhere*, London: 84, 86–87, 95, Appendix: 218–219, 221–224.

Charlton, J. (1952) "Proceedings of Autumn Meeting 1950 (Summary of Accounts of Bewcastle and Ruthwell Crosses)," *Transactions of the Cumberland and Westmorland Antiquarian and Archaeological Society* LI (new ser.), 191–192, 195.

Childe, V. G. and W. D. Simpson (1952) *Illustrated Guides to Ancient Monuments in the Ownership or Guardianship of the Ministry of Works*, vol. VI, *Scotland*, Edinburgh: 58, 85–85; 2nd ed. (1954).

Chrétien, C. D. (1932) *The Relation of 'The Dream of the Rood' to the Ruthwell Cross and to the Veneration of the Cross* (Ph.D. dissertation, Harvard University).* Abstract in *Harvard University Summaries of Theses, 1933*, 244–246, and P. Pulsiano, *An Annotated Bibliography of North American Doctoral Dissertations on Old English Language and Literature* (Medieval Texts and Studies, 3), East Lansing, Mich. (1988): 178.

Church of Scotland (1682) *Acts of the General Assemblies of the Church of Scotland Beginning at the Assembly Holden at Glasgow the 27. Day of November 1638; and Ending at the Assembly, Holden at Edinburgh the 6. Day of August 1649*, [printed abroad]: 92–93.

Church of Scotland (1691) *The Acts of the General Assemblies of the Church of Scotland from the Year 1638 to the Year 1649 Inclusive, to Which are Now Added the Index of the Unprinted Acts of these Assemblies*, Edinburgh: index p. 4.

Church of Scotland (1838) *Records of the Kirk of Scotland, Containing the Acts and Proceedings of the General Assemblies from the Year 1638 Downwards, as Authenticated by the Clerks of Assembly; with Notes and Historical Illustrations*, ed. A. Peterkin, vol. I, Edinburgh: 279, 333.

Church of Scotland (1843) *Acts of the General Assembly of the Church of Scotland, M.DC.XXX-VIII.-M.DCCC.XLII. Reprinted from the Original Edition, Under the Superintendence of the Church Law Society*, Edinburgh: 44.

Clapham, A. W. (1930) *English Romanesque Architecture*, vol. I, *Before the Conquest*, Oxford: 56–57, 60, 63, 68, 138nn.

Clark, C. (1807) "Farther Observations on Crosses," in J. Britton, "An Essay Towards a History and Description of Ancient Stone Crosses," in *The Architectural Antiquities of Great Britain, Represented and Illustrated in a Series of Views, Elevations, Plans, Sections, and Details of Various English Edifices: with Historical and Descriptive Accounts of Each*, London: vol. I, signature N, 29–34 (30); reprinted (1835): 87–94 (89).

Clayton, M. (1990) *The Cult of the Virgin Mary in Anglo-Saxon England* (Cambridge Studies in Anglo-Saxon England, 2), Cambridge: 150–151.

Clemen, P. (1892) "Merowingische und karolingische Plastik," *Jahrbücher des Vereins von Alterthumsfreunde im Rheinlande (Bonner Jahrbücher)* XCII, 1–147 (89).

Cloquet, L. (1903) "La Ruthwell Cross," *Revue de l'art chrétien* XLVI, 4th ser., XIV, 56–57.

Coatsworth, E. (1978) *The Iconography of the Crucifixion in Pre-Conquest Sculpture in England* (Ph.D. dissertation, Durham University).*

Coatsworth, E. (1980) "The Decoration of the Durham Gospels," in *The Durham Gospels together with Fragments of a Gospel Book in Uncial*, ed. C. D. Verey, T. J. Brown and E. Coatsworth, Early English Manuscripts in Facsimile, 20: 53–67 (61).

Coatsworth, E. (1988) "Late Pre-Conquest Sculptures with the Crucifixion South of the Humber," in *Bishop Aethelwold: His Career and Influence*, ed. B. Yorke, Woodbridge, Suffolk and Wolfeboro, N.H.: 161–193 (183, 185).

Collingwood, W. G. (1901) "Remains of the Pre-Norman Period," in *The Victoria History of the Counties of England: Cumberland*, vol. I, ed. J. Wilson, Westminster: 254–257.

Collingwood, W. G. (1904) "[On Bewcastle Cross]," *Proceedings of the Society of Antiquaries of Newcastle-upon-Tyne*, 3rd ser., I (no. 25), 219–233 (223).

Collingwood, W. G. (1907) "Some Illustrations of the Archaeology of the Viking Age in England," *Saga-Book of the Viking Club* V (no. 1), 110–141 (119–120).

Collingwood, W. G. (1913a) "On a Group of Northumbrian Crosses," *The Antiquary. A Magazine Devoted to the Study of the Past* XLIX, 167–173 (167–168).

C[ollingwood], W. G. (1913b) "Ruthwell and Bewcastle Crosses," *Yorkshire Archaeological Journal* XXII, 294–295.

Collingwood, W. G. (1915) "Notes on Early Crosses at Carlisle, Bewcastle and Beckermet," *Transactions of the Cumberland and Westmorland Antiquarian and Archaeological Society*, new ser., xv, 125–131 (127–128).

Collingwood, W. G. (1918) "The Ruthwell Cross in Its Relation to Other Monuments of the Early Christian Age," *Transactions and Journal of the Proceedings of the Dumfriesshire and Galloway Natural History and Antiquarian Society*, 3rd ser., v, 34–84.

Collingwood, W. G. (1925) "Early Carved Stones at Hexham," *Archaeologia Aeliana: Or, Miscellaneous Tracts Relating to Antiquity*, 4th ser., i, 65–92 (72–73, 83).

Collingwood, W. G. (1927) *Northumbrian Crosses of the Pre-Norman Age*, London: 69–71, 84–86, 112–114, 118–119.

Collingwood, W. G. (1932) "A Pedigree of Anglian Crosses," *Antiquity* vi, 35–54 (44–48).

Conway, M. (1912) "The Bewcastle and Ruthwell Crosses," *Burlington Magazine* xxi, 193–194.

Conway, M. (1913–14) "A Dangerous Archaeological Method, II" *Burlington Magazine* xxiv, 85–89.

Conway, M. (1915–16) "[Notes for 4 May, 1916]," *Proceedings of the Society of Antiquaries of London*, 2nd ser., xxviii, 203.

Cook, A. S. (1890a) "Caedmon and the Ruthwell Cross," *Modern Language Notes* v, 77–78, cols. 153–155; reprinted 1967.

Cook, A. S. (1890b) Letter: "The Date of the Ruthwell Cross," *The Academy. A Weekly Review of Literature, Science, and Art* xxxvii (no. 930) 1 March 1890, 153–154.

Cook, A. S. (1902) "Notes on the Ruthwell Cross," *Publications of the Modern Language Association of America* xvii (new ser., x), 367–390.

Cook, A. S. (1905) *The Dream of the Rood. An Old English Poem Attributed to Cynewulf*, Oxford: ix–xvii, xlvi.

Cook, A. S. (1912) "The Date of the Ruthwell and Bewcastle Crosses," *Transactions of the Connecticut Academy of Arts and Sciences* xvii (December), 213–361.

Cook, A. S. (1913) *The Bewcastle Cross* (read before the Modern Language Association of America, at Cornell University, Dec. 29, 1909), New Haven: 3–5, 7.

Cook, A. S. (1914a) "Layamon's Knowledge of Runic Inscriptions," *Scottish Historical Review* xi, 370–375 (370, 375).

Cook, A. S. (1914b) *Some Accounts of the Bewcastle Cross between the Years 1607 and 1861* (Yale Studies in English, 50), 44, 46–49, 60–61, 63, 70, 108, 123–124. Reprinted in R. T. Farrell, ed. (1977), *The Anglo-Saxon Cross*, with a new preface by R. T. Farrell.

Cook, A. S. (1915a) "Archaic English in the 12th Century," *Scottish Historical Review* XII, 213–215.

Cook, A. S. (1915b) Review of: J. K. Hewison (1914), *The Runic Roods of Ruthwell and Bewcastle*, in *Journal of English and Germanic Philology* XIV, 296–306.

Cook, A. S. (1917) Review of: G. F. Browne (1916), *The Ancient Shafts at Bewcastle and Ruthwell*, in *Modern Language Notes* XXXII, 354–366.

Cook, A. S. (1921) Letter, *The Times Literary Supplement* XX (no. 1015) 30 June 1921, 420.

Craig Gibson, A. (1859) "Runic Inscriptions: Anglo-Saxon and Scandinavian," *Transactions of the Historic Society of Lancashire and Cheshire* XI, 111–152 (120–122).

Cramp, R. (1959–60) "The Anglian Sculptured Crosses of Dumfriesshire," *Transactions of the Dumfriesshire and Galloway Natural History and Antiquarian Society* XXXVII, 9–20 (9–13).

Cramp, R. (1965) *Early Northumbrian Sculpture*, (Jarrow Lecture 1965) Jarrow.

Cramp, R. (1971) "The Position of the Otley Crosses in English Sculpture of the Eighth to Ninth Centuries," in *Kolloquium über spätantike und frühmittelalterliche Skulptur*, vol. II, ed. V. Milojčić (Institut für Ur- und Frühgeschichte, Universität Heidelberg, Vortragstexte 1970), Mainz: 55–63 (57, 59, 62–63).

Cramp, R. (1978) "The Evangelist Symbols and Their Parallels in Anglo-Saxon Sculpture," in *Bede and Anglo-Saxon England. Papers in Honour of the 1300th Anniversary of the Birth of Bede, Given at Cornell University in 1973 and 1974*, ed. R. T. Farrell (British Archaeological Reports, 46), Oxford: 118–130.

Cramp, R. (1984) *Corpus of Anglo-Saxon Stone Sculpture in England*, vol. I, *County Durham and Northumberland*, Oxford: 5nn, 9, 16, 21, 27, 38, 46, 74, 115, 171, 216, 220–221.

Cramp, R. (1986a) "Anglo-Saxon and Italian Sculpture," in *Angli e Sassoni al di qua e al di là del mare* (Settimana di Studio del Centro Italiano di Studi sull'Alto Medioevo, 32), Spoleto: 125–140 (135, 136).

Cramp, R. (1986b) "The Furnishing and Sculptural Decoration of Anglo-Saxon Churches," in *The Anglo-Saxon Church. Papers on History, Architecture, and Archaeology in Honour of Dr. H. M. Taylor*, ed. L. A. S. Butler and R. K. Morris (The Council for British Archaeology, Research Report 60), London: 101–104 (103).

Cramp, R. (1989) "The Artistic Influence of Lindisfarne within Northumbria," in *St. Cuthbert, His Cult and His Community to A.D. 1200*, ed. G. Bonner, D. Rollason, and C. Stancliff, Woodbridge, Suffolk and Wolfeboro, N.H.: 213–228 (216, 223, 225).

Cramp, R. (1991)	"Anglosassoni: scultura," in *Enciclopedia dell'arte medievale*, Rome: vol. 1, 753, 754.
Crowley, J. P. (1986)	"The Study of Old English Dialects," *English Studies* LXVII (no. 2), 97–112 (101–102, 104).
Dahl, I. (1938)	*Substantival Inflexion in Early Old English. Vocalic Stems*, ed. E. Ekwall, Lund: 4–7, 43, 45, 58, 60, 78, 123, 187, 192.
Dalton, O. M. (1911)	*Byzantine Art and Archaeology*, Oxford: 102–103, 236, 672nn.
[Dalton, O. M.] (1921)	*Guide to the Early Christian and Byzantine Antiquities in the Department of British and Medieval Art*, London: 61, 66, 126.
Dalton, O. M. (1925)	*East Christian Art: A Survey of the Monuments*, Oxford: 66–67, 174nn.
D'Ardenne, S. T. R. O. (1939)	"The Old English Inscription on the Brussels Cross," *English Studies. A Journal of English Language and Literature* XXI, 145–164 (148).
Deanesley, M. (1961)	*The Pre-Conquest Church in England*, Oxford: 123, 167, 170–171, 181–182.
Demus, O. (1970)	*Byzantine Art and the West* (The Wrightsman Lectures, 3), New York: 49.
Derolez, R. (1954)	*Runica Manuscripta. The English Tradition* (Rijksuniversiteit te Gent, Werken Uitgegeven Door de Faculteit van de Wijsbegeerte en Letteren, 118), Bruges: xxi–xxii, xxxii, 50, 60, 81, 87.
Derolez, R. (1983)	"Epigraphical versus Manuscript English Runes: One or Two Worlds?" *Mededelingen van de Koninklijke Academie voor Wetenschappen, Letteren en Schone Kunsten van België, Klasse der Letteren* XLV (no. 1), 71–93 (72, 82, 83).
Derolez, R. (1990)	"Runic Literacy among the Anglo-Saxons," in *Britain 400–600: Language and History*, ed. A. Bammesberger and A. Wollman, Heidelberg: 397–436 (421–422).
Dickins, B. (1932)	"A System of Transliteration for Old English Runic Inscriptions," *Leeds Studies in English and Kindred Languages* I, 15–19 (17–18).
Dickins, B. and A. S. C. Ross, eds. (1934)	*The Dream of the Rood* (Methuen's Old English Library, general eds. A. H. Smith and F. Norman), London: 1–13, 38–39 (bibliography); 2nd ed. (1945); 3rd ed. (1954); 4th ed. with additions and corrections (1956); reprinted (1960), New York (1966), London (1967).
Dickins, B. (1939)	"J. M. Kemble and Old English Scholarship (with a Bibliography of His Writings)," (Sir Israel Gollancz Memorial Lecture, read 15 March 1939) *Proceedings of the British Academy* XXV, 51–84 (65–66); reprinted in *British Academy Papers on Anglo-Saxon England*, ed. E. G. Stanley, Oxford (1990): 57–90 (72).

Dieter, F., ed. (1900) *Laut- und Formenlehre der altgermanische Dialekte*, Leipzig: 254.

Dietrich, F. E. C. (1865) *Disputatio de cruce Ruthwellensi et de auctore versuum in illa inscripto-rum qui ad Passionem Domini pertinent*, Marburg: 1–19.

Dinwiddie, J. L. (1909–10) "The Ruthwell Cross and the Story It Has to Tell," *Transactions and Journal of the Proceedings of the Dumfriesshire and Galloway Natural History and Antiquarian Society*, new ser., xxii, 109–121.

Dinwiddie, J. L. (1927) *The Ruthwell Cross and Its Story: A Handbook for Tourists and Students*, Dumfries.

Dinwiddie, J. L. (1933) *The Ruthwell Cross and the Ruthwell Savings Bank: A Handbook for Tourists and Students* (revised edition of J. L. Dinwiddie [1927]), Dumfries.

Dobbie, E. V. K. (1942) *The Anglo-Saxon Minor Poems* (The Anglo-Saxon Poetic Records, 6), New York: introduction: cxviii–cxxiii; bibliography: clxxiv–clxxvi; text: 114–115; notes: 204; reprinted (1968).

Dodwell, C. R. (1982) *Anglo-Saxon Art. A New Perspective*, Ithaca and Manchester: 11, 41, 109, 115, 309nn.

Duncan, H. (1833) "An Account of the Remarkable Monument in the Shape of a Cross, Inscribed with Roman and Runic Letters, Preserved in the Garden of Ruthwell Manse, Dumfriesshire," *Archaeologica Scotica: or, Transactions of the Society of Antiquaries of Scotland*, iv, part 2, 313–326; reprinted (1857).

Duncan, G. J. C. (1848) *Memoir of the Rev. Henry Duncan, D.D., Minister of Ruthwell*, Edinburgh and New York: 148–151.

Eldjárn, K. (1953) "Carved Panels from Flatatunga, Iceland," *Acta Archaeologica* xxiv, 81–101 (95).

Elliott, R. W. V. (1959) *Runes, An Introduction*, Manchester: 19, 36–37, 39, 42, 62, 74, 76, 80, 88–96, 100–102; corrected reprint (1963), reprinted (1971), 2nd ed. (1989).

Enlart, C. (1905) In *Histoire de l'art depuis les premiers temps Chrétiens jusqu'à nos jours*, ed. A. Michel, vol. I, *Des débuts de l'art Chrétien à la fin de la période romane*, part 2, "L'architecture romane," Paris: 521.

Enlart, C. (1906) In *Histoire de l'art depuis les premiers temps Chrétiens jusqu'à nos jours*, ed. A. Michel, vol. II, *Formation, expansion et évolution de l'art gothique*, part 1, "Formation et développement de la sculpture gothique, II: La sculpture en Angleterre," Paris: 202.

Farrell, R. T., ed. (1977) *The Anglo-Saxon Cross*, Hamden, Conn.; reprint of Cook (1914b), *Some Accounts of the Bewcastle Cross between the Years 1607 and 1861*, and Stevens (1904), *The Cross in the Life and Literature of the Anglo-Saxons*, with new introductions.

Farrell, R. T. (1978)	"The Archer and Associated Figures on the Ruthwell Cross—a Reconsideration," in *Bede and Anglo-Saxon England: Papers in Honour of the 1300th Anniversary of the Birth of Bede, Given at Cornell University in 1973 and 1974*, ed. R. T. Farrell (British Archaeological Reports, 46), Oxford: 96–117.
Farrell, R. T. (1986)	"Reflections on the Iconography of the Ruthwell and Bewcastle Crosses," in *Sources of Anglo-Saxon Culture*, ed. P. E. Szarmach with the assistance of V. D. Oggins (Studies in Medieval Culture, 20), Kalamazoo, Mich.: 357–376.
Ferguson, R. (1856)	*The Northmen in Cumberland and Westmorland*, London: 71.
Fleming, J. V. (1966)	"'The Dream of the Rood' and Anglo-Saxon Monasticism," *Traditio* xxii, 43–72 (54).
Forbes, M. D. and B. Dickins (1914)	"The Inscriptions of the Ruthwell and Bewcastle Crosses and the Bridekirk Font," *Burlington Magazine* xxv, 24–29.
Forbes, M. D. and B. Dickins (1915)	"The Ruthwell and Bewcastle Crosses," *Modern Language Review* x, 28–36.
Ford, B., ed. (1988)	*The Cambridge Guide to the Arts in Britain*, vol. I, *Prehistoric, Roman and Early Medieval*, Cambridge: 123, 127, 128–130, 183–184, 215; reprinted as *The Cambridge Cultural History*, vol. I, *Early Britain*, Cambridge (1992).
Fowler, R. (1966)	*Old English Prose and Verse*, London: 97; revised ed. (1973); reprinted (1978).
Friesen, O. von (1933)	*Runorna*, Stockholm: 53–54.
Garde, J. N. (1991)	*Old English Poetry in Medieval Christian Perspective: A Doctrinal Approach*, Cambridge: 90–112 (92).
Gardner, A. (1935)	*A Handbook of English Medieval Sculpture*, Cambridge: 20, 22, 24–26, 30, 31nn.
Gardner, A. (1951)	*English Medieval Sculpture*, Cambridge: 21–22, 25, 28nn; new enlarged ed. of A. Gardner (1935).
Gardner, J. (1975)	*The Construction of Christian Poetry in Old English*, London and Carbondale, Ill.: 98–99.
Garnett, R. (1903)	*English Literature, an Illustrated Record in Four Volumes*, vol. I, *From the Beginnings to Henry VIII*, London: 25.
Göller, K. H. (1971)	*Geschichte der altenglishen Literatur*, with the assistance of U. Böker (Grundlagen der Anglistik und Amerikanistik, 3) Berlin: 112, 116.
Gordon, A. (1726)	*Itinerarium Septentrionale: Or, a Journey thro' most of the Counties of Scotland and Those in the North of England*, London: 160–161, pls. 57–58.

Gough, R. (1789) *Vetusta Monumenta: Quae ad rerum Britannicarum memoriam conser-*
 vandam Societas Antiquariorum Londini sumptu suo edenda curavit,
 London: notes to engravings by A. de Cardonnell, pls. LIV–LV.

Grant, R. J. S. (1991) "'The Dream of the Rood' Line 63b: A Part-time Idiom?" *Neuphilolo-*
 gische Mitteilungen XCII, 289–295 (292, 293).

Grebanier, E. B. D., S. Mid- *English Literature and its Background*, New York: 9; 2nd ed. (1949),
 dlebrook, S. Thompson shorter ed. (1950).
 and W. Watt (1939)

Greenfield, S. B. (1965) *A Critical History of Old English Literature*, New York: 136, 191; sec-
 ond printing, 1968.

Greenfield, S. B. and *A New Critical History of Old English Literature*, with a survey of the
 D. G. Calder (1986) Anglo-Latin background by M. Lapidge, New York: 194, 195, 253.

Greenfield, S. B. and *A Bibliography of Publications on Old English Literature to the End of*
 F. C. Robinson (1980) *1972*, Toronto and London: 265–267.

Grein, C. W. M. (1865) "Notice of Dietrich's Pamphlet, 'Disputatio . . . '," *Literarisches Zen-*
 tralblatt für Deutschland xxv, 660.

Grimm, W. C. (1821) *Ueber deutsche Runen*, Göttingen: 169.

Guinn, L. E. (1959) *English Runes and Runic Writing: The Development of the Runes and*
 their Employment (Ph.D. dissertation, University of Pennsylvania),
 chap. IV, "The Ruthwell and Bewcastle Crosses."* Abstract in P. Pul-
 siano, *An Annotated Bibliography of North American Doctoral Disserta-*
 tions on Old English Language and Literature (Medieval Texts and
 Studies, 3), East Lansing, Mich. (1988): 5–6.

Haigh, D. H. (1857) "The Saxon Cross at Bewcastle," *Archaeologia Aeliana: Or, Miscellane-*
 ous Tracts Relating to Antiquity, new ser., I, 149–195 (167–177, 180,
 183–184).

Haigh, D. H. (1861) *The Conquest of Britain by the Saxons; a Harmony of the "Historia Bri-*
 tonum," the Writings of Gildas, the "Brut," and the Saxon Chronicle,
 with Reference to the Events of the Fifth and Sixth Centuries, London:
 37–41, pl. II.

Hall, S. (1910) *Dr. Duncan of Ruthwell, Founder of Savings Banks*, Edinburgh and
 London: 114–121.

Hammerich, F. (1873) *De episk-kristelige Oldkvad hos de gotiske folk*, Copenhagen: 22–24.*

Hammerich, F. (1874) *Älteste christliche Epik der Angelsächsen, Deutschen und Nordländer*,
 Gütersloh: vi–vii, 32–35, 37–38.*

Haney, K. E. (1985) "The Christ and the Beasts Panel on the Ruthwell Cross," *Anglo-Saxon*
 England XIV, 215–231.

Harbison, P. (1987) "The Date of the Crucifixion Slab from Duvillaun More and Inishkea North, Co. Mayo," in *Figures from the Past. Studies on Figurative Art in Christian Ireland in Honour of Helen M. Roe*, ed. E. Rynne, Dublin: 73–91 (81).

Haverfield, F. (1911) "Cotton Iulius F. VI. Notes on Reginald Bainbrigg of Appleby, on William Camden and on some Roman Inscriptions," *Transactions of the Cumberland and Westmorland Antiquarian and Archaeological Society*, new ser., XI, 343–378 (373–374).

Haverfield, F. and W. Greenwell (1899) *A Catalogue of the Sculptured and Inscribed Stones in the Cathedral Library, Durham*, Durham: 45–47.

Hawkes, J. (1989) "Museum Notes, 1989: 1. The Miracle Scene on the Rothbury Cross-Shaft," *Archaeologia Aeliana*, 5th ser., XVII, 207–211 (207).

Healey, A. di P. (1985) "Anglo-Saxon Use of the Apocryphal Gospel," in *The Anglo-Saxons. Synthesis and Achievement*, ed. J. Douglas Woods and D. A. E. Pelteret, Waterloo, Ontario: 93–104 (103–104).

Hearn, M. F. (1981) *Romanesque Sculpture. The Revival of Monumental Stone Sculpture in the Eleventh and Twelfth Centuries*, Oxford: 22–23.

Henderson, G. (1985) "The John the Baptist Panel on the Ruthwell Cross," *Gesta* XXIV (no. 1), 3–12.

Henry, F. (1933) *La sculpture irlandaise pendant les douze premiers siècles de l'ère chrétienne*, Paris: 62, 65, 109, 130, 145, 164, 182.

Henry, F. (1940) *Irish Art in the Early Christian Period*, London: 82, 174; reprinted (1947).

Henry, F. (1962) *L'art irlandaise*, [La-Pierre-qui-Vire (Yonne)]: 133, 149nn, 150; completely revised ed. of F. Henry (1940); English ed., *Irish Art in the Early Christian Period (to 800 A.D.)*, London and Ithaca, N.Y. (1965).

Hewison, J. K. (1913) "Notes on the Runic Roods of Ruthwell and Bewcastle," *Proceedings of the Society of Antiquaries of Scotland* XLVII, 348–359.

Hewison, J. K. (1914) *The Runic Roods of Ruthwell and Bewcastle with a Short History of the Cross and Crucifix in Scotland*, Glasgow.

Hewison, J. K. (1921) *The Runic Roods of Ruthwell and Bewcastle*, Dumfries.

Hewison, J. K. (1923) *The Romance of the Bewcastle Cross, the Mystery of Alcfrith, and the Myths of Maughan*, Glasgow: 10–12, 52.

Hickes, G. (1703) *Linguarum Veterum Septentrionalium Thesaurus Grammatico-Criticus et Archaeologicus. Pars Tertia: seu Grammaticae Islandicae Rudimenta*, Oxford: tab. IIII, p. 5; facsimile: *English Linguistics, 1500–1800. A Collection of Facsimile Reprints* 248, Menston, Yorks. (1971).

Higgitt, J. (1986)

"Words and Crosses: The Inscribed Stone Cross in Early Medieval Britain and Ireland," in *Early Medieval Sculpture in Britain and Ireland*, ed. J. Higgitt (British Archaeological Reports, British Series, 152), Oxford: 125–152 (126, 130–133, 136–137, 146, 148).

Higgitt, J. (1990)

"The Stone-Cutter and the Scriptorium. Early Medieval Inscriptions in Britain and Ireland," in *Epigraphik 1988. Fachtagung für mittelalterliche und neuzeitliche Epigraphik, Graz, 10–14 Mai 1988*, ed. W. Koch (Österreichische Akademie der Wissenschaften, philosophisch-historische Klass, Denkschriften, Bd. 213), Vienna: 149–162 (156).

Higgitt, J. (forthcoming)

"The Latin Inscriptions on the Ruthwell Cross."*

Hodges, C. C. (1925)

"The Ancient Cross of Rothbury," *Archaeologia Aeliana: Or, Miscellaneous Tracts Relating to Antiquity*, 4th ser., I, 159–168 (161–162, 164–165).

Hodgkin, R. H. (1935)

A History of the Anglo-Saxons, Oxford and London: 362–364; 2nd ed. (1939), 3rd ed. (1952), reprinted (1967).

Hogg, R. M. (1992)

A Grammar of Old English, vol. I, *Phonology*, Oxford and Cambridge, Mass.: 5.

Howlett, D. R. (1974a)

"Three Forms in the Ruthwell Text of 'The Dream of the Rood'," *English Studies. A Journal of English Language and Literature* LV (no. 1), 1–5.

Howlett, D. R. (1974b)

"Two Panels on the Ruthwell Cross," *Journal of the Warburg and Courtauld Institutes* XXXVII, 333–336.

Howlett, D. R. (1976a)

"A Reconstruction of the Ruthwell Crucifixion Poem," *Studia Neophilologica. A Journal of Germanic and Romance Languages and Literature* XLVIII (no. 1), 54–58.

Howlett, D. R. (1976b)

"The Structure of 'The Dream of the Rood'," *Studia Neophilologica. A Journal of Germanic and Romance Languages and Literature* XLVIII (no. 2), 301–306 (303).

Howlett, D. R. (1978)

"Two Notes on 'The Dream of the Rood'," *Studia Neophilologica. A Journal of Germanic and Romance Languages and Literature* L (no. 2), 167–173.

Howorth, H. H. (1914)

"The Great Crosses of the Seventh Century in Northern England," *Archaeological Journal* LXXI (2nd ser., XXI), 45–64.

Howorth, H. H. (1917)

The Golden Days of the Early English Church from the Arrival of Theodore to the Death of Bede, London: vol. III, 269–271, 304–320.

Hubert, J. (1938)

L'art pré-roman, Paris: 157–158.

Hunter Blair, P. (1956)

An Introduction to Anglo-Saxon England, Cambridge: 160, 309.

Huppé, B. (1970) *The Web of Words. Structural Analysis of the Old English Poems Vainglory, The Wonder of Creation, The Dream of the Rood, and Judith*, Albany: 74, 103.

Hutchinson, W. (1794) *History of the County of Cumberland, and Some Places Adjacent, from the Earliest Accounts to the Present*, Carlisle: vol. I, 91–92; reprinted with a new introduction by C. R. Hudleston (Classical County Histories, general ed. J. Simmons) (1974).

Innes, C. (1860) *Scotland in the Middle Ages. Sketches of Early Scottish History and Social Progress*, Edinburgh: 288–289.

Irving, E. B. Jr. (1986) "Crucifixion Witnessed, or Dramatic Interaction in *The Dream of the Rood*," in *Modes of Interpretation in Old English Literature. Essays in Honor of Stanley B. Greenfield*, ed. P. R. Brown, G. R. Crampton, and F. C. Robinson, Toronto: 101–113 (109–110).

Jessup, R. F. (1936) "Reculver," *Antiquity* x, 179–194 (186).

Johnston, P. M. (1924) "Romanesque Ornament in England: Its Sources and Evolution," *Journal of the British Archaeological Association*, new ser., xxx, 91–104 (104).

Kaiser, R. (1954) *Alt- und mittelenglische Anthologie*, Berlin: 76; 2nd ed. (1955).

Kaiser, R. (1958) *Medieval English. An Old English and Middle English Anthology*, Berlin: 96. Revised and enlarged translation of Kaiser (1954).

Kantorowicz, E. H. (1960) "The Archer on the Ruthwell Cross," *Art Bulletin* xlii (no. 1), 57–59; reprinted in *Selected Studies by Ernst H. Kantorowicz*, Locust Valley, N.Y. (1965): 95–99.

Keller, W. (1938) "Zur Chronologie der ae. Runen," *Anglia. Zeitschrift für englische Philologie* lxii (N.F., l), 24–32 (29–31).

Kemble, J. M. (1840) "On Anglo-Saxon Runes," *Archaeologia: or Miscellaneous Tracts Relating to Antiquity Published by the Society of Antiquaries of London* xxviii, 327–372 (349–360). Article reprinted separately, London (1976).

Kemble, J. M. (1844) "Additional Observations on the Runic Obelisk at Ruthwell, the Poem of the Dream of the Holy Rood, and a Runic Copper Dish Found at Chertsey," *Archaeologia: or Miscellaneous Tracts Relating to Antiquity Published by the Society of Antiquaries of London* xxx, 31–46.

Kemble, J. M. (1856) *The Poetry of the Codex Vercellensis, with an English Translation*, part 2 (Ælfric Society, 6), London: ix.

Kendrick, T. D. (1938) *Anglo-Saxon Art to A.D. 900*, London: 126–142.

Kendrick, T. D., T. J.
 Brown and R. L. S.
 Bruce-Mitford (1960)
Evangeliorum Quattuor Codex Lindisfarnensis, Olten and Lausanne: 120, 255.

Kennedy, C. W. (1943)
The Earliest English Poetry. A Critical Survey of the Poetry Written before the Norman Conquest with Illustrative Translations, London: 260–261.

Ker, W. P. (1912)
English Literature: Medieval (Home University Library of Modern Knowledge, 45), London and New York: 48–49; reprinted Folcroft, Pa. (1977), and Norwood, Pa. (1978); reprinted as *English Medieval Literature* with bibliographical notes by P. Gibson, London and New York (1969).

Kilpiö, M. (1987)
"Hrabanus' *De laudibus sanctae crucis* and *The Dream of the Rood,*" *Mémoires de la Société Néophilologique de Helsinki* (publié sous la direction de T. F. Mustanoja) XLV, 177–191 (188).

King, A. (1986)
"The Ruthwell Cross—a Linguistic Monument (Runes as Evidence for Old English)," *Folia Linguistica Historica* VII (no. 1), 43–79.

King, R. L. (1876)
"Runes and Rune-Stones," *Fraser's Magazine,* new ser., XIII, 747–757 (754–755).

Kingsley Porter, A. (1927)
"The Tomb of Hincmar and Carolingian Sculpture in France," *Burlington Magazine* L, 75–91 (75, 81, 88).

Kingsley Porter, A. (1928)
Spanish Romanesque Sculpture, Florence: vol. I, 1–3, 5, 7–8, 12–13. German ed., *Romanische Plastik in Spanien,* Munich (1928): vol. I.

Kingsley Porter, A. (1929)
"An Egyptian Legend in Ireland," *Marburger Jahrbuch für Kunstwissenschaft* V, 25–38 (25–31, 38).

Kingsley Porter, A. (1931)
The Crosses and Culture of Ireland (Five lectures delivered at the Metropolitan Museum of Art, February and March 1930), New Haven: 86–87, 99–104, 112.

Kitzinger, E. (1936)
"Anglo-Saxon Vinescroll Ornament," *Antiquity* VI, 61–71 (65–70).

Kitzinger, E. (1956)
"The Coffin-Reliquary," in *The Relics of Saint Cuthbert,* ed. C. F. Battiscombe, Oxford: 224, 294–295, 297–300, 306.

Kitzinger, E. (forthcoming)
"Interlace and Icons: Form and Function in Early Insular Art," in *The Age of Migrating Ideas,* ed. J. Higgitt and M. Spearman, Edinburgh.*

Klaeber, F. (1936–37)
Review of: H. Bütow (1935), *Das altenglische "Traumgesicht vom Kreuz,"* in *Englische Studien. Organ für englische Philologie unter Mitsberucksichtigung des englischen Unterrichs auf höheren Schulen* LXXI (part 1), 84–86.

Krapp, G. P. (1932)
The Vercelli-Book (The Anglo-Saxon Poetic Records, 2), New York and London: xxxix–xl.

Kraus, F. X. (1896–1908) *Geschichte der christlichen Kunst*, vol. I, *Die hellenistisch-römische Kunst der alten Christen. Die byzantinische Kunst. Anfänge der Kunst bei den Volkern des Nordens*, Freiburg: vol. I, 612–616.

Krause, W. (1935) "Was man in Runen ritze," *Schriften der Königsberger gelehrten Gesellschaft. Geisteswissenschaftliche Klass* xii, 46–51.* Article reprinted Halle (1943): 9.

Laistner, M. L. W. (1957) *Thought and Letters in Western Europe: A.D. 500 to 900*, revised ed., London: 363.

Lang, J. (1988) *Anglo-Saxon Sculpture*, Aylesbury: 9, 16, 20, 22, 27–29.

Lang, J. (1991) *Corpus of Anglo-Saxon Stone Sculpture*, vol. III, *York and Eastern Yorkshire*, with contributions by J. Higgitt, R. I. Page, and J. R. Senior, Oxford: 1, 46, 54, 65, 138, 140.

Langenfelt, G. (1931–32) "Notes on the Anglo-Saxon Pioneers," *Englische Studien. Organ für englische Philologie unter Mitsberucksichtigung des englischen Unterrichs auf höheren Schulen* lxvi (no. 2), 161–244 (182–183).

Lass, R. (1991) "Of Data and 'Datives': Ruthwell Cross *Rodi* Again," *Neuphilologische Mitteilungen* xcii, 395–403.

Leclercq, H. (1950) "Ruthwell," in *Dictionnaire d'archéologie chrétienne et de liturgie*, ed. E. Cabrol and H. Leclercq, Paris: vol. 14, part 1, col. 187.

Leeds, E. T. (1936) *Early Anglo-Saxon Art and Archaeology, Being the Rhind Lectures Delivered in Edinburgh 1935*, Oxford: 14.

Lentzner, K. (1890) *Das Kreuz bei den Angelsächsen. Gemeinverständliche Aufzeichnungen*, Leipzig: v–vii, 9–19.

Lethaby, W. R. (1912a) "The Ruthwell Cross," *Burlington Magazine* xxi, 145–146.

Lethaby, W. R. (1912b) "The Ruthwell Cross," *Architectural Review* xxxii, 59–63.

Lethaby, W. R. (1913) "Is Ruthwell Cross an Anglo-Celtic Work?" *Archaeological Journal* lxx (2nd ser., xx), 145–161.

L[ethaby], W. R. (1917) Review of: G. F. Browne (1916), *The Ancient Cross Shafts at Bewcastle and Ruthwell*, in *Burlington Magazine* xxx, 232–236.

Liljegren, J. G. (1833) *Run-urkunder*, Stockholm: 186, no. 1623.

Luick, K. (1921–40) *Historische Grammatik der englischen Sprache*, Leipzig: 31–32.

MacEwen, A. R. (1913–18) *A History of the Church in Scotland*, London, New York, and Toronto: vol. I, 108–109.

MacKie, E. W. (1975) *Scotland, An Archaeological Guide: From Earliest Times to the 12th Century A.D.*, London: 21, 42–46, 139, 158.

Mac Lean, D. (1985) *Early Medieval Sculpture in the West Highlands and Islands of Scotland* (Ph.D. dissertation, Edinburgh University).*

Magnusen, F. (1836) "On the Ruthwell Obelisk and Anglo-Saxon Runes" (English translation of Magnusen [1836–37]), *Report Addressed by the Royal Society of Northern Antiquaries to its British and American Members*, trans. G. G. MacDougall and J. M'Coul, 81–188.

Magnusen, F. (1836–37) "Om Obelisken i Ruthwell og om de angelsaxiske Runer," *Annaler for Nordisk Oldkyndighed, udgivne af det kongelige nordiske oldskrift-selskab*, 243–337.

Mahler, A. E. (1978) "*Lignum Domini* and the Opening Vision of the *Dream of the Rood*: A Viable Hypothesis?" *Speculum* LIII, 441–459 (441–443).

Maillé, G. A. (1971) *Les cryptes de Jouarre*, Paris: 214–215, 273.

Malone, K. (1948) "The Middle Ages. The Old English Period (to 1100)," in *A Literary History of England*, ed. A. C. Baugh, New York and London: 78–79; 2nd ed. (1967).

March, H. C. (1891) "The Pagan-Christian Overlap in the North," *Transactions of the Lancashire and Cheshire Antiquarian Society* IX, 49–88 (65–66).

Marquardt, H. (1961) *Bibliographie der Runeninschriften nach Fundorten. Erster Teil. Die Runeninschriften der Britischen Inseln* (Herausgegeben vom Skandinavischen Seminar der Universität Göttingen im Auftrag von Wolfgang Krause), *Abhandlungen der Akademie der Wissenschaften in Göttingen, philologisch-historische Klasse*, 3rd ser., XLVIII, 1–168 (112–123).

Martin-Clarke, D. E. (1947) *Culture in Early Anglo-Saxon England. A Study with Illustrations*, Baltimore: 26–36.

Maughan, J. (1857) *A Memoir of the Roman Station and Runic Cross at Bewcastle, with an Appendix on the Roman Inscription on Caeme Craig, and the Runic Inscription in Carlisle*, London, Carlisle, Brampton, and Newcastle: 13–14, 17, 30nn, 32.

McAdam Muir, P. (1904) "The Ruthwell Cross," *Transactions of the Scottish Ecclesiological Society* I, part 1, 135–140.

McEntire, S. (1986) "The Devotional Context of the Cross before A.D. 1000," in *Sources of Anglo-Saxon Culture*, ed. P. E. Szarmach, with the assistance of V. D. Oggins (Studies in Medieval Culture, 20), Kalamazoo, Mich.: 345–356.

McFarlan, J. (1885) *The Ruthwell Cross*, Edinburgh and London; 2nd ed. Dumfries (1896).

McFarlan, J. (1885–87) Letter read November 19, 1885, *Proceedings of the Society of Antiquaries of London*, 2nd ser., XI, 6.

McKerrow, M. H. (1936) "Field Day to Ruthwell, Dumfries and Sweethart Abbey, 27 June 1936," *Transactions of the Hawick Archaeological Society*, 64–67.

Medd, P. G. (1962)

"Rood and Stow—the Cross and the Holy Place as Factors in Anglo-Saxon Parochial Evangelization," *Church Quarterly Review* CLXIII, 151–165 (156–159).

Mercer, E. (1964)

"The Ruthwell and Bewcastle Crosses," *Antiquity* XXXVIII (no. 152), 268–276.

Metcalfe, F. (1880)

The Englishman and the Scandinavian; or, a Comparison of Anglo-Saxon and Old Norse Literature, London: 138.

Meyer, J. (1925)

Kirker og Klostre i Middelalderen (Norsk Kunsthistorie, 1), Oslo: 135.*

Meyvaert, P. (1982)

"An Apocalypse Panel on the Ruthwell Cross," *Medieval and Renaissance Studies (Proceedings of the Southeastern Institute of Medieval and Renaissance Studies, Summer 1978)*, ed. F. Tirro (Medieval and Renaissance Series, 9), Durham, N.C.: 3–32.

Mitchell, A. and J. T. Clark, eds. (1906–8)

Geographical Collections Relating to Scotland, Made by Walter Macfarlane (Publications of the Scottish History Society, vols. 51–53), Edinburgh: vol. III, 187–189, 255.

Morey, C. R. (1942)

Medieval Art, New York: 187.

Morsbach, L. (1906)

"Zur Datierung des Beowulfepos," *Nachrichten von der Königlichen Gesellschaft der Wissenschaften zu Göttingen, philologisch-historische Klasse*, 251–277 (256, 260, 275).

Mowbray, C. (1936)

"Eastern Influence on Carvings at St. Andrews and Nigg, Scotland," *Antiquity* X, 428–440 (436).

Müller, S. (1880)

"Dyreornamentikken i Norden, dens Oprindelse, Udvikling og Forhold til samtidige Stilarter," *Aarboger for Nordisk Oldkyndighed og Historie, udgivne af det kongelige nordiske oldskrift-selskab*, 185–403 (265–324).

Murray, J. A. H. (1870–72)

"The Dialect of the Southern Counties of Scotland: Its Pronunciation, Grammar, and Historical Relations," *Transactions of the Philological Society* (part 2), 1–251 (17, 20–21).

Musset, L. (1965)

Introduction à la Runologie, in part from notes by Fernand Mossé (Bibliothèque de Philologie Germanique, 20), Paris: 187, 190, 204–205.

Neilson, G. (1917)

Review of: G. F. Browne (1916), *The Ancient Cross Shafts at Bewcastle and Ruthwell*, in *Scottish Historical Review* XIV, 289–291.

Neuman de Vegvar, C. L. (1987)

The Northumbrian Renaissance: A Study in the Transmission of Style, London and Toronto: 203–227, 276–277.

Nicolson, W. (1809)

Letters on Various Subjects, Literary, Political, and Ecclesiastical, to and from W. Nicolson, ed. J. Nichols, London: vol. I, nos. 23, 24, 26, 30, 47, 65.

Nicolson, W. (1902) "Bishop Nicolson's Diaries, Part II," ed. H. Ware, *Transactions of the Cumberland and Westmorland Antiquarian and Archaeological Society* new ser., II, 155–230 (195–196).

Nordhagen, P. J. (1969) "A Carved Marble Pilaster in the Vatican Grottoes. Some Remarks on the Sculptural Techniques of the Early Middle Ages," *Acta ad Archaeologiam et Artium Historiam Pertinentia* IV, 113–119 (117).

Norman, F. (1936) Review of: H. Bütow (1935), *Das altenglische "Traumgesicht vom Kreuz"*, in *Beiblatt zur Anglia. Mitteilungen über englische Sprache und Literatur und über englischen Unterricht* XLVII, 6–10 (8–9).

Ó Carragáin, É. (1978) "Liturgical Innovations Associated with Pope Sergius and the Iconography of the Ruthwell and Bewcastle Crosses," in *Bede and Anglo-Saxon England: Papers in Honour of the 1300th Anniversary of the Birth of Bede, Given at Cornell University in 1973 and 1974*, ed. R. T. Farrell (British Archaeological Reports, 46), Oxford: 131–147.

Ó Carragáin, É. (1982) "Crucifixion as Annunciation: The Relation of the 'Dream of the Rood' to the Liturgy Reconsidered," *English Studies. A Journal of English Language and Literature* LXIII (no. 6), 487–505 (488–489, 504–505).

Ó Carragáin, É. (1986) "Christ over the Beasts and the Agnus Dei: Two Multivalent Panels on the Ruthwell and Bewcastle Crosses," in *Sources of Anglo-Saxon Culture*, ed. P. E. Szarmach, with the assistance of V. D. Oggins (Studies in Medieval Culture, 20), Kalamazoo, Mich.: 376–403.

Ó Carragáin, É. (1987a) "A Liturgical Interpretation of the Bewcastle Cross," in *Medieval Literature and Antiquities. Studies in Honor of Basil Cottle*, ed. M. Stokes and T. L. Burton, Cambridge: 15–42 (15–17, 19, 33, 36–40).

Ó Carragáin, É. (1987b) "The Ruthwell Cross and Irish High Crosses: Some Points of Comparison and Contrast," in *Ireland and Insular Art, A.D. 500–1200 (Proceedings of a Conference at University College Cork, 31 October–3 November 1985)*, ed. M. Ryan, Dublin: 118–128.

Ó Carragáin, É. (1987–88) "The Ruthwell Crucifixion Poem in Its Iconographic and Liturgical Contexts," *Peritia. Journal of the Medieval Academy of Ireland* VI–VII, 1–71.

Ó Carragáin, É. (1988) "The Meeting of Saint Paul and Saint Anthony: Visual and Literary Uses of a Eucharistic Motif," in *Keimelia: Studies in Medieval Archaeology and History in Memory of Tom Delaney*, ed. G. Mac Niocaill and P. F. Wallace, Galway: 1–58.

Ó Carragáin, É. (1992) "Seeing, Reading, Singing the Ruthwell Cross: Vernacular Poetry, Old Roman Liturgy, Implied Audience," in *Medieval Europe 1992, Prepublished Papers* VII, *Art and Symbolism*, York: 91–96.*

Ó Carragáin, É. (forthcoming) "Rome Pilgrimage, Roman Liturgy and the Ruthwell Cross," in *Peregrinatio: Pilgerschaft und Pilgerziel* (12. Internationaler Kongress für

christliche Archäologie, Bonn 22–28 September 1991, Kongressakten) *Jahrbuch für Antike und Christentum*, Ergänsungsband.*

Ó Carragáin, É. (forthcoming) *Rome, Ruthwell, Vercelli (The Old English Crucifixion Poem, Its Early Audiences, and Cultural Contact between Anglo-Saxon England and Italy)*.*

O'Loughlin, J. L. N. (1931) Letter: "The Dream of the Rood," *Times Literary Supplement* xxxx (no. 1533), 27 August 1931, 648.

Okasha, E. (1971) *Hand-List of Anglo-Saxon Non-Runic Inscriptions*, Cambridge: 108–112.

Okasha, E. (1983) "A Supplement to *Hand-List of Anglo-Saxon Non-Runic Inscriptions*," *Anglo-Saxon England* xi, 83–118 (110, 118).

Okasha, E. (1990) "Vernacular or Latin? The Languages of Insular Inscriptions, A.D. 500–1100," in *Epigraphik 1988. Fachtagung für mittelalterliche und neuzeitliche Epigraphik, Graz, 10–14 Mai 1988*, ed. W. Koch (Österreichische Akademie der Wissenschaften, philosophisch-historische Klass, Denkschriften, Bd. 213), Vienna: 139–147 (142, 144–145).

Okasha, E. (1992) "Literacy in Anglo-Saxon England: the Evidence from Inscriptions," in *Medieval Europe 1992, Prepublished Papers* vii, *Art and Symbolism*, York: 85–90.*

Page, R. I. (1959a) "Language and Dating in OE Inscriptions," *Anglia. Zeitschrift für englische Philologie* lxxvii, 385–406 (387–403).

Page, R. I. (1959b) "An Early Drawing of the Ruthwell Cross," *Medieval Archaeology* iii, 285–288.

Page, R. I. (1962) "The Use of Double Runes in Old English Inscriptions," *Journal of English and Germanic Philology* lxi (no. 4), 897–907 (898, 900–905).

Page, R. I. (1973) *An Introduction to English Runes*, London: 3–4, 6, 15, 23, 28, 30, 34, 46, 48, 51, 55–56, 58, 134–135, 138, 140, 148–153, 158–161, 172, 217, 219–220.

Page, R. I. (1987) *Runes*, London and Berkeley: 20, 39, 42, 62.

Page, R. I. (1990) "Dating Old English Inscriptions: The Limits of Inference," in *Papers from the Fifth International Conference on English Historical Linguistics, Cambridge, 6–9 April 1987*, ed. S. Adamson, V. Law, N. Vincent, and S. Wright, Amsterdam and Philadelphia: 357–377 (363–366, 369–370, 373).

Pak, T.-Y. (1969) *Runic Evidence of Laminoalveolar Affrication in Old English* (Ph.D. dissertation, Bowling Green State University).* Abstract in P. Pulsiano, *An Annotated Bibliography of North American Doctoral Dissertations on Old English Language and Literature* (Medieval Texts and Studies, 3), East Lansing, Mich. (1988): 6.

Panofsky, E. (1960)

Renaissance and Renascences in Western Art (Figura: Studies of Art History, vol. 10), Stockholm, (Gottesmann Lectures, Uppsala University), Copenhagen: 43, 44nn; revised ed. New York (1964), reprinted (1969 and 1972).

Parker, C. A. and W. G. Collingwood (1917)

"A Reconsideration of Gosforth Cross," *Transactions of the Cumberland and Westmorland Antiquarian and Archaeological Society*, new ser., XVII, 99–113 (111).

Partridge, A. C. (1982)

A Companion to Old and Middle English Studies (The Language Library, ed. D. Crystal), London:

Paues, A. C. (1907)

"Runes and Manuscripts," in *The Cambridge History of English Literature*, vol. I, *From the Beginnings to the Cycles of Romance*, Cambridge: 12. Numerous editions.

Paues, A. C. (1911)

"The Name of the Letter ȝ," *Modern Language Review* VI (no. 4), 440–454 (451).

Payne, R. C. (1976)

"Convention and Originality in the Vision Framework of 'The Dream of the Rood'," *Modern Philology* LXXIII (no. 4, part 1), 329–341 (338–339).

Pearsall, D. (1977)

Old English and Middle English Poetry (The Routledge History of English Poetry, 1, general ed. R. A. Foakes), London: 23–24, 46.

Peers, C. R. (1926)

"English Ornament in the Seventh and Eighth Centuries (Annual Lecture on Aspects of Art, Henriette Hertz Trust)," *Proceedings of the British Academy* XII, 45–54 (48–50).

Peers, C. R. (1927)

"Reculver: Its Saxon Church and Cross," *Archaeologia* LXXVII, 241–256 (255).

Pennant, T. (1774)

A Tour in Scotland, and Voyage to the Hebrides; MDCCLXXII, Chester: 84–86; 2nd ed. London (1776); 5th ed. London (1790); another ed. (1796): 96–98. Reprinted in *A General Collection of the Best and Most Interesting Voyages and Travels in All Parts of the World; Many of Which are Now First Translated into English*, ed. J. Pinkerton, London (1809): vol. III, 213–214. Rewritten as a third-person account in "A Second Tour of Scotland, and a Voyage to the Hebrides, by Thomas Pennant, Esq. of Downing, in Flintshire. Performed in the Year 1772," in *The British Tourists; or Traveller's Pocket Companion, through England, Scotland, and Ireland Comprehending the Most Celebrated Tours in the British Islands*, ed. W. Mavor, London (1800): 97–302 (120).

Pfeilstücker, S. (1936)

Spätantikes und germanisches Kunstgut in der frühangelsächsischen Kunst. Nach lateinischen und altenglischen Schriftquellen (Kunstwissenschaftliche Studien, 19), Berlin: 113, 116–118.

Pijoán y Soteras, J. (1942)

Summa Artis: Historia general del arte, vol. VIII, *Arte bárbarico y prerománico desde el siglo IV hasta el año 1000*, Madrid: 141, 145–150.

Pilch, H. (1970) *Altenglische Grammatik. Dialektologie, Phonologie, Morphologie, Syntax* (Commentationes Societatis Linguisticae Europaeae, I, 1) Munich: 42–43, 47, 52, 60.

Pilch, H. and *Altenglische Literatur*, Heidelberg: 25–26, 135, 196, 199.
H. Tristam (1979)

Ploss, E. (1958) "Der Inschriftentypus 'N.N. me fecit' und seine geschichtliche Entwicklung bis ins Mittelalter," *Zeitschrift für deutsche Philologie* LXXVII, 25–46 (35).

Pococke, R. (1887) *Tours in Scotland 1747, 1750, 1760, by Richard Pococke, Bishop of Meath*, ed. D. W. Kemp (Publications of the Scottish History Society, 1), Edinburgh: 32.

Poole, A. L., ed. (1958) *Medieval England*, revised ed., Oxford: vol. II, 486.

Prior, E. S. and A. Gard- "Mediaeval Figure-Sculpture in England," *Architectural Review* XII, 3–17 (7).
ner (1902)

Prior, E. S. and A. Gard- *An Account of Medieval Figure-Sculpture in England*, Cambridge: 109–125.
ner (1912)

Raith, J. (1937) Review of: B. Dickins and A. S. C. Ross, eds. (1934), *The Dream of the Rood*, in *Beiblatt zur Anglia. Mitteilungen über englische Sprache und Literatur und über englischen Unterricht* XLVIII, 66–68.

Raw, B. C. (1967) "The Archer, the Eagle and the Lamb," *Journal of the Warburg and Courtauld Institutes* XXX, 391–394 (391–392).

Raw, B. C. (1970) "*The Dream of the Rood* and its Connections with Early Christian Art," *Medium Aevum* XXXIX (no. 3), 239–256 (239, 252).

Raw, B. C. (1990) *Anglo-Saxon Crucifixion Iconography and the Art of the Monastic Revival* (Cambridge Studies in Anglo-Saxon England, 1), Cambridge: 12, 20, 245.

Reil, J. (1904) *Die frühchristlichen Darstellungen der Kreuzigung Christi* (Studien über christliche Denkmäler. Neue Folge der archäologischen Studien zum christlichen Altertum und Mittelalter, 2), Leipzig: 115nn, 120nn.

Repp, T. G. (1833) "Letter from Mr Thorleif Gudmundson Repp, A.M., F.S.A. Scot. to the Hon. Mountstewart Elphinstone, Honorary Member S. A. Scot, Regarding the Runic Inscription on the Monument at Ruthwell," *Archaeologica Scotica: or, Transactions of the Society of Antiquaries of Scotland*, IV, part 2, 327–336; reprinted (1857).

Ricci, A. (1929) "The Chronology of Anglo-Saxon Poetry," *Review of English Studies. A Quarterly Journal of English Literature and the English Language* V (no. 19), 257–266 (262–263).

Richter, C. (1910) *Chronologische Studien zur angelsächsischen Literatur auf Grund sprachlich-metrischer Kriterien* (Studien zur englischen Philologie, 33), Halle: 93.

Rivoira, G. T. (1907) *Le origini della architettura lombarda e delle sue principali derivazioni nei paesi d'oltr'Alpe*, Rome: vol. II, 262. English edition, *Lombardic Architecture, Its Origin, Development and Derivatives*, trans. G. McN. Rushforth, London (1910): vol. II, 143; revised ed. with additional notes, Oxford (1933): vol. II, 151.

Rivoira, G. T. (1912) "Antiquities of St. Andrews," *Burlington Magazine* xxi, 15–25 (24–25).

Robertson, D. W. Jr. (1951) "The Doctrine of Charity in Mediaeval Literary Gardens: A Topical Approach through Symbolism and Allegory," *Speculum* xxvi, 24–49 (27).

Romilly Allen, J. (1885) "The Crosses at Ilkley. Part 3," *Journal of the British Archaeological Association* xli, 333–358 (340, 346).

Romilly Allen, J. (1889a) "Classification and Geographical Distribution of Early Christian Inscribed Monuments in Scotland," *Journal of the British Archaeological Association* xlv, 299–305 (301, 305).

Romilly Allen, J. (1889b) *The Monumental History of the Early British Church*, London: 158, 208–210.

Romilly Allen, J. and J. Anderson (1903) *The Early Christian Monuments of Scotland. A Classified, Illustrated, Descriptive List of the Monuments, with an Analysis of Their Symbolism and Ornamentation*, introduction being the Rhind Lectures for 1892 by J. Anderson, Edinburgh: part 1, xxix–xxxi, xlviii–lxii; part 2, 414; part 3, 442–448.

Ross, A. S. C. (1933a) "The Linguistic Evidence for the Date of the 'Ruthwell Cross'," *Modern Language Review*

R[oss], A. S. C. (1933b) "Primitive English -E in Flexional Endings," *Leeds Studies in English* ii, 88.

Rousseau, H. (1888) "The Ruthwell Cross," *Reliquary*, new ser., ii, 85–88.

Rousseau, H. (1902) "La Ruthwell Cross," *Annales de la Société d'Archéologie de Bruxelles* xvi, 53–71.

Rydberg, V. (1874) "Skalden Kadmon och Ruthwell-korset," *Göteborgs Handels- och Sjöfartstidning*, 24 September; reprinted in *Skrifter af Viktor Rydberg, XIV. Varia, II*, Stockholm (1899): 516–523.

Samuels, M. L. (1952) "The Study of Old English Phonology," *Transactions of the Philological Society*, 15–47 (25, 37nn).

Samuels, P. (1988) "The Audience Written into the Script of 'The Dream of the Rood'," *Modern Language Quarterly*, 49 (no. 4) 311–320 (312).

Sarrazin, G. (1913) *Von Kädmon bis Kynewulf. Eine litterarhistorische Studie*, Berlin: 114–115, 117–118, 167–168.

Saunders, O. E. (1932) *A History of English Art in the Middle Ages*, Oxford: 6, 12–16, 20.

Savage, A. (1986) "Mystical and Evangelical in *The Dream of the Rood*: The Private and the Public," in *Mysticism: Medieval and Modern*, ed. V. M. Lagorio (Salzburg Studies in English Literature, under the direction of E. A. Stürzl: Elizabethan and Renaissance Studies, ed. J. Hogg, 92:20) Salzburg: 4–11 (4, 6, 11).

Saxl, F. (1943) "The Ruthwell Cross," *Journal of the Warburg and Courtauld Institutes* vi, 1–19; reprinted in *England and the Mediterranean Tradition*, Warburg and Courtauld Institutes, University of London, London (1945): 1–19.

Saxl, F. and R. Wittkower (1948) *British Art and the Mediterranean*, London: 15–16.

Scarth, H. M. (1860) "Remarks on Some Ancient Sculptured Stones Still Preserved in this Island, and on Others Once Known to Exist, Particularly Those Recorded to Have Stood in the Cemetery of the Abbey at Glastonbury," *Somersetshire Archaeological and Natural History Society Proceedings* x, 111–130 (122–125, 128).

Schaar, C. (1949) *Critical Studies in the Cynewulf Group* (Lund Studies in English, 17), Lund: 35; reprinted New York (1967).

Schapiro, M. (1944) "The Religious Meaning of the Ruthwell Cross," *Art Bulletin* xxvi (1944), 232–245. Reprinted in M. Schapiro, *Late Antique, Early Christian and Medieval Art. Selected Papers*, vol. III, New York, 1979: 150–176, 186–192.

Schapiro, M. (1963) "The Bowman and the Bird on the Ruthwell Cross and Other Works: The Interpretation of Secular Themes in Early Medieval Religious Art," *Art Bulletin* xlv (1963), 351–355; reprinted in M. Schapiro, *Late Antique, Early Christian and Medieval Art. Selected Papers*, vol. III, New York, 1979: 177–186, 192–195.

Schlauch, M. (1956) *English Medieval Literature and Its Social Foundations* (Polska Akademia Nauk, Komitet Neofilologiczny), Warsaw: 62.

Schücking, L. L. (1927) "Die angelsächsische und frühmittelenglische Dichtung," in *Die englische Literatur im Mittelalter*, ed. H. Hecht and L. L. Schücking (Walzels Handbuch der Literaturwissenschaft), Potsdam: 1–68 (27–28).

Schwab, U. (1978) "Das Traumgesicht vom Kreuzesbaum. Ein ikonologischer Interpreta-
 tionsansatz zu dem ags. Dream of the Rood," in *Philologische Studien.*
 Gedenkschrift für Richard Kienast, ed. U. Schwab and E. Stutz, Heidel-
 berg: 131–192 (144, 161–162).

Sephton, J. (1895–96) "On Some Runic Remains," *Proceedings of the Literary and Philosophi-*
 cal Society of Liverpool L, session 85, 183–209 (186, 199–203).

Seton, G. (1887) "Statement Relative to the Ruthwell Cross," *Proceeding of the Society of*
 Antiquaries of Scotland XXI, session 1886–87, 194–197.

Sgarbi, R. (1988) "Note sulla fonetica dei testi runici in inglese antico," *Istituto Lombardo,*
 Rendiconti, Classe di Lettere e Scienze Morali e Storiche CXXII, 129–143
 (129, 136–140).

Sharratt, F. and P. *Écosse romane* (La nuit des temps, 63), [La-Pierre-qui-Vire (Yonne)]:
 Sharratt (1985) 32–35.

Shippey, T. A. (1972) *Old English Verse,* London: 81–84.

Shore, T. W. (1906) *Origin of the Anglo-Saxon Race: A Study of the Settlement of England*
 and the Tribal Origin of the Old English People, London: 41, 328.

Sievers, E. (1890) "Zu Cynewulf," *Anglia. Zeitschrift für englische Philologie* XIII (N.F., I),
 1–25 (21).

Sievers, E. (1891) *Runen und Runeninschriften,* Strassburg: vol. I, 242, 244; 2nd ed.
 (1902): vol. I, 253, 255.*

Sinclair, J., ed. (1794) *The Statistical Account of Scotland, Drawn up from the Communications*
 of the Ministers of the Different Parishes, vol. X, Edinburgh: 226–227;
 reprinted as *The Statistical Account of Scotland, 1791–1799,* ed. D. J.
 Withrington and I. R. Grant, vol. IV, *Dumfriesshire,* introduction by
 I. B. Cowan, Edinburgh (1978): 455–456.

Sisam, K. (1946) "Notes on Old English Poetry," *Review of English Studies. A Quarterly*
 Journal of English and the English Language XXII (no. 88), 257–268
 (261–262).

Sisam, K. (1953) *Studies in the History of Old English Literature,* Oxford: 34–35, 122,
 132–133.

Sjöborg, N. H. (1822) *Samlingar för nordens fornälskare, innehållande inskrifter, figurer,*
 ruiner, verktyg, högar och stensättningar i Sverige och Norrige med
 plancher, Stockholm: vol. I, 34.

Skeat, W. W. (1911) *English Dialects from the Eighth Century to the Present Day* (The Cam-
 bridge Manuals of Science and Literature), Cambridge: 18–20.

Smith, M. B. (1907) "Old English Christian Poetry" in *The Cambridge History of English Literature*, vol. I, *From the Beginnings to the Cycles of Romance*, Cambridge: 41–64 (56). Numerous editions.

Snell, F. J. (1912) *The Age of Alfred. 664–1154* (Handbooks of English Literature, 1), London: 142–143.

Snyder, J. (1989) *Medieval Art. Painting, Sculpture, Architecture, 4th–14th Century*, New York: 189–190.

Stanley, E. G. (1987) "The Ruthwell Cross Inscription: Some Linguistic and Literary Implications of Paul Meyvaert's Paper 'An Apocalypse Panel on the Ruthwell Cross'," in *A Collection of Papers with Emphasis on Old English Literature*, ed. E. G. Stanley (Publications of the Dictionary of Old English, 3), Toronto and Leiden: 384–399.

Stephens, G. (1866–67) *The Old-Northern Runic Monuments of Scandinavia and England Now First Collected and Deciphered by George Stephens, Esq., F.S.A*, 4 vols., London and Copenhagen: 405–448.

Stephens, G. (1882–84) "Prof. S. Bugge's Studies on Northern Mythology Shortly Examined," *Mémoires de la Société royale des Antiquaires du Nord*, new ser., 289–414 (348–371). Danish version: "Prof. Bugge's studier over Nordisk Mytologi," *Aarboger for Nordisk Oldkyndighed og Historie* (1883), 215–363.

Stephens, G. (1884) *Handbook of the Old-Northern Runic Monuments of Scandinavia and England*, Edinburgh and Copenhagen: 30–132.

Stephens, G. (1894) *The Runes, Whence Came They*, London: 12.

Stevens, W. O. (1904) *The Cross in the Life and Literature of the Anglo-Saxons* (Yale Studies in English, 23), New York: 46–47, 78; reprinted in R. T. Farrell (1977), *The Anglo-Saxon Cross*.

Stevenson, R. B. K. (1956) "The Chronology and Relationships of Some Irish and Scottish Crosses," *Journal of the Royal Society of Antiquaries of Ireland* LXXXVI (no. 1), 84–96 (86).

Stevenson, R. B. K. (1971) "Sculpture in Scotland in the 6th–9th Centuries A.D.," in *Kolloquium über spätantike und frühmittelalterliche Skulptur*, vol. II, ed. V. Milojčić (Institut für Ur- und Frühgeschichte, Universität Heidelberg, Vortragstexte 1970), Mainz: 65–74 (70–71).

Stevick, R. D. (1967) "The Meter of the 'Dream of the Rood'," *Neuphilologische Mitteilungen* LXVIII (no. 2), 146–168 (164–165).

Stokes, M. (1887) *Early Christian Art in Ireland* (South Kensington Museum Art Handbooks), London: part 2, 7–10; 2nd ed. revised by G. N. Count Plunkett,

Dublin (1911): 107–109; new ed. Dublin (1928): part 2, 6–8; reprinted Freeport, N.Y. (1972).

Stoll, R. (1967)

Architecture and Sculpture in Early Britain. Celtic, Saxon, Norman, trans. J. Maxwell Brownjohn, London: 307, 320, 328.

Stone, J. M. (1896)

"The Runic Crosses of Northumbria," *Scottish Review* xxvii, 292–304. Revised edition in *Studies from Court and Cloister*, Edinburgh and London (1905), part 2, 1 (207–219, 221–222).*

Stone, L. (1955)

Sculpture in Britain. The Middle Ages (Pelican History of Art), Harmondsworth: 10–13; 2nd ed. (1972).

Strzygowski, J. (1918)

Die Baukunst der Armenier und Europa. Ergebnisse einer vom kunsthistorischen Institute der Universität Wien 1913 durchgefuhrten Forschungsreise (Arbeiten des kunsthistorischen Instituts der Universität Wien, IX–X), Vienna: vol. II, 719.

Strzygowski, J. (1923)

The Origin of Christian Church Art, New Facts and Principles of Research, trans. O. M. Dalton and H. J. Braunholtz, Oxford: 231–232, 241–242.

Strzygowski, J. (1926)

"Die christliche Kunst vor dem Jahre 1000. (2:) Die irisch-angelsächs. Blüte in Bedas Zeit," in *Der Norden in der bildenden Kunst Westeuropas. Heidnisches und Christliches um das Jahr 1000*, ed. J. Strzygowski (Kunsthistorischen Institut der Universität Wien. Beiträge zur vergleichenden Kunstforschung, 4), Vienna: 111–112, 118, 123, 134.

Stuart, J. (1856–67)

Sculptured Stones of Scotland, Aberdeen and Edinburgh: vol. II, (1867) lxxxiii–lxxxix, xcv; notes to the plates, 12–16; pls. XIX–XX.

Stuhlfauth, G. (1897)

Die Engel in der altchristlichen Kunst (Archäologische Studien zur christlichen Altertum und Mittelalter, 3), Freiburg im Breisgau: 71–72.

Swanton, M. J., ed. (1970)

The Dream of the Rood (Old and Middle English Texts, ed. G. L. Brook), Manchester and New York: 9–42; revised ed. (Exeter Medieval English Texts and Studies), Exeter (1987): bibliography, 90–92.

Sweet, H., ed. (1885)

The Oldest English Texts (Early English Text Society), London: 125–126.

Sweet, H. (1887)

A Second Anglo-Saxon Reader, Archaic and Dialectal, Oxford: 87; 2nd ed. revised by T. F. Hoad, Oxford (1978): 103.

T[. . .], A. H. (1916)

Review of: G. F. Browne (1916), *The Ancient Cross Shafts at Bewcastle and Ruthwell*, in *Archaeological Journal* lxxiii, 302–305.

Tait, A. C. F. (1946)

"The Sandbach Cross," *Transactions of the Historic Society of Lancashire and Cheshire* xcviii, 1–20 (3–4).

Talbot Rice, D. (1957a) *The Beginnings of Christian Art*, London: 133.

Talbot Rice, D. (1957b) "Visible Evidence of Anglo-Saxon England," in *Anglo-Saxon England*, London: 31.

Taylor, H. (1903) "The Ancient Crosses of Lancashire," *Transactions of the Lancashire and Cheshire Antiquarian Society* xxi, 1–110 (56, 58–60).

Taylor, I. (1879) *Greeks and Goths. A Study on Runes*, London: 5, 12.*

Thundyil, Z. P. (1972) *Covenant in Anglo-Saxon Thought. The Influence of the Bible, Church Fathers, and Germanic Tradition on Anglo-Saxon Laws, History, and the Poems "The Battle of Maldon" and "Guthlac,"* Madras: 192.

Vietor, W. (1895) *Die northumbrischen Runensteine. Beiträge zur Textkritik. Grammatik und Glossar*, Marburg: 2–13.

Vietor, W. (1915) Review of: A. S. Cook (1912), "The Date of the Ruthwell and Bewcastle Crosses" and A. S. Cook (1914b), *Some Accounts of the Bewcastle Cross*, in *Beiblatt zur Anglia. Mitteilungen über englische Sprache und Literatur und über englischen Unterricht* xxvi, 1–10 (1–5).

Vigfusson, G. and F. Y. Powell (1883) *Corpus Poeticum Boreale. The Poetry of the Northern Tongue from the Earliest Times to the Thirteenth Century*, vol. I, *Eddic Poetry*, Oxford: 435.

Wakelin, M. (1988) *The Archaeology of English*, London and Totowa, N.J.: 20, 54, 56, 57, 59–63.

Warburg Institute (1941) *Guide to the Photographic Exhibition of English Art and the Mediterranean*, London: 20–23.*

Wardale, E. E. (1935) *Chapters on Old English Literature*, London: 18, 179, 182.

Watson, G., ed. (1974) *The New Cambridge Bibliography of English Literature*, vol. I, *600–1660*, Cambridge: cols. 222–223, 300–301.

Webster, L. and J. Backhouse, eds. (1991) *The Making of England. Anglo-Saxon Art and Culture, A.D. 600–900*, London and Toronto: 79, 109, 149, 171, 182.

Weigall, A. (1927) *Wanderings in Anglo-Saxon Britain*, London: 139–141.

Weightman, J. (1907) *The Language and Dialect of the Later Old English Poetry* (B.A. Honors Thesis, University of Liverpool), v–vi.

Werner, M. (1984) *Insular Art. An Annotated Bibliography* (A Reference Publication in Art History. Medieval Art and Architecture), Boston: 252–255.

Werner, M. (1990) "The Cross-Carpet Page in the Book of Durrow: The Cult of the True Cross, Adomnan, and Iona," *Art Bulletin* lxxii (no. 1), 174–223 (180, 191, 192, 193nn, 198, 199).

Whellan, W. (1860) — *History and Topography of the Counties of Cumberland and Westmorland with Furness and Carmel, in Lancashire*, Pontefract: 7–8.

Whitelock, D. (1952) — *The Beginnings of English Society* (Pelican History of England, 2), Harmondsworth: 210, 228–229; reprinted (1956, 1959, 1962, 1963), reprinted with revisions (1965).

Wiley, R. A., ed. (1971) — *John Mitchell Kemble and Jakob Grimm. A Correspondence 1832–1852. Unpublished Letters of Kemble and Translated Answers of Grimm*, Leiden: 14, 87, 91, 137, 138, 178, 189, 190, 205, 231, 242.

Willett, F. (1956–57) — "The Ruthwell and Bewcastle Crosses. A Review," *Memoirs of the Manchester Literary and Philosophical Society* xcviii, 94–136; reprinted separately: University of Manchester, Museum Publications, new ser., 7, Manchester (1957).

Wilser, L. (1895) — "Alter und Ursprung der Runenschrift," *Korrespondenzblatt des Gesamtvereins der deutschen Geschichts- und Altertumsvereine* xliii, 137–143 (139).

Wilson, D. (1851) — *The Archaeology and Prehistoric Annals of Scotland*, Edinburgh: 543–549.

Wilson, D. (1863) — *Prehistoric Annals of Scotland* (2nd edition of D. Wilson [1851]), 319–330.

Wilson, D. M. (1960) — *The Anglo-Saxons* (Ancient People and Places, ed. G. Daniel), London and New York: 61, 152, 155, 220; revised ed. Harmondsworth (1971): 54, 148, 150, 168, reprinted (1972, 1975); 3rd ed. (1981): 57, 153, 155, 174.

Wilson, D. M. (1984) — *Anglo-Saxon Art from the Seventh Century to the Norman Conquest*, New York: 72–79.

Wilson, R. M. (1952) — *The Lost Literature of Medieval England* (Metheun's Old English Library, general eds. A. H. Smith and F. Norman), London: 66.

Wimmer, L. F. A. (1887) — *Die Runenschrift*, trans. F. Holthausen, Berlin: 73, 134, 224; revised and expanded ed. of *Runeskriftens Oprindelse og Udvikling i Norden*, Copenhagen (1874)*.

Woolf, R. (1958) — "Doctrinal Influences on 'The Dream of the Rood'," *Medium Aevum* xxvii (no. 3), 137–153 (145, 153).

Wrenn, C. L. (1932) — "Late Old English Rune-Names," *Medium Aevum* i, 24–34 (33).

Wrenn, C. L. (1943) — "The Value of Spelling as Evidence," *Transactions of the Philological Society* 14–39 (19–22); reprinted in C. L. Wrenn, *Word and Symbol: Studies in English Language*, London (1967): 129–149 (133–135).

Wrenn, C. L. (1946) "The Poetry of Caedmon," (Sir Israel Gollancz Memorial Lecture, read 19 February 1947), *Proceedings of the British Academy* xxxiii, 277–295 (278, 289–291); reprinted in *Essential Articles for the Study of Old English Poetry*, ed. J. B. Bessinger Jr. and S. J. Kahrl, Hamden, Conn. (1968): 407–427 (408, 420–422).

Wrenn, C. L. (1967) *A Study of Old English Literature*, London: 8, 44, 103, 134, 136–137.

Wülcker, R. P. (1878) "Über den Dichter Cynewulf," *Anglia. Zeitschrift für englische Philologie* i, 483–507 (490, 496–506).

Wülcker, R. P. (1885) *Grundriss zur Geschichte der angelsächsischen Literatur mit einer übersicht der angelsächsischen Sprachwissenschaft*, Liepzig: 134–138, 189, 513.

Wülcker, R. P. (1894) *Die Verceller Handschrift, die Handschrift des Cambridger Corpus Christi College CCI, die Gedichte der sogen. Caedmonhandschrift, Judith, der Hymnus Caedmons, Heiligenkalender nebst kleineren geistlichen Dichtungen* (Bibliothek der anglesächsischen Poesie, 2), Leipzig: 111–116.

Wülcker, R. P. (1896) *Geschichte der englischen Literatur von den ältesten Zeiten bis zur Gegenwart*, Leipzig and Vienna: 32.

Zimmermann, E. H. (1916–18) *Vorkarolingische Miniaturen*, Deutscher Verein für Kunstwissenschaft (Denkmäler deutscher Kunst, III Sektion. Malerei, part 1), Berlin: 29–30.

Zupitza, J. (1882) "Verse vom Kreuze zu Ruthwell," in *Alt- und mittelenglisches Übungsbuch zum Gebrauche bei Universitäts-Vorlesungen*, Vienna: 3–7 (1915 ed.). In many editions with various editors.

Index

•

Plates

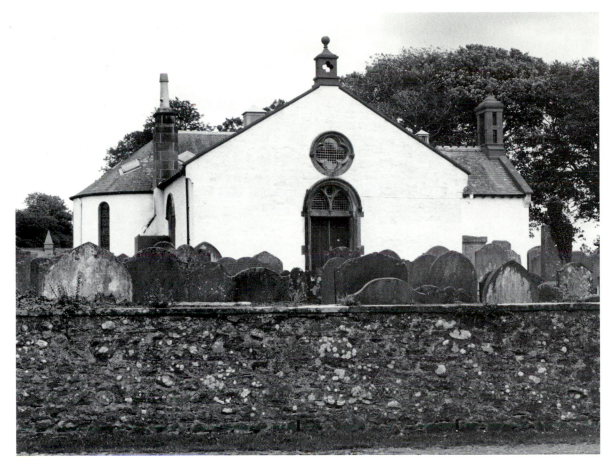

1. Ruthwell church, west front, main entrance (photo: Brendan Cassidy)

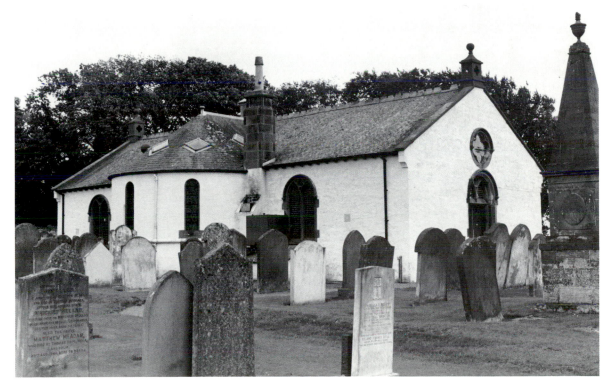

2. Ruthwell church, north and west views (photo: Brendan Cassidy)

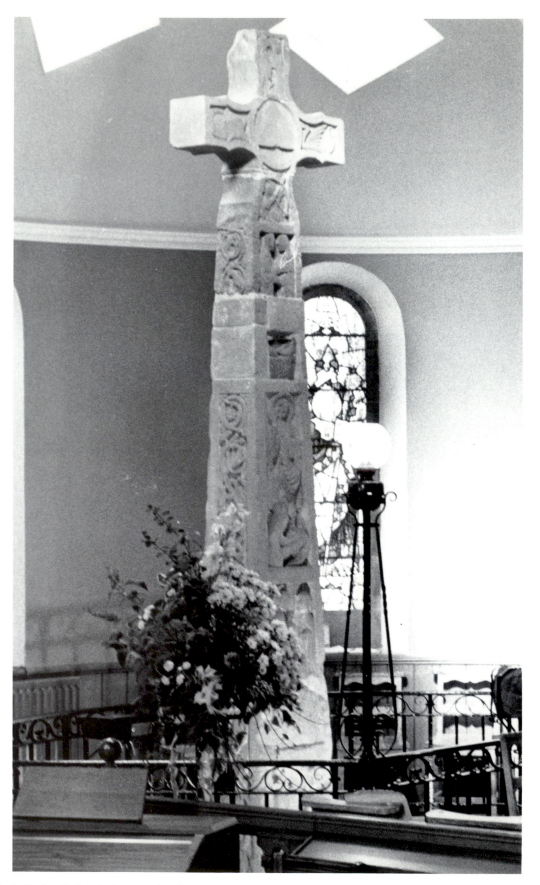

3. Ruthwell church, interior view from west entrance showing the south and west sides of the Ruthwell cross (photo: Brendan Cassidy)

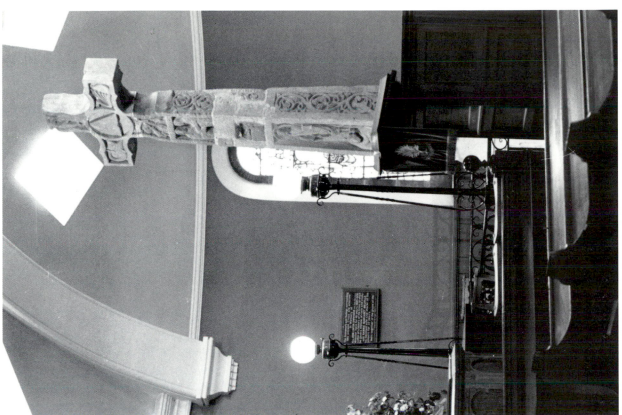

5. Ruthwell church, interior view from east end showing the south and east sides of the Ruthwell cross (photo: Brendan Cassidy)

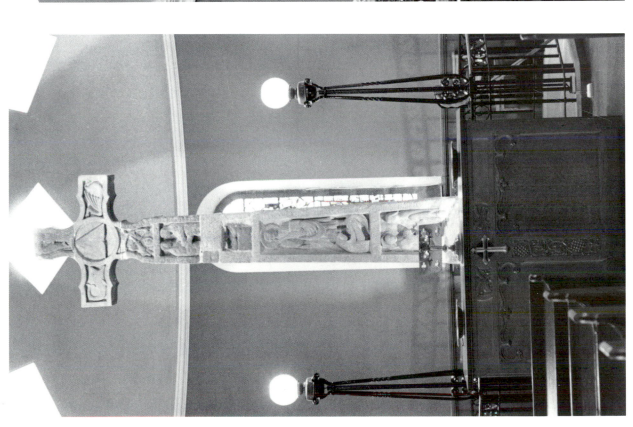

4. Ruthwell church, interior view showing the south side of the Ruthwell cross (photo: Brendan Cassidy)

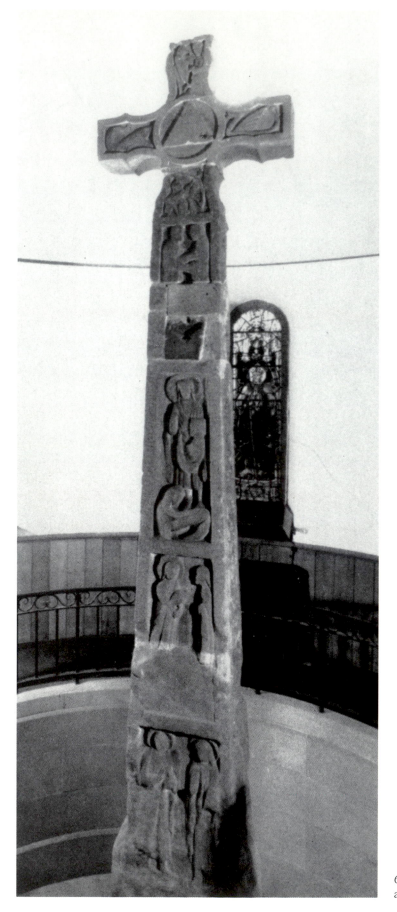

6. Ruthwell cross, south side (photo:
after Mercer [1964] pl. XLII)

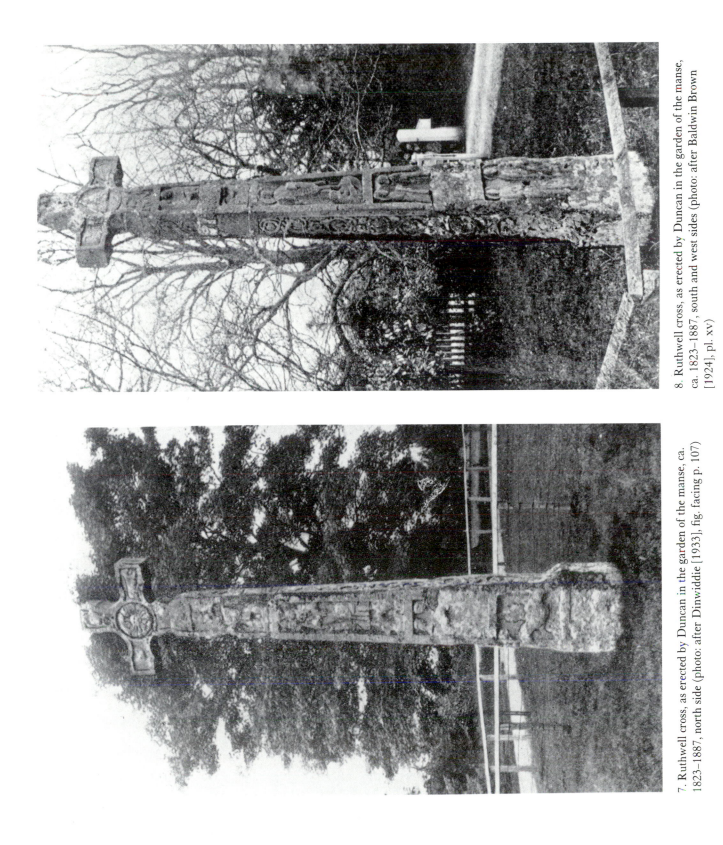

7. Ruthwell cross, as erected by Duncan in the garden of the manse, ca. 1823–1887, north side (photo: after Dinwiddie [1933], fig. facing p. 107)

8. Ruthwell cross, as erected by Duncan in the garden of the manse, ca. 1823–1887, south and west sides (photo: after Baldwin Brown [1924], pl. xv)

10. Detail of Duncan's wax model: the figure with the lamb (photo: courtesy of Mrs. Mary Martin, Curator, Ruthwell Museum)

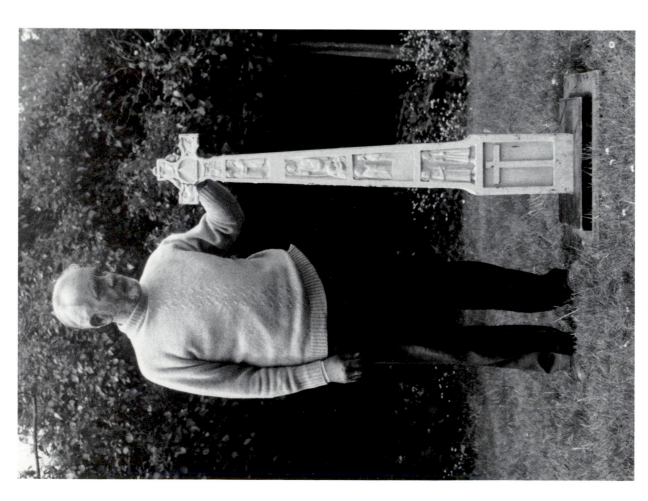

9. Wax model of the Ruthwell cross made by Henry Duncan, shown here with Duncan's descendant, Hugh Duncan F.R.I.B.A., the present owner (photo: courtesy of Mrs. Mary Martin, Curator, Ruthwell Museum)

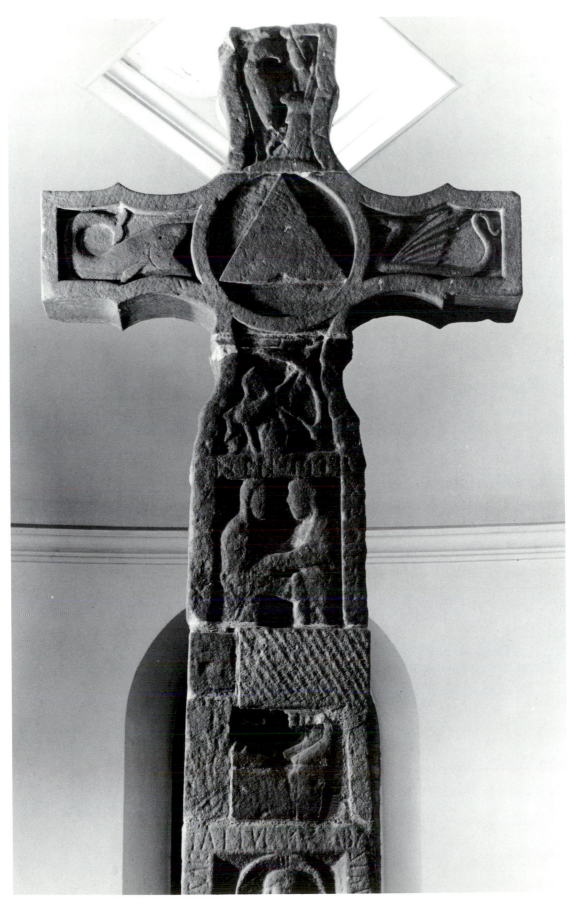

11. Ruthwell cross, south side, top section (photo: Durham University, Department of Archaeology)

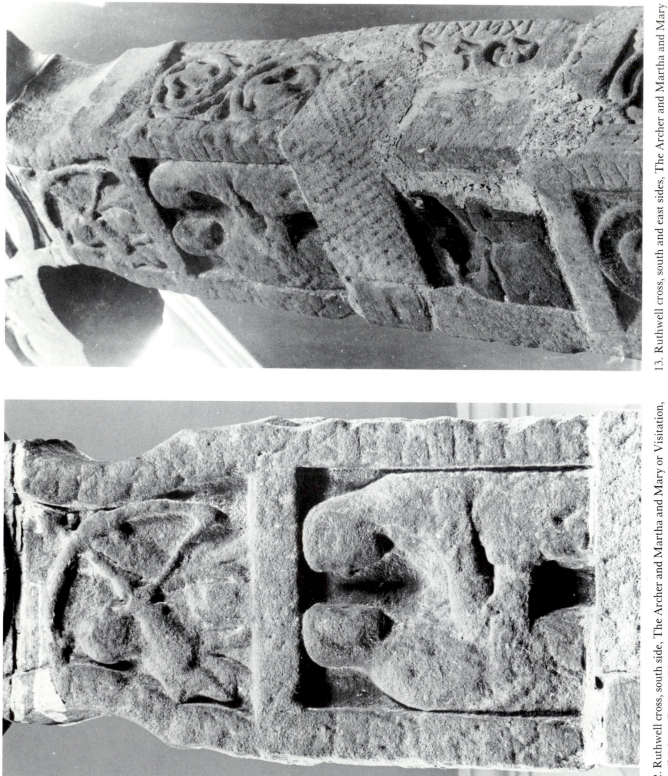

12. Ruthwell cross, south side, The Archer and Martha and Mary or Visitation, detail (photo: Durham University, Department of Archaeology)

13. Ruthwell cross, south and east sides, The Archer and Martha and Mary or Visitation (photo: University of London, Warburg Institute)

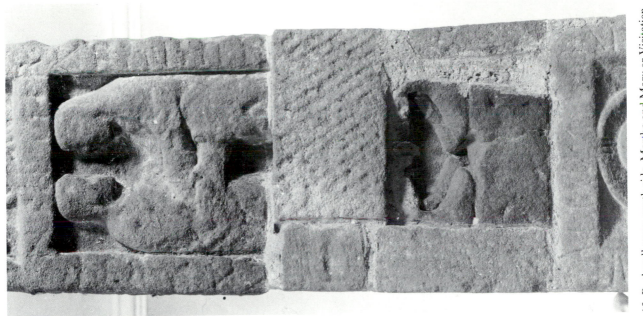

15. Ruthwell cross, south side, Martha and Mary or Visitation (photo: University of London, Warburg Institute)

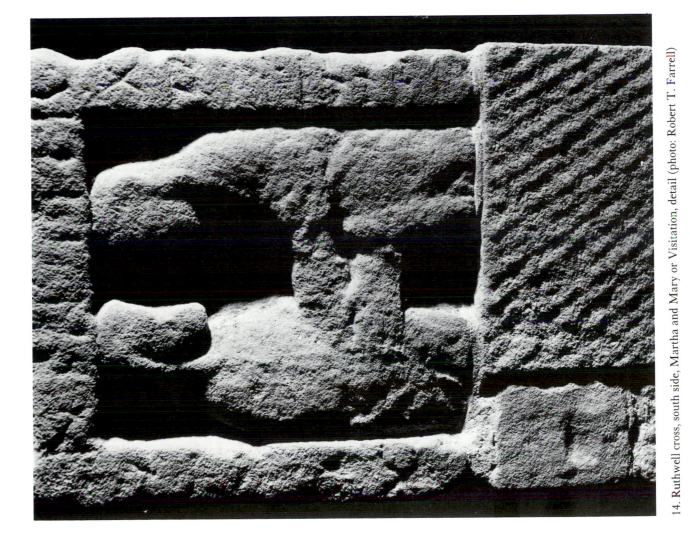

14. Ruthwell cross, south side, Martha and Mary or Visitation, detail (photo: Robert T. Farrell)

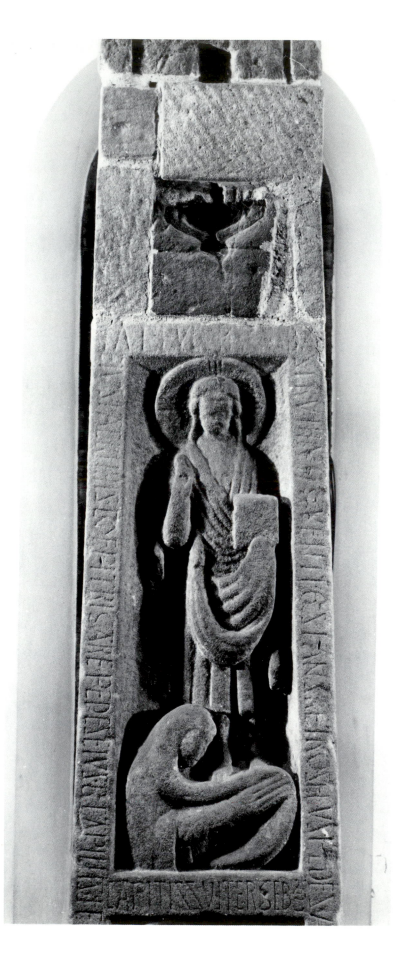

16. Ruthwell cross, south side, Christ and Mary Magdalene, and lower part of Martha and Mary or Visitation (photo: Durham University, Department of Archaeology)

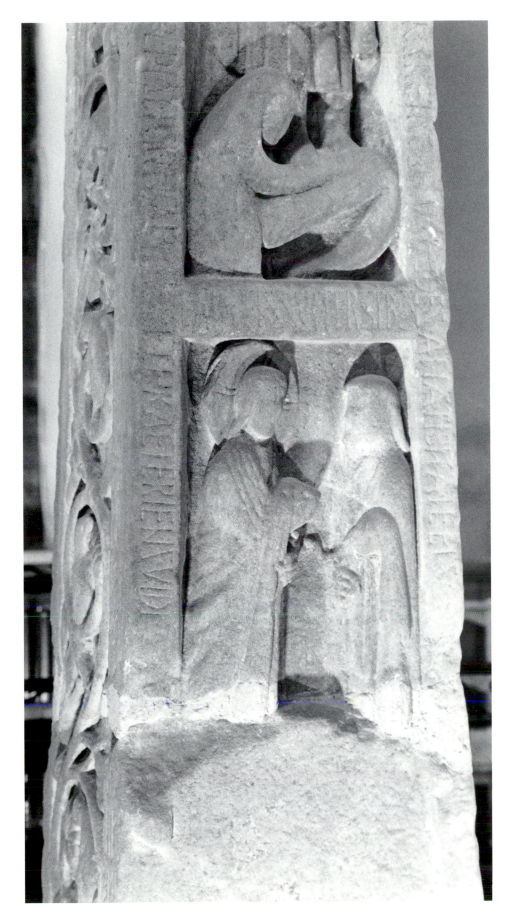

17. Ruthwell cross, south side, Jesus Healing the Blind Man, and Christ and Mary Magdalene, detail, lower part (photo: Brendan Cassidy)

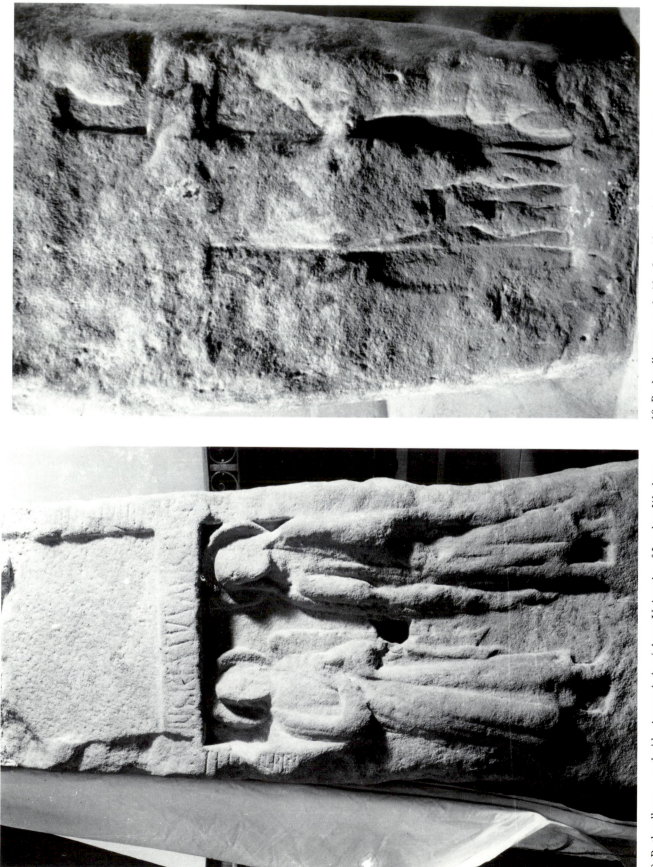

19. Ruthwell cross, south side, Crucifixion (photo: Robert T. Farrell)

18. Ruthwell cross, south side, Annunciation (photo: University of London, Warburg Institute)

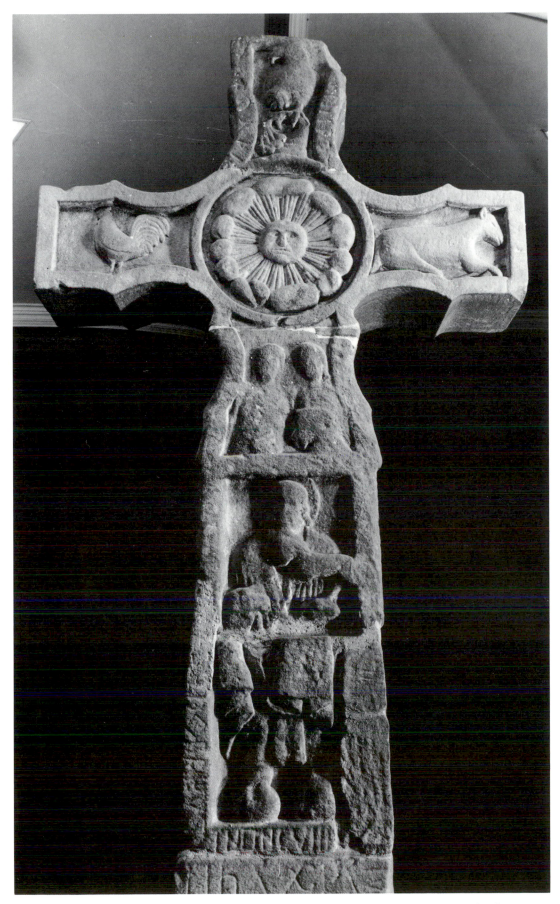

20. Ruthwell cross, north side, top section (photo: Durham University, Department of Archaeology)

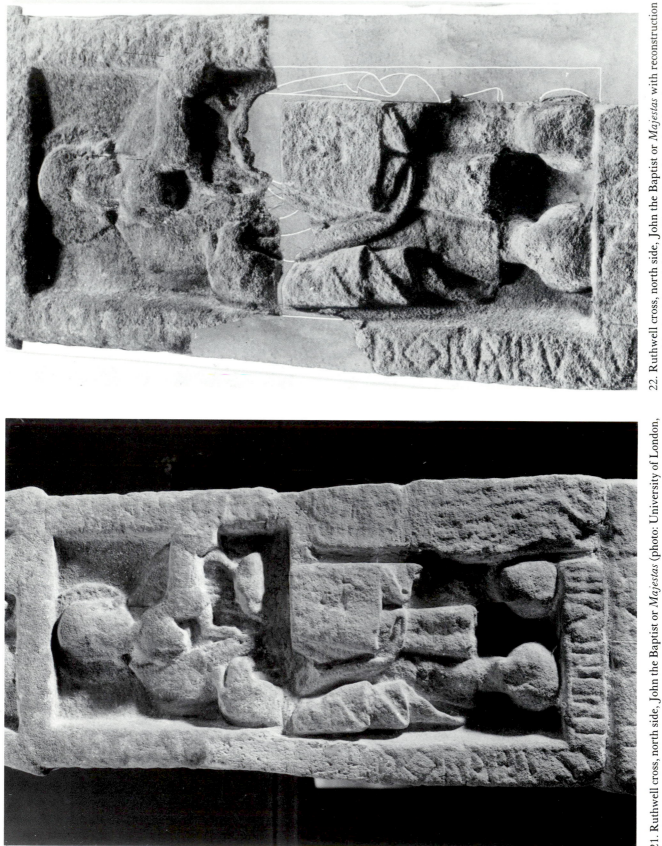

22. Ruthwell cross, north side, John the Baptist or *Majestas* with reconstruction suggested by Saxl (1943) (photo: University of London, Warburg Institute)

21. Ruthwell cross, north side, John the Baptist or *Majestas* (photo: University of London, Warburg Institute)

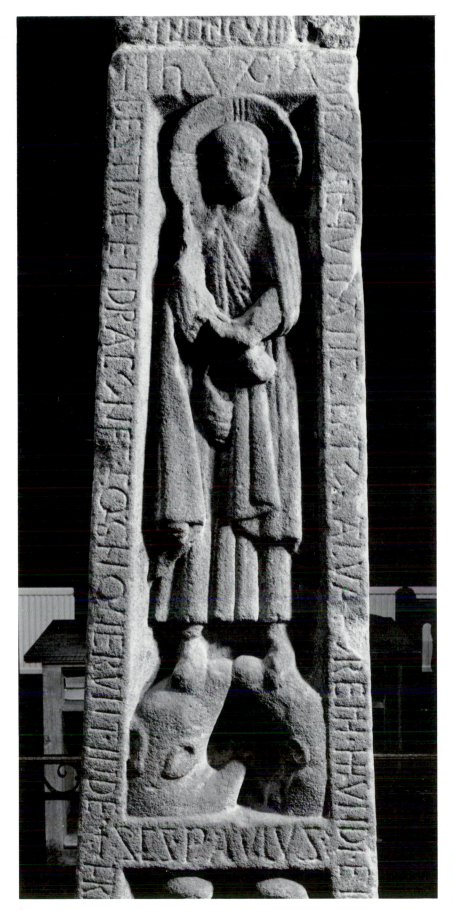

23. Ruthwell cross, north side, Christ on the Beasts (photo: Durham University, Department of Archaeology)

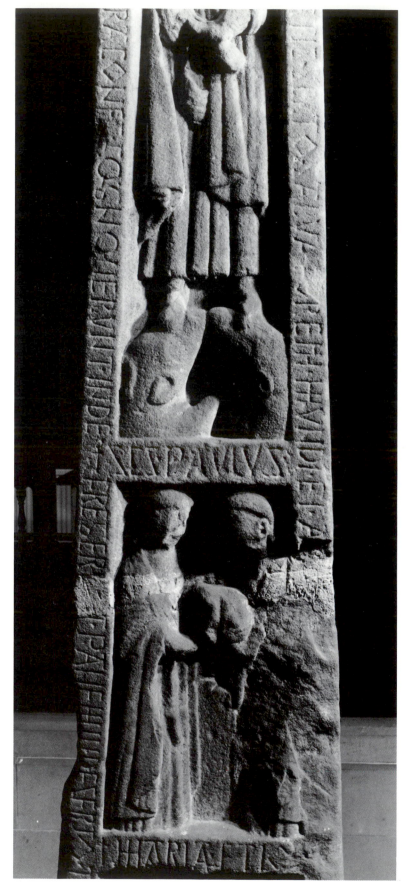

24. Ruthwell cross, north side, Paul and
Anthony Breaking Bread, and Christ on
the Beasts, detail, lower part (photo:
Durham University, Department of
Archaeology)

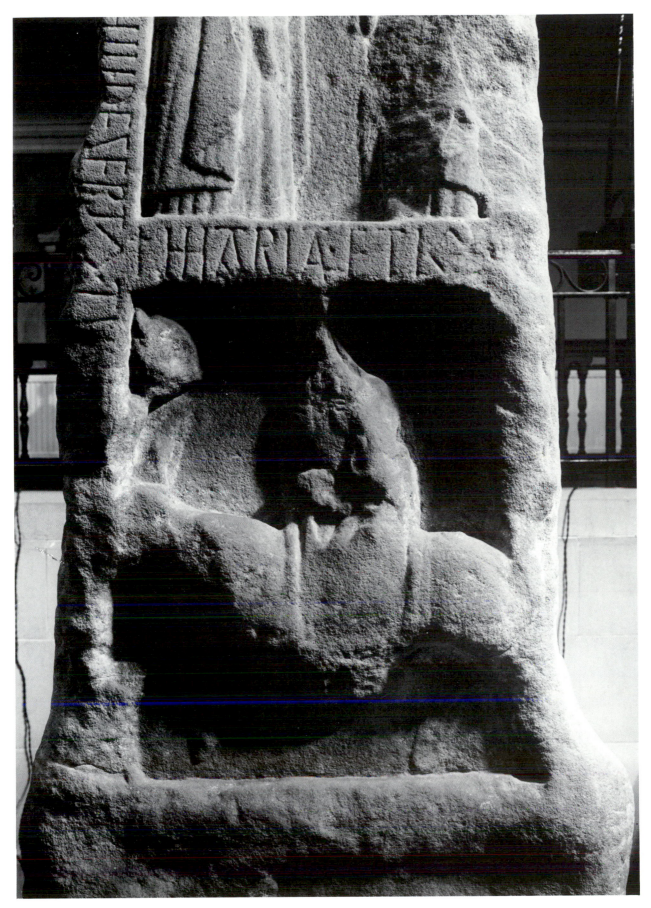

25. Ruthwell cross, north side, Flight into or out of Egypt, and Paul and Anthony Breaking Bread, detail, lower part (photo: Durham University, Department of Archaeology)

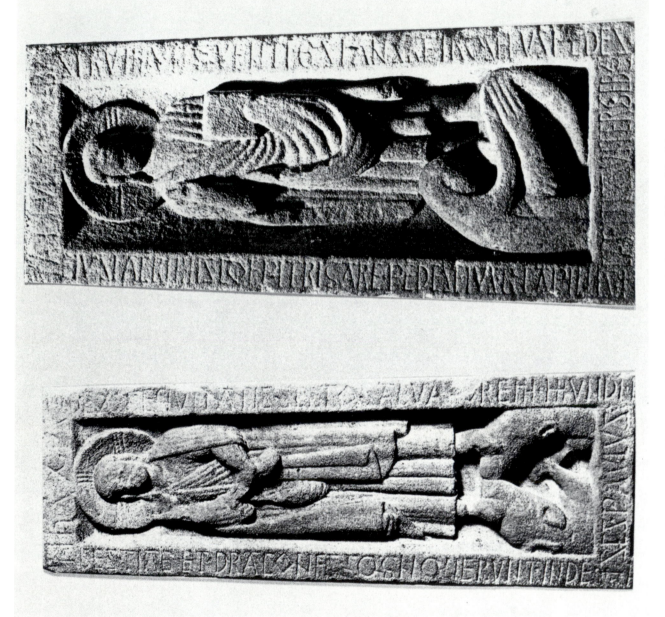

26. Ruthwell cross, left: north side, Christ on the Beasts; right: south side, Christ and Mary Magdalene

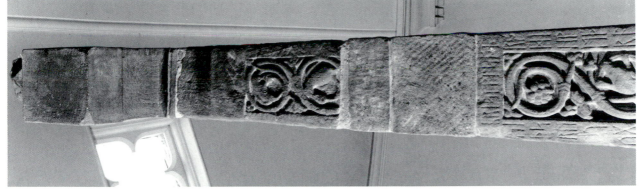

29. Ruthwell cross, west side, detail, upper section (photo: Durham University, Department of Archaeology)

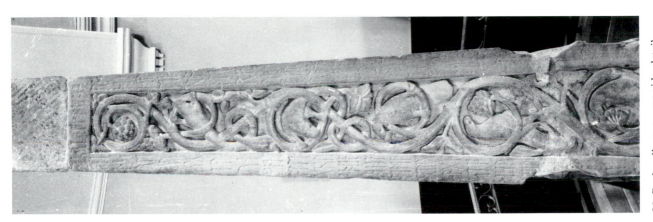

28. Ruthwell cross, west side, detail, middle section (photo: University of London, Warburg Institute)

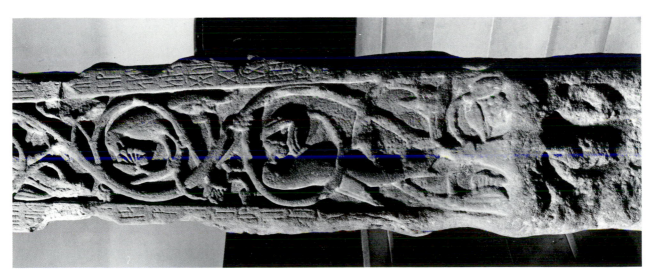

27. Ruthwell cross, west side, detail, lower section (photo: Durham University, Department of Archaeology)

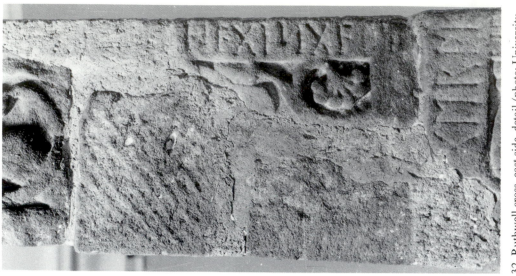

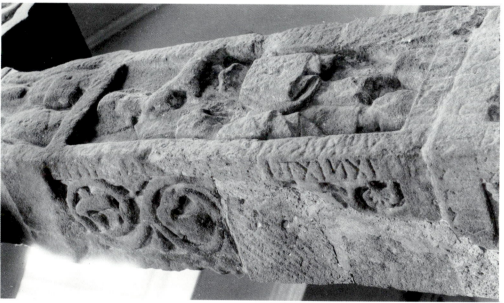

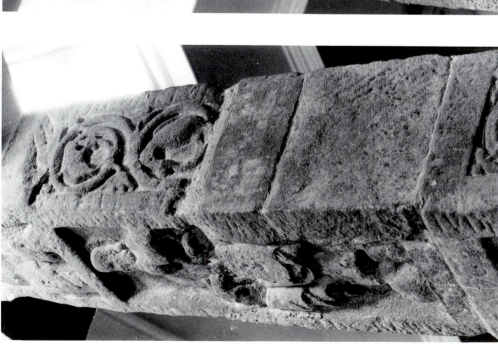

30. Ruthwell cross, north and west sides. John the Baptist or *Majestas* (photo: University of London, Warburg Institute)

31. Ruthwell cross, north and east sides. John the Baptist or *Majestas* (photo: University of London, Warburg Institute)

32. Ruthwell cross, east side, detail (photo: University of London, Warburg Institute)

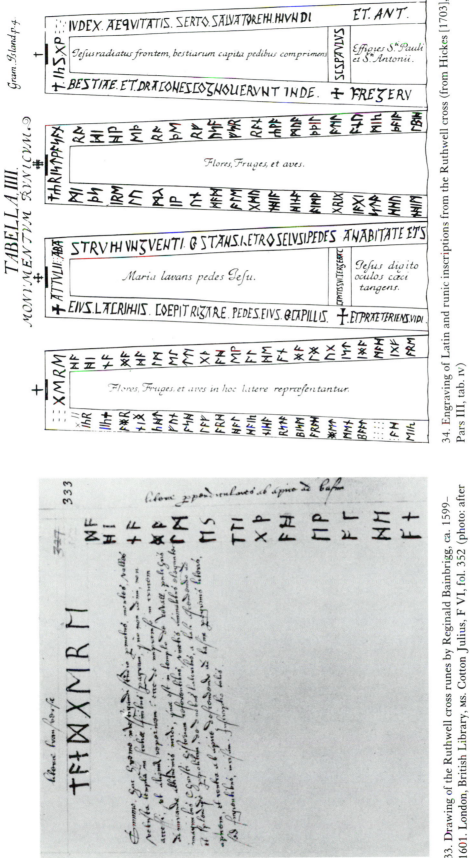

33. Drawing of the Ruthwell cross runes by Reginald Bainbrigg, ca. 1599–1601. London, British Library, ms. Cotton Julius, F VI, fol. 352 (photo: after Page [1959b], pl. xxvi)

34. Engraving of Latin and runic inscriptions from the Ruthwell cross (from Hickes [1703], Pars III, tab. IV)

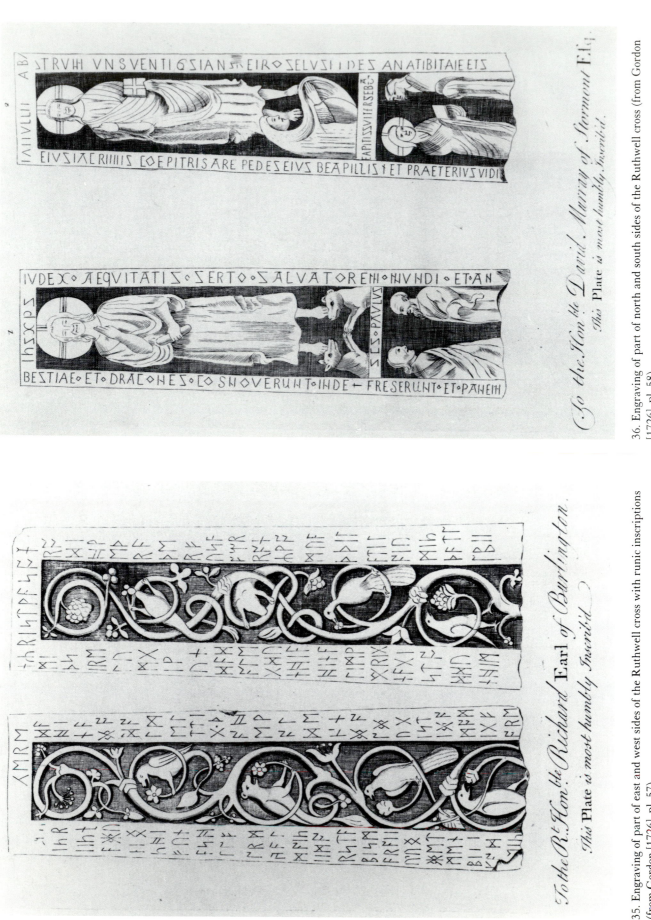

To the Hon.ble David. Murray of Stormont F.Esq.
This Plate is most humbly Inscrib'd.

36. Engraving of part of north and south sides of the Ruthwell cross (from Gordon [1726], pl. 58)

To the R.t Hon.ble Richard Earl of Burlington.
This Plate is most humbly Inscrib'd

35. Engraving of part of east and west sides of the Ruthwell cross with runic inscriptions (from Gordon [1726], pl. 57)

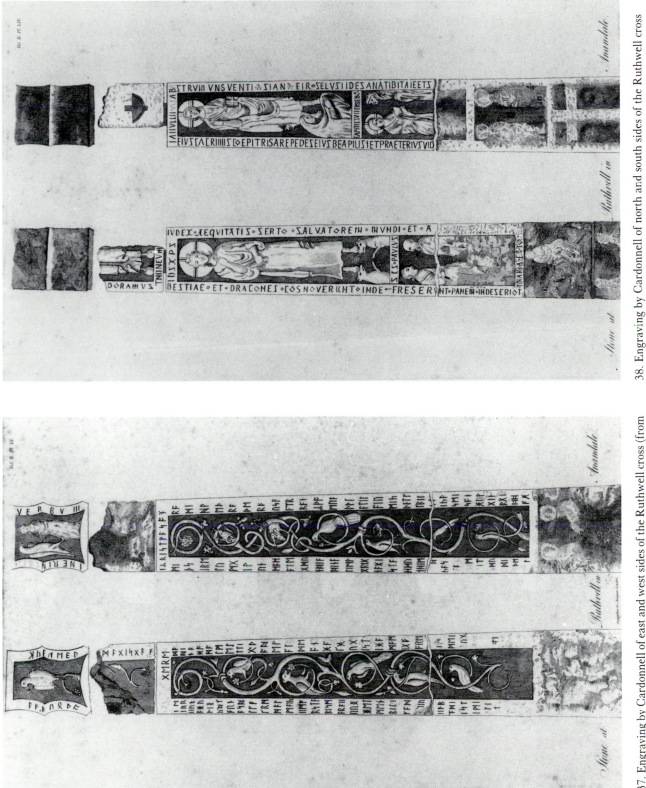

38. Engraving by Cardonnell of north and south sides of the Ruthwell cross
(from Gough [1789], II, pl. 54)

37. Engraving by Cardonnell of east and west sides of the Ruthwell cross (from
Gough [1789], II, pl. 55)

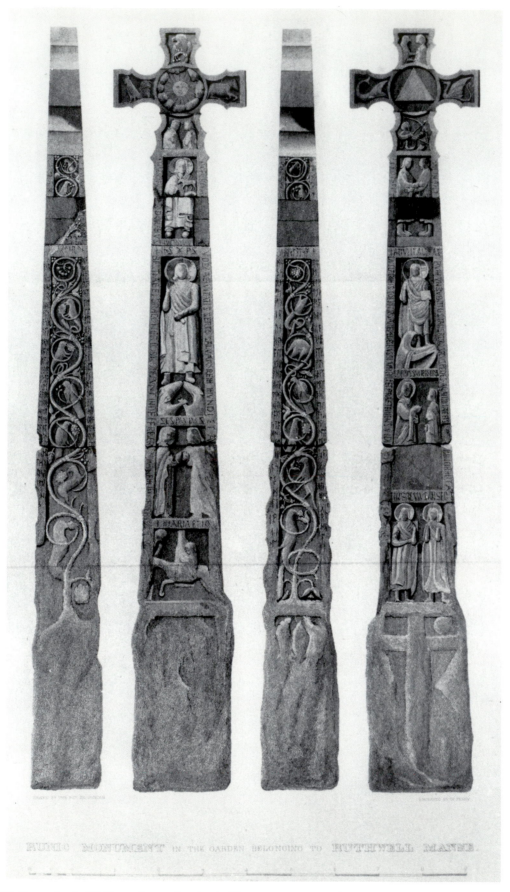

39. Engraving by W. Penny from a drawing by Henry Duncan of the four sides of the Ruthwell cross (from Duncan [1833], pl. XIII)

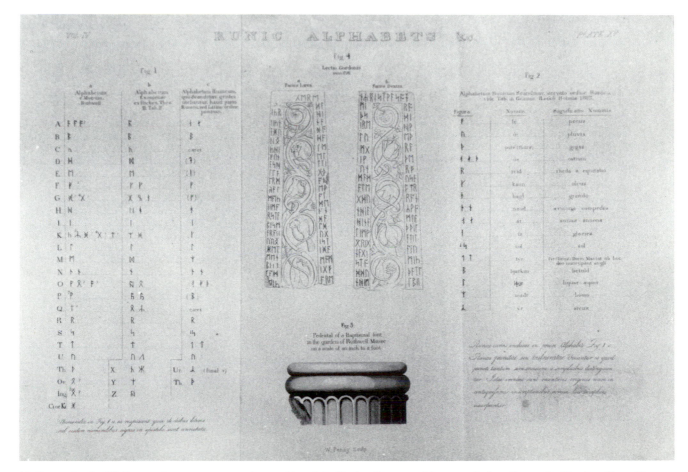

40. Engraving of runes on east and west sides of the Ruthwell cross (from Duncan [1833], pl. xiv)

41. Engraving by W. Penny of runes on east and west sides of the Ruthwell cross, with transcription of runes by Gordon, (from Duncan [1833], pl. xv)

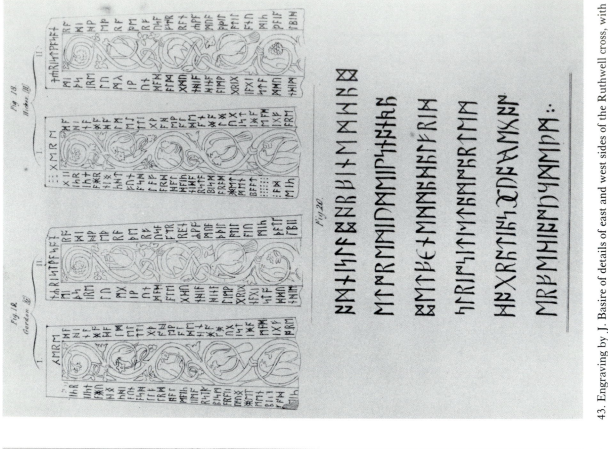

43. Engraving by J. Basire of details of east and west sides of the Ruthwell cross, with transcriptions of runes by Gordon and Hickes (from Kemble [1840], pl. xviii)

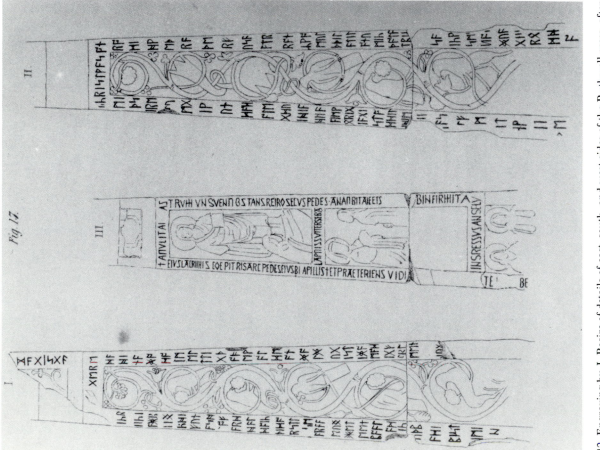

42. Engraving by J. Basire of details of east, south, and west sides of the Ruthwell cross, after Duncan (from Kemble [1840], fig. 17)

44. Engraving of runes on east and west sides of the Ruthwell cross (from Haigh [1861], pl. II)

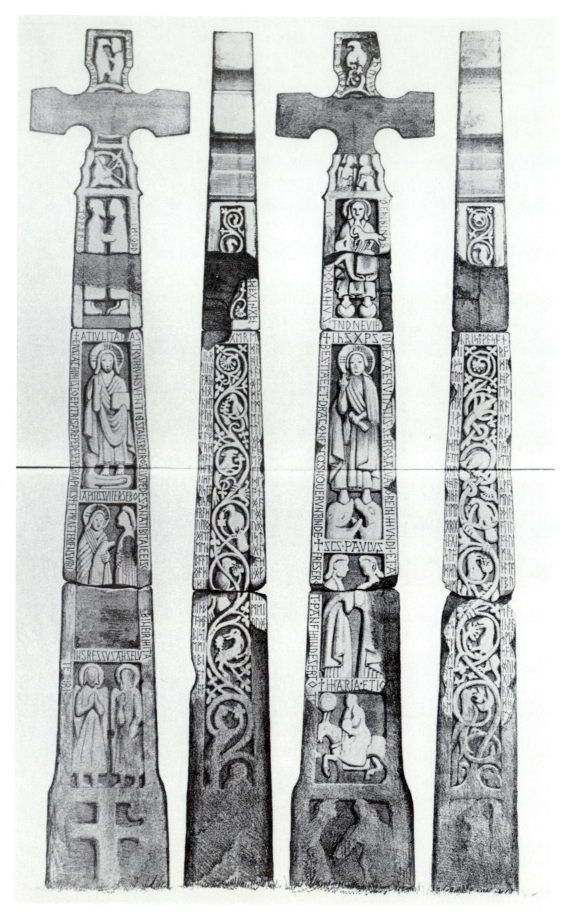

45. Engraving of four sides of the Ruthwell cross (from Stuart [1867], pls. XIX–XX)

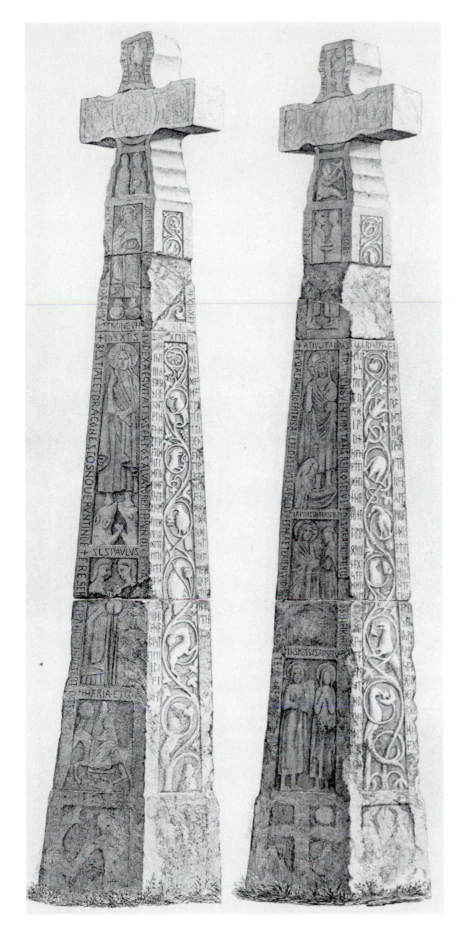

46. Engraving of two views of the
Ruthwell cross (from Stephens
[1866–67], pl. facing p. 405)

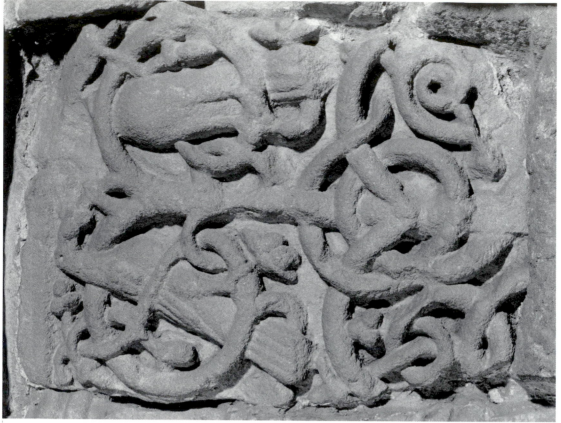

48. *Vine scroll frieze fragment,* St. Paul's Church, Jarrow (photo: Durham University, Department of Archaeology)

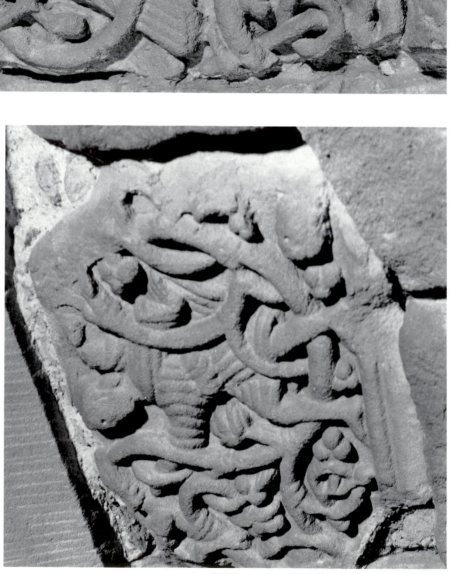

47. *Vine scroll frieze fragment,* "Hunter Relief," St. Paul's Church, Jarrow (photo: Durham University, Department of Archaeology)

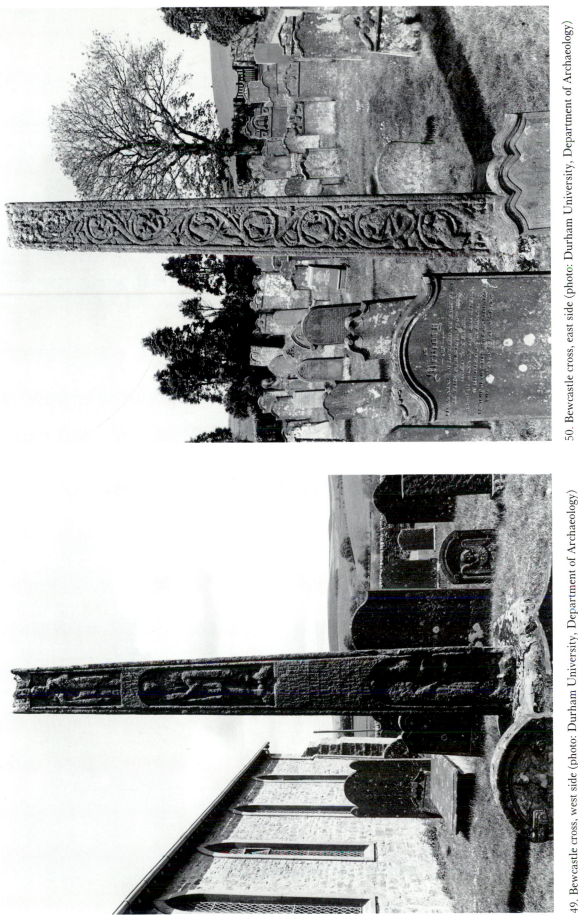

49. Bewcastle cross, west side (photo: Durham University, Department of Archaeology)

50. Bewcastle cross, east side (photo: Durham University, Department of Archaeology)

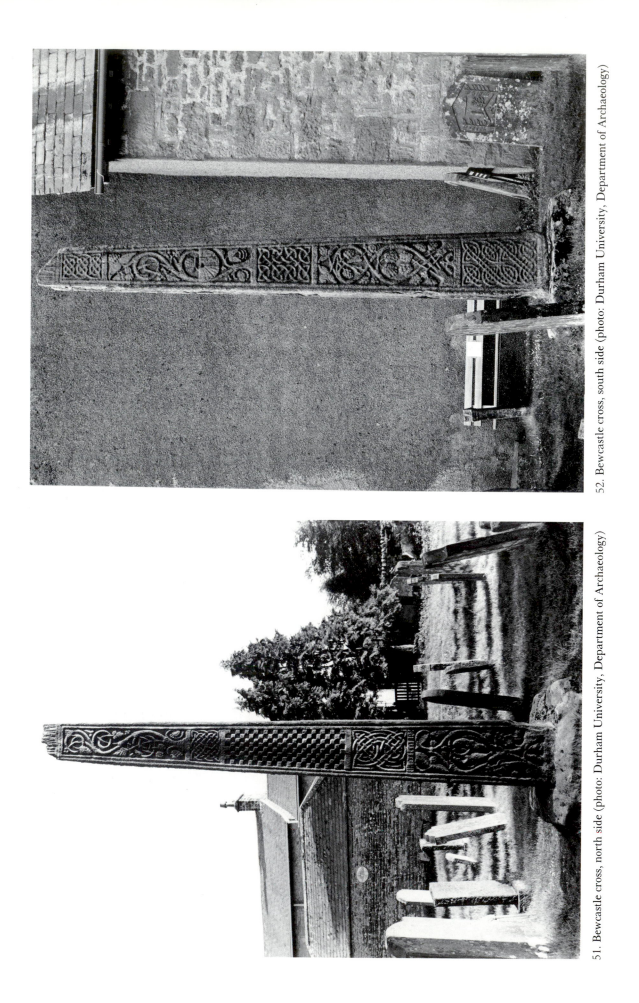

52. Bewcastle cross, south side (photo: Durham University, Department of Archaeology)

51. Bewcastle cross, north side (photo: Durham University, Department of Archaeology)

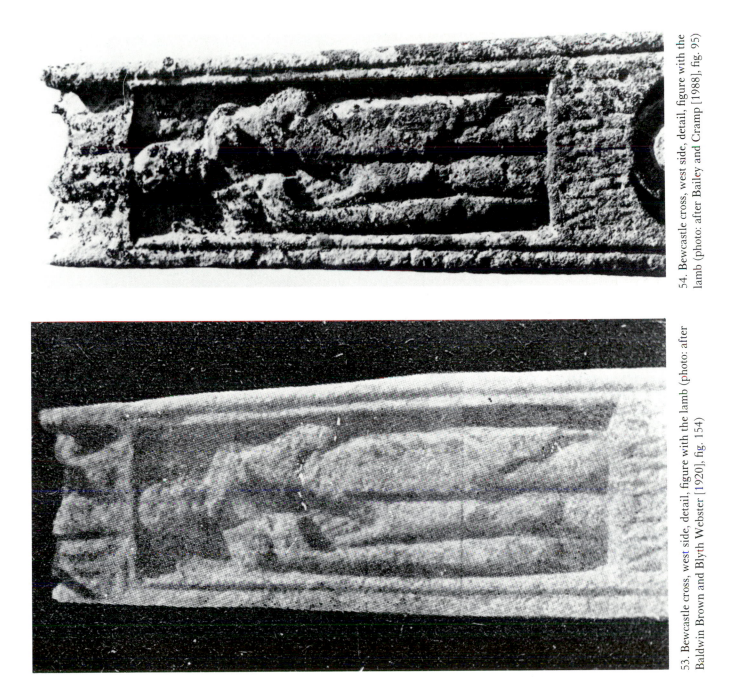

54. Bewcastle cross, west side, detail, figure with the lamb (photo: after Bailey and Cramp [1988], fig. 95)

53. Bewcastle cross, west side, detail, figure with the lamb (photo: after Baldwin Brown and Blyth Webster [1920], fig. 154)

56. Cross-slab, St. Peter's Church, Monkwearmouth (photo: Durham University, Department of Archaeology)

55. Acca's cross, Hexham Abbey (photo: Durham University, Department of Archaeology)

57. *Majestas* with the Lamb, from the *Liber Floridus*, early twelfth century. Ghent, Bibl. de l'Université, MS. 92, fol. 88 (photo: after *Lamberti S. Audomari canonici, Liber Floridus*, ed. A. Derolez, Ghent, 1968, pl. p. 179)

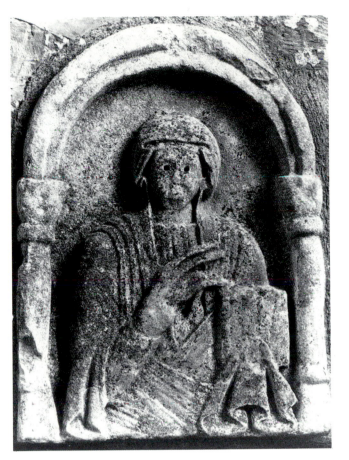

58. Virgin Mary (?), stone relief, eighth century. Breedon-on-the-Hill, Leicestershire (photo: after D. M. Wilson, *Anglo-Saxon Art*, New York, 1984, fig. 88).

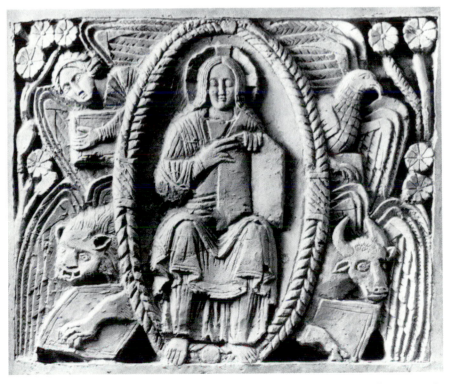

59. Christ between Symbols of the Evangelists, from the Tomb of Bishop Agilbert, seventh century. Jouarre, Abbey, crypt (photo: after J. Hubert, J. Porcher and W. F. Volbach, *L'Europe des invasions*, Paris, 1967, pl. 89)

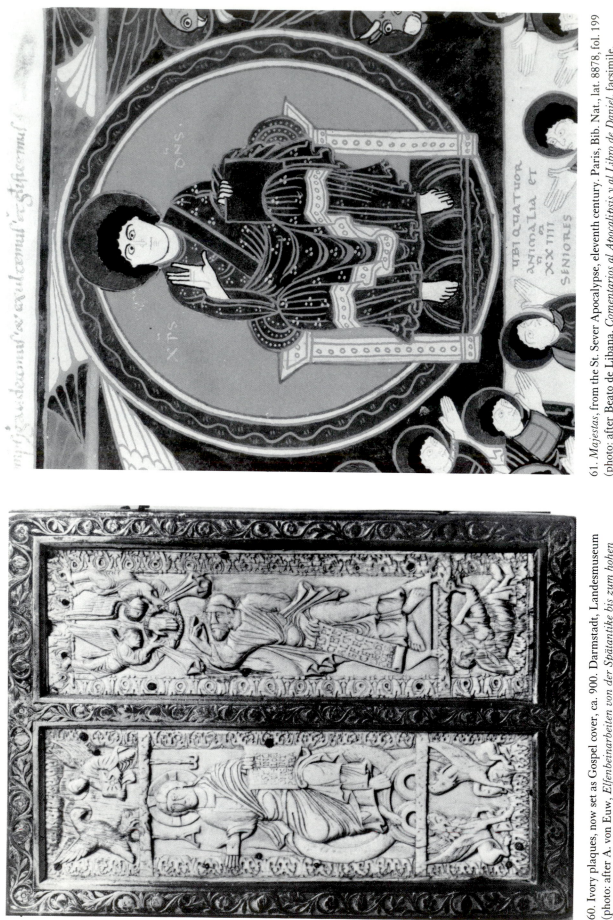

61. *Majestas*, from the St. Sever Apocalypse, eleventh century. Paris, Bib. Nat. lat. 8878, fol. 199 (photo: after Beato de Libana, *Comentarios al Apocalipsis y al Libro de Daniel*, facsimile, Madrid, 1984)

60. Ivory plaques, now set as Gospel cover, ca. 900. Darmstadt, Landesmuseum (photo: after A. von Euw, *Elfenbeinarbeiten von der Spätantike bis zum hohen Mittelalter*, Frankfurt am Main, 1976, no. 6)

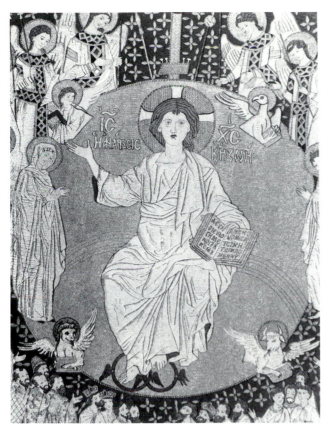

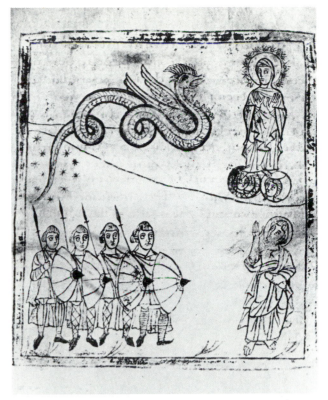

62. *Majestas*, from embroidered dalmatic, thirteenth–fourteenth century. Rome, Vatican (photo: Fogg Art Museum, Cambridge, Mass.)

63. Woman Clothed with the Sun, from the Trier Apocalypse, ninth century. Trier, Stadtbibliothek, Cod. 31, fol. 37r (photo: after *Trierer Apokalypse*, facsimile, ed. R. Laufner and P. Klein, Graz, 1975)

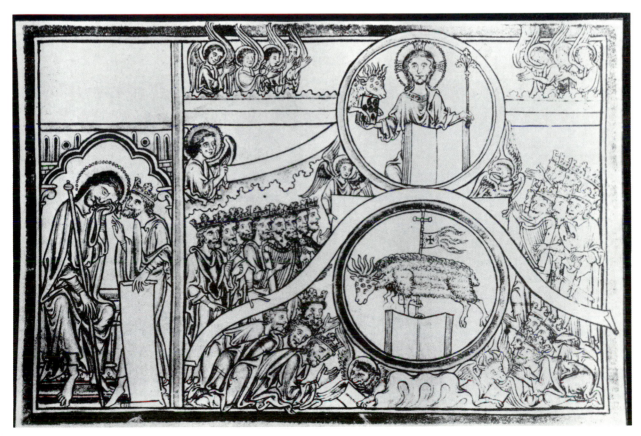

64. Lion of Judah, from Apocalypse manuscript, thirteenth century. Paris, Bib. Nat., fr. 403, fol. 7r (photo: after L. Delisle and P. Meyer, *L'apocalypse en français au XIIIᵉ siècle, [Bibl. nat. fr. 403]*, facsimile, Paris, 1900–1901)

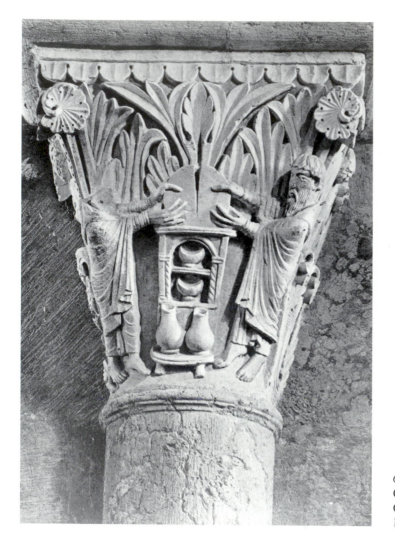

65. Paul and Anthony Breaking Bread.
Capital in the narthex, Vézelay
Cathedral (photo: after P. Deschamps,
Vézelay, Paris, 1943, pl. 25)

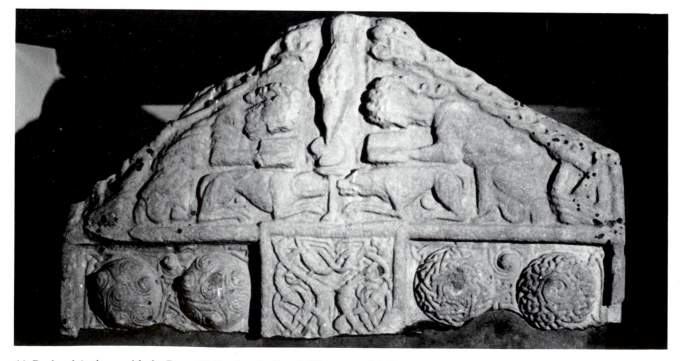

66. Paul and Anthony with the Raven Delivering the Bread. Nigg cross-slab, Nigg, Rosshire, Scotland (photo: Cameron Mac Lean)